The Face of Jizō

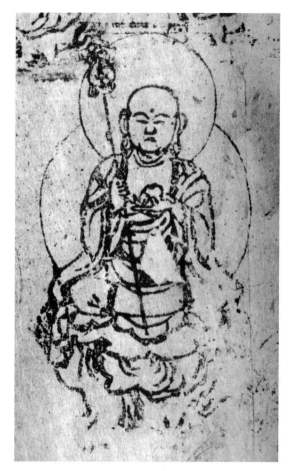

Detail of stamped woodcut image *(inbutsu)* of *sentai* Jizō (one thousand Jizōs), ca. fourteenth century. Courtesy of Gangōji.

Farther on, I find other figures of Jizo, single reliefs, sculptured upon tombs. But one of these is a work of art so charming that I feel a pain at being obliged to pass it by. More sweet, assuredly, than any imaged Christ, this dream in white stone of the playfellow of dead children, like a beautiful young boy, with gracious eyelids half closed, and face made heavenly by such a smile as only Buddhist art could have imagined, the smile of infinite lovingness and supremest gentleness. Indeed, so charming the ideal of Jizo is that in the speech of the people a beautiful face is always likened to his—"Jizo-kao," as the face of Jizo.

Lafcadio Hearn, *Glimpses of Unfamiliar Japan* (1894)

The Face of Jizō

Image and Cult in Medieval Japanese Buddhism

HANK GLASSMAN

University of Hawai'i Press
Honolulu

17 16 15 14 13 12 6 5 4 3 2 1

Library of Congress Cataloging-in-Publication Data
Glassman, Hank.
 The face of Jizō : image and cult in medieval Japanese Buddhism / Hank Glassman.
 p. cm.
 Includes bibliographical references and index.
 ISBN 978-0-8248-3443-2 (hardcover : alk. paper)—ISBN 978-0-8248-3581-1 (pbk. : alk. paper)
 1. Ksitigarbha (Buddhist deity)—Cult—Japan. 2. Buddhism—Japan—History—1185–1600. 3. Buddhist art and symbolism—Japan. 4. Idols and images—Japan—Worship. I. Title.
 BQ4710.K74J336 2012
 294.3'42113—dc23

 2011034561

Designed by Wanda China

Printed by Sheridan Books, Inc.

This book is dedicated to my Campanella

Narita Miu
成田弥宇
(1961–1990)

You sent me to the Rokudō mairi *at Chinnōji.*
You sent me to the 25 bosatsu *at the Hakone Pass.*

　「僕もうあんな大きな暗の中だってこわくない。きっとみんなの
ほんとうのさいわいをさがしに行く。どこまでもどこまでも僕たち一
緒に進んで行こう。」
　——宮沢賢治、『銀河鉄道の夜』

Contents

Plates follow page 100

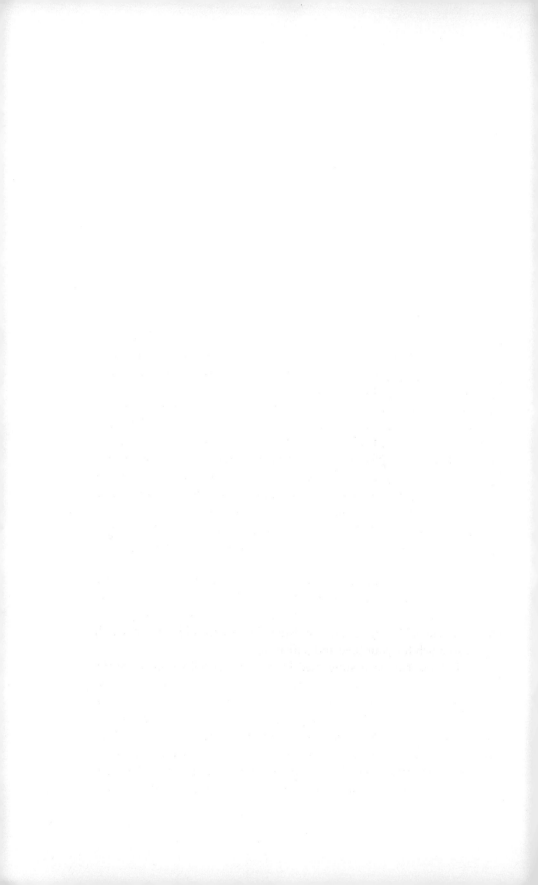

Acknowledgments

This book has, in the end, taken quite some time to complete. The original idea came to me on Mount Kōya in 1984. It occurred to me that I should write a book about the small stone figures nestling in great numbers into the roots of the ancient trees there. It seemed it would interesting to explore the relationship between Jizō, the bodhisattva of myth and legend, and these anonymous sentinels on the mountain, also called Jizō. Many other projects have intervened, and as I have juggled these projects with teaching and family life, more than a quarter century has slipped by. While most of my work on the book took place in a necessary state of isolation, I owe a debt of gratitude to the great many people who helped me along the way in the research and the writing. Teachers and friends, as well as scholars long since passed on before I was born, I thank each of you all for your part in bringing this work to fruition after many years of labor.

First, I thank my parents, Arthur and Lenore. I begin to know some of the things you have known. I wish you could both be here with me. Also, appreciation and love go to my family. To my wife, Rosy, and my children, Caleb, Varney, Oscar, and Mila. And to my siblings. Thank all of you so much for your love and patience.

This book has been supported by a yearlong fellowship from the National Endowment for the Humanities (2005–2006), by grants to travel to Japan awarded by the Haverford College Alumni Fund and the Japan Foundation (2008 and 2009), and by subventions for image rights and production from Haverford and from the Warner Fund at the University Seminars at Columbia University. The ideas presented here have also benefited from discussions following my presentation of the work at Columbia in the Seminar on Buddhist Studies. Additionally, the John

B. Hurford Humanities Center at Haverford has supported my work in various ways, including funds for two summer undergraduate research assistants.

Portions of the work were presented at conferences—"History and Material Culture in Asian Religions," University of Pennsylvania; "Voices in Japanese Literature: Symposium in Honor of Susan Matisoff," University of California, Berkeley; "Monsters and the Monstrous in Premodern Japanese History and Culture," Indiana University; "Symposium on the Medieval Development of Nanto Bukkyō," Ōtani University; "Sand, Stones, and Stars: Nature in the Religious Imagination," Yale University; "Elective Affinities: Seventh Triennial Conference of the International Association of Word and Image Studies (IAWIS/AIERTI)"; "Third Annual Nara ehon, emaki Conference," held in Nara, Japan; and the "First International Buddhist College (IBC) Buddhist Studies Conference," held at Than Hsiang Temple, Penang, Malaysia—as well as at several meetings of the American Academy of Religion and the Association for Asian Studies. I have also shown some of the images and discussed the book's themes during invited talks at the University of British Columbia; the University of California, Santa Cruz; the Institute of Buddhist Studies, Graduate Theological Union, Berkeley; and at Columbia University. On these occasions I received much feedback, advice, and critiquing, and I would like to thank the organizers of these gatherings as well as the participants for making it possible for me to share my work and develop my ideas in conversation with others.

This is a book with many illustrations, and I deeply appreciate all of the people who were instrumental in helping me gain permissions and high-quality reproductions for the images. From Gangōji and the Gangōji bunkazai kenkyūjo, Takahashi Nariaki and Rev. Tsujimura Taizen. From the Nara National Museum, Kimura Maki and Yuyama Ken'ichi. Rev. Matsuura Shinkai of Mibudera and Tōshōdaiji; Rev. Ishida Ta'ichi, Tōshōdaiji; Rev. Sakaida Kōdō, Rokudō Chinnōji; Rev. Sakai Suga, Seki Jizō-in; Moritani Yoritsui, Daienji; Shirayama Yoshihida, Jizō-in Tsu; Tanabe Hiroshi, Ōkuraji, Nara; Rev. Nishiyama Myōgen, Denkōji, Nara; Rev. Ōnishi Seigen and Fukuoka Masayoshi, Kiyomizudera; Rev. Kawasaki Junshō, Rokuharamitsuji; Morikawa Hiromi, Iwanami shoten; Nishio Michihiro, Yata Jizōson; Rev. Sakai Eikō, Fukuchi'in; Nara Rev. Sakai Shōdō, Fukuchi'in; Rev. Ukai Kōgyoku, Seiryōji; Rev. Ōkoji Kaikō, Nōman'in; Okamoto Takashi, Kunaicho Sannomaru Shōzo'in. At the Metropolitan Museum of Art, Barbara Ford, Masako Watanabe, and Sinead Kehoe; Thomas Lisanti and Margaret Glover of the New York Public Library and the Spencer Collection; Julia Meech and John C. Weber; Holly Frisbee, Philadelphia Museum of Art; Meghan Mazel-

la, Museum of Fine Arts, Boston; Stephanie Wada and Gratia Williams Nakanishi, Mary Griggs Burke Collection; Bettina Clever, Köln Museum für Ostasiatische Kunst; Adriana Proser, Elizabeth Bell, Marian Kocot, and Martha McGill, Asia Society, New York; Elizabeth Saluk, Cleveland Museum of Art; Michael Jamentz; Kumasaki Tsukasa, Mie kenritsu hakubutsukan; Katsura Michiyo, International Research Center for Japanese Studies, Kyoto.

And with many, many thanks for collegial conversations, for friendship, for mentoring, for encouragement and inspiration, for references to books and articles, for meals, for drinks, for couches to sleep on, for all the help that you have given me: Watari Kōichi, Kōdate Naomi, Matsuoka Hideaki, Hino Takuya, Hyōtan-ya (Ōi ningyōten), Melanie Trede, Zhiru Ng, Lori Meeks, Jacqueline Stone, James Foard, William LaFleur, Keller Kimbrough, David Quinter, Conan Carey, Furue Mitsuru, Yoko Koike, Okuyama Michiaki, Hayashi Makoto, Yoshida Kazuhiko, Paul Swanson, Yamaji Sumi, Abe Yasurō, Motoi Makiko, Ōkawa Naomi, Shimizu Kunihiko, Ishikawa Tōru, Tokuda Kazuo, Barbara Ruch, Mimi Yiengpruksawan, William Bodiford, Tomoko Sakomura, Miyata Noboru, Paul Watt, Philip Yampolsky, Debbie Friedman, Rev. Philip Zaeder, Rabbi Everett Gendler, Itō Akira, Rev. Takaoka Shūchō, Aoki-Takaoka Chizuko, Watanabe Gufu, Watanabe Atsuko, Nakamura Osamu, Andy Corturier, Duncan Williams, Eisho Nasu, Max Moerman, Manabe Shunshō, Barbara Ambros, Matsuo Kenji, Carin Berger, Jan Chozen Bays, Jack VanAllen, Patricia Yamada, Elizabeth Harrison, Manabe Kôsai, Marinus Willem deVisser, Ellen Sidor, Temenos, Tersina Rowell Havens, Mark McGuire, Helen Hardacre, Caroline Hirasawa, Haruko Wakabayashi, Keller Kimbrough, Nishiyama Miki, Carl Bielefeldt, Jacqueline Stone, Bernard Faure, Susan Matisoff, Tom Hare, Jeffrey Moss, Jan Nattier, Richard Payne, Lisa Grumbach, Andrew Hare, Michael Foster, Hun Lye, Hashimoto Hiroyuki, Richard Jaffe, Buzzy Teiser, Ryuichi Abé, Michael Como, Mark Rowe, James Robson, Mark Unno, Jane-Marie Law, Gail Chin, Sarah Ross, Erika Hanson, Gordon Goldstein, Joe Arcidiacono, Chris Napolitano, Rory Lydon, Joe Lamb, Anna Goldstein, Hilary Illick, Pierre Valette, Clint Elliott, the Narita family of Odawara, the Moriyama and Okuda families of Yokohama. Thank you, thank you, thank you.

While I have been blessed with a host of well-wishing and perceptive friends and colleagues, I am by nature disorganized. I have done my best to curb my tendencies and have relied heavily on others to catch my mistakes and set them right. These angels include Jesse Drian and Murakami Masataka, two wonderful and energetic Haverford students who worked with me two summers, and Rosemary Wetherold, my brilliant copy edi-

tor. Patricia Crosby of University of Hawai'i Press has been a steady and patient hand in guiding the project over the years, and I am truly grateful for her faith in me. No doubt, scattered errors in fact and interpretation will remain. However, they are far, far fewer for the generous and gracious help of all these good folks.

The Iconology of Jizō

THE HISTORY OF BUDDHISM in Japan is from its very origins a history of images. The poles of attraction and anxiety marking the first encounter with the foreign religion and its icons set up an oscillation felt down through the centuries. It was the gift of a Buddha statue in the mid-sixth century from the Korean kingdom of Paekche (known in Japan as Kudara) that first inspired the court to embrace and propagate Buddhism. In the chronicler's account of this event, appearing nearly two centuries later in the *Nihon shoki*, the awestruck emperor and his court are drawn to the image's "countenance...of severe dignity" and find the neighboring ruler's description of the power and truth of the Buddhist faith appealing, but they are not sure what course of action to take.[1] There is considerable trepidation that bowing down to this god of foreign provenance might anger the local deities. From this time forward, the competition and cooperation between indigenous gods and imported ones was to be mediated through the visual field.

> King Seimei of the Korean kingdom of Kudara dispatched Kishi Nurishichikei and other retainers to Japan. They offered as tribute a gilt bronze statue of Śākyamuni Buddha, ritual banners and canopies, and several volumes of sūtras and commentaries.... Thereupon, the emperor inquired of his assembled officials, "The Buddha presented to us from the country to our west has a face of extreme solemnity. We have never known such a thing before. Should we worship it or not?"[2]

Here we see the ways in which the face of the saint serves to foster a direct and visceral emotional connection. The reaction, however, is a

decidedly ambiguous one. The account given in the *Nihon shoki* goes on to describe the troubles and the debates that ensued from the worship of this image by the powerful statesman Soga no Iname. After an epidemic claimed many lives in the capital, the statue was seized and thrown into a canal. Still, after this ambivalent start, as subsequent entries in the *Nihon shoki* attest, statues continued to be imported from the peninsula over the ensuing decades; carvers and painters specializing in Buddhist iconography also made their way across the straits.

Before long, Buddhism became a driving force in Japanese religious and political life, and this trend only deepened over the course of the seventh century. The enshrinement of a colossal Buddha image in the capital, at Nara's Tōdaiji in the middle of the eighth century, marks the adoption of Buddhism as a powerful tool of statecraft. Its consecration, or "eye-opening," by the Indian monk Bodhisena, who painted in the pupils of the completed statue (the final act required to bring the image to life), also indicates the truly international character of the new faith. Clearly, the reasons for the eventual enthusiastic adoption of Buddhism in Nara-period Japan are complex, and a desire for improved political and cultural relationships with the mainland—especially on the part of clans with blood ties to the continent, like the Soga, a Korean immigrant lineage—no doubt played a large part. Nevertheless, the story of the impression made by the Buddha image in the brief and semi-mythological account of the *Nihon shoki* is a compelling one.

Images speak to the human mind and heart in a direct way that texts cannot. In this book, I explore the function and meaning of visual representation found in the history of one religious tradition. My aim is to make clear how images of the bodhisattva Jizō were essential to certain men and women at specific times, in specific places, in their efforts to understand this deity, to understand Buddhism, to understand themselves and their place in the world. Also, I take the writing of this book as an occasion to ponder the role of images in religious life more generally. As is clear in the earliest account of a Buddhist image in Japan—the *Nihon shoki* entry cited above—interpretation of the numinous power of icons was from the beginning ambivalent. (My interpretations will also be necessarily thus.) If nothing else, this incident and its aftermath demonstrate how the effects of religious works of art reverberate far beyond the frame; they cannot be contained within the body of the statue, but flood out into society.

It is my sincere hope that this book might also be of interest to those outside the field of Japanese history, as we together devise ways to think more deeply and more complexly about the use of images in religious cultures. There are moments in my narrative where a close knowledge of the

time and place will prove essential, but I will endeavor to move forward in a way that brings along as many people as possible. To this end, I have glossed Japanese and Buddhist terms in the text, providing romanization and a short explanation to help along the reader less familiar with the field, and have confined names and terms in Asian scripts to a glossary at the back. There may be places where the uninitiated may scratch their heads in puzzlement, but I ask them to press on, trying to keep the larger canvas in mind. I trust that the gist of my arguments will thus be available to any interested reader, not just to close colleagues.

This book is largely inspired by the methodological approaches developed by Aby Warburg, an art historian who lived around the turn of the last century and was a student of the Italian renaissance. While it is a commonplace today to insist that the scholarly examination of religious art must go beyond an analysis of form, style, and simple iconographical content, in Warburg's day the type of formalist analysis that would come to dominate twentieth-century art history was being heralded as the great new approach, a scientific method suited to the modern world. Going against the scholarly fashions of his time, Warburg insisted upon a different mode of investigation, one that took contextual meaning as a primary object, while at the same time refusing to be hemmed in by a narrow view of historical possibility. He occasionally referred to this approach as "iconology."[3] Bernard Faure has warned of the "double pitfalls" of formalism and historicism inherent in such an enterprise: "Iconological interpretation, despite (or because of) its sophistication, tends to hermeneutic overkill."[4]

Although Warburg never developed his methods into a clear and distinct discipline (Robert Klein famously quipped that it was a "science without a name"), his writings contain a great many tantalizing hints and his oeuvre as a whole provides a fascinating model for the contemporary student of religious art.[5] It has been said that Aby Warburg was the father of cultural studies, and indeed his approach (which he sometimes called *Kulturwissenschaft*) is just the sort of comprehensive and integrative method that scholarship produced under the banner of "cultural studies" has tried to be. For Warburg, though, images in particular were always the central point of inquiry. He could also be saddled with a similarly paternal role in the creation of what we have been calling visual culture (a term that refers to the study of visual culture rather than the objects of that study, as its name might wrongly imply).[6] Warburg felt that the doctrinal, political, economic, and social dimensions of a culture are most clearly expressed through the images it creates. I agree with this assessment and also follow Warburg in his insistence that images reveal points of tension in history and culture, fissures or fault lines that can

lead us to deeper understandings if we have the curiosity and fortitude to plumb them.[7]

Francis Haskell, in his fascinating work on the uses of images as sources and as evidence by historians from Petrarch to Huizinga, praises Aby Warburg for his embrace of ordinary images. It is not that Warburg had disdain for aesthetically pleasing images or great works of art, but rather that he felt just as much, if not more, could be learned from the quotidian painting or the clumsily carved statue. While many scholars in his day were interested in "low art" and in the folk, primitive, or grotesque, Warburg's innovation was to combine high and low in his investigations.[8] Just as he had an aversion to the "border police" at the edges of the disciplines and sought to integrate various methodologies into his investigations, Warburg worked to break down the imaginary barriers between the elite and the popular.

Giorgio Agamben maintains that Warburg's approach to images and to their contexts has deep implications for the practice of historical scholarship. In confronting the past through images, seeing through our own eyes what the people we study saw, we are forced to examine our own subjectivity in a visceral response that collapses the diachronic and the synchronic:

> The greatest lesson of Warburg's teaching may well be that the image is the place in which the subject strips itself of the mythical, psychosomatic character given to it, in the presence of an equally mythical object, by a theory of knowledge that is in truth simply disguised metaphysics. Only then does the subject rediscover its original and—in the etymological sense—speculative purity.[9]

That is, for Warburg, images offered a door to the interior worlds of historical actors. And while image and word certainly form an opposition in his thought, he also saw them as an inevitably linked synergistic pair. At the historical moment when his colleagues were emphasizing the timeless nature and universality of great artworks, Warburg insisted upon understanding all visual artifacts as embedded in specific social, economic, and narrative contexts.[10]

While the present study is nominally a book about the deity Jizō, it is also a book about the religious culture of medieval Japan as a whole. By focusing on the worship of one bodhisattva, we are able to discern the transformation and popularization of Buddhism throughout Japan over the course of the medieval period in a manner quite different from the sect-based approach taken by many scholars over the past half century.

In this book I intend to use certain strains of Warburg's thought to

create a kind of ad hoc method. That being said, it is never necessary for this method to become more than just that, a heuristic lens, serving where it will to allow us to see into the past with greater clarity. In reading Warburg, I have learned something about a different way of attending to images—a new way to listen to the stories they tell. I hope through this study to make a small contribution to the growing body of scholarship on "living images" in Asian religions. In studies such as Richard Davis' *Lives of Indian Images* or Donald Swearer's *Becoming the Buddha*, the idea of the nonmaterial aspects of religious icons is made clear. Through rituals of consecration and animation, through the practices and beliefs of the image's devotees, statues and paintings take on lives of their own to become "real presences," to borrow Robert Campany's term.[11] The notion of living images has been a potent one in Japan, and Jizō statues (resembling as they do the ordinary human Buddhist monk) are particularly rich in legends of embodied interventions on behalf of believers.[12] Criticizing the historicist and contextual research of Baxandall and others, Faure has pointed out that in an attempt to go beyond formalism by clarifying the economic, social, and political networks standing behind images, this research still poses a real danger of reducing the complexity of the religious icon to the fact of the object itself. Faure argues that what is missing is the response of the beholder, not just as an aesthetic reaction; icons need to be studied with an eye to "the *performative* function they have in a ritual context" (emphasis added).[13]

This book examines the Jizō cult from its first flourishing in the late twelfth century through its expansion and transformation in the late medieval period and into the "early modern" seventeenth century. It undertakes this examination through the cult of images. The study is an iconological one. I use the word "iconological" in the sense originally intended by Aby Warburg, not as recast by his widely influential disciple Erwin Panofsky.[14] For Panofsky, "iconology" referred to a level of analysis that unpacks the symbolic meanings of iconographies to interpret the meaning of the art object against its social and cultural background. For Panofsky, iconology was a tool for reading the encoded language of masterpieces of religious art, a language that was sui generis and sprung from the mind and soul of the artistic genius. For Warburg, the term had more to do with reading meanings through historical context and looking for ways to restore connections that would have existed in the mind of the contemporary viewer but are lost to modern eyes. With its attention to elements of the visual that are beyond the plastic, such as dance, performance, dreams, visions, and oracle, the present study is similarly less about the images themselves than about the events, actions, and stories that surrounded them and suffused them with an aura of miraculous efficacy.

The purpose of this book is to demonstrate the centrality of images in the promotion and dissemination of the Jizō cult and additionally (if only between the lines) to outline a general theory of images. Central to this imagined theory is the idea that it is a fundamental error to regard religious images first and foremost as works of art.[15] Icons are not art per se; to read them this way is to mistake them for something else. The powerfully affecting properties of paintings and statues depicting Jizō, while they are certainly also grounded in an aesthetic response, are really at core about the sacred power or efficacy of the object. This numinous quality is known as *ling* in Chinese, *rei* in Japanese.[16] My framework for this hermeneutic endeavor is a narrative one. The story I tell here is not the only explanation for the ubiquity of Jizō in Japanese Buddhism, nor can it exhaust all meanings of this bodhisattva's cult. It is but one possible telling, and I hope it is a compelling one for some readers. In this version of the story of Jizō's centrality in Japanese Buddhism, this bodhisattva who was an extremely important figure in China is utterly transformed in medieval Japan. While keeping most of the attributes he had in Chinese Buddhism as "lord of the underworld," he was assimilated to local gods of boundaries, fertility, and sexuality in Japan.[17] (Dare we call them indigenous, even autochthonous?[18]) Jizō's cult, especially through its connection to the journey of the soul in the otherworld, became closely intertwined with rituals of pacification for the victims of natural disasters and for the war dead. He also became the champion and special protector of those on the margins of personhood itself: women, children, and "the unconnected," or *muen*.

Jizō at the Threshold

Jizō has always been a bridging figure in Japan; he oversees life's transitions and guards the territory at the peripheries. It is no accident that one of Japan's most celebrated Jizō images is located at the checkpoint town of Seki ("Barrier") on the great east-west road, the Tōkaidō. Jizō's liminal nature made him an essential element in the creation and implementation of the logic of *honji suijaku* (literally, "original ground and trace manifestation"), whereby Buddhist deities were identified with local gods.[19] In legends of trips to the otherworld he has invariably been the Virgilio, the psychopomp, the guide through hell. Jizō also represents the possibility of return from that place, the presence of hope in the midst of despair. As a bodhisattva with the appearance of a human renunciant, he replicates the role of the Buddhist clergy, mediating between this world and the next.

In the sutras describing Jizō's past lives and his present mission, he is the savior of sentient beings in the period of "a world without a Buddha" (J. *mubutsu sekai,* Ch. *wufo shijie*) between the death, or *parinirvāṇa,* of the founder Śākyamuni and the advent of the future Buddha Maitreya.[20] The problem of the death of the historical Buddha and continued access to his teachings, blessings, and saving power has been a perennial one in the doctrinal, ritual, and soteriological formulations of the religion. This crucial question—why call it a problem?—manifests in many guises, from the cult of relics and stupa worship, to the notion of the essentially deathless and ever-abiding Śākyamuni of the *Lotus Sutra,* to the desideratum, common among monks of the Yogācāra school to pray for rebirth in the Tuṣita heaven at the pinnacle of our world of form, a kind of way station. They vow to dwell there with the future Buddha Maitreya until the time of his far distant advent. Of course, devotion to Amida Buddha (Ch. Amituo, Skt. Amitābha), lord of a glorious paradise in the west, is another response to Śākyamuni's absence. None of these concepts were ever mutually exclusive, but rather they meshed together in an endless variety of combinations. Jizō's charge from the Buddha to watch over and care for the beings in this long interval has often been invoked throughout East Asia, and in fact one source for his initial popularity in China was the enthusiastic promotion of his cult by the millenarian Sanjie jiao, or Three Stages Sect. This movement, which was suppressed as a heresy by the government of the Sui dynasty from the start of the seventh century, was particularly influenced by the *Shilunjing* (J. *Jūringyō*), or *Sutra of Ten Wheels.*[21] Inherent in the doctrines of the sect and its approach to Jizō (Ch. Dizang) was a theory of decline: the present day is a particularly corrupt age, and reliance upon Jizō is the surest way to avoid the sufferings of hell. This is a way of thinking that held great sway in Japan from the late eleventh century forward. From the Hossō school to the Pure Land schools, Jizō was widely held up as a savior for beings living in these evil latter days.[22]

Some scholars have argued that over the course of the medieval period Jizō's role as a deity progressed increasingly from offering salvation in the next world to providing boons and protection to the living. While this distinction between "benefits for the next life" *(raise riyaku)* and "benefits in this life" *(gense riyaku)* is a very common one in the study of Japanese religion, I do not think it is particularly useful when applied to this bodhisattva, especially when looking for change through time. Jizō was invoked in rainmaking ceremonies from an early date and, with Kannon, was considered a protector of women in childbirth. This pair was referred to in the latter context as the light-emitting bodhisattvas *(hōkō bosatsu).*[23] These are early examples of Jizō worship for "benefits in this

life." Of course Jizō was also from the start a savior in the hells as he had
been in China, and furthermore in Japan he became identified with King
Enma, the supreme judge of hell, but he was also often invoked in more
practical matters, the grave or mundane concerns of the living. What is
true of Jizō is that as the middle ages wore on, his cult became more and
more associated with liminal times and places, with marginal people, and
with the special dead. This book is about his movement into that terri-
tory, the world of betwixt and between, a zone where his cult flourished.
By the close of the medieval period, Jizō had become the most familiar
and intimate figure in the Japanese Buddhist pantheon.

The story I will tell here is that of the emergence of Jizō as the bodhi-
sattva of the *muen*, the unconnected, and thus as the bodhisattva par ex-
cellence. The Jizō cult thrived at the margins of the capital in Kyoto, near
the cremation grounds and burial sites of Toribeno to the east and Ada-
shino to the northwest. The gateway to the former, just north of Kiyo-
mizudera, is known as the crossroads of the six paths of rebirth, *rokudō
no tsuji*. It is here that a few storied Jizō temples stand—Rokuharami-
tsuji, Rokudō Chinnōji, Saifukuji—and across town at the entrance to
Adashino we find the Nenbutsuji and the Seiryōji temples. Both areas,
Toribeno (Higashiyama) and Adashino (Saga), were important centers
for religious performance of the chanters and storytellers, sites for stag-
ing plays and ecstatic dances. It is here, in these sites on the edges of the
city near the places of death overseen by marginal and outcaste perform-
ers and ritual specialists, that the Jizō cult found its full expression. From
the time of the first national explosion of the Jizō cult as promoted by
Ritsu, Shingon, and Zen monks in the thirteenth century, Jizō has oc-
cupied a central place in Japanese Buddhist practice. As Tanaka Hisao
has suggested, the Jizō cult was spread by many groups: among them
the mountain ascetic *(shugen)* practitioners and Pure Land preachers, as
well as the elite and influential priests of Nara.[24] One of the lessons of the
present study is that attention to the cult of a particular deity, or focus
on devotion to a particular practice, can yield insights not readily attain-
able when the object of inquiry is a sectarian lineage. Looking at Japa-
nese Buddhism and Japanese religious culture through the lens of the Jizō
cult, we are able to see many things often lost in the gaps between sects,
schools, and social classes. It is in fact these liminal spaces between that
we will be seeking out—and by "liminal" here I mean not only standing
at some geographical or social crossing or border (though certainly that
too) but also standing at doctrinal, institutional, and familial fault lines.
These interstices were a particular interest of Warburg's, since he saw
images as devices born out of contradictions and oppositions, as embodi-

ments of cultural and ideological conflict.[25] Images, then, act as intermediaries between various social groups and different lineages of practice and of philosophy. Negotiations about soteriologies, about family, about sentiency itself, take place at the site of the image.

For Warburg, the gesture of the image, that frozen motion, is the expression of something inexpressible in words that unites polar forces. The message is not intelligible at a distance. It is deeply contextual and local, even if drawing upon global discourses.[26] The images that appear in this study are conducive to this sort of interpretation. They reconcile opposing forces: a Buddhist deity with a local god; the ideal of renunciation with cults of fertility and sexuality; the world of death with the wild forces of generative potential.

Jizō's cult attained a range of diffusion and a special status in Japan qualitatively different from what it had seen in Korea or China, and much of Jizō's popularity was directly related to his assimilation to local gods and local practices. The mechanisms by which this diffusion through the religious culture of Japan took place will be a principal subject of this book; we will turn first to the Buddhist and Shintō enthusiasms of the aristocratic Fujiwara family and eventually to village phallic stones, where Jizō images were erected on the very spots that these semi-autochthonous gods of various sorts had occupied. The custom of piling small stones in front of Jizō images, so often remarked upon by travelers to Japan, is evidence of the influence of the ancient practices associated with these deities upon his cult. As Ōshima Takehiko has written, "Jizō more than any other buddha or bodhisattva came to represent, like the *dōsojin* and the *sae no kami*, the protector of boundaries, and thus was offered the same obeisance of stone-piling."[27] The deities referred to here, the *dōsojin* and the *sae no kami*, are a central topic of the fourth and final chapter. This roadside god of physical and existential boundaries embodies the liminal aspects of Jizō's cult: (1) a close identification with performance by marginal "beggar priests," religious specialists in the *ars dramatis;* and (2) an increasing association with gestation, childbirth, and the care of the infant dead.

Rather than an attempt to conclusively determine origins or pin down meanings, this study is a way to tell a story. How people in Japan celebrated Jizō and brought him to life down through the centuries, how they imagined him into being—this is the story I am telling. This is a book about the human impulse to create religious meaning through word and image. As much as anything, it is meant to serve as a reminder that visual images not only are created with brush and pigment or with chisel and file but are in fact the physical instantiations of beliefs, yearnings,

dogma, and tales first given expression through voice or in writing. When we open up these images of Jizō, figuratively and literally, we find them to be stuffed with stories, echoing with a multiplicity of voices, filled with complex human relationships. And indeed, the images themselves come to inspire more stories, and thus the dynamic relationship between text and image continues to reverberate down through the centuries.

While remaining historically grounded and sensitive to context, I have tried, to a certain degree at least, to allow my imagination to have free reign. This is a hint from Warburg's methodology, especially as described by Margaret Iversen in her article on "Warburgian invention."[28] Here Iversen sees important parallels between Warburg's approach to problems and the discipline of feminist history. Welcoming marginal voices into the center and making clear the pervasive influence of folk traditions in the creation and development of Japanese Buddhism, I hope I will be able to clarify a few murky areas in the story of Jizō in Japan. If at points I have overstepped in my interpretations or been too free in my descriptions, I hope the reader will indulge me, knowing that this work is an inevitably imperfect attempt at translating something felt (and not just by me) at the deepest level of consciousness—a strong pull of attraction toward the evocative and simple figure of Jizō, the bodhisattva monk. I have tried to capture some of this feeling with the title of the book.

The term "Jizō face" *(Jizōgao)* refers to a roundish face with a gentle and friendly expression exuding love, compassion, innocence, and benevolence.[29] Jizō's iconographical features are known to all. Any Japanese person over the age of three or four, even one unable to recognize any other deity, could easily identify "O-Jizō-sama." He is all but unique among bodhisattvas in that he is represented as a shaven-headed monk wearing a surplice. All other major bodhisattvas wear an elaborate headdress, are coiffed, and are covered in jewelry. Jizō is also known by the things he carries, "attributes," or *jimotsu*, in art historical parlance; these are the ringed monk's staff *(shakujō)* and the wish-granting jewel *(mani, nyoi hōju)*. These two items are visible in most of the images reproduced in these pages.[30] It is in part this ease of recognition that helps create a feeling of closeness with the bodhisattva. In an expression that is perhaps not as common as it once was in Japan, one expresses relief at seeing a friendly face or finding a helpful presence in a difficult situation by exclaiming, "I feel as if I've encountered a buddha in the midst of hell!" *(jigoku de hotoke ni atta yō da)*. "Jizō" is often substituted for "buddha" in this phrase. The simile dates back to the medieval period, where we find it in the *Tale of the Heike (Heike monogatari)*. Major Counselor Narichika has incurred the wrath of his liege, the tyrant Kiyomori. He is

to be tortured and in all likelihood executed, but his ally Shigemori—Kiyomori's eldest son, who had already saved his life on one occasion—arrives on the scene. We find them at the moment that Shigemori opens the door to the cell in which Narichika has been confined, and finds him prostrate on the floor, afraid to lift his eyes. In Helen Craig McCullough's translation:

> "What's happened to you?" Shigemori said. Then Narichika knew who had come, and a pitiful look of joy spread across his countenance. Even thus, it seemed, must appear the faces of sinners in hell who behold the bodhisattva Jizō.[31]

Watari Kōichi, the young doyen of Jizō studies, has insisted that people who write books on Jizō should offer their own "theory of Jizō" (*Jizō ron),* even a partially formed one.[32] Toward this end, allow me to put forward the following assertion. Jizō in Japan reached a degree of approachability, familiarity, even intimacy, for devotees that had been unknown on the continent, and this owes largely to his position as the guardian of spatial boundaries, the protector of the limen, and the savior of people and spirits on the verge of becoming something else. My necessarily fragmentary theory of Jizō, then, is developed in various ways over the next chapters: (1) this bodhisattva proved a very malleable figure, easily associated with local deities; (2) his iconographical identity as a monk made him a convenient and powerful stand-in for the human clergy and, in more than a merely metonymical way, for Buddhism itself; (3) Jizō is a bodhisattva characterized by motion, both in the ambulatory nature of Jizō images and in the ecstatic dancing of worshippers; and, finally, (4) Jizō's eventual association with liminality both above and below, in this world and the next, guaranteed him a large and devoted following from all quarters of society.

By focusing on images, I hope to draw forth a certain special quality, perhaps most palpable in those rough and ambiguous stones that have been given a bib and a cap and thus been transformed into Jizō statues. While this book contains many plates of wooden statues and painted works on paper or silk, one of its primary fascinations is the power of stones to engage the human heart. It is then in large part dedicated to those artisans, both named and unknown, who carved images of Jizō throughout the Japanese countryside and to those hands, ancient and modern, that took an old grave monument or a worn statue and gave it new life, setting it aright again, bestowing it with new meaning and new life as a Jizō image, another silent witness to the ages (fig. 1.1; plate 1).

Figure 1.1 Jizō images and grave fragments at Mount Kōya. Photo by Joe Arcidiacono.

A Brief Overview of the Jizō Cult in Japan

For the purposes of this study, the Jizō cult does not begin in earnest until the twelfth century. It is really the embrace by members of the Fujiwara family both in the northeastern outpost of Hiraizumi and in the old capital, Nara, to the south of Kyoto that begins to bring the worship of Jizō into the bosom of Japanese religious culture.[33] That is not to say that Jizō had been completely unknown before this time. For the most part, though, during the Heian period (794–1185) he was worshipped as one of a set of five deities along with Amida Buddha within the nascent Pure Land school of Mount Hiei or, within the tantric or esoteric traditions of Shingon and Tendai, as a pair with the bodhisattva Kokuzō or as one of the eight great bodhisattvas or, again with Kokuzō and others, as master of a "cloister" in the Womb World mandala (J. *taizōkai mandara*, Skt. *garbhadhātu mandala*).[34] There is textual evidence that at least the name "Jizō" was known in Japan during the eighth century, but the first reli-

ably datable texts and images are from the ninth.[35] Though any number of statues claim an earlier provenance, Mochizuki Shinjō rightly insists that there were no images of Jizō in Japan prior to the ninth century.[36]

In a certain sense this is not very surprising, given that the Dizang (i.e., Jizō) cult in China was, by the ninth century, still in its relative infancy. Writing in the 1970s, Hayami Tasuku declared, "Jizō worship in China was an extremely new bodhisattva cult that developed in the seventh century."[37] More recently, Zhiru has fleshed out this statement considerably, conclusively demonstrating the Chinese origins of the cult and further suggesting that the worship of Dizang did not, even on the continent, reach its efflorescence until the ninth century.[38] The veneration of Dizang as practiced in China was certainly influential on Japanese practice from the start (and continued to provide direct models in punctuated intervals into the thirteenth and fourteenth centuries and even into the seventeenth). However, in the interests of concentrating on the development of Jizō worship in Japan, I will resist the temptation to delve too deeply here.

There are clear continuities and connections, but in many ways the Jizō cult in Japan is fundamentally different from that of Dizang in China. Nearly every Japanese book or article on Jizō, popular and scholarly alike, remarks upon his emotional proximity to believers. He is seen as the friendliest of bodhisattvas, as a loving and nurturing presence always close at hand. This feeling of intimacy and benignity stands in contrast to the image of him held in China, where he has been the essentially compassionate yet somewhat remote and august "lord of the underworld."[39] It is Jizō in the former guise, the "O-Jizō-sama" so familiar to every Japanese person of the past five or six centuries, who will be the subject of this book. An important part of the creation and perpetuation of the bodhisattva's sweet and sometimes mischievous disposition has to do with his close association with specific images in specific locales with specific legends attached to them. This is attested to by a story contained in the thirteenth-century *Shasekishū* (Sand and Pebbles) of a nun whose opening invocation to her preferred protector lists it among the most famous Jizō images in the Nara area: "'I do not rely on the Fukuchi'in Jizō, the Jurin'in Jizō, the Chisokuin Jizō, and certainly not upon the Jizōs which stand in the city streets. Praises be unto my Bodhisattva Jizō of Yata.'"[40] The idea of the local instantiation of the deity embodied in a particular statue or painting or carved in stone is essential to understanding the character of Jizō in Japan.

When it comes to dating the rise of the popularity of Jizō in Japan, there has been some disagreement among scholars. Tani Shindō describes a sudden rise in interest in Jizō worship during the later ninth or the

tenth century.[41] Others have assumed fairly widespread veneration of Jizō from the very start of the Heian period, at the turn of the ninth century.[42] Hayami Tasuku, however, insists that while a few images do appear in important places during the tenth and eleventh centuries, and courtier diaries reveal that ceremonies involving Jizō occasionally took place, it is not until the Kamakura period—that is, until the thirteenth century or so—that we see a real movement for the worship of Jizō as an independent deity.[43] Of course, these political periodizations devised by historians have little to do with life on the ground, but it does seem that there was a strong wave of clerical interest in Jizō from the middle of the twelfth century that pulled in sculptors, painters, and their aristocratic patrons. This sharp rise in attention to Jizō as a savior appropriate to the latter age of the decline of the Buddhist religion (the "law," or the Dharma)—known in Japanese as *mappō*, or "the perishing of the law"—continued unabated, moving from elite circles to a much broader diffusion by the end of the thirteenth century. At this juncture, however, it makes sense to take a step back and speak in a more general way about this deity called Jizō (Ch. Dizang, K. Jijang, Skt. Kṣitigarbha) and about the class of beings known as bodhisattvas.[44]

Within the Mahayana Buddhist tradition, there are posited certain celestial savior figures of limitless compassion and deep wisdom called bodhisattvas. These nearly omniscient and omnipotent beings appear widely in the scriptures, popular tales, and art of Buddhist communities across the world and down through history. The bodhisattva is ostensibly on the road to eventual Buddhahood but postpones final and complete enlightenment in order to stay behind in the world and save sentient beings. This mission includes teaching, through word, deed, and living parable; it also includes rescue from physical danger, poverty, despondency, and the like. The *Kannon Sutra*, contained within the *Lotus Sutra*, sings the praises of the bodhisattva Kannon (Ch. Guanyin, Skt. Avalokiteśvara). The faithful are promised that Kannon will shatter the sword of the executioner, will grant the birth of sons, will cause the person who has fallen from a high cliff to "hang suspended in midair like the sun."[45] Bodhisattvas came to be seen as rescuers and teachers who were accessible through petitionary prayer and wholehearted devotion. Widespread reports of miracles confirmed the efficacy of such prayers and made clear the multiple roles of the bodhisattva.

Among these, Jizō has been particularly famous as an intercessor on the behalf of the dead. Leaving aside the complex question of Jizō's origins, let us join him in media res as a savior from hell toward the end of the Tang dynasty, that is, in the late eighth century.[46] The rise of Dizang (J. Jizō) worship is closely bound to an increasing focus on the hell realm

among Chinese Buddhists from around the seventh century onward. It is the articulation of the tortures of the judged, hell's geography, and the apparatus of the infernal bureaucracy in medieval China that forms the immediate background for the further development of the cult of Dizang as it arrived in Japan. As we shall see, while Jizō's role in Japan becomes quite diverse, the association with the underworld, judgment in the next life, and rescue from hell is always present. In fact, some of the earliest proponents of Jizō in Japan—the disciples and grand-disciples of the master of the Yōkawa district on Mount Hiei, Ryōgen—saw Jizō as a savior of the damned. At the close of the tenth century, a Tendai monk named Genshin, Ryōgen's disciple in fact, compiled a description of the six paths of transmigration, the *Ōjōyōshū*, focused primarily on the horrors of the hell realms. This widely influential work set many of the patterns and details that would be indispensable down through the ages for textual and especially visual representations of the torture of sinners there.[47] In that work Genshin paraphrases the *Shilunjing* as follows:

> Before dawn each morning, Jizō Bodhisattva enters into *samādhi*s [meditative states] as numerous as the sands of the Ganges. Traveling about the *dharmadhatu* [the whole of the phenomenal world], he saves beings from suffering. Because of his compassionate vow, he surpasses the other great heroes [*daishi*, that is, bodhisattvas].[48]

Considering the nature of his cult in China, it is not surprising that initial interest in Jizō in Japan begins from his role as an intercessor for the dead undergoing judgment and punishment in the infernal regions.

Hell belief in China begins in earnest with the creation of the legend of the descent to the otherworld by Mulian (J. Mokuren, Skt. Maugalyāyana), the disciple of the Buddha most renowned for thaumaturgy, to rescue his mother from her posthumous suffering there. This story, with its ritual cycle, the summer festival called Yulanpen, is wholly Chinese in origin, with only vague precedent in Indian Buddhism.[49] This ceremony, the so-called Ghost Festival, has long been the most important event in the Buddhist calendar of all East Asian countries. In this story, Mulian, the great magician-saint, is ultimately unable to save his mother through the use of his own powers. As she suffers in the realm of hungry ghosts, every drink of water or morsel of food he offers her turns to flame. Upon the advice of the Buddha, Mulian establishes a feast for the monks coming off their summer rainy-season retreat. At the moment that the spiritual energy of the monks is most concentrated, their practice most pure, their minds most guarded, Mulian makes an offering to them, perhaps more in the guise of filial son than that of Buddhist monk.

He presents a tribute of lights, incense, flowers, prayer, robes, and five hundred kinds of food, thus not only saving his mother but also simultaneously releasing seven generations of ancestors. This Ghost Festival is the primary opportunity for symbolic exchange between the laity and the monastic community and is the best opportunity for the transfer of spiritual merit to the accounts of the family dead. As such, the development of this ceremony and its narrative was a crucial moment in the Sinification of Buddhism through accommodation to specifically Chinese notions of ancestor veneration.[50]

The story of Dizang, the bodhisattva Jizō, develops within this context. In the *Dizang pusa benyuan jing* (J. *Jizō bosatsu hongankyō*, Sutra of the Original Vow of Jizō Bodhisattva), the sutra of Jizō's "primal vow" (not to attain enlightenment until the hells are empty), we read of two past lives of Jizō in which he saved his own mother. In the first of these lives, Jizō is incarnated as the daughter of a Brahmin family, living in a different cosmological time, during the period of "image dharma" (Ch. *xiangfa,* J. *zōhō*) of a buddha of the distant past. In this period, according to the tripartite scheme developed in the East Asian millennial historical narrative, believers have no direct access to the buddha of the age because he has entered *parinirvāṇa,* and they must rely upon reflections of him found in the words of scripture and in many various carved and painted images.[51] The Brahmin daughter finds herself before an image of the buddha, whom she supplicates to help her save her mother, and the veneration of images plays a central role in the drama of salvation. As is the case in the various Chinese versions of the tale of Mulian, the Brahmin girl's mother is wicked and contemptuous of Buddhism:

> Another time, inconceivable *asamkhyeya* eons ago, there was a Buddha named Enlightenment-Flower Samadhi Self-Mastery King Thus Come One. That Buddha's life span was four hundred billion *asamkhyeya* eons. During his Dharma-Image Age, there lived a Brahman woman endowed with ample blessings from previous lives who was respected by everyone. Whether she was walking, standing, sitting, or lying down, the gods surrounded and protected her. Her mother, however, embraced a deviant faith and often slighted the Triple Jewel.
>
> The worthy daughter made use of many expedients in trying to convince her mother to hold right views, but her mother never totally believed. Before long, the mother's life ended and her consciousness fell into the Relentless Hell.
>
> When her mother's life ended, the Brahman woman, knowing her mother had not believed in cause and effect while alive, feared that her karma would certainly pull her into the Evil Paths. For that reason, she

sold the family house and acquired many kinds of incense, flowers, and other gifts. With those she performed a great offering in that Buddha's stupas and monasteries. She saw an especially fine image of the Thus Come One Enlightenment-Flower Samadhi Self-Mastery King in one of the monasteries. As the Brahman woman beheld the honored countenance, she became doubly respectful while thinking to herself, "Buddhas are called Greatly Enlightened Ones who have attained All-Wisdom. If this Buddha were in the world I could ask him where my mother went after she died. He would certainly know."

The Brahman woman then wept for a long time as she gazed longingly upon the Thus Come One. Suddenly a voice in the air said, "O weeping worthy woman, so not be so sorrowful. I shall now show you where your mother has gone."

The Brahman woman placed her palms together as she addressed space, saying, "Which virtuous divinity is comforting me in my grief? Ever since the day I lost my mother, I have held her in memory day and night, but there is nowhere I can go to ask about the realm of her rebirth."

The voice in the air spoke to the woman again, "I am the one whom you behold and worship, the former Enlightenment-Flower Samadhi Self-Mastery King Thus Come One. Because I have seen that your regard for your mother is double that of ordinary beings, I have come to show you where she is."[52]

In the other past life story, Jizō is a Brahmin girl named Bright Eyes (Ch. Guangmu, J. Kōmoku) living in the age of a buddha named Pure Lotus Eye. A clairvoyant monk enters a trance in response to the girl's request that he reveal her dead mother's whereabouts. He finds the mother undergoing most terrible suffering and asks the girl what her mother had done. It seems that the mother had possessed a preternatural appetite for fish and turtles, especially relishing their roe. In abandoning herself to this predilection, she had taken the lives of countless sentient beings. In this story, the monk instructs Bright Eyes to set up images of the Pure Lotus Eye buddha ("mold and paint his image for the benefit of the living and the dead") and worship him by reciting his name. Thus the veneration of icons is of central importance to the mother's salvation in both past life stories of the bodhisattva.

Also—like the scripture of Mulian, the *Yulanpen Sutra*—the *Dizang pusa benyuan jing* is a so-called apocryphal text, meaning that it was composed in China and not in India. (Yet it would be wrong to assume that people living in centuries past would have had any reason to doubt the "authenticity" of the text.[53]) Another apocryphal sutra essential to

the understanding of the Jizō cult as it came to Japan is the *Shiwang jing* (J. *Jūōkyō*, Sutra of the Ten Kings), which describes in considerable detail the courts of the ten kings of hell and the progress of the dead through those places of judgment and punishment. Interestingly, Dizang is largely absent in the text of the scripture, though he seems to have played a much more significant role in visual representations.[54] The ten kings are met with in succession as the dead pass through a period of judgment in the underworld; the first seven are visited in the seven weeks, or forty-nine days, following the death of the individual. The most prominent of these kings is the one met with in the fifth week, King Yama (Ch. Yanlo *wang* or Yanmo *wang*, J. Enra ō or Enma ō), originally drawn from Indian mythology but utterly transformed in East Asia. In a sutra composed in thirteenth-century Japan (another, much rarer level of apocryphon), the *Jizō jūō kyō*, or the *Sutra of Jizō and the Ten Kings*, insists that Jizō and Enma are in fact one—both advocate and judge. This actually echoes a belief found from a slightly earlier period in Japan.[55]

The idea that Jizō and Enma are different manifestations of the same entity stems from the Japanese practice, well established by the time of the composition of the *Jizō jūō kyō*, of drawing equivalencies between Buddhist deities and local ones. This is called *honji suijaku*, as mentioned above. In this system, foreign gods—for instance, the root or primordial cosmic buddha of the esoteric Tendai and Shingon sects, Dainichi (Skt. Vairocana)—are matched with one figure or another from the Japanese pantheon; in Dainichi's case a common match is the sun goddess and progenitrix of the imperial line, Amaterasu ōmikami. The system was not a rigid one-to-one correspondence but rather allowed multiple and shifting identifications. However, this equivalence between Jizō and Enma was one that was extremely well known and widely cited in premodern Japan in both text and image. In Chinese and Korean paintings of the ten kings, Jizō was often accorded a central position. What is quite different in Japan is that Jizō is represented at the court of Enma, the fifth and greatest king, where he pleads on behalf of the deceased. Enma's palace is equipped with a great mirror, oft depicted in visual representations, in which all the sins the dead committed while alive are projected, so there is no possibility for dissemblance.[56] Additionally, there is a great staff topped by the faces of two deities *(dōji)*, one friendly and the other fearsome. As the wicked approach, the wrathful face appears and spits out iron cables that wrap around the body of the sinner.[57] The immense popularity of Jizō in medieval and early modern Japan was fueled in large part by the belief that Jizō was the best advocate for the sinner being judged before the magistrate Enma, since Jizō was in fact the alter ego of this terrifying and intimidating judge. This relationship

described in the *Jizō jūō kyō* is made very explicit in Japanese paintings of Enma or Jizō.[58]

As mentioned above, the twelfth century marks the true beginning of Jizō worship in Japan. Around midcentury, Kiyohira, a powerful aristocrat of the Ōshū Fujiwara family, placed three sets of six Jizō statues on the altar of his family mausoleum, the Golden Hall, the Konjikidō, of the Chūsonji temple in the remote northern outpost of Hiraizumi. It is very clear that Jizō's strong presence in this relatively small sanctuary was closely related to his association with memorial services and the care of the dead. There is additionally some indication that the choice to enshrine the eighteen Jizōs was related to this warrior's desire to pacify the souls of those he and his family had slaughtered in battle and to atone for his sins in this regard.[59] The idea of Jizō's power to give comfort to the resentful dead is a key to his ever-increasing importance through the medieval period. The twelfth century saw the beginnings of an enthusiasm for Jizō veneration in the great temples of Nara that was to endure for many centuries. The rebuilder of the Tōdaiji, Shunjōbō Chōgen, who had sojourned in Song-dynasty China, was a key figure in the sponsorship of a few Jizō projects.[60] One of the most prominent of these is the standing Jizō statue in Tōdaiji's Kōkeidō by renowned Kamakura-period sculptor Kaikei. A similar standing Jizō by Kaikei from the late twelfth century can be found in the Mary and Jackson Burke Collection (see fig. 2.4).

It is in the thirteenth century, however, that we witness a true explosion of interest in the bodhisattva. The creation of a great number of Jizō images during this century attests to a bourgeoning cult, as does the circulation of an unprecedented number of legends or folktales *(setsuwa)* about Jizō. We find these tales preserved in the *Shasekishū*, the *Konjaku monogatarishū* (Tales of Times Now Past), the *Shintōshū* (Collection of the Way of the Gods), and especially the *Jizō bosatsu reigenki* (Miraculous Tales of Jizō Bodhisattva). Most significantly, the majority of these stories are related to the production of images and to the miracles performed by images come to life.[61]

This steep rise in popularity was due in large part to the fashioning of Jizō's approachable guise as a Buddhist monk, a familiar and in many ways a very ordinary figure. At the same time, of course, this Buddhist monk is absolutely extraordinary. He is exemplary monk but also guide, mediator between life and death, shaman, thaumaturge, and teacher. A few stories taken from the *Jizō bosatsu reigenki* (hereafter, *Reigenki*) will give the reader a sense of the relationship between the bodhisattva and images drawn in these tales.

The textual history of the *Reigenki* is a complex one that we shall

not enter into here, but as many of the stories are also included in the seventeenth roll of *Konjaku monogatarishū,* it is clear that the text was, in some form, in circulation by the thirteenth century.[62] It is perhaps worthwhile recounting the short preface in some detail here. The *Reigenki* begins by singing the praises of Jizō as a bodhisattva who travels through all six realms (*deva*s, or gods; *asura*s, or titans; humans; animals; hungry ghosts; and hell dwellers) and as the consummate savior from hell. It refers to the time he taught a certain Mr. Wang the "hell-smashing verse" *(hajigoku ge),* thus ensuring him King Enma's pardon.[63] The preface also notes that Jizō is able to save those condemned to a special hell for monastics and that he "softens his light" (a familiar phrase from works on *honji suijaku*) by himself appearing "in the image of a monk" to save sinners. The preface closes by assuring us that all who hear these miracle tales, those who slander them as well as those who praise them, will ride together on the boat of Jizō's great vow and arrive at the other shore of nirvana, unfailingly gaining the full enlightenment of the buddhas.

After the preface, there is a lengthy excursus that extends to reflections on Jizō's name, on his place as a bridging figure in the "world without a Buddha," on his function as the savior in the six paths, and on the objects he holds (the monk's staff and wish-granting jewel). It mentions his ability to destroy bad karma and to substitute his own body for those of sinners in hell, specifically citing the discussion of this in the tenth-century compendium *Zongjinglu* (Mirror of the Various Schools).[64] The discussion also mentions his special position as the "bodhisattva who is the hopeless sinner of great mercy" *(daihi sendai no bosatsu);* his vow to postpone his own enlightenment until such time that all others—bodhisattvas, humans, dragons, demons, and all the rest—have all attained Buddhahood.[65] The collection is devoted to stories of Jizō miracles, most of them reporting events that occurred in Japan and even providing specifics of location and date and sometimes the names of those involved.[66] The first story in the collection concerns the elder Jitsuei of the Miidera in Kyoto, the putative compiler of the *Reigenki.*[67]

This tale, which also appears in the *Konjaku monogatarishū* 17:12, states that in 1033 a somewhat dilapidated old Jizō statue enshrined in the Miidera was replaced by a newly carved image of Amida Buddha. A certain Myōsan *shōnin* gave it to Jitsuei, who had it repaired and painted and placed in the Shōbōji, a subtemple of the Miidera. After this, a young novice of about ten years of age came to Jitsuei in a dream, sat on his lap, and hugged him around the neck. In the dream, Jitsuei prayed before this statue of Jizō. The boy revealed that he was in fact this very same Jizō (it is worth noting that he did not say "Jizō image") and had been commissioned by a nun, the wife of a former abbot of Miidera.

At this point, Jitsuei noticed a man dressed as a monk standing behind the boy and holding a hatchet. He asked the boy in the dream, "Who is that man standing behind you? His face is dark, and my eyes are dazzled by your light." The boy explained that this was the sculptor who had carved him and that, because of this connection, he had been allowed to follow along and bask in the bodhisattva's light. Looking to the north, Jitsuei beheld one hundred thousand Jizō images sitting facing him, and he bowed down in prayer. He quickly awoke from his dream, knowing that this sculptor had been one of great faith and that he had carved and painted the image without accepting payment. The story ends by extolling the merit of those who copy sutras and make Buddhist images. It states that even those who drink alcohol, eat meat and the five pungent roots (such as onions, garlic, and leeks, said to give rise to negative emotional and mental states), and do not immerse themselves in the right doctrine can gain much good fortune in this manner. If the heart is sincere, the act of carving an image, even one as tiny as a sesame seed, generates great merit.[68]

While there are scores of stories about miraculous images in the *Reigenki,* we will confine ourselves to briefly summarizing three more here. The first (1:9) concerns a nun from Yoshino, in the south of Yamato Province; the second (2:8), a monk from Izu named Kaizō; and the third (3:6), a courtier of the Nara period named Yukiharu. The first of these stories, "How a Nun from Yoshino in Yamato Made a Jizō Statue" (Washū Yoshino no kōri no nikō, Jizōson no zō o tsukuru koto), begins with a dream seen by the widow of a preacher named Shōrenbō. Shōrenbō had been a proselytizing preacher, and the text tells us that, typical of these types, he was not too terribly assiduous in Buddhist practice, really being a performer for the crowds. Having passed the age of seventy, though, he often forgot the tunes of the hymns he used in his shows, lost his voice, and so on. Eventually he became sick and died. It was three years after this that his wife, the nun of the title, had a dream of walking alone down a mountain path in a distant and desolate place. There was no sun, and it was darker than midnight; she had no choice but to take shelter under a rock outcropping and wait for the dawn. Then, still in the dream, she heard the laments of a ghostly voice, which gave her a start until she recognized the voice as that of her late husband, Shōrenbō. She asked him, "What's wrong?" *(ikaniya).* He told her that in life he had broken the precepts and had not practiced confession. He had bilked the Buddhist devotees who formed his audiences of their hard-earned money, and he had committed other crimes. However, because he had been a worshipper of Jizō, three times a day the bodhisattva now visited him in hell. Jizō, he told her through choked sobs, took his

place during those visits, allowing himself to be tortured in Shōrenbō's stead. Jizō also would recite a poem for him at these times: "All alone on a deserted path in the shadow of deep mountains. Ah, how many ages will this body have to wander on?" *(Hito mo naki miyama kakure ni tada hitori, aware kono mi ha ikuyo henuran).* Upon waking, the nun immediately went to a sculptor and commissioned him to carve a small Jizō image about one meter (three *shaku*) in size and started to make copies of the *Lotus Sutra* while praying for her dead husband. She took the statue to Nichizō, a renowned saint and ascetic living by the Yoshino River, and asked him to perform the eye-opening *(nyūgan)*, or animation, ceremony. An overjoyed Shōrenbō then appeared to her again in a dream to tell her that, due to her efforts, he had been reborn in a celestial realm; he supplicated her to continue offering suffrages *(tsuizen)* that he might be born into Amida Buddha's western paradise, the Pure Land of Ultimate Bliss. The nun woke up and tried to fall asleep again, but saw only disturbing hallucinations and inauspicious signs. We are given to understand that she will not rest easy until she performs more rites for Shōrenbō. The tale then goes on to extol the benefits of memorial rites for ancestors, citing the *Jizō jūō kyō* and the *Lotus Sutra.* It ends by praising the *Lotus Sutra* and rituals related to it, admonishing the audience not to believe those shallow in faith who may claim that Jizō was not present at Vulture Peak when Śākyamuni preached that holy scripture.[69]

The next tale concerns a monk named Kaizō *shōnin* from the island of Ōshima, off the Izu Peninsula, a place closely associated with the syncretic mountain religion called *shugendō.* The lineage's founder, En no gyōja, had been exiled there at one point. The tale describes the island as an extremely harsh and inhospitable place, subject to violent waves and inundation, a frontier even birds and beasts could not cross. It seems that in the eighth century, though, there was one ascetic brave enough to live there. This was Kaizō *shōnin.* He established a temple on Ōshima and installed a life-size Jizō statue as the main image. The narrator remarks: "Since Jizō takes the borderlands and the most despised frontiers as his home, and befriends the most evil tribes with the deepest and heaviest karmic burden, know that even such a forsaken place as this could receive some measure of his benefits."[70] Kaizō was unlike any mere mortal. He followed strange and unknown practices and rituals. The blessed name of the bodhisattva was always on his lips, and his prayer beads never left his grasp. His heart was full of compassion and benevolence; he undertook heroic efforts to control and purify his body, speech, and mind; he was a true teacher, an exemplar of the way. He had total facility in magical powers, and as he strode across the waves and flew about

riding a cloud, he carried a statue of Jizō on his back. The simplicity of his life was such that he "clothed himself in grasses and made wood his victuals" *(mokujiki sōe)*.[71] He always sought to dwell under trees and atop rocks. To him, these places were practice halls encrusted in the seven jewels, every bit as resplendent as the lotus ponds and jeweled towers of the Pure Land. When he reached the ripe old age of one hundred, an amazing event occurred. On the twenty-fourth of the month, Jizō's feast day, Kaizō declared, "Now I will leave the merits of teaching the way in the hands of the bodhisattva." He grabbed his ringed staff, stepped into his shoes, and walked out into his garden. A white cloud descended and looked as if it would engulf the holy man, but he scrambled atop it and rose into the sky. After thirty-five days, he returned briefly, but then flew away, never to be seen again. Surely, this saint of unfathomable mystical powers was a manifestation of Jizō Bodhisattva, an avatar of the Dharmakāya.[72] Verily, he was the pilot of nonaction, the master of quiescence *(mui no shinan, jakumetsu no nushi)*. The tale, *Reigenki* 2:8, is entitled "The Jizō Set Up by the Holy Man Kaizō" (Kaizō shōnin kenryū no Jizō no koto) and closes with an entreaty to "take refuge in this worthy one [*son*]" and depend upon Jizō's compassionate vow. Given the context, it would seem that the "worthy one" probably refers to the statue created by Kaizō, but the name of the temple where it is enshrined is not mentioned.[73]

The third story we will examine is *Reigenki* 3:6, "A Jizō Image Carved from a Tangerine Tree" (Kōji no ki Jizō no zō no koto).[74] One Chūjō no Yukiharu, a successful courtier who lived in the ninth century, deeply lamented the sudden death of his mother and wanted to find a way to memorialize her and ensure her posthumous salvation. He donated lavishly to a temple she had frequented and prayed with all his heart, "May she gain the karma to be born on a lotus stand in the highest rank of the Pure Land; may she distance herself from the suffering of the five obstacles and the three subjugations to obtain spotless Buddhahood."[75] There was a tangerine tree in his mother's garden that she had loved more than anything in the world. He had a Jizō statue about one meter tall (three *shaku* and two *fun*) carved from the wood of this tree and had sutras chanted. Thus praying for his dear mother's salvation, he poured out his feelings for her in a dedicatory text quoted at length in this miracle tale. Owing to his efforts, she was born into the Tuṣita heaven and came to him in a dream to deliver the news of her salvation. She also appeared in a dream to one of her ladies-in-waiting, one with whom she had been particularly intimate, and told her that although she had fallen into the deepest hells for sins she had committed while alive, she had been saved through the prayers and offerings of her filial son

Yukiharu. The Jizō that he had commissioned traveled down to King Enma's court to plead with the judge on the mother's behalf and also stood in for her, letting his own body instead be tortured in the Avici hell. The flames of hell were doused and transformed into a great lake where lotus flowers bloomed—breaking through the surface to reveal sinners transformed into small children who sat atop their petals. The mother herself was able to fly up out of hell accompanied by Jizō as they climbed unimpeded to the Tuṣita heaven, borne on a white cloud. The mother reported that the tangerine wood statue that her son Yuki-haru made rose from hell (where he was saving the beings) three times a day to visit her. At the end of her dream soliloquy to her erstwhile lady, the mother declared that the tangerine wood statue was a "living image" *(shōjin no zō)* and that it surpassed even millions of avatars of the bodhisattva. The fame of the statue spread, attracting the interest of the ruler; then, without even being summoned, the statue appeared for an audience before the emperor. Yukiharu was moved to tears when he heard of this. The text continues, citing the statue's influence on the Shingon patriarch Kūkai and explaining the close relationship between Jizō and the important tantric deity Fudō *myōō* (Skt. *Acala Vidyārāja*, the Bright King Immovable).[76] After retelling the story of the Brahmin girl Bright Eyes from the *Dizang pusa benyuan jing*, the tale closes by explaining that the statue was much revered in Yukiharu's day but that it no longer exists, because it accompanied him to the Pure Land at the time of his death and never returned.[77]

Each of these stories places emphasis on the miraculous nature of images and the possibility of real embodiment of the deity through the production of icons. The statues fly, they walk, they speak. They are images in motion. Jizō is a dynamic figure, described as bustling here and there, whether juggling cases in the courts of hell or planting a rice paddy for a sick old woman. As we see in these stories there is a conflation, or perhaps "unity" is a better word, between the deity and a particular statue. As we saw above in the case of the old nun of Nara's pledge of exclusive worship to the Yata Jizō, the uniqueness of the local, immediate instantiations was emphasized. And yet images of Jizō are not strictly bound by place.

Jizō statues are ambulatory. The story of Kaizō has him flying through the sky carrying a Jizō on his back. We can imagine that it was not the life-size statue that he had carved, but rather a smaller one that would fit in a portable shrine with shoulder straps. The tradition of cir-culating a small Jizō image from home to home among believers using this sort of device is well attested in various locales, especially in the

Kantō region. These are the so-called *mawari* Jizō, or "rounds-making Jizō."[78]

Bernard Faure has remarked, "On the whole, Buddhist iconology has valorized stillness. Buddhist icons are, strictly speaking, 'still life' or 'suspended animation.'"[79] While his larger point that a Buddhist image can be likened to a reliquary or a tomb—having an adamantine body that is hermetic, with no "outflows" (Skt. *āsrava*, J. *rō*, Ch. *luo*)—is well-taken, Jizō is clearly an exception to this rule of stillness. Faure does note that if an icon is in motion, it is often sexualized, which is occasionally the case with Jizō statues, but it is also clear that Jizō images are generally mobile. When we see a Jizō image in a temple or a museum or as a photograph in a book, this motion can often be lost. Part of my project in this book is to restore this dynamism at least in some small measure. Aby Warburg is a model in this respect; he was preoccupied with gesture and with movement and sought to restore meaning to religious images, meaning that had been erased by the passage of time.[80] The restorative mission, perhaps a doomed one from the start, grew out of a consciousness that icons are (had been) living things and that to deprive them of movement and voice is an act of lethal violence. As Philippe-Alain Michaud has written of Warburg, his aim as a historian was to resurrect the image, restoring voice to body, bringing it back to life to hear it speak again:

> He sees the work of scholarship [as] trying to reestablish the synchrony between image and discourse as both demiurge and montage: "The tone and timbre [*Klangfabre*, 'sonorous color'] of those unheard voices can be recreated by the historian who does not shrink from the pious task of restoring the natural connection between word and image."[81]

In this study, we shall see the ways in which legend and icon are intimately bound up in the medieval Jizō cult. Rare is a Jizō statue or painting without a story. The narrative or biographical impulse is very strong in Japanese Buddhism.[82] While I have little confidence that I can bring those images back to life in these pages, perhaps the reader will be able to discern some echoes of "those unheard voices." Art historian Mochizuki Shinjō shares Bernard Faure's opinion that buddhas and bodhisattvas are usually immobile, but finds an exception in Jizō and says that his movement is an indication of an active intent to save the sentient beings. Mochizuki points to the ringed staff, which suggests that Jizō is indeed walking; he also notes that standing statues of Jizō typically have one foot placed in front of the other and that, in paintings, Jizō often has a

lotus dais under each foot to accommodate his dynamism.[83] We can find
this arrangement in the scene in the *Yata Jizō engi e* (Illustrated Origins
of the Yata Jizō) where the bodhisattva is saving a sinner from the great
cauldron of hell (fig. 1.2). In contemporary representations in various
media, he is seen flying through the air, forging a raging river with a child
on his shoulders, or leading the dead across a bridge. Again and again,
we encounter him as psychopomp, but never as a passive guide. He is
also a dynamic protector and advocate, riding forth on a cloud and turn-
ing back halfway to regard his flock. He is labeled in the inscription as
the "living Jizō" (*shōjin* Jizō; fig. 1.3).

Further reinforcing the image of Jizō as a bodhisattva in motion, one
of his most common epithets in Japan is "the great teacher who mani-
fests throughout the six paths" *(rokudō nōge Jizō bosatsu).* This refers
to his tireless travels through all regions of this samsaric Sāhā (J. Shaba)
world.[84] In an iconography previously believed to be unique to Japan,
Jizō has been repeatedly represented in a set of six images, one for each
of the realms of transmigration.[85] This is an old practice, dating back
at least to the twelfth century, as we saw at Hiraizumi's Konjikidō. The

Figure 1.2 The Yata Jizō
rescues Manmai *shōnin*
from hell. Detail from *Yata
Jizō engi e,* ca. fourteenth
century. Yata Jizōin, Kyoto.
Courtesy of Yata Jizōin and
Nara National Museum.

six-Jizō motif remained a popular one through the medieval period and continues to be employed frequently to this day, especially at the entrances to temple graveyards. Many Japanese scholars have claimed that the iconography of six Jizōs was a Japanese innovation. Manabe Kōsai, for instance, places the first textual reference to "the six Jizōs," or *roku Jizō* at the turn of the twelfth century in Miyoshi Tameyasu's *Shui ōjōden* (Collected Tales of Birth in the Pure Land).[86] Furthermore, Mochizuki sees the six Jizōs as a product of Japanese folk belief.[87] The idea of the six Kannons can already be found in the sixth-century *Moho zhiguan*, Tiantai Zhiyi's *Great Calming and Insight*. Hayami Tasuku proposes that the idea of six Jizōs was based on this other set of six, which was popular in Chinese Tiantai by the tenth century and, accordingly, also in Japanese Tendai. He states that there is no evidence of the six Jizōs either in the Dunhuang murals or in Chinese miracle tale collections and concludes that the notion of six Jizōs was probably developed by Tendai and Shingon priests in Japan.[88] However, Zhiru has recently written about and reproduced a very early and extremely rare example of this motif from China's Shaanxi Province, dating to the end of the seventh century. More

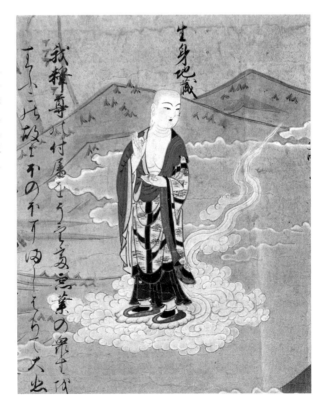

Figure 1.3 The inscription reads, "*shōjin* Jizō" (living Jizō). Detail from *Yata Jizō engi e,* ca. fourteenth century. Yata Jizōin, Kyoto. Courtesy of Yata Jizōin and Nara National Museum.

common, but still somewhat rare, is the representation of Dizang sur-
rounded by smaller vignettes of the six paths; this iconography is also
seen primarily in the Shaanxi region.[89] In Japan, by contrast, the group-
ing of six Jizōs in both art and legend has been incredibly common from
the Kamakura period forward.

For our purposes, the most fascinating aspects of the six-Jizō iconog-
raphy are its wide variation and a stubborn preoccupation, found among
ancient and modern scholars alike, with finding a textual basis in order
to establish an orthodox version. This search for written justification for
iconographical convention is a theme we will take up again in the next
chapter; the authors of thirteenth-century manuals describing the visual
representation of deities repeatedly express consternation when they are
faced with some types of iconography and are unable to find a ritual
manual or a sutra that sanctions such a configuration. This is clearly true
in the case of the six Jizōs (fig. 1.4).[90]

The "canonical" sources for the worship of the six Jizōs, the *Renge
zanmai kyō* (Lotus Samāhdi Sutra) and the *Hosshin in'nen jūō kyō* (Jizō
and Ten Kings Sutra), are both Japanese apocrypha composed around

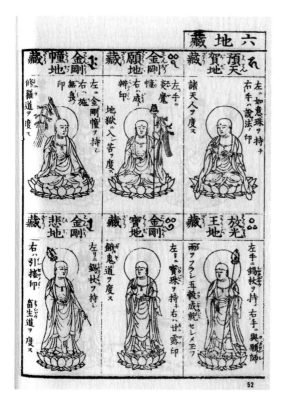

Figure 1.4 The Jizōs of the six
realms, *rokudō* Jizō. From the *Bu-
tsuzu i* of 1690 [Kino 1972].

the late twelfth or the thirteenth century. The names of the six Jizōs and their attributes vary widely from text to text and from image to image. One may carry a censer or a rosary in one place, and in another some carry a percussion instrument. In many sets all six are identical and hold the staff and the jewel, but others label each by a separate name and depict different attributes. One of the first attempts to sort these out can be found in a story from the *Reigenki* about a Shintō shrine priest from Kyūshū named Tamayori no Koretaka. Although Koretaka was the head priest of a shrine and came from a long line of Shintō priests, he had been a sincere believer in Buddhism since the time he was a small child, being especially devoted to Jizō and always chanting the bodhisattva's name. He became ill and died near the end of the tenth century, and on his way to the netherworld he met six beautiful novice monks, each holding a different object or forming his own mudra (hand gesture). The one holding a censer told him that they were the six Jizōs who saved people in the six paths. They told him of their dismay that some people are confused regarding their appearance and worship images that are haphazard and iconographically incorrect. They asked him to return to the world of the living and set up six statues accurately reflecting their forms just as he had seen them, to pay them obeisance, and to be sure that they were facing south.[91] This seems to be an attempt to settle the heated debate transpiring in the pages of iconographical manuals, and most certainly in monasteries and ateliers as well, about how to represent these six figures for whom no iconographical or ritual manual *(giki)* existed.

The meaning of Jizō is intimately tied to his iconography. Jizō's manifestation as a seemingly ordinary Buddhist monk allows him to simultaneously fulfill many roles for many constituencies. As a monk he is assimilated to important figures of the earlier tradition, such as disciples of the Buddha like Mahākāśyapa, who has the same assignment of awaiting the advent of Maitreya, and Maudgalyāyana (Mulian), a thaumaturge with close connections to the otherworld.[92] He also comes to represent monks in general. In Japan, he is particularly associated with Ritsu and Zen sect monks who were sought out for the efficacy of their funerary rites. A great many tales of the *Reigenki*, like the story of Kaizō summarized above, claim that this or that monk was in fact a living incarnation of the bodhisattva. As we have noticed by now, Jizō in Japan is often described as a young monk or even as a child novice.[93]

When asked about the role of icons, many modern Buddhists, both in the West and in East Asia, often remark that they serve a merely symbolic function. Twentieth-century art historians similarly sought to exam-

ine works from religious visual culture in and of themselves, tracing stylistic influence and identifying iconographical lineages. In either case, the removal of context strips away much of the essential meaning inherent in the images. In this book, I will attempt to take an iconologically nuanced view of the subjects, remembering that as we gaze at images, they also gaze back at us. To borrow a phrase from Faure, "I want to focus precisely on the vision of icons, on the asymmetrical exchange of glances that characterizes icon worship."[94]

To call this study an iconological one is to invoke Warburg, but what exactly is involved in this approach that I am referring to as iconological? The purpose of this book is to demonstrate the ways in which particular iconographies of Jizō—the six Jizōs, the *raigō* (welcoming-descent) Jizō, the nude Jizō, the warrior Jizō—represent a dynamic negotiation and mediation of symbolic turf. As Warburg rightly noted of the paintings and sculpture of the quattrocento, there is a tension inherent in religious works of art that reveals a clash of influences.[95] As broad cultural and historical trends—dynamically pivoting between embodiment and ecstasy, mediation and direct experience—take solid and stable form in the shape of icons, we are presented with an opportunity to understand them more fully. Again, for Warburg, the image was a site of conflict and contestation, an opposition of ideas encoded or compressed in a gesture that necessarily remains unfinished. It is precisely this dynamism locked into the static instant of representation that I wish to release in this investigation of icons, their stories, and their peregrinations.

The Face of Jizō: Where I Enter

Jizō is, was, and has been a deity whose constituencies are many and varied. In present-day Japan, Jizō is famous as the savior and protector of unborn children. While many have assumed some antiquity to this aspect of the Jizō cult, it is in fact quite new, dating back to around the 1970s or so.[96] That being said, it was not a random event that Jizō was enlisted as the protector of (or, more accurately perhaps, protector *from*) the spirits of the unborn.

It is here that my long years of interest in the Jizō cult began. On a summer trip to Japan as a college student, I got the sad news from home that my sister had lost her child in the eighth month of her first pregnancy. She had to go to the hospital to deliver the baby stillborn, I learned. Distraught by this news and shaken by the mental image of the dead

child, feeling enormous compassion and sadness for my sister, I realized that here was a deity devoted to just such life events. My prayers and my thoughts turned to Jizō.

When I had arrived in Japan on this trip a few weeks earlier, I had been struck by the ubiquity of small stone figures. They stood by the roadside, on street corners in small well-tended wooden shrines, in halls on the grounds of Buddhist temples, chained to soda vending machines; they were everywhere I looked. I had quickly learned the name of this deity, Jizō, and had heard of his role as "the protector of women, children, and travelers." Not long after this, I began to see the temples offering Jizō images for sale, then lines and lines of Jizō statues, for the repose, rest, salvation of the stillborn and aborted. When I heard about my sister's baby, I felt I had a new friend to whom I could turn.

As my studies continued, I decided for a number of reasons that Jizō would be an excellent object of inquiry, an ideal window into Japanese religion in all its beauty and complexity. Jizō contains so many of the themes crucial to the study of religion in Japan: the fusion of Buddhism and local traditions, the cult of bodhisattvas, funerary ritual, gender, lay-monastic relations, and so on. When I first visited Mount Kōya, I was deeply impressed with the number of Jizō images I saw there in so many different contexts. Many of these, wearing the red cotton bib associated with Jizō, were in fact merely the broken finials of gravestones (*gorin no tō* or *hōkyōin tō*). Others were vaguely anthropomorphic rocks. Yet each had a small plastic basket in front with a few coins from pilgrims. Many had small offerings of flowers and water. I had seen there large and prominently placed Jizō statues, such as the monumental six *mizu-kake* (water-splashing) Jizōs in bronze on the approach to the Oku no in, where pilgrims line up to use bamboo ladles to splash water high onto the faces and shoulders of the images. Yet it was the small fragments of forgotten graves, now adorned with bibs and hats and set up in the crotches of ancient towering trees as Jizō images, that seemed to hold some deep meaning that I could not place.[97] I was drawn to these stones at a deep emotional level. In this, I know I am not alone, as these little images receive much attention from the many pilgrims to Mount Kōya. These recycled and fragmentary images seemed to me to be expressive of a certain harmony, forged over the centuries, between local, autochtho-nous cults dedicated to nature, to trees, on the one hand, and the univer-sal religion of Buddhism on the other. Little did I know, but this small deity contained worlds upon worlds.

As I began to study the history of the Jizō cult in East Asia, I quickly realized that he had originally been seen primarily as a savior from the

hell realms, an intercessor with the judge of the dead, King Enma, on the behalf of the sinful accused. Though I had intended to write a doctoral dissertation on Jizō, it became clear to me that the subject was a deep and vast one that would require a slower approach. I wrote the dissertation on medieval Buddhist discourses surrounding mothers and motherhood, as I felt that this could bring me closer to one of my central questions about the transformation of Jizō over the course of the medieval period. I wanted to know how it had come to pass that such a bodhisattva, the guide and protector in the infernal regions, should have become "the protector of women, children, and travelers."

This book focuses on the Jizō cult during the medieval period and the first century or so of the early modern. When, as a beginning graduate student, I would tell Japanese scholars that I was working on the Jizō cult, I would often receive in response a gently chiding chuckle, which I found mysterious. Now I understand their amusement. The Jizō cult in Japan is a topic of great complexity, and I had entered into it in a rather headlong manner. The figure of Jizō as a monk and his association with multiple doctrinal strands of the Japanese religious tradition made his cult, from its origins, one of great adaptability and mutability. Instantiated in images of wood or bronze, fixed in paintings and woodblock prints, Jizō nevertheless remains dynamic. Representations of the deity reveal movement, as befits a bodhisattva always ready to step into any situation to save sentient beings.

The Chapters of This Book

In the next chapter, we begin our investigation by looking into Jizō images of the early medieval period and thinking about statues and paintings associated with religious institutions of Nara, the "Southern Capital" ("Nanto" in Japanese). First examining early thirteenth-century statues of the deity that contain within themselves substantial information regarding their creation, we then move on to an iconography called the Jizō *dokuson raigō*, or solitary Jizō in welcoming descent, and finally remark on the spread of this Nara cult to the eastern Kantō region, Kyoto, and other locales by the end of the century. The iconological key in Chapter Two is the worship of the four deities of the Kasuga shrine, the family shrine of the Fujiwaras. Jizō became assimilated to the main god *(kami)* of this site, Amenokoyane, the ancestral god of the clan. This was accomplished through the logic of *honji suijaku*, the idea, already encountered above, that Buddhist deities have local manifestations. This

cult was supported and enthusiastically disseminated by the priests associated with the Kōfukuji, Kasuga's Buddhist sister institution. Many of these priests were prominent Fujiwara clan members, and their close involvement was an important aspect of the meteoric rise of the Jizō cult in the thirteenth century.

Chapter Three takes up the central role of the performing arts, ritual theater, and dance in the development of the Jizō cult in Kyoto. Beginning with the sacred dances and oracular practices of the Kasuga Wakamiya, which enshrined a Jizō image in its worship hall, we extend this discussion to the early performance traditions of *sarugaku* ("monkey music," Noh) and *kyōgen* (comedic theater) in Nara and Kyoto. The religious dramas and dances of medieval Kyoto were important to the ever-increasing popularity of the deity over the course of the fifteenth and sixteenth centuries. These shows were staged at religious institutions in the vicinity of large graveyards and charnel grounds and served to appease the restless dead and the unconnected or marginal departed *(muen botoke)*. Reading in diaries and other documentary sources of the day, we find that dance played a major role in worshipping images of Jizō. We also learn that just as his devotees danced in shrine halls and in the streets, Jizō himself was known as a dancer.

In the fourth and final chapter, we turn to the development of Jizō as a deity of safe childbirth and a protector of dead children in the next world. First examining the creation of a new place in hell—a sort of "children's limbo" known as *sai no kawara*—at the end of the medieval period, we proceed to the assimilation of Jizō to the worship of the old gods of the road and of boundaries, the *dōsojin* and the *sae no kami*. It was ultimately this connection between Jizō and the "autochthonous" deities of fertility and protection that made him the ubiquitous presence he became by the close of the medieval period. This connection is also the key to his role in the modern cult of offerings for the unborn, *mizuko kuyō*. This chapter closes with an examination of the fascinating tale of the "safe-childbirth Jizō of Kiyomizuzaka" *(Kiyomizuzaka no koyasu Jizō)*, a story that, both in its narrative and in the circumstances surrounding its composition, tells us a great deal about the nature of images in the Jizō cult. Of course, paintings and statues have aesthetic value and create an according response in the viewer (when they are not hidden images, or *hibutsu*), but as is clear in the case of this *koyasu* Jizō and so many others related over the course of this study, the most important aspect of the image is not the visual but rather the narrative. The stories explaining the origins and the miracles of images are essential to their efficacy.

Thousands upon Thousands

One persistent motif in the iconography of Jizō is the multiplication of bodies. According to scripture and legend, Jizō sends countless avatars or "division bodies" *(bunshin),* otherwise known as "transformation bodies" *(keshin),* through the six paths to save beings in distress. When Jitsuei, after being addressed in a dream by the living Jizō statue at Miidera, looks to the north, he sees one hundred thousand Jizōs facing him. There is a tension between the singular image—in this case one so clearly unique that it has the sculptor tagging along—and the unfathomable replication of the image that leaves the mind baffled and awestruck. There are many Jizō images in which the central large figure is surrounded by literally thousands of smaller Jizō images. This iconography is referred to as *sentai* Jizō, or "one thousand Jizōs" (fig. 1.5; plate 2). A particularly striking example can be found in the collection of the Bunkachō, Nara National Museum. This is a painting from the Muromachi period that places an array of one thousand Jizōs against the landscape of Nara (plate 3). Hayashi On has written about this remarkable painting.[98] There are also sculptural representations of this idea—for example, in the Fukuchi'in Jizō image in Nara, the mandorla, the almond-shaped background serving as a halo, has smaller Jizōs carved all over its surface. The inscription on the image dates it to 1254 and states that Jizō enters one thousand *samadhi*s (states of meditative stability) each day, making one thousand bodies to save the beings in the six paths (fig. 1.6).[99] Kyoto's Chionji also has an early Kamakura-period sculptural *sentai* Jizō, this one with all of the tiny images carved separately from the central image, which is itself only a little over thirteen centimeters tall. At Jizō's feet are King Enma and the deities produced at the time of one's birth and responsible for reporting to the king on the deeds of a lifetime, the *kushōjin.*[100]

Multiple Jizōs were also produced through the devotional practice of stamping out images, *inbutsu,* using small woodblocks, or carving them from thin slats of wood (figs. 1.7–1.11; plate 2). While other deities were worshipped in this manner, Jizō was by far the most popular subject for this sort of treatment. People would cultivate a daily routine of imprinting six Jizōs a day, or sometimes twelve or twenty-four. Some surviving examples bear the inscription of a date by each group of images, such as one such album maintained from the first to the fourth month of 1327.[101] Printed Jizō images were also made into amulets, or *fuda,* to be distributed to the faithful. In the next chapter, we will read of the enthusiastic promotion of the Jizō cult in the Kantō region by Kamakura-period monk Ryōhen using this method. These *fuda* could also be placed inside

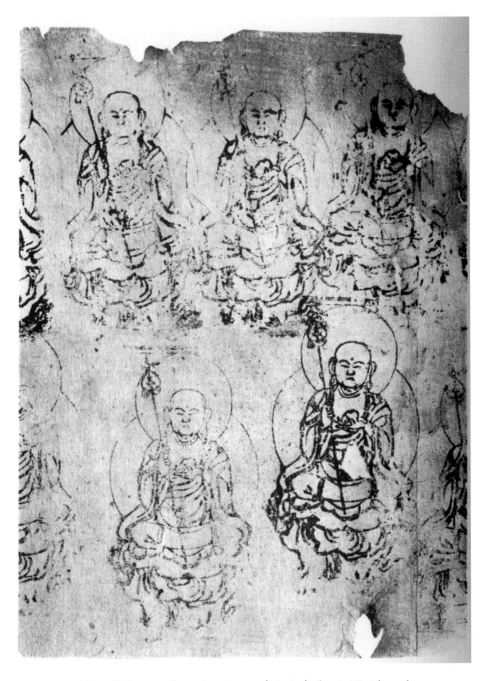

Figure 1.5 Detail of stamped woodcut images *(inbutsu)* of *sentai* Jizō (one thousand Jizōs), ca. fourteenth century. Courtesy of Tōshōdaiji.

Figure 1.6 Detail of the *mani* gem and the mandorla of the Fukuchi'in Jizō, showing the multiplication of images, ca. thirteenth century. Fukuchi'in, Nara. Courtesy of Fukuchi'in and Shibundō.

Figure 1.7
Stamped woodcut images *(inbutsu)* of *sentai* Jizō, ca. fourteenth century. Courtesy of Tōshōdaiji.

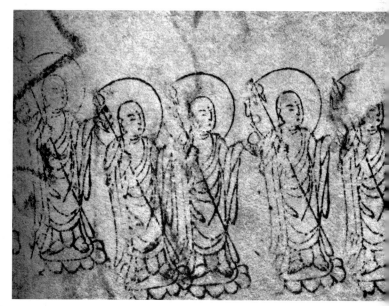

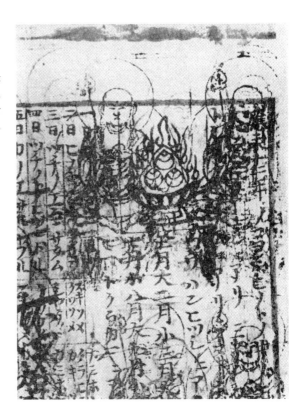

Figure 1.8 Stamped woodcut images *(inbutsu)* of *sentai* Jizō, printed on a calendar for the year 1402. Courtesy of Gangōji.

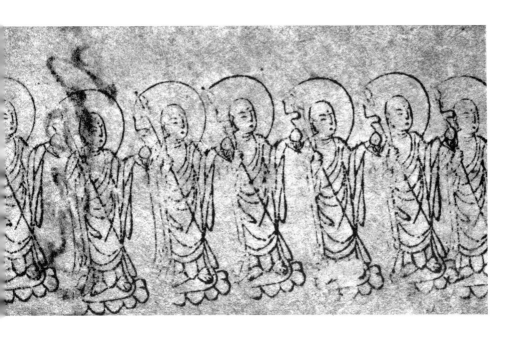

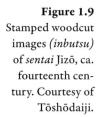

Figure 1.9
Stamped woodcut
images *(inbutsu)*
of *sentai* Jizō, ca.
fourteenth cen-
tury. Courtesy of
Tōshōdaiji.

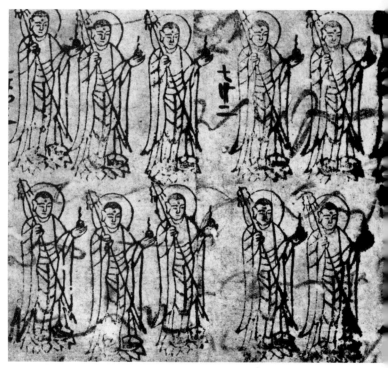

of statues, creating a *sentai* Jizō invisible to the fleshy eye but crucial to
the efficacy of the image. In 1983 a small thirteenth-century Jizō stat-
ue was found to contain thousands of such tiny printed images along
with a votive text *(ganmon)* dated 1249. This text documents the pres-
ence of the printed Jizōs and dedicates the merit accrued by the pious act
(fig. 1.12).[102]

Finally, temples throughout Japan dedicate a corner of their pre-
cincts to the *sentai* Jizō. These are collections of old or abandoned grave-
stones, often given a red bib and sometimes a cap to transform them into
Jizō images, whatever their original iconography may have been. These
discarded and broken fragments from memorials set up by forgotten fam-
ilies to honor their dead hold the emotions and prayers of parents and
children, husbands and wives, aunts and uncles, and grandchildren. The
now anonymous dead are thus reborn as replications of Jizō, thousands
of bodies ready to help and to protect the living. We shall have occasion
to revisit this last type of *sentai* Jizō, the ultimate evidence of the multi-
tudes of unconnected dead, the *muen,* who surround us. The commit-
ment of Jizō to save all such beings, without conditions and without any
particular previous relationship, can be described as compassion without

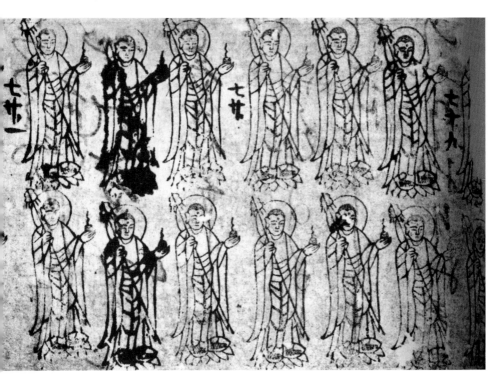

ties *(muen no jihi)*. This is the deepest and most sincere sort of universal love within the Buddhist taxonomy of compassion.

In one fascinating story, Jizō has to be reminded of the phrase. This is the legend of a courtier named Minamoto no Koretaka and is the origin tale of the Rokuharamitsuji Jizō, further discussed in Chapter Three. Koretaka, fallen into hell after a sudden illness, sees a young monk rushing about saving sinners and prostrates himself on the ground to plead for help. The little monk, Jizō, sizes him up and replies, "I am a Jizō with no tie to you" *(ware ha nanji ni en naki Jizō nari)*, then turns his back and stalks away. When Koretaka uses the expression in his repeated entreaty to be restored to life—"Please, I beg you to employ the 'compassion without ties' of the bodhisattvas" *(aōgi negawaku ha daishi muen no jihi o motte)*—Jizō has little choice but to comply.[103] In this story there is some tension between the notion of individual Jizō images who appear in hell to save their devotees, as we see in many legends, and the savior whose compassion is unconditional and indiscriminate. When this Jizō says that he is a "Jizō with no tie" to Koretaka, we are again reminded of the invocation of the old nun of Nara who spurns the Chisokuin Jizō, the Fukuchi'in Jizō, and the others in her dedication to the Yata Jizō. The

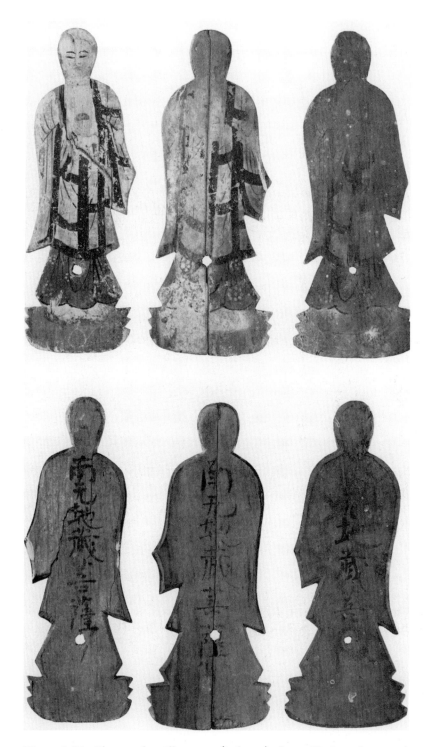

Figure 1.10 Flat wooden silhouettes *(itabutsu)* of *sentai* Jizō, ca. fourteenth century. Courtesy of Gangōji.

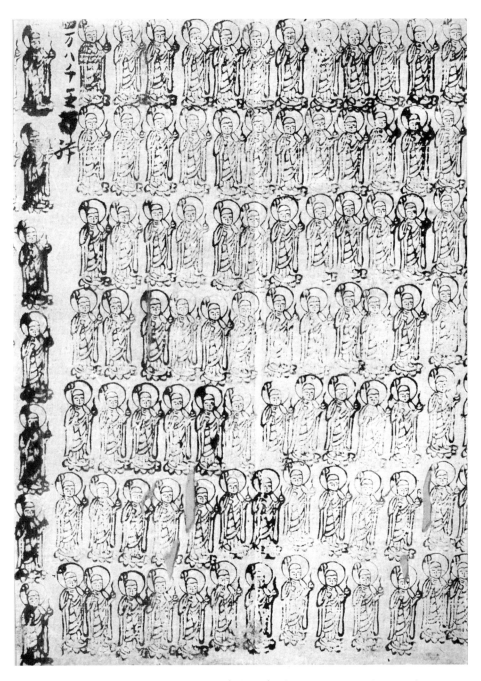

Figure 1.11 Stamped woodcut images *(inbutsu)* of *sentai* Jizō, ca. fourteenth century. Courtesy of Tōshōdaiji.

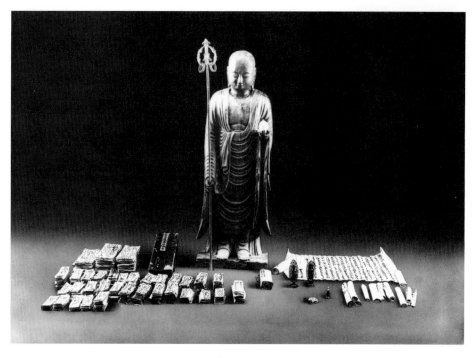

Figure 1.12 Jizō at the Cologne Museum for Oriental Art with contents displayed, ca. thirteenth century. Courtesy of Museum für Ostasiatische Kunst, Cologne (Inv.-No. B 11, 37). Photo by Rheinisches Bildarchiv, Cologne.

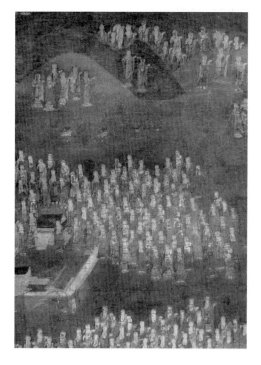

Figure 1.13 Detail of *Kasuga sentai Jizō,* ca. thirteenth century. Courtesy of Nara National Museum. (See plate 4.)

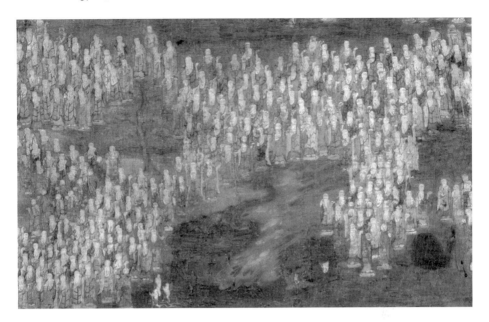

Figure 1.14 Detail of *Kasuga sentai Jizō,* ca. thirteenth century. Courtesy of Nara National Museum. (See plate 3.)

idea of the "thousand Jizōs" is that there is an infinitude of saviors, each of them Jizō and each ready to extend the hand of compassion to sentient beings. This iconography is closely related to the Kōfukuji-Kasuga cult and the idea of Jizō as a special savior of monks and also of the Fujiwara clan. There are a number of *sentai* Jizō paintings from the mid-Kamakura period, and one closely related to the Kōfukuji is presented here (plate 3; figs. 1.13 and 1.14).[104]

Monastic Devotion to Jizō

AS WE HAVE SEEN, Jizō's dramatic rise to prominence within the Japanese Buddhist pantheon began at the close of the Heian period. We will here trace the expansion of his cult during the Kamakura period, beginning with images created by the aristocratic clergy of the Fujiwara family's home temple, Kōfukuji, and moving on to other monks of Nara, the "Southern Capital," especially those in the Saidaiji lineage. This examination will finally follow these monks to the Kantō region, where we can witness the beginnings of popular cults dedicated to roadside images of Jizō, perhaps the sort of Jizō worship most immediately familiar to modern Japanese.

This is a chapter about the engagement of Buddhist clerics with Jizō images, both in their personal devotional practice and their promotion of the Jizō cult for others. For the most part, we will focus on the thirteenth century, when the Jizō cult in Japan experienced unprecedented growth. The Cologne statue is by no means unique among Kamakura-period statues in having a wealth of "internal interest." The present chapter on monastic devotion to Jizō begins with an image created sometime between 1221 and 1226 and now owned by the Asia Society of New York City. Since it is held in the Mr. and Mrs. John D. Rockefeller 3rd Collection, here it will be referred to as the Rockefeller Jizō. The small statue is a well-traveled one, selected to journey to the 1904 World's Fair—the Louisiana Purchase Exposition in St. Louis, Missouri—as part of an exhibition of Japanese Buddhist art. It was apparently seen there and admired by the renowned champion of Japanese culture, Ernest Fenollosa (plate 4).[1]

Having seen this Jizō on exhibit twice at the Asia Society, once in 1989 and once in 2005, I fully concur. It is a spectacular image, delicate,

jewel-like, and emotionally moving. The exterior surface of the statue, with its well-preserved polychrome painting and lacework of gold foil and intricate carving, is breathtakingly affecting, but it is the interior of the statue that will occupy us here. When we look inside this small statue, we find that it opens a view into the world that created it.

The former owner of the statue, Horiguchi Sōzan, who acquired it in 1926, authored a loving and meticulous description of the image in 1955, including excellent and detailed photographs of its interior and exterior.[2] In his book, he stresses again and again that the statue should be ranked among the greatest works of Japanese Buddhist sculpture, as it is no way inferior to pieces carved by Unkei and Kaikei now listed as national treasures *(kokuhō)*. In fact, when Horiguchi showed photographs and later the image itself to a number of the most eminent scholars in the field, asking their opinion regarding the identity of the sculptor, they wavered between these two geniuses of the thirteenth century but felt sure that it was the work of one or the other. Later, Horiguchi noticed that if he shined a flashlight through the gap where the neck attaches to the hollow body, he could make out a great deal of writing on the interior surface of the diminutive statue. In the *yosegi zukuri* (wood joinery) style, very much in vogue during the Kamakura period, separately carved pieces of wood were pieced together, creating cavities in the head and torso. This in turn made it possible to insert crystal eyes, texts, and all sorts of objects into the statues.[3] Whoever made this Jizō image had chosen to use brush and ink to write directly on the interior surfaces of the wood pieces before they were assembled to form the statue. Horiguchi found, however, that no matter how many hours he spent peering in through the neck with his flashlight, there was no way to read more than a small fraction of what was written there.

Finally, he decided that for the good of future scholarship and to satisfy his own mounting curiosity, he would disassemble the statue. He describes the tense scene, sitting with Sekino Kintarō—professor at Tokyo University of Fine Arts (Tōkyō bijutsu daigaku) and, known by his craft name "Shōun," the foremost Buddhist sculptor of his day—ready to perform the task. Filled with trepidation, they slowly pried the statue apart, terrified they might permanently damage it.[4] The statue came in half cleanly without disturbing any of the cut gold foil, or *kirikane*, or even a speck of sawdust, revealing its long-hidden messages. The inscriptions and texts contained within the statue provide a wealth of information on the doctrinal, institutional, and ritual circumstances of its creation. Reading the text brushed onto the concave interior of the two halves of this statue carved from *hinoki* cypress, we learn that the project had at least twenty-one sponsors, among them four of the top-ranking monks of the

Kōfukuji temple. As we shall see presently, Jizō worship in the thirteenth century was closely connected to the Kasuga cult, so important to the clergy of Kōfukuji. Let us now explore those inscriptions in some detail in an effort to understand the rapid rise of the popularity of the Jizō cult in thirteenth-century Japan.

The body of the Cologne Jizō contains some one thousand Jizō images. The Rockefeller Jizō does as well, but not on slips of paper; here the images are written within the body in the form of one thousand *siddham* letters, Sanskrit letters referred to as the seed, or *bija* (J. *shūji*) of the deity. Jizō's *bija* is the character "ka," 𑖎. The front half of the statue has one thousand repetitions of this symbol written in a tiny hand (fig. 2.1). Although the short English summary that appears in the opening pages of Horiguchi's book states that "in the hollowed interior of the image are enshrined one thousand miniature images of the same bodhisattva," this seems to be a misunderstanding on the part of the translator. Horiguchi's gripping account of his inspection of the inside of the image suggests that he is in fact referring to the *bija* syllables when he speaks of one thousand Jizōs contained within the statue.[5]

Besides these many "ka" characters, there are two mantras transcribed in Chinese characters (one of them the well-known *on kaka-ka bi sanmae sowaka* from the *Mahāvairocana Sutra*), and the phrase *namu rokudō nōge Jizō bosatsu*, or "hail Jizō bodhisattva, the teacher who manifests throughout the six paths." There is also a four-line *gatha* (verse) and the signature of one monk.[6] All of this, together with a line transferring to the salvation of all beings the merit generated by the dedication of the statue, can be taken as the primary votive document, or *ganmon*, of this statue. Let us now turn to the content of the *gatha* and the identity of the monk whose name is recorded inside this front half of the statue.

The monk who signed this text humbly calls himself the *shamon* Chōken. His simple prayer (it had to be simple, for there was hardly any room left over after all the "ka" characters had been written!) consists of a single *gatha* from the *Dizang pusa benyuan jing* (Sutra of the Original Vow of Jizō Bodhisattva), along with his wish for the benefit of all beings in the *dharmadhatu*. This *gatha* in which Śākyamuni asks Jizō to become the savior of beings until the advent of Maitreya, is often cited in commentarial literature and folktale.

> Humans and Gods and other beings of the present and future,
> I now earnestly entrust to you.
> With great spiritual penetrations, skill in means, take them across.
> Do not allow them to fall into the evil paths.[7]

Figure 2.1 Detail of front interior of standing Jizō, Zen'en, 1220s. Mr. and Mrs. John D. Rockefeller 3rd Collection (Rockefeller Collection 1979.202a-e), Asia Society, New York. From Horiguchi 1955.

Horiguchi believes that the entirety of the front half was written by Chōken with no draft and was done quickly and spontaneously. He also states that Chōken may have been a scholar monk of Kōfukuji who later became a priest of the Takama shrine where the statue seems to have been dedicated. He further conjectures that Chōken was probably involved in ascetic practices and mountain practices on Kasuga's Mount Mikasa, in the area where the Takama shrine is located, a peak called Fu'unpu. While these statements by Horiguchi may be speculative, they are by no means baseless.

This Chōken, whoever he was, was likely the principal patron of the project, since his name appears alone while the signatures to the posterior half of the image's inscription number twenty. Chōken must have been quite a powerful and influential person in his world, as the signatories to the larger list include four men of extremely distinguished family origin and ecclesiastic rank: Han'en, the fifty-fourth *bettō* (abbot) of Kōfukuji; Jisson, the fifty-fifth; Jisshin, the fifty-sixth; and Enjitsu, the fifty-seventh.[8] The latter three were sons of towering figures, Fujiwara imperial regents: respectively, Motofusa, Motomichi, and Michi'ie. Their uncles, male cousins, and brothers were similarly the most powerful men in the land. Their sisters and aunts were imperial consorts and queen mothers. Each of the four was invited by the emperor on multiple occasions to perform special rituals, often including prayers for rain at the Dragon Cave, or Ryūketsu, at Mount Murō.[9] Notably, each also served as the general rector *(kengyō)* of Mount Kinpusen, and so these four were some of the early ecclesiastical members of the Tōzan order of *shugendō*.[10] We shall turn to their prayers found in this Jizō image presently, but first let us join Horiguchi in further speculation upon the identity of this main patron, Chōken.

Horiguchi insists that it is essential to see Chōken as a monk skilled in the practice of consciousness-only (J. *yuishiki*, Skt. *vijñaptimātra* or *cittamatra*) meditation, an ascetic who shunned official position. In this, Horiguchi says, our Chōken must have had a great deal in common with later *shugendō* practitioners and the ascetic monks who ran the grueling thousand-day circuit of Mount Hiei, the *kaihōgyō* beginning in the mid-Heian period.[11] Although Chōken was an accomplished scholar, his devotion to his Buddhist practice led him to reject the accolades that would have been accorded him. Clearly Horiguchi's speculations here are just that, but let us relate two more for good measure. Horiguchi considers that Chōken may have been the abbot of the temple of the Takama deity, Takamadera, and created this Jizō as an embodiment of the root deity *(honji)* of Takama *myōjin*. Finally, is it possible that Chōken may have been another name for Junkō *shōnin* of Kōfukuji's Shūzen'in cloister, teacher to both Han'en and Jisson?

The identity of the main patron of this Jizō project, *shamon* Chōken, may never be clear, but we do know a considerable amount about a number of the others who signed the inscriptions on the interior of the rear half of the image. Besides the four eminent and powerful monks mentioned above, there are sixteen others. While most of these names are not identifiable in the historical record, two sculptors known for their works in the Kamakura period do appear there: Zen'en and Zenshun.[12] Both of these sculptors were part of what is today known as the Zen school, because of the shared Japanese character *zen* (good) in their names, and both had extremely close ties to Kasuga and Kōfukuji and also to the Ritsu monks at Saidaiji in Nara. Zenshun had carved a statue of Shōtoku *taishi* in 1268 for Gangōji and, in 1280 for the occasion of Eison's eightieth birthday, was commissioned to create the important portrait statue of the Ritsu patriarch preserved in the Saidaiji. Zen'en lived from 1197 to 1256 but was only rediscovered by scholars in the latter half of the twentieth century. Kuno Takeshi, writing in the 1960s a number of years after Horiguchi, established that Zen'en was almost certainly the sculptor responsible for fashioning this Jizō statue.[13] Besides these two sculptors and the four high-ranking monks, there are also signatures by three, possibly four, more sculptors, five or six more monks, and five women whose names suggest that may have been nuns or at least lay novices. The sculptors, too, would be nominal monks.[14]

The inscription that they have signed here, along with the one in the head of the image, closely ties this image to the Kasuga cult. Most prominent among the writings is the mantra of Vairocana Buddha as seen in the Womb World (or Taizōkai) mandala: *no maku manda boda na abira unken* (fig. 2.2). The primordial and universal buddha of the esoteric Buddhist tradition, Vairocana (J. Dainichi), was seen as the general representative of the Buddhist guise of the Kasuga shrine in the *honji suijaku* scheme. That is, while each of the five Shintō deities of the shrine had its own Buddhist alter ego, Dainichi stood for the five as a unity. The mantra, complete with pitch notations to guide vocalization, appears under an invocation of the Takama deity: *namu Takama daimyōjin*. Although the Takama deity does not appear in the standard lists of Kasuga gods, it is understood that this figure was very important to the people who dedicated the statue.

The lines of votive text *(ganmon)* that appear further down on the body, toward the bottom, sing the praises of Jizō *bosatsu*, "the teacher who manifests throughout the six paths," and go on to pray for peace and ease in this life. Continuing, the *ganmon* asks for good rebirth for the petitioners and their parents. This is followed by six "ka" syllables in *siddham* script, and then a line that reads, "*namu Kasuga daimyōjin,*"

Figure 2.2 Detail of back Interior of standing Jizō, Zen'en, 1220s. Mr. and Mrs. John D. Rockefeller 3rd Collection (Rockefeller Collection 1979.202a-e), Asia Society, New York. From Horiguchi 1955.

praising the deity of Kasuga, also said to be identical to Jizō. The next line, fascinatingly, is written not in Chinese characters but in the hiragana syllabary; it prays for the distribution of the generated merit to all beings in the *dharmadhatu* without distinctions, using language similar to Chōken's. Since the prayer is in hiragana (so-called *onnade*, or "a woman's hand"), it is very likely that this particular prayer was transcribed

by one of the women involved in the project. The *ganmon* next invites private prayer, stating, "The prayer within my heart will certainly be fulfilled: the twenty-fourth day, *imisu*." The last word, written in katakana, represents the internally voiced prayer, kept secret from others.[15]

This formula for a silent petition or prayer—*shinchū shogan ketsujō enman*, "may the wish in my heart may without fail be manifested"—can be found in the *Kasuga gongen kōshiki*, by Gedatsubō Jōkei; this work is an influential liturgical and ceremonial text discussed below in greater detail.[16] In the head is another inscription, but it is not signed and thus it is unclear if the supplicant is Chōken, one of the other signatories, or another person altogether. This inscription also invokes the Kasuga deity and borrows a line reminiscent of Jōkei's writing. Using the language of the *Jizō kōshiki*, it prays that the subject might meet with the god of Kasuga—the Kasuga *myōjin*, here figured as Jizō—in birth after birth, life after life, and continually draw close to him.[17] It also asks that he or she be included in the assembly of those who clearly discern the correct analysis of the consciousness-only philosophy and the proper doctrine within the holy teachings. It ends with a prayer for the speedy realization of full enlightenment.

Jizō as Amenokoyane: The Bodhisattva as *Honji* of the Third *Kami* of Kasuga

So why is it that this Jizō image seems to bear such an intimate connection to the Takama deity and the Kasuga deity? It is almost as if, rather than the bodhisattva Jizō, the real intended object of worship was one or the other of these Shintō gods. To understand this more fully, let us turn back the calendar one generation and examine the place of Jizō in the doctrine and practice of Gedatsubō Jōkei, the great reviver of Hossō (Ch. Faxiang, Skt. Yogācāra) studies at Kōfukuji.[18]

Owing in large part to the efforts of monks from Nara, Jizō went from being a somewhat marginal figure in the pantheon of Heian-period Buddhism to become quite central in the Kamakura period. Especially crucial to this process was the eminent Gedatsubō Jōkei. While the bodhisattva Jizō per se was not a major figure in Jōkei's own practice, it was Jōkei's influence and that of his disciples that came to guarantee Jizō a prominent place in the medieval religious landscape.

Jōkei (1155–1213) was a monk of the Hossō school and a member of the Fujiwara family; both affiliations are essential to an understanding of his approach to the Jizō cult.[19] Jōkei was the grandson of the ill-fated Fujiwara courtier Michinori, who is usually referred to as Shinzei,

his clerical name. Jōkei, like many of his uncles and male cousins, was made a monk at an early age. He was sent to Nara at eleven to become a monk and entered the Fujiwara clan temple, Kōfukuji, at fifteen. He became an accomplished scholar, adept fund-raiser, and effective institution builder, revitalizing Kōfukuji, Hossō studies, and Nara Buddhism in general. Jōkei was associated by an earlier generation of modern scholars with the hidebound ways of the traditional Nara schools and their opposition to the new sects of Buddhism that appeared around the turn of the thirteenth century; however, Jōkei was in fact an early and important figure in the redefinition and realignment of those schools.[20] For Jōkei, Jizō would become an important part of the Hossō sect's program of outreach. For those who came after, Jizō images were key in bringing the Buddhism of Nara to the rest of Japan.

As a Fujiwara, Jōkei revered Jizō as the root deity behind Amenokoyane, the ancestral god of his clan. This worship of the Shintō god in Buddhist guise was made possible though the doctrinal system of *honji suijaku* (referred to in Chapter One). In this system of thought, firmly established by the late twelfth century, one-to-one equivalencies were drawn between the Buddhist deities (*honji*, or fundamental ground) and local gods, now recast as avatars (*suijaku*, or manifest traces) of the buddhas and bodhisattvas. The main Kasuga god, the third of the four original shrine seats of Kasuga, was invariably linked to Jizō in this sacred taxonomy, while Buddhist denotations of the other Kasuga gods varied somewhat from text to text.[21] In 1196, Jōkei wrote a ceremonial script, or *kōshiki*, dedicated to Jizō, drawing heavily on the *Shilunjing* and emphasizing the traditional connection between the bodhisattva and the future buddha, Maitreya. In this text he also made explicit the identity between Jizō and the Kasuga deity. He made this link in other *kōshiki* as well; for example, in the *Kasuga gongen kōshiki* he wrote:

> The Third Sanctuary is Jizō Bodhisattva, the teacher able to transform through the six realms, who received his charge from the Buddha *(fushoku)* in the clouds of Tuṣita, and who descends into the flames of hell to save those of fixed karma *(jōgō)*. During the middle period between the last Buddha and the next, deeply do we depend upon his guidance in this life and the life to come.[22]

What Jōkei expressed in his doctrinal treatises in Sino-Japanese prose, artists expressed iconographically. As we have seen, the small Rockefeller Jizō was created in the 1220s, likely as part of a set representing Buddhist versions of the Kasuga gods. Below we will examine several other images that depict this doctrine of local instantiation in various

ways. In either its composition or in the legends surrounding it, each of these images ties the Jizō cult to Kasuga and to Kōfukuji. The next image to take up in this context is the Jizō statue that was held at Chisokuin, a cloister of Tōdaiji.

This was a secret image, not on view to the public, and one with a miraculous history. The early fourteenth-century *Kasuga gongen genki e* (Illustrated Miracles of the Kasuga Deity), commissioned by Saionji Kinhira and painted by Takashina Takakane, contains numerous legends of Jizō, many of them tying him decidedly to the Kasuga cult and to the third shrine.[23] In two particularly striking examples from the illustrations, we find Jizō flying on a cloud to return to the shrine and later leaving it in a carriage to visit Buddhist clerical debates at Kōfukuji (fig. 2.3; plate 5). The accompanying text explains the details of the homecoming and the departure of the Kasuga deity. We see him in his form as a monk, as Jizō, surrounded by the low-ranking ritual specialists of the shrine, the *warabe* or *jin'nin,* dressed in yellow court robes. These *warabe,* who were dedicated to Jizō as their personal deity, were essential for the operation of the shrine and the successful performance of rituals there.[24] The next chapter will focus in more closely on the relationship between the Jizō cult and ecstatic performance.

A number of the stories also involve Jōkei. Other nearly contemporary records tell us of Jōkei's apparent involvement in the Jizō cult, such as the story of the Chisokuin Jizō at Tōdaiji.[25] A text called the *Kōfukuji ranshōki* tells us that Jōkei carved this image at the Ryūgejuin, the hall he occupied at Kōfukuji, while an account left by the Hossō monk Ryōhen in 1252 says the Chisokuin image is a self-portrait by the Kasuga deity himself.[26] The latter story has it that Jōkei went into retreat in 1195 at the Kasuga shrine, sequestering himself and praying to see the living shape of the god. One night he was visited by a strange old man who told him to fetch some sandalwood and then carved the wood quickly to create the "living body" *(shōjin)* of the Kasuga Daimyōjin.[27] He said he would leave the dedication ceremony in Jōkei's hands and suddenly vanished.

In this legend of the Chisokuin image, it is the Kasuga god himself who carves the statue and Jōkei is both petitioner and witness. We can note a certain narrative similarity with the legend of the Yata Jizō image, said to have been carved by Manmai *shōnin* after his return from the underworld and his salvation by a living Jizō (*shōjin no* Jizō). In the first chapter, we read the story of the "Shintō" shrine priest Koretaka, who was told by the six Jizōs to return to the world of the living and correct their iconographical mistakes. Ono no Takamura is another example of a person who returns from hell to carve a Jizō statue.[28]

Finally, we find a story that uses another shrine priest's trip to hell

Figure 2.3 *Kasuga gongen genki
e* 11:4, ca. 1309. Courtesy of the
Museum of the Imperial Collections
(Sannomaru shōzōkan).

to reconfirm the connection between Amenokoyane and Jizō. Of course
in doing so, it also affirms the relationship between Buddhism and *kami*
worship. Here, a *kami* priest of the thirteenth century dies and is pre-
sented before Enma's court for judgment. A Buddhist monk comes to tell
the king that the Shintō priest should be released right away, because he
has always served the monk faithfully. After the ordeal, the perplexed but
grateful priest turns to the monk, saying that he has throughout his life
worshipped only the Kasuga Daimyōjin, not any Buddhist deity, where-
upon the savior monk reveals his true identity as that selfsame god of
the Third Sanctuary at Kasuga, clarifying that his *honji* is the Chisokuin
Jizō. Thus it is not a transcendent or universal Jizō who is the *honji*, but a
specific image. The statue in this case is not a representation of the deity;
it is itself the deity.[29]

 These tales speak to the close relationship between Kasuga, ancestral
shrine of the powerful Fujiwara family, and the Kōfukuji temple. Chi-
sokuin was to become a very important site at Tōdaiji, and its image
renowned as a particularly miraculous one. In identifying the Kasuga
myōjin with the bodhisattva Jizō, the monks of Kōfukuji made a wise de-

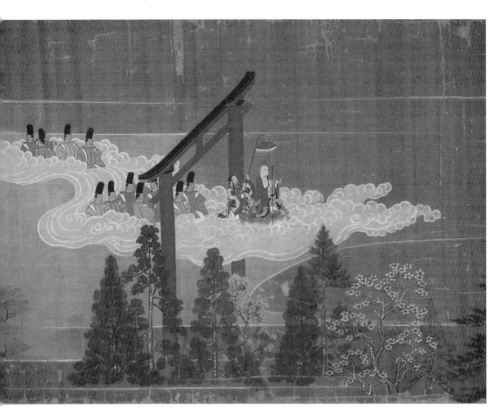

cision.[30] His form as a monk meant that Jizō could be assimilated to the Buddhist monks of the temple, creating an implicit equivalence between them and the Fujiwara clan god. In the paintings from the *Kasuga gongen genki e*, we saw the return of the god to the shrine as Jizō the monk. The thirteenth-century compendium of legends entitled *Shasekishū* also emphasizes the connection between Jizō and the Kasuga *myōjin*, as well as the link to Jōkei.[31]

Jōkei's name appears, albeit posthumously, along with those of a number of important priests of Nara on the "roll of karmic affinity" *(kechien kōmyō)* contained inside a 1228 image of Jizō now housed in the Denkōji temple in Nara (plate 6). This diminutive statue was opened in 1952 during the process of restoration, revealing its fascinating contents. I have written about this image elsewhere and will not go into great detail here, but would like to emphasize Jōkei's evident relationship to the project.[32] This Jizō image contains two other small statues as well as relics of Śākyamuni Buddha. A votive document included in the statue makes it clear that these four together—the Jizō image and the three other deities contained therein—are meant to represent the whole of the Kasuga shrine

complex. The document, written by the principal patron, an eighty-three-year-old nun named Myōhō, enlists the help of the four Kasuga gods and names them. It has been speculated that this was the private image *(nenji butsu)* of a high-ranking Fujiwara woman, the nun Myōhō.

The Denkōji Jizō does indeed have much in common with the small Rockefeller Jizō discussed above. It is of similar size, date, composition, and doctrinal meaning. Actually, Sugiyama Jirō has suggested that it was carved by the sculptor Zen'en, the same man who carved the Rockefeller Jizō.[33] It is significant that he reached this conclusion without having seen the Rockefeller Jizō, but based on stylistic similarities to other works of Zen'en's discovered nearly at the time he was writing. As Horiguchi remarks, the similarity in appearance between the two images, particularly in facial expression, is striking.[34] It is also worth noting that, even though quite different in their particulars, the two projects are also quite similar in their complexity and sophistication. Actually, the names of a few figures appear both here, on the "roll of the karmically affiliated" *(kechien kōmyō)* discovered in the Denkōji Jizō, and on the one inside the Rockefeller Jizō: the monks Son'en and Jissan and the nun Seiren. The *kechien* list of the Denkōji Jizō is much longer, with a total of nearly 260 names written out in Myōhō's own hand. Of great interest to us is, of course, the clear connection to the Kasuga cult and the ingenious expression of the *honji suijaku* idea. Furthermore, as Hayashi On has noted, the dedicatory text written by Myōhō follows Jōkei's *Jizō kōshiki* very closely.[35]

With the Denkōji Jizō, Zen'en (if Sugiyama's attribution is accurate) recreates a set of four or five statues he had carved earlier in the same decade, this time encapsulating the totality of the Kasuga shrine within one image. The Rockefeller Jizō statue was most likely one of a group of images of the Kasuga *honji butsu* carved by Zen'en in the early 1220s. There exists a small eleven-headed Kannon *bosatsu* in the Hasedera iconography, with a staff and a vase, representative of the fourth Kasuga deity. The stylistic similarities between the Rockefeller image and this statue are remarkable, down to the extensive inscriptions inside the work (here the repeated *bija* is that of Kannon) and the list of patrons, among whom Zen'en appears.[36]

The diminutive size of the Denkōji Jizō and the Rockefeller Jizō accentuate the intimacy and meticulous craftsmanship of these images. In both size and composition, the Denkōji Jizō and the Rockefeller Jizō can also be compared to the Jizō statue at the Tōdaiji's Kōkeidō, carved by the eminent Kamakura-period sculptor Kaikei and commissioned by Myōhen, whose name also appears on the Denkōji *kechien* list.[37] As we have seen, the *yosegi zukuri* technique offered a new level of realism and refinement to carved images and also created cavities within the body of

the statue, which could be filled with scriptures, images, and votive documents. In addition, it presented an opportunity to write inside the statues. Such writing could be very elaborate, as in the case of the Rockefeller Jizō or it could be quite minimal, like the inscription found inside another small statue of Jizō, now in the Burke Collection, that was carved and signed by Kaikei, using his craft name "An'ami" (figs. 2.4 and 2.5).[38]

In such projects, considerable attention was given to the formal aspects of the iconography, but equally important was the clear and careful exposition of doctrinal content. This was accomplished through various means, visual, textual, and ritual. In the case of the Denkōji Jizō statue, the Buddha relic and the tiny statue of the Medicine Buddha, Yakushi *nyorai*, in the head represent the gods of the first and second sanctuaries, respectively; in the left thigh, the eleven-headed Kannon image in the Hasedera style stands for the fourth sanctuary.[39] These three are all contained within the body of Jizō, representing the relationship between the Kasuga gods. In this sense, the Denkōji Jizō stands as a symbolic diagram for the cult of Kasuga and speaks to the tightly entwined meanings of Jizō for members of the Kasuga/Kōfukuji community.

Thus the Denkōji image is analogous to the spiritual maps known as Kasuga mandara. The Japanese word *mandara* transliterates the Sanskrit word *maṇḍala,* derived from the word *manda* (circle). Originally the term *mandara* referred to the geometric and symmetrical cosmic maps of the esoteric *(mikkyō)* sects of the Vajrayāna tradition. However, by the Kamakura period the term came to refer also to quite a different type of image. This sort of *mandala,* often called the shrine mandara *(miya mandara),* is a representation of the precincts of the holy site, depicting the buildings and the natural landscape along with the deities of the place. Most often, these Shintō gods are shown in their Buddhist guise.[40] These come in a number of forms; while some place Jizō at the center, others feature a deer, the tutelary animal of the shrine. Still others represent the Kasuga god as an empty carriage or a gentleman in Japanese court dress. Most images have as their primary iconographical theme a plan of the buildings of the shrine arrayed at the foot of Mount Mikasa, and feature roundels of the four gods (or five, including the Wakamiya) ranged above the shrine buildings (fig. 2.6). Others focus on Jizō, with the single bodhisattva represented as approaching the viewer, while the roundels above hold the Buddhist translations of each of the shrine gods.

In an image owned by the Nara National Museum, Jizō appears centrally as the deity Amenokoyane in his strikingly human Buddhist guise and also appears above in the floating snapshots of the Buddhist manifestations of the Kasuga deities appearing in the top register. This is an extreme case of *honji suijaku* whereby the visible form of the god

Amenokoyane—that is, the monkish shape of Jizō bosatsu—is iconographically glossed as Jizō the "fundamental ground" *(honji)* of the deity. As is the case with the Denkōji image, the subordinate relationship of the other gods to Jizō is quite clear. This was accomplished in other works in different ways, such as a statue of Jizō standing atop a white deer, the messenger of the god, or a painting of a thousand Jizōs working to save beings in each of the six realms set against the background of a Kasuga land-scape (plate 3).[41]

Jizō as a Guide to the Dying: Amida's Pure Land, Local Landscapes, Alternate Pure Lands

The landscape of Kasuga, both natu-ral and built, was transformed into a pure land during the Kamakura pe-riod, a time when terrestrial instantia-tions of otherworldly sites became an important concept, one directly related to a doctrinal stance of radical non-dualism.[42] Significantly, however, some questions surround the precise identifi-cation of this pure land, and these ques-tions have important doctrinal implica-tions. While the term "pure land" tends in Japan to refer primarily to the west-ern land of ultimate bliss, or Sukhāvatī (J. Gokuraku, An'yō), presided over by Amida Buddha, this label does not affix easily to the Kasuga pure land. Mount Mikasa came to be seen as a local manifestation of Gṛdhakūṭa, India's Vulture Peak, where the Bud-

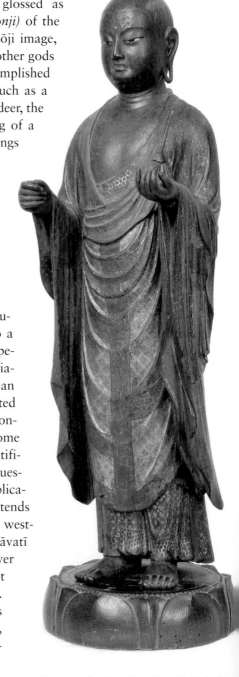

Figure 2.4 Standing Jizō, Kaikei, thir-teenth century. Courtesy of Mary Griggs Burke. Photo by Ichikawa Kazumasa

Figure 2.5 Detail of back interior of standing Jizō, Kaikei, thirteenth century. Courtesy of Mary Griggs Burke. Photo by Sheldan C. Collins.

dha delivered the *Lotus Sutra*, and indeed Jōkei wrote a *kōshiki* on rebirth into Śākyamuni's pure land, Ryōzen *jōdo*. This identification also appears in a well-known story about the Kasuga deity's Tarō (eldest son), Myōe *shōnin*.[43]

The Noh play *Kasuga ryūjin*, by Zeami, is based on this tale, in which Myōe goes to the Kasuga deity to inquire about the success of his meticulously planned trip to India. He is told through an oracle that he should instead remain in Japan and should rest assured that Mount Mikasa is in truth none other than Vulture Peak and that Kasuga is the selfsame pure land described in the *Lotus Sutra* as the dwelling place of the Buddha after his "death," or passage into nirvana.[44] This vision of Kasuga as the pure land of Śākyamuni fits well with the devotional cult dedicated to the historical Buddha and made so popular in Nara by Jōkei and Myōe among others. It seems that Kasuga was also seen as a different sort of "pure land" at times; that is, it was also the Tuṣita heaven presided over by the future buddha Maitreya. Being born into the Tuṣita heaven was a particular desideratum for Jōkei and other scholar monks.[45]

In Nara's Nōman'in temple, there is a remarkable painting of the Pure Land above the Kasuga plain, *Kasuga jōdo hensō mandara* (Mandara of the Transformation

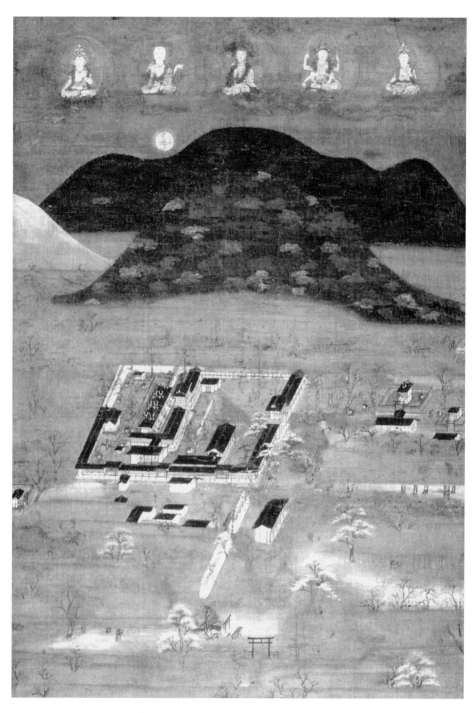

Figure 2.6 Kasuga mandara, ca. fourteenth century. Courtesy of the Mary and Jackson Burke Foundation, New York. Photo by Sheldan C. Collins.

Tableau of the Kasuga Pure Land) (fig. 2.7; plate 7). In it, we find an array of three buddhas, rather than the usual solitary buddha, presiding over a unique pure land. In the central position is Amida Buddha, with his flanking bodhisattvas Kannon and Seishi. The two additional figures are Yakushi, the Medicine Buddha, to his lower right and Śākyamuni, the founder, to the lower left. The shrine buildings and natural landscape of Kasuga can be seen ranged below. The message is that the three lands of these buddhas—Amida's Gokuraku; the Jōruri, or lapis lazuli, pure land of Yakushi; and Śākyamuni's Ryōzen *jōdo* (the Vulture Peak pure land)—are in essence one. The part of the painting that most draws our attention is the small Jizō riding up and away from the third sanctuary of the Kasuga shrine borne atop a cloud, toward these pure lands, with a smaller monk reverently in tow. A group of a few monks watch and press their palms together on a cloud across the way; musicians trail in on a nearby cloud.[46] This small figure accompanying Jizō is the monk Shōen, whose story is told in the *Shasekishū* and in the *Kasuga gongen genki e*. I offer Royall Tyler's translation of the latter (notes omitted):

> There once lived in the Southern Capital a monk named Shōen, the "Deputy's Prelate," a disciple of the Venerable Gedatsu. Although

Figure 2.7 Detail of *Kasuga jōdo hensō mandara,* ca. fourteenth century. Nōman'in, Nara. Courtesy of Nōman'in and Nara National Museum.

known as a scholar, he fell into the demon realm. Then he possessed a woman and said many things, among which were the following.

"Our Daimyōjin's ways are certainly wonderful. He will not have anyone who has done Him the least honor, however great a sinner that person may be, go to any hell other than the one He himself holds ready beneath the Kasuga meadows. Each morning He fills the ablution vessel of Jizō Bosatsu, and from the Third Sanctuary asperses this hell with a wand. A single drop in the sinner's mouth relieves for a moment that sinner's pain, and the sinner comes a little closer to right thoughts. Then He intones for the sinner essential passages and *dharani* [magical spells] from the Mahāyāna Canon. He does this every single day. Thanks to His ministrations, the sinners gradually rise and pass out of hell.

"The scholar-monks listen to the Daimyōjin discourse on *hannya* [*prajñā*, the highest wisdom] at Kōzen, east of Kasuga-yama, where they hold discussions and debates exactly as in the human realm. Those who were once scholars are all scholars here. It is an awesome privilege to hear the Daimyōjin preach, and to see Him with one's own eyes."

Jizō is the *honji* of the Shrine's Third Sanctuary. People say his blessings are especially wonderful. He serves [as] the guide whom we invoke when we call the Buddha's Name. As *honji* or as *suijaku* He is equally worthy of trust.[47]

Tyler suggests that the legend refers to an incident that occurred around 1240, which makes good sense given Shōen's dates. It also accords with the ever-increasing emphasis on Jizō within the Kasuga cult as practiced by the monks of Nara during the thirteenth century.

As Minobe Shigekatsu has suggested, the readers of *Shasekishū* and *Kasuga gongen genki* would have been familiar with this monk, who was rather well known. He was particularly famous, one might say notorious, because of the widespread rumor of his violation of the precepts by having sex with a woman, leading to the birth of a daughter who became the nun Shinnyo of the Chūgūji convent and who is, incidentally, mentioned in *The Tale of Lady Nijō (Towazugatari)*.[48] For his sins, Shōen has been suffering in a special hell below the Kasuga plain. In this hell, Jizō approaches him and the other monks early each morning and showers them with relief in the form of cool water to drink and expositions on sutra digests and *dhāraṇī*s (incantations in Sanskrit).

The idea of a special hell for Jizō devotees is indeed surprising and would seem to lend some credence to Pure Land critics who, as we shall see below, claimed that those who worship him would surely go to hell. In fact, this is a place that Motoi Makiko has associated with the *fukusha* (Ch. *fushe*), a sort of anteroom to birth into the Tuṣita heaven of Miroku

(Maitreya). She has shown that this concept of a separate place in hell meant for Jizō devotees was developed from a Chinese legend in the *Dizang pusa xiang lingyan ji* (Record of Miraculous Events Surrounding Dizang Images) that tells of a man who dies and goes to the underworld but is released from the court of Taizan *fukun* (Ch. Taishan *fuqun*) because he had been a Jizō devotee.[49] He is offered a tour of hell for his trouble and accepts the proposition. Traveling through hell, he sees a number of his dead relatives as well as several monks he recognizes from the Sahā world (our ordinary earthly existence) undergoing terrible tortures. He exhorts them all to call upon the name of Jizō.

On his return to the court of Taizan *fukun*, he sees a resplendent building with "roof tiles of clouds and eaves of blossoms" and inquires about it. The hell warden giving him the tour tells him that many of the disciples of Jizō who in deep faith create paintings and statues of the bodhisattva are born directly either into Sukhāvatī or into the Tuṣita heaven. Those who worship Jizō but have weaker faith are born into Jizō's Pure Land, Mount Karada to the south.[50] The sinful Jizō devotees with little merit will arrive at this infernal refuge called the *fukusha*. There they do not suffer but wait for the advent of Maitreya, when they will be born into the Sahā world during his golden age of the future. As the man peers inside, he sees a multitude of rooms and halls full of men and women, among them the relatives and acquaintances he had told to worship Jizō. They gratefully inform him that they have been able to come to this place because they followed his advice. He returns to the Sahā world and tells people to create Jizō images in painting and sculpture, and of course many do so.

This story appears in Japan in the *Jizō bosatsu reigenki e*.[51] This story of the *fukusha*, or a variant of it, seems to have had some influence on Mujū Ichien, who in his *Shasekishū* mentions a very similar ranking for Jizō believers. After establishing that Jizō's nature is merciful and affirming that Jizō will save those who call on him only with their last breath or even those who have no connection to him at all, Mujū writes in Jizō's voice: "My Pure Lands are as follows: for the highest grade, Sukhāvatī (An'yō) and Tuṣita (Chisoku); for the middle grade, Mount Karada and Mount Fudaraku; and for the lowest grade, the *fukusha* and good human or divine rebirth."[52]

In the present tale represented in the mandara, Shōen is being transported to the local heaven of the Kasuga god at Kōsen, a place much like Tuṣita, where he will have the reward of spending his days in scholarly debate on points of doctrine (see fig. 2.7; plate 7). He will wait there in the Tuṣita heaven until his rebirth in the world at the advent of Maitreya (Miroku) in the distant future. Clearly, birth into the inner sanctum of the

forty-nine cloisters of Tuṣita heaven (Chisoku nai'in), where one abides with the bodhisattva Miroku himself, had long been a desideratum of Hossō sect priests, but here, in the visual representation of the tale, Jizō takes on the role of guide, suggesting the influence of Pure Land faith. In fact, though, it is quite unclear what the destination of Jizō and Shōen might be here. Is it possible that the place of arrival is left intentionally vague?

I do not mean to suggest that Jizō has no place in the Miroku cult. His association with it is well attested in China, and, of course, as the representative of the Buddha and the protector of beings in Sahā during the interim period of "the world without a Buddha" *(mubutsu sekai)* between the passing of Śākyamuni and the coming of Maitreya, there is quite a natural link between Jizō and this buddha of the future.[53] Iconographically and notionally, however, there is significant debt to the Amidist tradition in this particular "transformation tableau," as Victor Mair would call it.[54] Jizō was an original member of the group of five deities who formed the core of the imagery of *raigō*, or "welcoming descent."[55] Here Jizō appears as a guide to the pure land (again, which pure land remains ambiguous), a role pointed to by his frequent appellation "Jizō the guide" (*injō* Jizō).

The Nōman'in mandara reveals a fascinating world of doctrinal possibilities and offers insight into the development of the Kasuga cult and Jizō worship among the Nara sects during the Kamakura period. Jōkei and his disciple Shōen both had close personal connections to Jizō and to the Kasuga deity. The Chisokuin Jizō served as a bridge or mediating figure between Ryōhen and his forbearer Jōkei, demonstrating how monks often formed quite close relationships with particular statues. There is a curious image that today resides at the Shin Yakushiji in Nara: the so-called Kagekiyo Jizō, or Otama Jizō ("the balls Jizō").[56] The statue was originally created in the manner of the Denkōji Jizō—that is, it was a nude image meant to wear Buddhist robes—but it was later fitted with carved wooden robes. That the robes detach from the image was only discovered in 1984 when the statue was sent out for repair. The restorers found a votive document inside the statue that indicated it was made by the monk Sonpen to memorialize his master, the chief prefect Jisson of Kōfukuji, who died in 1236.[57] The reader will remember this Jisson as one of the four particularly eminent patrons of the Rockefeller Jizō. A famed scholar of Hossō doctrine, he is an important figure in the *Kasuga gongen genki*, which indeed briefly touches upon his relationship with Sonpen, who served as his personal attendant.[58]

The statue reveals then, in its original "nude" form, a more personal connection between master and disciple within this context. The icono-

graphical guise of Jizō is ideal for the purpose. The statue of Jizō easily becomes a double for the late master, much in the fashion of the Zen *chinsō*, portraits of dead abbots created to serve a ritual function for their communities of disciples. Sonpen had the image carved as a nude statue, explains the votive document contained within, that he might change the robes daily and thus continue to minister to the physical needs of his master in death as he had in life. One might imagine that he actually used the lavish robes once worn by Jisson, who, one will remember, was a son of the imperial regent Fujiwara no Motofusa. Of course, for monks of the Kōfukuji, the body of Jizō also represents the body of the Kasuga god. In this complex fashion, Sonpen's daily devotions to the statue were able to encompass an extended symbolic range of meaning. What this statue makes crystal clear is something true of the Jizō cult in general: no single interpretation is possible where Jizō is concerned. It is not the case that because he is a special savior of the sinful that he cannot save the holy monk; just because he is the god of Kasuga does not mean that he is any less the doppelganger of Enma, the judge of hell.

Jizō and the Iconography of the Pure Land—Pentad, Single, Triad

It is Jizō's dual nature as the apotheosis of a Shintō god who is also the alter ego of the king of hell that accounts for much of the burgeoning popularity of his cult during the thirteenth century. This complex identity can unlock the meaning of our next topic, the iconography of the solitary Jizō in welcoming descent, or Jizō *dokuson raigō* (plate 8). This sort of image, which became extremely popular during the thirteenth and fourteenth centuries, demonstrates the wide influence of the Kasuga cult and the Nara schools in early medieval Buddhism. The *raigō* Jizō iconography began along the lines of a static Kasuga mandara, but by the middle of the fourteenth century it became characterized by motion. As time progressed, the body of the deity became more animated in these paintings, twisting its hips and striking a dynamic pose (figs. 2.8 and 2.9; plate 9). In the most typical iconography, Jizō rides down on a cloud toward the viewer. Presumably, such images were hung in a manner analogous to the group *raigō* paintings (the *shōju raigō* discussed below) and placed before the gaze of the dying so that they might spend their last moments comforted by the knowledge that Amida and his holy retinue would escort them and guide them on to what lay beyond. There is always an ambiguity with regard to the period after death within Japanese Buddhism. That is, there is a belief, reinforced by the most important rituals of the ancestral cult, that the dead will spend their first forty-nine

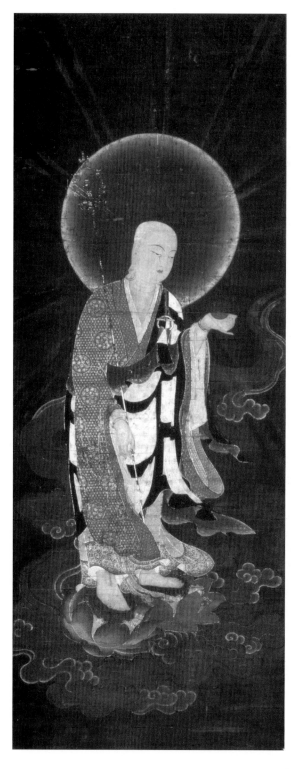

Figure 2.8 Jizō in welcoming descent, ca. fourteenth century. Jizō-in, Tsu City, Mie Prefecture. Courtesy of Jizō-in and Mie kenritsu hakubutsukan.

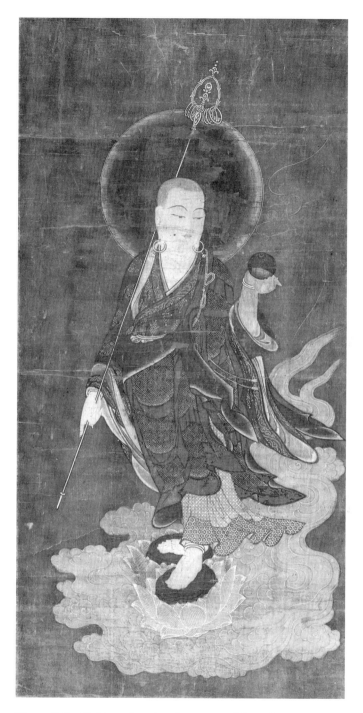

Figure 2.9 Jizō in welcoming descent, ca. fifteenth century.
Courtesy of Museum of Fine Arts, Boston (William Sturgis Big-
elow Collection 11. 62627).

His original body is that of Vairocana [the primordial buddha of the
 Vajrayāna tradition];
it has been countless *kalpas* since he attained complete
 enlightenment.
In order to save the sentient beings,
he manifests as the Daimyōjin [the Kasuga deity, Amenokoyane]
 [from the *Kasuga gongen kōshiki*]

Of the sentient beings whose bodies in the five paths [of
 transmigration]
are oppressed in places of suffering,
those who take refuge in Jizō
are delivered from all manner of pain.
Even those who have committed the five grave sins [of matricide,
 patricide, etc.],
if they constantly call upon Jizō
who travels at will through all the various hells,
he will certainly serve as their proxy, taking their pain upon himself.
 [from the *Jizō kōshiki*]

The first section of four lines also appears in *Senjūshō* (Collected Mis-
cellany).[80] A close variant of the second passage—that is, the final eight
lines—partially translated into Japanese prose, can be found in Taira Ya-
suyori's late twelfth-century miracle tale collection, *Hōbutsushū* (Collec-
tion of Treasures). While Jizō is certainly an august presence—the Kasuga
deity himself—and also the embodiment of Dainichi, he is represented
again and again as a familiar and intimate friend, the advocate who
will take the place of the sinner suffering in hell and offer up his own
"flesh of forbearance" *(ninniku no hadae)*. This is especially clear in the
Hōbutsushū passage, where this promise is immediately followed by the
story of an old woman who lived in Nishi Sakamoto near the Kannon'in
and kept a small Jizō statue and prayed to it. Too weak to plant her rice
field and bereft of the help of her lazy and neglectful son, she fell into
dismay, but one night she dreamt of a small monk who reassured her.
The next day, she found to her great surprise that the small Jizō statue
had come to life and performed the task of setting out seedlings for her
as she slept; she knew this because the hands and feet of the statue were
still caked with mud from the paddies.[81] This evidence of the nocturnal
peregrinations of the image is a very common motif in Jizō miracle tales,
again demonstrating an emphasis on animation, inspiration, and motion
in icons. In stories of Jizō there is often the moment when he steps down
off of the dais, or arises from his lotus seat, to do the work of the world.

The sutras portray him as the ultimate yogi, entering into a deep trance every morning before dawn to emanate into the universe countless avatar bodies with helping hands.

As so many have observed, it is this feeling of closeness and intimacy that most typifies the Jizō cult in Japan. From an early period, Jizō was understood to be a very approachable and human deity. His form as a monk marked him as a being of our world as much as of the other world. In *shōju raigō* images, his presence is made conspicuous by his white skin, standing in sharp contrast to the golden hue of the rest of the bodhisattvas in Amida's entourage. Also, there are many legends in which some ordinary monk, often a young novice, is revealed to be none other than Jizō. It is in large part his monkish guise that accounts for the feeling of proximity.[82]

One curious aspect of the *dokuson raigō* imagery is that, through its iconography, it links Jizō to the idea of salvation through faith in Amida while simultaneously removing him from an exclusively Pure Land context. It seems that the cult of Jizō in Nara underwent a broadening from the time of Jōkei. For Jōkei, Jizō had been important as a savior of the sinful in hell and was also specifically tied to the Kasuga cult. The inscription on the Weber Jizō illustrates the ways in which Kōfukuji monks continued to combine these functions for centuries after Jōkei's death. At the same time, in the generations immediately following Jōkei's, Jizō became a generalized savior and guide to paradise (albeit, as is clear in the case of the Nōman'in transformation tableau, the question of which pure land Jizō might guide the devotee to was not always clear).[83] What is very evident, regardless of the ultimate destination of the dead, is that Jizō was always seen as a bodhisattva with one foot in this world and one in the next.

Jizō at the Borders of Sects, Doctrines, and Institutions

Although Jizō was in many ways associated with birth in Amida's Pure Land, especially due to his presence in standard *raigō* imagery, there was some notable opposition to his worship in Pure Land circles. While much of this was based in doctrinal and soteriological objections, a strong element of sectarian territoriality undoubtedly was also at work here. The thirteenth century was an exciting time in Japanese Buddhism, and much of this new energy came from the active propagation of various new and established sects in the Kantō region, the new seat of political power.[84] In the latter half of the thirteenth century, Ritsu monks and Zen monks were perceived as competition by Pure Land monks, who had managed

to found a substantial number of temples in the Kantō dedicated to the worship of Amida. In their effort to co-opt established temples, Ritsu sect missionaries, for their part, relied on Jizō's connection to Amida's Pure Land in their reassignment of those temples.[85]

Thus, Pure Land and Ritsu monks vied for the patronage of the warrior class, especially that of the Minamoto and Hōjō families, the most powerful clans of the samurai elite. A third party in this competition for support was the newly established Zen sect, led in Kamakura by Yōsai (or Eisai), who also championed the Jizō cult. In fact, the promotion of the Jizō cult by Zen priests among warriors in the East (Kamakura) and in the capital was an important aspect of its ascendancy during this period.[86]

Of course, it would be wrong to project today's sectarian boundaries back into the thirteenth century.[87] Pure Land elements certainly existed within the doctrinal schema of many thirteenth-century advocates of the Jizō cult. The fierce intersectarian strife that developed in later periods was not widespread during the Kamakura period, as some may assume, and incidents of cooperation and conversation across sectarian boundaries were quite common. However, some monks did identify Pure Land faith and Jizō worship as competing and incompatible movements. Remember, the *Shasekishū* reported even the abuse of Jizō statues perpetrated by some of the more radical-minded Pure Land followers. There is also an incident, reported in the illustrated hagiography *Hōnen shōnin ekotoba,* in which Hōnen expressed in no uncertain terms his disapproval of the worship of Jizō. Perhaps it is more accurate to say that he objected to the intrusion of Jizō into an established triad, and the resulting creation of an unauthorized iconography. It happened at the Ungōji temple. Hōnen was invited there around 1201 to perform services and saw, installed on the main altar, a triad composed of Amida, Kannon, and Jizō. He was displeased with this novel arrangement in which Jizō replaced the bodhisattva Seishi of the traditional arrangement, and refused to recite any sutras until the Jizō statue was taken down and replaced with an image of Seishi.[88]

One can imagine various reasons for Hōnen's displeasure. One is the natural response, of upholding correct or traditional iconographies and rejecting innovation. Another is the question of compositional symmetry. While Kannon and Seishi form a nearly identical matched pair as they flank Amida—only the small Buddha image in the crown of Kannon or the water vase in Seishi's serve to distinguish them in many instances— Jizō and Kannon do not resemble each other in the least. Jizō is a shaven-headed monk in ascetic's robes, while Kannon is a resplendent bodhisattva with chignon, headdress, and jewelry. They are a very important pair

in some contexts, but they are very different from each other in appearance (fig. 2.11).[89] Another possible reason for Hōnen's objections could be his renowned identity with Seishi (the hagiography suggests as much in conjecturing on reasons for his displeasure). In the nascent Pure Land community, it was suggested that according to various miraculous events witnessed by followers, the master Hōnen was not actually a human being but rather a saving manifestation of Seishi. The final possibility I will offer is perhaps here the most plausible. It is the soteriological argument, hinted at above, that the worship of Jizō represented an untoward anxiety about the efficacy of Amida's vow to save all beings without exception. This aspect of the Jizō cult was no doubt most troubling for Hōnen and his disciples. In thirteenth-century Japan, the worship of Jizō was closely linked to the idea of salvation from hell. Part of the force of the Pure Land movement during this period was the gospel of assured birth in the land of Ultimate Bliss, which carried a corresponding preclusion of birth in hell. The notion of this sort of "insurance" represented by Jizō

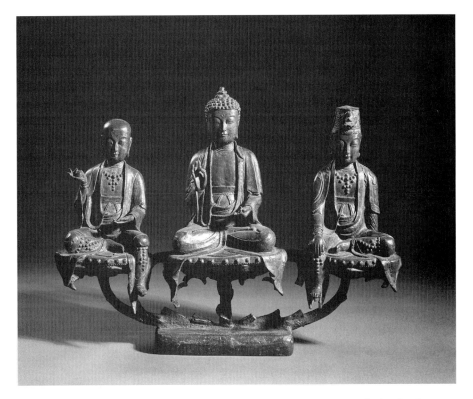

Figure 2.11 Amida triad, Korea, ca. fifteenth century. Courtesy of Cleveland Museum of Art (1918.501).

worship was no doubt anathema to the most devout, "fundamentalist" of the Pure Land thinkers.[90]

Other monks promoted the Jizō cult as a natural extension of the worship of Amida. Ryōhen was a grand-disciple of Jōkei and a talented Hossō scholar but left the cloister to build himself a grass hut on the Kasuga plain. He was also a fervent Amida devotee who advocated the worship of Jizō. In his *Nenbutsu ōjō ketsushin ki* (The Record on Setting the Heart and Mind on Birth into the Pure Land through the Nenbutsu) he singles out the worship of Jizō as most appropriate for those living in this corrupt age and says that Jizō is the guide for those living in a Buddha-less world *(mubutsu sekai)*. People should pray that Jizō accompany them day and night like a shadow, he writes, and bring them to a meeting with Amida in welcoming descent at the time of death. Ryōhen then singles out for criticism those Pure Land followers who exclude Jizō from their prayers or make light of him.[91] In the early 1250s, Ryōhen had become the master of the Chisokuin at Tōdaiji, establishing it as a major study center for Hossō doctrine. He records that every day without fail he performed services before the main image of Chisokuin, the small Jizō statue that the Kasuga deity was said to have carved for Jōkei. Sugiyama Jirō has pointed out that the statue currently enshrined at the Chisokuin does not match a fifteenth-century description of the miraculous image.[92] He suggests that the nude Jizō image now housed at Denkōji could possibly be the one formerly in the Chisokuin. Whether this is the case or not, the Chisokuin Jizō was one of the most famous in Nara during the Kamakura period. It is noteworthy that Ryōhen moved from his position as an official monk, *kansō*, to that of a hermit living in a grass hut, the model for a world-renouncing monk, or *tonseisō*, and seems to have eventually again taken up a position as an elite monk in the hierarchy of Nara Buddhism.

These terms deserve some explanation here. Over the past twenty years, historians of Japanese religion have transformed the known landscape of Kamakura-period Buddhism. A central factor in this reevaluation of the religious movements of thirteenth- and fourteenth-century Japan has been a new appreciation for the role of monks from the Nara schools, especially the Ritsu sect. Where an earlier generation of scholars saw a sort of revolution or reformation led by founders of the period's "new" sects—Pure Land, Zen, and Nichiren Buddhism—now it is well established that at least as important were the radicals of the established sects.[93] Matsuo Kenji has labeled these reformers of both the new sects and of Nara "old" Buddhism as *tonseisō*—that is, monks who have "cast off the world." Indeed, the term *tonsei* (world-discarder) was one they used themselves in their writings. They wore black robes to distinguish

themselves from the white-robed monks and nuns in service at imperially sponsored temples. Matsuo Kenji has insisted that there was a sharp distinction between the *tonseisō* and the so-called official monks, or *kansō*. While Matsuo's insistence that the two groups were absolutely distinct from one another—that official monks, *kansō*, and renunciant monks, *tonseisō*, did not mix at all—is surely too strict and has met with some criticism for its rigidity, it is quite useful as a heuristic model.[94] Through this theory, Matsuo has had a profound influence on the study of Kamakura-period Buddhism. It is certainly true that contemporaries used the terms "black robes" and *tonsei* to talk about a certain type of monk and, later, certain groups and lineages. It is perhaps mistaken, however, to insist that this line was one that could not be crossed in either direction. In fact, we can find many instances of monks represented in sources as *tonseisō* later serving in an official capacity and again renouncing imperial and institutional sponsorship. The great rebuilder of Tōdaiji, Shunjōbō Chōgen is, like Ryōhen, a good example of a *tonseisō* who became in many respects a *kansō* late in life. Of course Chōgen's is not a typical case, nor is Monkan's, another possible example of an imperially sponsored *tonseisō*.[95] However, the biographies of the monks involved with the Rockefeller Jizō also demonstrate the permeability of these categories.

These aristocratic monks, highly ranked and well connected, are not typical examples either but do serve to illuminate the way the categories of *tonseisō* and *kansō* can be seen as a continuum or a rhetorical typology rather than the sort of opposition imagined by Matsuo. Han'en, Jisson, and the others on numerous occasions performed rainmaking ceremonies at the Dragon Cave at Mount Murō in accord with imperial orders. The last of the four eminent monks we have been examining, Enjitsu, however, became a *tonseisō* while still serving in a prominent role as a *kansō* at Kōfukuji. This did not go unnoticed and indeed provoked vociferous complaints when, at age twenty-two, he was appointed the abbot of Kōfukuji in 1235. Besides his unprecedented youth, there was the accusation that he "dressed in the clothing of a *tonseisō*" and strode through the streets of Nara on foot in black robes. This was considered outrageous behavior for one who would be the abbot.[96]

The close association that Kōfukuji and other "official" temples had with *tonseisō* such as the Saidaiji group and *shugendō* lineages is an essential part of the story and is one key to understanding the dissemination of the Jizō cult in the thirteenth century. The monks of the Ritsu sect—particularly the disciples of Eison, another grand disciple of Jōkei's—were very influential in creating a new sense of religious urgency and spreading the Buddhist mission widely through diverse populations during the thirteenth century. In doing so, they also spread certain ideas

and practices local to Nara; among these was a close affinity for Jizō. Beyond the immediate Nara region, the Jizō cult became most closely associated with Pure Land Buddhism, as can be seen below in the cases of the Ritsu sect monks Dōgo (or Dōgyo) and Ninshō. First we examine the activities of Ninshō as he promoted the Jizō cult through a connection to Pure Land Buddhism.

In the Kantō region, as one might expect, the link between the Kasuga god Amenokoyane and Jizō was not emphasized as it had been in Nara, but there was already an established iconographical link between Jizō and the Minamoto clan god, Hachiman.[97] In this case, Hachiman is represented as a monk holding a staff—the "monk form," or *sōgyō* Hachiman—and is referred to as Hachiman *dai bosatsu*, the "great bodhisattva." The monk-deity is an unmistakable visual or iconographical reference to Jizō, and here too the rules of the *honji suijaku* system demonstrate their flexibility. A Shintō deity is represented as a Buddhist monk and takes on the title of a bodhisattva; however he retains his Shintō name and his role as the patron and ancestor of the Minamoto warrior clan.

Ritsu monks like Eison and his disciple Ninshō frequently described themselves as *tonseisō*. In this, they sought to distinguish themselves from the majority of monks, whom they saw as lax and mired in the concerns and trappings of the secular. It was in order to spread their mission and garner the support of warriors that they came to the Kantō region and also headed west to Kyūshū (where there is also evidence of their promotion of the Jizō cult). It is also quite clear that important Hōjō family temples Ninshō took over in the Kantō region, such as Gokurakuji and Shōmyōji, had strong roots in the Pure Land tradition.[98] Tsutsumi Teiko has shown that in the latter half of the twelfth century, the Pure Land monks of Hōnen's lineage had great influence in the Kantō, but of course we must also remember that, even amidst competition for patronage and territory, this was a period of considerable intersectarian curiosity, cooperation, and conversation.[99]

A key element of the Ritsu program was the idea that salvation was aided by the direct intervention of the mediating figure of the monk. In many ways, this is not that much different from the Pure Land emphasis on the priestly function of the "good friend," the *zenchishiki* (Ch. *chanzhishi*, Skt. *kalyanamitra*) that became so important in deathbed rituals, especially with the deepening of the medieval period.[100] Although Hōnen had preached a gospel of total reliance on Amida's vow, this more proximate notion of "other power" proved very attractive. Ninshō and other Shingon-Ritsu monks were tireless evangelists for the Buddhist faith and presented themselves as the true heirs to Śākyamuni's tradition. While

many monks in Japan at this time did not uphold strictures against meat eating, alcohol, and sex, the Ritsu monks (along with certain other highly visible Nanto monks of the period, of whom Myōe is the classic example) made a point of the purity of their conduct. Indeed, it is the monastic rigor and purity of the Ritsu monk that allowed him to enter into ministry to the most "unclean" element of society—sufferers from Hansen's disease, or leprosy—and also to perform the task of burying the dead without fear of taking on ritual pollution.[101]

Funerals were an important part of the spread of the Nara schools in the Kantō and other regions, both at elite and common levels. One of the legacies of Ninshō's travels is the presence of late thirteenth-century *gorin no tō*, stupas of the five elements, throughout Japan.[102] These stupas, composed of five shapes and displaying five *bonji*, or *siddham* (mystical Sanskrit letters), represent, from top to bottom, the five elements: air (pointed jewel), wind (hemisphere), fire (pyramid), water (sphere), and earth (cube). They also express a Shingon idea that an indestructible, adamantine body can be created through assiduous Buddhist practice. This connects the iconography of the grave to theories of gestation and to a soteriology of form.[103]

Ninshō had these *gorin no tō* built in many places from Hakone to Nagasaki. Many early ones can still be seen in Nara at the headquarters of his sect, Saidaiji. A bias toward theological and doctrinal developments has blinded scholars to the important transformation of death ritual that overtook all levels of Japanese society during the thirteenth century. Ritsu monks who had sojourned in China, foremost among them Chōgen, brought their experience of Song death rituals to bear on local practice.

Ninshō, like his master Eison, propagated Buddhism among lepers and outcastes. While traveling in the Kantō region, he distributed a great number of woodblock prints of Jizō and urged people to worship them. One account says, "He made Jizō images and gave them to men and women—one thousand three hundred fifty-five in all."[104] To this day a number of Jizō temples in the region are associated with Ninshō and the Saidaiji lineage. As Shimizu Kunihiko suggests, Ninshō's devotion to Jizō and his recommendation of the cult to followers in the east may reveal the particular influence of Ryōhen. Ninshō distributed small paper amulets far and wide as he walked the countryside in eastern Japan. The Tōshōdaiji preserves a small stamped amulet of Jizō signed by Ryōhen on the back (fig. 2.12); another, found along with many others in the interior of a seated Jizō statue by Zen'en at Ōkuraji, has the dynamic quality of the *dokuson raigō* (fig. 2.13). We have seen the example of the thirteenth-century Cologne Jizō (fig. 1.12), which contained one thousand such stamped images. Printing made it possible to disseminate this

Figure 2.12 Jizō amulet woodblock print, distributed by Ryōhen, thirteenth century. Courtesy of Gangōji.

Figure 2.13 Jizō amulet woodblock print from interior of seated Jizō image by Zen'en, thirteenth century. Courtesy of Ōkuraji, Nara.

iconography and the cult of Jizō to a broad population very inexpensively. These amulets acted as talismans and as assurance of a karmic connection to the deity and were no doubt greatly valued by those who received them.

The engagement of reform Ritsu monks in the Jizō cult is quite clear in their fund-raising and temple founding activities. Ninshō erected Jizō images in Hakone near Kamakura, in Ikoma near Nara, in Hiroshima, and elsewhere, thus spreading the cult widely throughout Japan. Also, as Hosokawa Ryōichi has pointed out, while Ninshō is a particularly well-known monk of this Ritsu reform movement, there were many others carrying on a variety of activities around the country. Among these, one who was especially instrumental in promoting both Pure Land faith and the Jizō cult was Dōgo, master of the temple Hōkongōin in Saga, in northwestern Kyōto near Seiryōji.

Dōgo's legend forms the core of the Noh play *Hyakuman* (One Million), originally entitled *Saga monokurui* (The Crazy Woman at Saga) and probably written by Zeami's father, Kan'ami. This play is discussed in more detail in the next chapter, but let us take a brief look at it here. The play develops a legend of this Ritsu monk's boyhood and tells of his accidental separation from his mother in a holiday crowd and dramatizes her resulting madness. The drama focuses on the reunion of a mother and a son and his founding, in thanksgiving, of the Jizō hall at the temple Saga Seiryōji in the Arashiyama area. While the details of Dōgo's early life are somewhat shrouded in legend, the hagiography has it that after his father died when he was three years old, his mother found herself unable to care for the boy and abandoned him outside the Tōdaiji gates. The foundling was raised in the cloister and went on to become a promising young monk.[105]

Dōgo demonstrated his skill as a fund-raiser and organizer and was known, even during his lifetime, as the "one hundred thousand saint," Jūman *shōnin,* due to his successes in gathering that number of patrons for the establishment of a stone monument. He also organized large gatherings for ecstatic dancing *(nenbutsu)* performances known as the *yūzū nenbutsu* or *odori nenbutsu.* The first of these that he undertook was in conjunction with the rebuilding of the temple Mibudera, renowned for its Jizō image. The dances became an annual event and formed the basis for the Mibu *kyōgen,* a religious drama performed as a mute play. As we shall see in the next chapter, the repertoire of the Mibu *kyōgen* and the related Saga *dainenbutsu kyōgen* came to include many plays featuring Jizō. It was also Dōgo who started this ritual at Saga Seiryōji. Hosokawa has suggested that Dōgo's activities in Saga were in fact related to the presence there of the cremation and funeral site of Adashino and also to

the bourgeoning Jizō cult at Mount Atago, which looms above the area. All that remains of Seiryōji's Jizō hall now is the graveyard that may well have been its primary raison d'être. There we find a *gorin no tō* that is Dōgo's grave marker as well as the stone pillar, inscribed with some of the names of its great number of patrons, which gave him the epithet "Jūman *shōnin.*"

Stone Jizō Images and the Eastward Development of the Cult

Finally, I'd like to touch just briefly on an important related topic, the prominent place of Jizō in the masterly and evocative art of the descendants and disciples of the Chinese Buddhist stone carver I Gyōmatsu (Ch. Yi Xingmo). I Gyōmatsu came from Song China at the end of the twelfth century on the invitation of the important Nanto monk Shunjōbō Chōgen to assist in the rebuilding of Tōdaiji after it was torched by Taira no Shigehira during the Genpei wars. Gyōmatsu and the men who made the journey with him were to literally reshape the tradition of Japanese religious sculpture and memorial practice. The next generation of stone carvers to work closely with the monks of Nara were Gyōmatsu's son or very close disciple, I Gyōkichi, and another disciple called Ōkura Yasukiyo; their followers in turn are known as the Iha, active in the Nara area and surrounding regions.

These sculptors had a very close relationship with Eison and Ninshō. Some of this group of carvers journeyed to the Kantō with the monks of the Ritsu sect and left many monuments in Kamakura and in Hakone. This group that traveled east is now referred to as the Ōkuraha. In the carvings of third-generation I school carver I Yukiuji seen at Ikoma near Nara, dating from around the turn of the fourteenth century, Jizō images take a very prominent role. Two examples of Yukiuji's work in the mountain temples of Ikoma near Nara are inscribed with the year 1294: a single standing Jizō at Ōganji; and another at Sekibutsuji, a member of an Amida triad with Kannon (fig. 2.14). There are also many nearby cliff carvings, or *magai butsu*, by I school carvers.

At a place hundreds of miles away, near the Hakone Pass, there is a pond called Shōjin ike with an incredible group of Jizō images from the same period.[106] These are the works of the Ōkura school carvers Ōkura Yasu'uji, the son or possible close disciple of Yasukiyo, and other carvers, among them a man named Shin'a. The largest and most visible of these images is the so-called *rokudō* Jizō, created in 1300 (fig. 2.15). This large monumental carving of Jizō at a mountain pass greeted and protected travelers on the Tōkaidō, the great east-west thoroughfare of Japan con-

Figure 2.14 Sekibutsuji Jizō,
Ikoma, ca. thirteenth century.
Courtesy of Sekibutsuji. Photo
by author.

necting the old cultural capitals of Nara and Kyoto to the growing and flourishing capital city of the warrior regime in the Kantō, Kamakura. The cliff-face carving had originally featured a wooden hall that projected out from the rock and protected the statue and, one might well imagine, many a traveler caught in a sudden downpour or hailstorm or seeking a night's lodging. This small building was destroyed in the cataclysmic eruption of Mount Fuji in the fourth year of the Hōei era, 1707. The *rokudō* Jizō (also known as the *roku* Jizō) was left uncovered for close to three centuries but fortunately has not suffered much damage or erosion. The size and aesthetic balance of the *rokudō* Jizō are impressive, but equally as affecting are the many small Jizō images carved into the rocks along the shore of the nearby lake. When I first visited the site in the summer of 1987, I was struck by the desolate beauty of the place, marked only by a small sign across the highway from the *rokudō* Jizō, which briefly explained the history of this place, Shōjin ike (also known

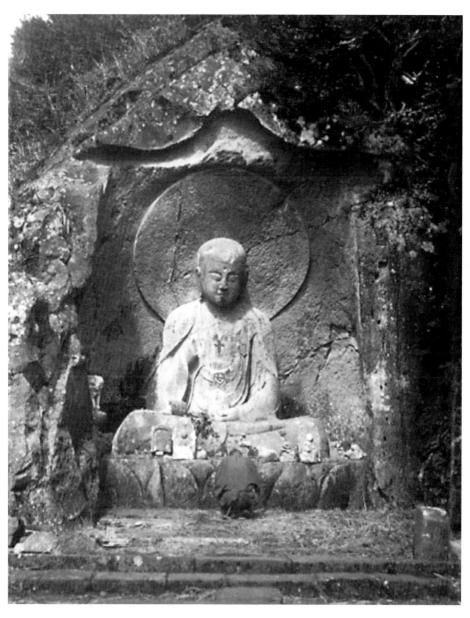

Figure 2.15 Monumental *rokudō* Jizō, ca. 1300. Hakone Pass. Early twentieth-century photo taken before restoration. Reproduced from a tourist postcard in author's collection.

as the Chi no ike, the Pond of Blood) and its sculptures. Over the next decade, the site was cleaned up and restored, a tunnel dug under the well-traveled National Highway Number One (saving visitors the mad dash across), a new wooden structure built to house the *rokudō* Jizō, along with another hut with restrooms, and an amusing if rather garish interpretive light show revealing Jizō's role fighting demons in hell, the stern visage of King Enma, and so on.

On that first visit, though, it was quite overgrown and seemed like a forgotten place. Continuing carefully down the steep hillside from the sign, I was surprised to find at the shore of the lake little straw figurines of people and horses as well as small bamboo rafts holding the remains of paper lanterns. This was apparently still the site of active religious endeavor, in this case the ceremony of floating lanterns to send the souls of ancestors back across the water of the lake, having welcomed them back into the world of the living for the late-summer Obon festival.[107] The air in that deserted spot was still charged from the rite of a day or so earlier. Then nearby, as I lifted my eyes from the narrow and muddy path, I spotted a great rock with many small Jizō images carved into it. These images are known as the "twenty-five bodhisattvas," *nijūgo bosatsu,* an appellation usually reserved for the entourage of Amida in welcoming descent. In fact, besides the numbers of Jizō images, there is also an Amida image carved into the rock face here (figs. 2.16–2.20). Furthermore, an apparently important face of the carving also contains three *bija* letters that form a Jizō, Amida, Kannon triad: "i," "hrih," "sa" (fig. 2.19). The *bija* "i" here is the symbol for one of the six Jizōs, Kongōhō Jizō, sometimes identified as the savior of the hungry ghosts (see fig. 1.4).

The presence of Amida here among the small crowd of Jizō images is perhaps not surprising, but it is certainly rare. Comparable images, both by the related I school of carvers, can be found in the carvings at Tōno, a mountain pass in Himeji Prefecture, where Amida is carved on the main face of a boulder and a smaller Jizō image can be found around the side of the same stone, or at Ikoma's Sekibutsuji, where Jizō is in a triad with Amida and Kannon, but the Hakone group is unique in its gathering of many Jizōs together with one Amida. The conjunction of Amida and Jizō is clearly part of the increasing assimilation of Kasuga-based Jizō worship to the Amida cult in the thirteenth century. This is a trend we have seen in the most pronounced fashion with Ryōhen, but it was certainly an important part of Ninshō's program of proselytization as well.

This crowd of small Jizō statues on the shores of a small lake at the Hakone Pass, with the monumental Jizō on the cliff above, demonstrates the bourgeoning of the Jizō cult at the close of the thirteenth century and its relationship to Pure Land faith. The *rokudō* Jizō caught the at-

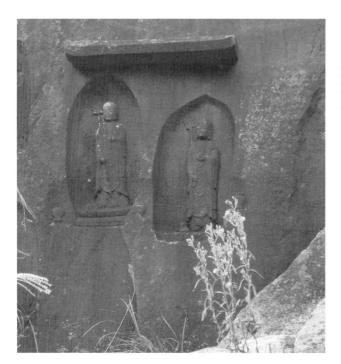

Figure 2.16 Nijūgo bosatsu, ca. 1300. Hakone Pass. Photo by author.

Figure 2.17 Nijūgo bosatsu, ca. 1300. Hakone Pass. Photo by author.

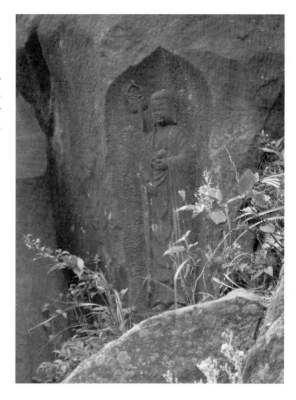

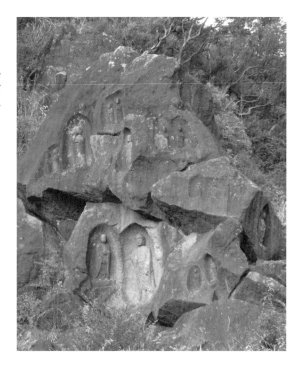

Figure 2.18 Nijūgo bosatsu, ca. 1300. Hakone Pass. Photo by author.

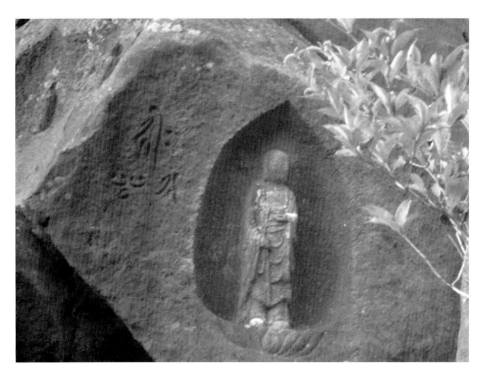

Figure 2.19 Nijūgo bosatsu, ca. 1300. Hakone Pass. Photo by author.

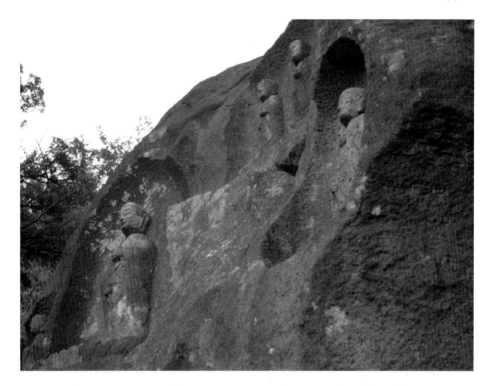

Figure 2.20 Nijūgo bosatsu, ca. 1300. Hakone Pass. Photo by author.

tention of the great art historian Ernest Fenollosa, who was told it had
been carved by Shingon saint Kōbō *daishi*, Kūkai, in the ninth century.
Fenollosa allows that the great saint may indeed have been involved in
the project, but surely at the level of design and not execution:

> Japan is full of wayside shrines to Jizō, whose stone images are almost
> covered by votive offerings of pebbles by travellers. One of the most
> striking of these early Jizōs is cut, life-size and in high relief, out of a
> mountain ledge on the little path across the Hakone mountains from
> Ashinoyu to Hakone. This is said to have been carved by Kōbō him-
> self on his journey to the North; yet, though the conception is primitive
> Tang and mostly of Kōbō, he hardly would have spared time for its ex-
> ecution. It is more likely that it was afterwards prepared from his draw-
> ings. (Macrons added)[108]

Of course, we know today that the sculpture is of a much later date (and
alas the little path is now Highway One) and that the attribution is a
false one, as are most of the great number of attributions made to Kōbō

daishi Kūkai and Eshin *sōzu* Genshin. The association of this thirteenth-century Jizō and of the Jizō cult in general with Kūkai's Shingon sect is, however, both important and instructive in this case.

It is here that we begin to see Jizō's role in the spread of Buddhism in Japan at the beginning of the medieval period. The Ritsu monks who sponsored the carving of these monuments and the two *gorin no tō* that stand nearby were students of Shingon Buddhism. The use of the stupa-like *gorin no tō* is in itself a sign of the profound influence of Shingon esoteric practice on the Ritsu monks of the thirteenth century.[109] (The graves were later believed to be those of the brothers Soga, storied in legends of the medieval period.) Many monks of this period, especially the so-called *tonseisō*, were eclectic in their approaches to doctrine and practice.[110] Ninshō, Eison's prominent disciple, took the lead in this project at the Hakone Pass, and like other monks in the Saidaiji lineage, he was very interested in Shingon esotericism. Thus, from the end of the thirteenth century and stretching into the fourteenth, Ninshō and other monks of the Nanto Shingon-Ritsu movement, along with their artisan partners, seem to have spread an active Jizō cult closely related to the worship of Amida and Pure Land faith, both in the Yamato region near Nara, in the Kantō, and elsewhere. While the worship of the so-called Udayāna image of Śākyamuni known as the Seiryōji Shaka is central in the iconographical program of the Ritsu sect during this period, it is clear the Jizō was also a very important figure.

The imagery of the *dokuson raigō* Jizō, inspired by Pure Land painting and first developed as an iconography within the Kasuga cult, was for a brief period immensely popular, evidenced by the large number of surviving examples, particularly from the fourteenth and fifteenth centuries.[111] As seen in the printed amulets distributed throughout the Kantō by Ninshō, this was a way of looking at Jizō that, while originally tied with some specificity to the Kasuga cult, soon became widely disseminated among the common folk and the warrior classes as well as the aristocracy.[112] Of course, his position as guide of the dead through the terrors of the intermediate state (J. *chū'u*, Ch. *zhongyou*, Skt. *antarābhava*) and on to subsequent birth in the Pure Land makes him closely analogous to the priests of this world; especially Zen monks and Ritsu monks who performed the great majority of funerals during this period. They must have seemed to contemporary people to be living Jizōs.[113] Still, Jizō had no special sectarian identity, and his cult was often assimilated to the worship of Amida.

In Chiba and Saitama prefectures north of Tokyo, for instance, there are a number of stone steles *(itabi)* that feature Jizō and Amida in combination. Here, there are usually six Jizōs, sometimes three, as figures or

as *bija*, topped variously by a single *bija* of Amida, a triad of *bija*, or a figural representation of the three Pure Land deities. As Kobayashi Yasushi has pointed out, on a number of images, such as the 1343 stele at Chōgenji in Saitama Prefecture, the six Jizōs float down in a line across the surface of the stele as if in procession, their motion through space conveyed clearly, carrying the cymbals, banners, censers, and bells that real monks would have used in funeral ceremonies. As we saw in Chapter One, the attributes, or *jimotsu*, of the six Jizōs were imprecise, with considerable disagreement between textual prescriptions and visual renderings; needless to say, the six monks carrying banners and percussion instruments are not part of any standard set.[114] As they descend there is an engaging sense of motion conceived through the flowing robes of the monks and the banners the Jizōs carry, Warburg's *bewegtes Beiwerk*. As the iconography of the six Jizōs was never a firmly decided matter, here the stone carvers were free to style them after monks presiding at a funeral, thereby greatly emphasizing the overlapping semantic valence that makes a Jizō image always also an image of a monk. Any ordinary, human monk becomes a living, breathing instantiation of the deity.

Above, we have traced the close connection between the influential Kasuga Jizō cult and the explosion of the popularity of Jizō during the thirteenth century. As monks of the Nara schools, both *tonseisō* and *kansō*, came to see Jizō as a special savior, and one with deep local connections, it was natural that they should have included the bodhisattva in their ministry beyond the Nara region. Matsuo Kenji has written that the history of Japanese Buddhism consists in precisely the history of interactions between the *kansō* and the *tonseisō;* the case of the Jizō cult certainly supports this view.[115] As we have seen, the initial patrons of Jizō in the early twelfth century were predominantly the monks of Kōfukuji and members of the Fujiwara family—two categories that saw much overlap. This influence, which we cannot call anything but elite, was rapidly transmitted to transform the lives of the common people by the so-called *tonseisō* of the Ritsu school and the Zen and Shingon sects.

In the present chapter we have ranged from Nara to the Kantō, tracing the efflorescence of Jizō within the Kasuga veneration of the monks of Kōfukuji and his connection to the Amidist Pure Land faith that swept Japan in the early medieval period. In the next chapter we will examine the place of ecstatic performance, dance, and spirit possession in the creation and worship of Jizō images in medieval Nara and Kyoto. The Jizō cult was key in forging a link between Buddhist practices and traditional modes of religion.

The Jizō Dance

Ecstasy, Possession, and Performance

IN THE LAST CHAPTER we saw how the doctrinal and cultic interests of Buddhist clergy inspired the dramatic rise of Jizō worship during the thirteenth century. Beginning as a localized and rather particular interest in Jizō as the *honji* of the ancestral deity of the powerful Fujiwara family, the Kōfukuji-based cult was taken up by others in Nara who perhaps knew the bodhisattva best through this connection to Kasuga and Kōfukuji but took initiative in advocating the worship of Jizō to spread Buddhism to a wider spectrum of the population.

The development and efflorescence of the Jizō cult through the twelfth and thirteenth centuries in Nara led to its spread to the Kantō region and other far-flung places and affirmed its centrality in the cultic life of priests of the Kōfukuji and their associates and followers. The worship of Jizō represented a common thread among monks of the Nara sects, particularly the Shingon-inflected Ritsu of Eison, Ninshō, and Dōgo. The Jizō cult was used to build bridges to allies in the Kōfukuji hierarchy, like Ryōhen, but also to thirteenth- and fourteenth-century Zen monks who, like these Nara priests, were under heavy Song influence or were in fact Chinese themselves. Rankei Dōryū (Lanxi Daolong) of the Kenchōji in Kamakura comes to mind, or Enni Ben'en at Tōfukuji in Kyoto. Both men chose to make Jizō the temple's central image. In fact, the Zen connection to the spread of the Jizō cult is given somewhat short shrift in this account. However, we cannot underestimate the impact of the Zen strategy of placing Jizō images in villages at the crossroads and borders, using them for lodging for itinerant Zen priests. This greatly aided the medieval spread of the sect, especially Sōtō Zen.[1]

This trend was closely tied to the increasing adoption of Buddhist

death rituals by village populations. In another direction, the shogunal support of Rinzai sect temples in both Kamakura and Kyoto did much to bind warriors to the worship of Jizō. The early Kamakura period Zen master Myōan Yōsai was the founder of the great Rinzai temple Kenninji in Kyoto but taught his disciples to steep themselves in the doctrines and practices of Tendai, tantric *mikkyō,* and Zen. Yōsai was a great advocate of the Jizō cult.[2] Jizō worship was also prominent in Tendai circles as well, especially once Jizō was identified with Mount Hiei's Jūzenji god through *honji suijaku.* Leaving these intriguing topics for another time, however, in this chapter we take up the topic of performance in the Jizō cult.

In the last chapter we examined the beautiful mid-sixteenth-century *raigō* Jizō in the collection of Dr. John Weber (plate 9). As we saw, this image conforms iconographically to the traditional form of Jizō, holding his usual attributes of the monk's staff *(shakujō)* and wish-granting gem *(nyoi hōju),* while the inscription at the top—consisting in excerpts from two *kōshiki,* or ceremonials, written by Jōkei some four hundred years earlier—makes it clear that this in fact is a portrait of the Kasuga deity.

The encomium implies that the Kasuga deity is the earthly form of the primordial/universal Buddha Dainichi and that Jizō is the visible and approachable instantiation of the august Kasuga *myōjin.* In this way, the inscription represents a reversal of traditional *honji suijaku* thinking, making Jizō, the Buddhist deity, the familiar and intimate form of the Shintō *kami,* Amenokoyane, who is too lofty to be represented directly. In skillfully excerpting and reframing Jōkei's paeans to the two deities, the inscription approaches the philosophies of the Watarai Shintō of the Ise shrine or Yoshida Kanetomo's Yuiitsu Shintō. In these systems of thought, which arose in the medieval period as a reaction against Buddhist control of religious discourse, the primacy of *honji suijaku* is reversed; that is, this line of thinking holds that *kami* are the *honji,* the fundamental, and the buddhas and bodhisattvas are their provisional emanations, *suijaku.*[3] In the creative reworking or juxtaposition of Jōkei's texts found on the Weber Jizō, the bodhisattva is revealed as the local messenger of a more distant and ultimately formless god, effectively subordinating the Buddhist deity to the native one. Of course, though, the fundamental point is the identity between the two. The same idea is emphasized in the *Shasekishū* tale, seen in Chapter Two, about Jōkei carving the miraculous image formerly housed at Chisokuin according to the specifications dictated to him by a mysterious old man *(okina),* revealed to be the Kasuga deity himself. The wizened old man offers iconographical instructions to the monk-sculptor and cements the identification between himself, the ancestral *kami* of the Fujiwara, and the iconographical form of the monk-bodhisattva called Jizō.

The painted hanging scroll of Jizō in welcoming descent from the Weber Collection that we examined in Chapter Two was painted for the monk Kenjōbō Gyōhan (d. 1564), whose name and signature, or *kaō*, it bears. Gyōhan was an important cleric of his time and held the title of the head fund-raiser *(hongan)* of Kōfukuji's Konzōin temple. The hanging scroll also carries the signature of a man called Aki *no hōin* Ninsai, who most likely received it due to some close connection with his contemporary Gyōhan. Ninsai died in 1572, and his seventeenth-year memorial service was held in the Konzōin.[4] It is quite likely that the two worked together, since a major aspect of Gyōhan's position as the *hongan* of the temple would have been to arrange various performance events aimed at raising alms, and there is considerable evidence that Ninsai had an interest in such matters. In lay life, Ninsai was a doctor with the family name of Matsui and had been a great patron for the *sarugaku* performances in Nara in 1550.[5] He was awarded the high ecclesiastical rank of *hōgen* in recognition of his support on this occasion. By the time that he wrote his name on the hanging scroll now in the Weber collection, he had risen to the rank of *hōin*. It is worth noting that in either case, these clerical ranks may have been honorary, rather than indicating his vocation, since the awarding of such titles to doctors, scholars, Buddhist sculptors, and others was by no means uncommon.

In this chapter we will trace similar connections between clerics, patrons, and players, examining the role of religious performance in the development of the Jizō cult. Ritual theater, dreams, oracular practice, and female spirit possession will remain in focus as we follow the popularity of Jizō worship from Nara's Kasuga-Kōfukuji complex and the Ritsu reform movement through its transformation into spectacle, with the grand-scale performance events for alms collection and the *kanjin* (fund-raising campaigns) of fifteenth- and sixteenth-century Kyoto. Let us begin, though, at the wellspring of classical Japanese theater, Nara. The performance troupes responsible for the founding of Noh and the codification and development of its forbearer *sarugaku* were the four troupes of Yamato (Nara). Here is not the place to recount the history of Noh and *sarugaku*, but the aspect I'd like to emphasize is the religious roots of many Noh plays, revealing, as others have noted, an engagement with Buddhist ideas and with shamanistic religious ritual.[6]

Any number of canonical Noh plays take the Southern Capital of Nara as their setting. Many of the plays feature a woman who acts as a soothsayer or takes the role of a dancer, such as *Tamakazura, Kasuga ryūjin, Izutsu, Ama, Uneme,* and the noncanonical *Kashima.* These characters reveal the origins of Noh in the religious performance traditions of the Southern Capital. Often, the role of the priest in these plays, the

waki, who saves the ghostly female lead, the *shite,* is a cleric of one of the great Nara temples. Chikamoto Kensuke has pointed out that the Noh often takes up the idea that the Kasuga plain itself, and Mount Mikasa in particular, is a pure land. This theme is a pronounced one in the legends and iconography of the Nara sects. Chikamoto suggests that the action of *Uneme* and *Kasuga ryūjin* would have been impossible without Jōkei's propagation of this doctrine that the permanent abode of Śākyamuni as preached in the *Lotus Sutra*—that is, the Vulture Peak pure land, or Ryōzen *jōdo*—is immanent at Kasuga on Mount Mikasa.[7] In *Uneme* the priest *waki* comes upon a village woman planting a tree at the Kasuga shrine; she is later revealed to be the ghost of a court lady who took her own life by jumping into a pond at Kōfukuji, Sarusawa no ike.[8] In this pivotal scene, the *shite,* ghost of an ancient shrine maiden *(uneme)* of middling noble birth, tells the priest that until the eighth century, presumably some five or six centuries before the action of the play, the Kasuga deity had long been enshrined at Hiraoka in Kawachi but had then moved to a barren mountain, Mount Mikasa. She explains that the Fujiwara family planted a great many trees to honor the deity, their ancestor Amenokoyane. This motif in the play seems to have a basis in historical fact. Indeed, contemporary documents tell us that the eighth-century queen mother Kōmyō *kōgō* and her father, Fujiwara no Fuhito, helped move the soil for these plantings with their own hands.[9] The description of the god's move to Kasuga is described as the descent of his image or reflection *(yōgō).* Ryōhen, champion of the Jizō cult and close colleague of Jōkei's, in his *Jindai no maki shikenbun* (Personal Reflections on the "Age of the Gods" Scroll of the *Kojiki*) recounts that in the early days, when there were no trees at Kasuga, it was first decreed that *sakaki* should be planted. *Sakaki (Cleyera japonica)* is the sacred tree of the *kami,* used to this day at altars and held in the hands of shrine dancers and mediums or tied to their waists. The plays *Uneme, Kasuga ryūjin,* and *Ama* also each draw a connection between the female lead and the miraculous dragon girl of the *Lotus Sutra,* while simultaneously invoking the image of travel between worlds.[10] As Abe Yasurō has suggested, the fisher woman *(ama)* and the prostitute *(yūjo)* were created as a twin pair in the predominant soteriologies of the Kamakura period. These categories also influence the figure of the female dancers called *shirabyōshi* in legend and in practice.[11] Travel between social and spiritual worlds was clearly a theme here, as Sarusawa no ike was known during the medieval period as "the pond of the Dragon King's daughter," creating an implicit connection to the well-known legend of the Dragon Cave (Ryūketsu) beneath Kōfukuji.[12] The central theme of the Noh play *Ama* is in fact the construction of Kōfukuji atop the Dragon King's palace. The daughter of the Dragon King, familiar from

the folktale of Urashima Tarō and ancient mythology, moves between the mortal world and the mysterious underwater realm.

In these stories, the role of the *kami* in the dissemination of Buddhism is a very strong subtext, and in the thirteenth-century work *Gen'yōki* (Record of the Prime Original), there is a recapitulation of the story of the central figure of the Japanese mythological pantheon, the Sun Goddess Amaterasu, who sequesters herself inside the rock cave after being offended and attacked by her brother Susano'o.[13] In this medieval version of the story, however, Amenokoyane is said to be a dragon god, and Amaterasu herself his pearl. (It is widely known that every dragon carries a pearl in his beard.) We are reminded here of the sort of secondary or extended *honji suijaku* observed above in the case of the relationship between Jizō, the Kasuga deity, and Dainichi. The persistent presence of the old temples, locales, and prelates of Nara in the Noh theater is noteworthy. While it does not call for detailed explication here, we might just note that Jōkei is the *waki* in the play *Dairokuten* and that his temple Saidaiji is mentioned in *Uneme* and also appears in *Kasuga ryūjin*. Saidaiji is also essential to the story told in a play that we shall examine presently, *Hyakuman:* the shrine dancer who is the eponymous heroine of the play loses her young son in the press of the festival crowds at Saidaiji.[14] While the action of *Hyakuman* is centered at the Seiryōji in Saga, the connections to Nara and to Eison's lineage run very deep. Noh's mythology of itself is also closely tied to Nara's religious sites.

A founding legend of the Noh theater, as inscribed on the portrait of Kanze Kojirō Nobumitsu, great-grandson of Kan'ami, says that Kan'ami (Zeami's father) had been one of three brothers. The Kasuga deity appeared to the eldest and commanded, "Serve me with music!" Kan'ami's father refused to allow his eldest son to follow this somewhat lowly vocation, and the son died soon after. The same fate befell the second son, and the father finally relented and took his youngest to Yamato to place him in the service of the god at the Kasuga shrine. It was on the trip to Kasuga that the family met a priest, who gave the boy the name "Kanze."[15] It is clear that Zeami's troupe was much in demand in Nara and, besides Kasuga, regularly performed at Kōfukuji and Daigoji's Kiyotaki *no miya* shrine in the late fourteenth and early fifteenth centuries.[16] It is exceedingly evident that these performances were primarily rituals aimed at producing results, not "mere" dramatic art divorced from any sense of efficacy.[17] It is important to understand when thinking about Noh that this dramatic art was suffused with and founded upon a deep religious sensibility and that the actors and audience were fully aware of this. In an esoteric treatise, a secret text called *Meishukushū* (Collection on the Dwelling of Brightness/Collection on the Shuku God), the great

Noh actor and theorist Konparu Zenchiku describes the origins of Noh in *sarugaku* and emphasizes the importance of the god called Shukujin to the dramatic arts. Nakazawa Shin'ichi points out that the Shukujin (also called Shugūjin) is the god of other creative and technological specialists as well, such as carpenters and smiths. Nakazawa writes, "The Shugūjin has an intimate connection to the performing arts [*geinō*], and there is no god more medieval than this; this is *the* god of the middle ages."[18]

This fascinating work by Zenchiku is an explication (undertaken in the terms of *honji suijaku* theory) of the role of the Okina, the dance of the god known as "the old man" *(okina)*. The dance of the Okina is the ritual invocation opening all *sarugaku* Noh performances and also plays an essential role in traditional puppet theater.[19] In Kyōgen (capitalized here to distinguish it from the folk *kyōgen* of Mibudera and Seiryōji) and in puppet theater, the Okina dons a black mask and is called the Sanbasō. Zenchiku tells us that the Okina (and we might deduce by extension Sanbasō) is none other than the Shukujin himself. He is also identified with Dainichi Nyorai, the primordial buddha.[20] The most interesting connection for our purposes, however, is to the Kasuga god. We will remember that in the medieval legend of the Chisokuin Jizō, the god Amenokoyane appears to Jōkei as an old man *(okina)*. While all *okina* are not necessarily to be equated with the Okina of *sarugaku*, Zenchiku's secret treatise may give us reason to make this identification.

In *Meishukushū*, Zenchiku says, "The Kasuga deity and the Okina are the same.... That this god and the Okina are the same is the secret among secrets and there is a separate oral tradition and esoteric initiation regarding this."[21] That such plays should take place in Nara, the Kōfukuji precincts, and the Kasuga shrine is not surprising, then, given the origins of the Kanze school of Noh and the other four main Yamato *sarugaku* troupes. This of course includes Zenchiku's own Konparu troupe, and yet it is important to understand that living and working in the fifteenth century, Konparu stood in a long lineage of specialists in ritual drama in Nara. Let us move back some two hundred years to the thirteenth century and from there begin to explore in some detail the history of religious performance at a subsidiary organ of Kasuga and Kōfukuji, the Wakamiya shrine.

Sacred Dance, Ritual Drama, and the *Haiden* of the Wakamiya Shrine

The Wakamiya was established in 1135 through the divinely inspired efforts of Fujiwara no Tadamichi and is clearly a part of the Kasuga shrine in terms of affiliation and pantheon. However, Kōfukuji monks were the

central actors in its founding, and it remained firmly under their control right down through the centuries, even during the not infrequent periods of conflict between the temple and the shrine. Thus, the Wakamiya continued to be institutionally somewhat distant from the main shrine. The Wakamiya—especially its hall for sacred dances, the *haiden*—held an extremely important place in the religious life of the Southern Capital, Nara. The *haiden* was overseen by the dancers and the shrine maidens who lived there. The performance traditions of these shrine maidens, or *miko*, as well as the arts of their guests who performed various sorts of shrine dances such as *sarugaku, kagura,* or *seino*, formed the basis for the repertoire of the four troupes of Yamato *sarugaku*, the theatrical ancestor of the Noh theater. Above, the Noh in particular has been mentioned several times, but the practices of the Wakamiya *haiden* were the source for a great many other performance traditions that flourished in medieval Japan. In many ways, the importance of the *sarugaku* tradition over other modes like *dengaku* (frenetic, costumed "field dancing") or *furyū* (lavish costumed parades with magic and tumbling) or *kusemai* (a song and dance with drumming, often featuring a woman in *shirabyōshi* garb) is largely a retrospective one that derives from the future importance of Noh. As *sarugaku* was adopted by aristocratic and warrior court culture, becoming canonized as Noh in the sixteenth and seventeenth centuries, it overshadowed many important varieties of spectacle and ritual that, while some are preserved as folkloric pieces, are largely lost to us today.

For our purposes, a particularly interesting fact to note is that the principal image, *honzon*, of this hall was a Jizō statue. In fact, throughout the medieval period in various locales, religious performance was most commonly held in or near Jizō halls. The medieval city knew a rich variety of ritual specialists: monks, shrine priests, male dancers called *kagura'o, shugenja* (the adepts of esoteric mountain religion), and importantly the dynamic yin/yang diviners known as *sushi* (or *jushi*).[22] At Kasuga and Kōfukuji, and in Kyoto as well, their practice was closely tied to communication with the divine through performance, oracle, and possession. The god of ritual performers, Shukujin, whom Konparu Zenchiku said was the Okina, was related to the "stone god," Shakushi, and his worship was mediated through stones.[23] It is in fact impossible to understand the visible or visual aspects of Jizō worship in medieval Japan without careful attention to the ecstatic performance traditions that were the source for the later sublimated and refined dramatic traditions of the Noh theater.

Before we move on to the role of Jizō in the performance culture of medieval Kyoto, it is essential to note that while these dances to the gods may be understood in modern times as "folk performance," in fact they

were central to the religious life of the most socially and ecclesiastically elite members of society in the context of Nara and, later, Kyoto.[24] At the same time, the players themselves were decidedly marginal figures. They lived in a competitive world and practiced a demanding art, but were seen as somewhat dangerous, possessed of a holy yet wild energy and capable of taking pollution upon themselves in order to purify the space around them and pacify raging spirits. Their work in dramatic performance was essential to harnessing the rough and unbridled forces of creativity—we can call these *aragami* (rough gods), or Kōjin—and transforming these forces into their peaceful and protective aspect.[25]

In order to gain a fuller understanding of how the lives of female performers known as *miko, shirabyōshi, imayō, kugutsu,* and *yūjo,* and each with their own specializations, were tied to Jizō in important and complex ways, let us examine here a couple of contemporary sources.[26] The first of these is a series of inscriptions discovered in the eaves of a performance hall now at Shin Yakushiji in Nara. This building had in fact been the Wakamiya's main performance space, the *haiden,* home base for the shrine *miko,* and it housed a Jizō image as the main object of worship. (It was moved to the Shin Yakushiji at a later date in response to mysterious signs indicating the Jizō image's desire for relocation.) The second source is a detailed record of a ceremony held in 1349 in Nara, a special observance of the festival pageant known as the Wakamiya *on-matsuri.*[27] Here we can witness the full range of performance specialists and understand something more about the position of the shrine *miko* in this important ceremony and in the cultic life of the Kasuga-Kōfukuji complex in general.

First let us take a close look at the inaugural moment of the Waka-miya *haiden,* a hub of ritual life and contact with the gods for the monks of the Kōfukuji that became a driving motor in the development and spread of devotion to Jizō in Japan. This small Jizō hall that now stands at Nara's Shin Yakushiji holds great significance for telling this story. The materials found there demonstrate the close relationship between sexual-ity and performance as well as the importance of the Jizō cult to female religious specialists, dancers, and semisacred prostitutes. That it is also designated an Important Cultural Property because of its significance to the history of Buddhist architecture in Japan is perhaps merely inciden-tal to our interests here. First constructed during the Kamakura period, this little building has undergone much repair, renovation, and even re-location over the centuries. In its latest restoration, in the early 1990s, workers recovered fascinating historical materials in the form of small lath strips backing the eaves along the south wall. While this wooden latticework did serve a structural purpose, it also bears a good deal of

Plate 1 Grave fragments and Jizō images in graveyard at Mount Kōya. Photo by Joe Arcidiacono.

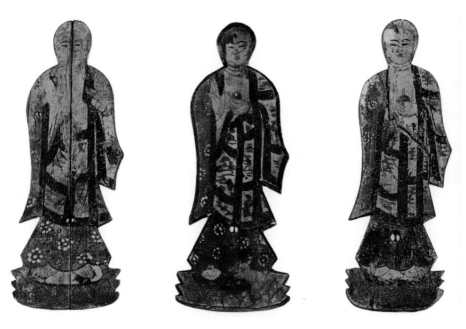

Plate 2 Wooden slats carved and painted as a sentai Jizō project. Courtesy of Gangōji Bunkazai Kenkyūjo, Nara.

Plate 3 *Kasuga sentai Jizōzu* (One Thousand Jizōs Crowd the Nara Plain), ca. thirteenth century. Collection of Nara National Museum. Courtesy of Nara National Museum.

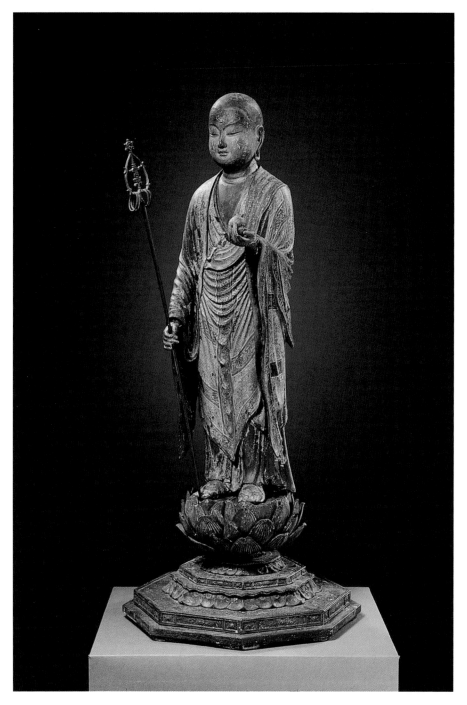

Plate 4 Standing Jizō, Zen'en, 1220s. Mr. and Mrs. John D. Rockefeller 3rd Collection (Rockefeller Collection 1979.202a-e), Asia Society, New York. Courtesy of Asia Society.

Plate 5 *Kasuga gongen genki e* 12:3, ca. 1309. Courtesy of the Museum of the Imperial Collections (Sannomaru shōzōkan).

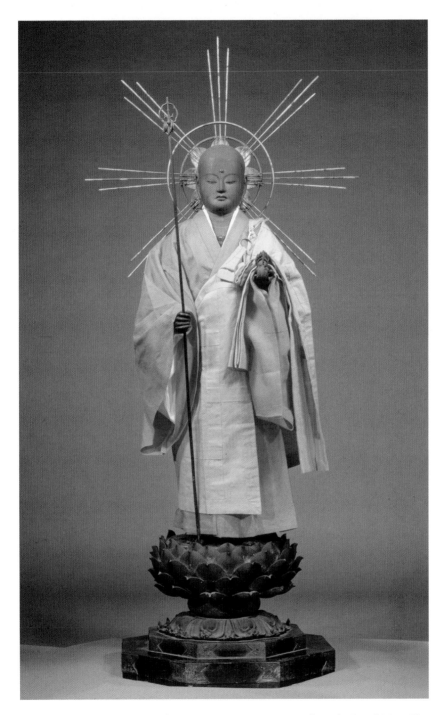

Plate 6 Standing Jizō, Denkōji, Nara, 1228. Courtesy of Denkōji and Nara National Museum.

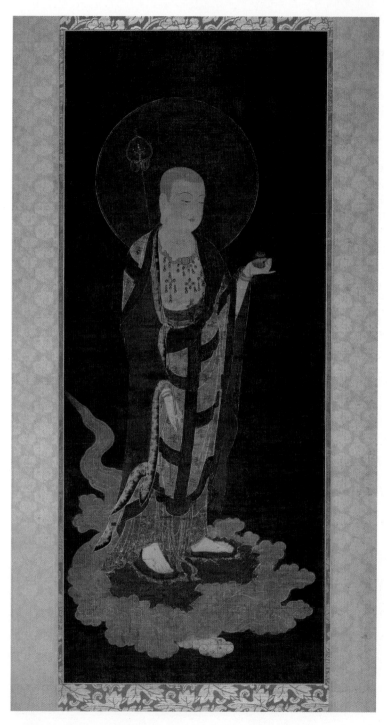

Plate 8 Jizō in welcoming descent, ca. fourteenth century. Courtesy of Museum of Fine Arts, Boston (William Sturgis Bigelow Collection 11.6185).

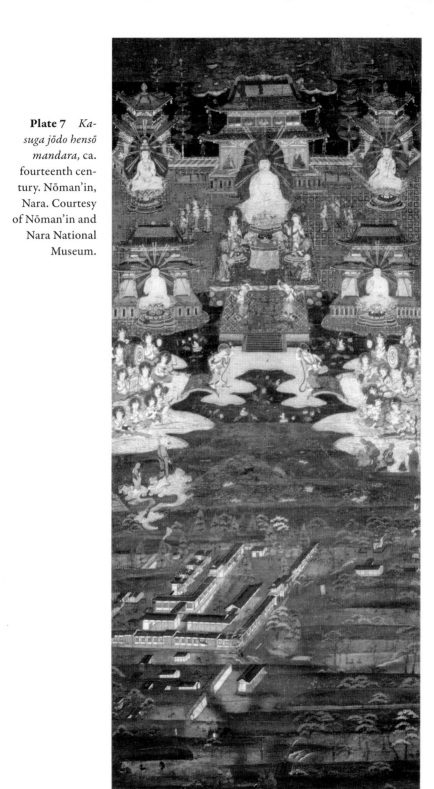

Plate 7 *Kasuga jōdo hensō mandara,* ca. fourteenth century. Nōman'in, Nara. Courtesy of Nōman'in and Nara National Museum.

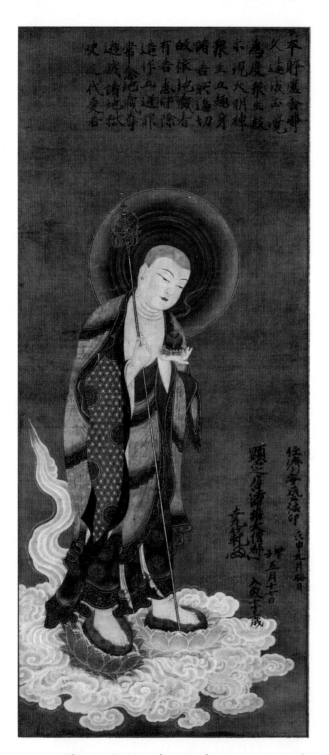

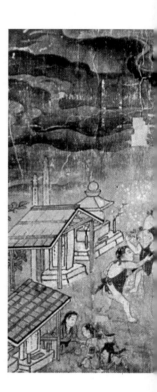

Plate 9　Jizō in welcoming descent, ca. sixteenth century. John C. Weber Collection, New York.

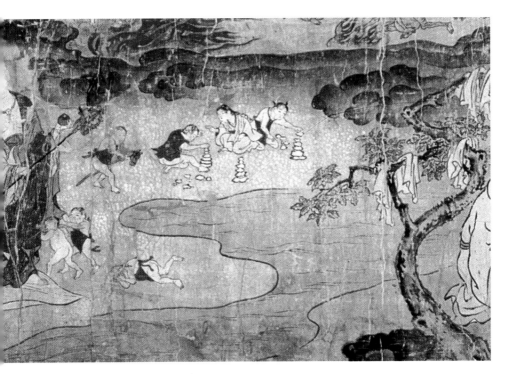

Plate 10 *Sai no kawara.* Detail of *Kumano kanjin jukkaizu,* ca. sixteenth century. Courtesy of Chinnōji, Kyoto.

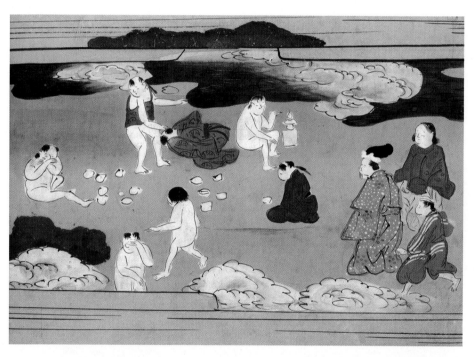

Plate 11 *Sai no kawara*. Detail of *Koyasu monogatari,* ca. seventeenth century. Reproduced by permission of the Spencer Collection, the New York Public Library, Astor, Lenox, and Tilden Foundations.

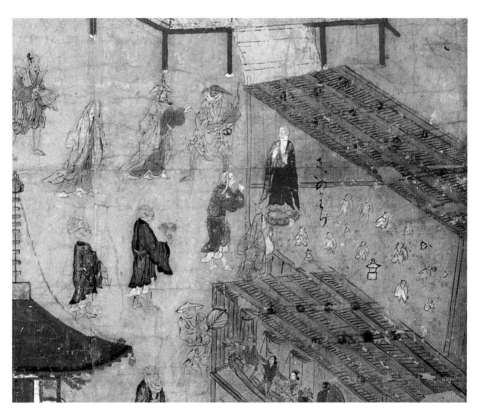

Plate 12 A Jizō statue presides over a diorama of *sai no kawara*. Detail of *Chinnōji sankei mandara,* ca. seventeenth century. Courtesy of Chinnōji, Kyoto.

Plate 13 Offerings table for *shōryō mukae* at Chinnōji, Kyoto. Photograph by
Amy Nakazawa.

Plate 14 The nun dreams of a small man and a small woman. Detail of *Koyasu monogatari,* ca. seventeenth century. Reproduced by permission of the Spencer Collection, the New York Public Library, Astor, Lenox, and Tilden Foundations.

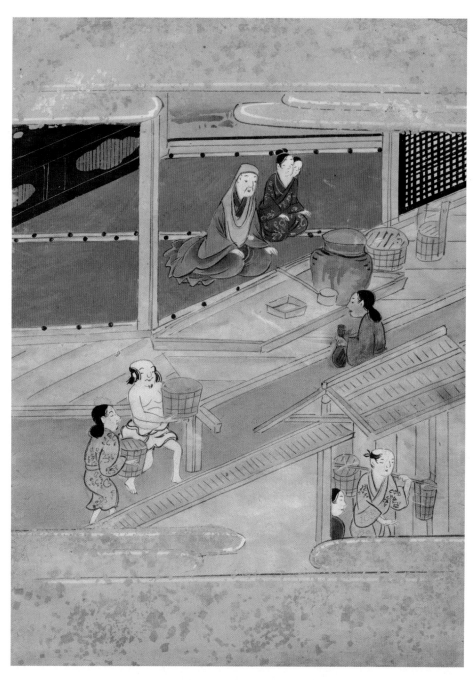

Plate 15 The twins help sell the miraculous sake and the brewery thrives. Detail of *Koyasu monogatari,* ca. seventeenth century. Reproduced by permission of the Spencer Collection, the New York Public Library, Astor, Lenox, and Tilden Foundations.

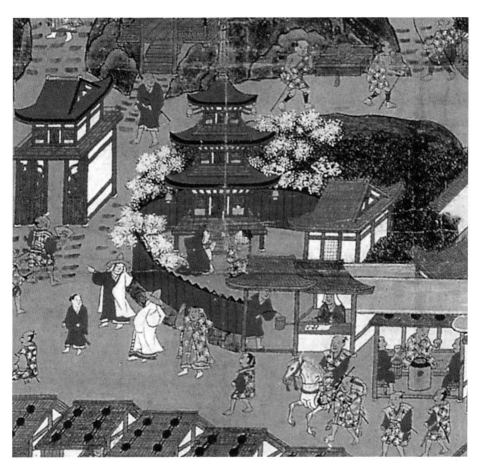

Plate 16 Taisanji, the *koyasu no tō*. Detail of *Kiyomizudera sankei mandara,* ca. sixteenth century. Courtesy of Kiyomizudera, Kyoto.

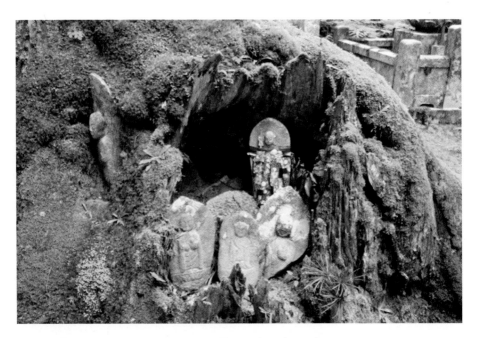

Plate 17 Jizō images on Mount Kōya. Photo by author.

Plate 18 Fragment of a stone stupa finial rededicated as Jizō and as *shaguji,* Mount Kōya. Photo by Joe Arcidiacono.

writing, both describing and blessing the building project. The earliest inscription is dated 1266, confirming that this Jizō hall was founded in the thirteenth century. Originally, the hall was surrounded by a veranda, and the eaves extended further than they do today, making dances possible there in rainy weather.[28] The *Shin Yakushiji engi* (Origins of Shin Yakushiji Temple), written in 1710, describes the history of this little hall and its principal image as follows:

> There is a hall of one thousand Jizōs [*sentai* Jizō]. The main image rides on a deer. This is because he is the *honji* of the Kasuga Daimyōjin. Long ago, this image was installed in the Wakamiya worship hall [*haiden*] by Myōe *shōnin*. One night, the voice of a crying child was heard coming from the ceiling. Several of the shrine attendants [*jin'nin*] heard this and thought it most strange. So they had the building moved to Shin Yakushiji. Thus it is installed at this temple today. This is why it is popularly called the night-crying Jizō [*yonaki* Jizō]. The [Kasuga] *jin'nin* still care for and maintain this hall.[29]

It is worth noting that the Jizō image currently housed in the Chisokuin is referred to as the *yonaki* Jizō. There is also an old stone image, phallic in shape, called *yonaki* Jizō at Mibudera (see fig. 4.13).

Another pair of strips found under the eaves are inscribed as follows on their interior surface: "[The Ritsu sect prelate] Shukurenbō of the Byakukōji has made and set up the Jizō statue in the *haiden* for the sake of the liberation and escape [from samsara] of the *miko* and *yūjo* of the Wakamiya shrine." It mentions that the *sō no ichi*, a woman named Yakushi, and the *miya no ichi*, a woman named Kongō, belong at the top of the roster of the *miko, yūjo,* and male shrine dancers *(kagura'o)* who came together as supporters of this Jizō project.[30] These titles indicate that the two women mentioned here were the principal *miko* of the thirteenth-century guild of shamanesses at Kasuga's Wakamiya. In the guild organization of *kagura* priestesses, the *sō no ichi* heads the list of ranks in the *honza* (main troupe), and the *miya no ichi* leads the *tōza* (east troupe).[31] The same names Yakushinyo (the woman Yakushi) and Kongōnyo (the woman Kongō) appear on a list of those with "karmic connection" *(kechien)* found inside a statue of Shōtoku *taishi* from Nara's Gangōji, dated 1270, but we cannot know for certain that they were the same women, for in those days many female religious took the names of deities. By the same token, it is also not unlikely that they are in fact the same women. It is worth mentioning in this context that the name "Jizōnyo" (the woman Jizō) also appears inside the same Shōtoku statue.[32]

From this and from later inscriptions found in the roof of the *hai-den*, we know that the Jizō hall, though it was located at Shin Yakushiji, remained the jurisdiction of the Kasuga shrine, or, more precisely, the Kōfukuji monks. The account cited above from the *Shin Yakushiji engi* suggests that in the eighteenth century it was still known to be the property of the Kasuga shrine. The *haiden* referred to above is the worship hall of the Kasuga shrine. Thus there were two buildings called the *haiden* of the Wakamiya, and the illustrations in the *Kasuga gongen genki e,* from 1309, give us an idea of how they appeared at the time of the dedication of the Jizō hall. There, especially in the picture at section 13:3, we can discern the interior of the performance hall at the Wakamiya shrine, where dance dedicated to the gods was offered up. In this hall for sacred music and dance, or *kagura den,* we find five *miko* playing thirteen-string zithers *(sō)* and drums. One of the five appears to be quite aged and is no doubt the *sō no ichi.* It seems likely that the building in question here is the *kagura* hall of the illustrated scroll, the one called the *haiden* in the inscriptions.[33] The situation was that the *miko* of Kasuga's Wakamiya were housed in the precincts of Shin Yakushiji, which was part of the Wakamiya shrine's holdings at that time.

As is very often the case in illustrated scrolls and books, the sacred image itself is hidden from view, but we know from the inscriptions that the principal image *(honzon)* of this ritual and of the hall where it was performed was a Jizō image. Furthermore, this Buddhist deity acted as a stand-in, or earthly representative, for the main god of the Kasuga shrine at this outpost of the shrine that was under Kōfukuji's control. In Chapter Two, we looked at two scenes from the *Kasuga gongen genki e* scroll and saw that the main deity was identified with Jizō; the god is himself depicted as a shaven monk, clearly Jizō bosatsu, and the text is also explicit on this point. In one he is riding upon a cloud, returning to the shrine and passing through the delimiting *torii* gate (see fig. 2.3). In another, he is headed out of the shrine to visit Kōfukuji monks, with the shrine attendants *(jin'nin)* to accompany his carriage out of the holy precincts (see plate 5).[34]

The dancing women at the *haiden,* the *jin'nin,* and the Kōfukuji monks were all servants of Jizō, manifestation of the Kasuga god. As we saw in the last chapter, he was worshipped by the Kōfukuji clerics through their prayer and scholarship; at the *haiden* he was worshipped with music and ecstatic dance by the *miko* and the *yūjo.*

The identities of the *yūjo* mentioned in the inscriptions are not clear, but one can surmise that they were not mere prostitutes. In fact, as the name *asobi*—the native Japanese, or *kun,* reading for the first character in the term—implies, they were no doubt ritual specialists of some sort

who may or may not have also worked as prostitutes. The verb *asobu* or *asobasu* means "to play" or "to entertain" but also refers to invoking the gods through ritual performance. There is an early Kamakura record of *yūjo* and *miko* dancing together onstage at the Kasuga Wakamiya *onmatsuri*. Here again the great popularity of the Jizō cult in the Southern Capital during the mid- and late Kamakura period should be emphasized, as well as that the *miko* who were depicted so realistically in the *Kasuga gongen genki e* were at the center of the project to build the Jizō hall.[35]

The inscriptions on these strips of lath under the eaves, painstakingly recopied with each reconstruction of the hall, serve as a sort of time capsule, giving us a glimpse into the cultic life of the Kasuga-Kōfukuji complex. The construction of this *haiden*, this hall for sacred performance, was undertaken through the leadership of the Ritsu sect prelate Shukurenbō of the Byakukōji temple on behalf of and through the cooperation of these female ritual specialists whose names appear on the lists discovered in the eaves. These writings tell us that the hall was founded by several *miko*, shamanesses of the Kasuga shrine, together with a number of *yūjo*.[36] The *miko* and *yūjo* who served this very Jizō hall, the small but pivotal Wakamiya *haiden*, were key figures in the life of the shrine. The performances and rituals they undertook there would eventually form the roots of the dramatic, comic, and religious theater of the *sarugaku* troupes of Nara.

Many have emphasized the influence of the Zen sect on Zeami's thought and his craft, and this is certainly a valid line of inquiry, especially if the Tendai esotericism so prominent in medieval Zen is taken into consideration.[37] However, when one is thinking about the roots of Noh in religious performance, it is rather these sorts of professionals— the *miko, shirabyōshi, imayō, yūjo*—who provided the direct models of ritual and theological practice. The history of Noh is intimately tied to the history of the Jizō cult and to the pacification of restless spirits, to the soothing and succor of the dead. The spirit possession that had been such an important part of performance in the context of the Wakamiya and other places became, in the later part of the medieval period, an essential tool for the control of dangerous ghosts in the capital.

It is quite clear that the same Kasuga-Kōfukuji community responsible for the expansion of the Jizō cult during the thirteenth century regarded the descent of the deity into a human vessel, usually a female one, as a central part of its religious practice. The Wakamiya shrine at Kasuga (a satellite of the Kōfukuji) was an important locus for such spirit possession.[38] A story about the eminent thirteenth-century nun Shinnyo, the same Shinnyo mentioned in Chapter Two as the daughter of Jōkei's errant disciple Shōen, illustrates this well. Eison's autobiography relates

this anecdote, in which Shinnyo, before she had become a nun, witnessed the ordination ceremony for a young acolyte. The ordination administered the newly reintroduced "full precepts." Deeply moved, she asked to know when this sort of ceremony had been revived and was told that it had happened eight years earlier, in 1235. To this, she remarked that miraculously she had had an amazing dream during that same period; it was a dream involving a laywoman and some priests playing stringed rhythm instruments *(shakubyōshi)* and dancing the *kagura* shrine dances. They put the instruments down and proceeded to discourse on the Dharma. The dream was then interpreted as an auspicious one, predicting and celebrating the revival of the Ritsu lineage by Eison and his disciples.[39]

The priests in Shinnyo's dream put down their instruments, and indeed, under the monastic rules—the very *vinaya,* or *ritsu,* that gave Eison's sect its name—the ordained are not supposed to indulge in musical entertainment or dance. This should in no way, though, be taken as a sign that the Ritsu group or other monks in Nara forbade music and dance. In fact, in a story in Mujū Ichien's thirteenth-century *Zōdanshū* (Collection of Miscellaneous Conversations), we read of a new abbot, or *bettō,* of Kōfukuji who decided to do away with these entertainments in an effort to return to Buddhist orthodoxy. After he had enacted the new ban, this *bettō* was visited in dream by the Kasuga deity, who rebuked him roundly and told him no uncertain terms that music and dance were to be reinstated immediately as an essential aspect of worship at the temple.[40] The communication with divine entities though music, dance, and mediumship was vital to worship at shrines dedicated to the *kami* and at Buddhist temples alike.

Female entertainers variously known as the *asobi, miko, yūjo, shirabyōshi,* and other names trace their origins to shrine maidens, to court ladies, and to practices of spirit possession that combined Buddhist ritual with Chinese geomantic belief and apotropaic magic. The many female subjects of possession found in the diaries and fiction of Heian-period writers provide some idea of the spectacle, as do clerical memoirs. The mediums and exorcists at these events were the ancestors of the craft of *sarugaku* and *onna kusemai.* It can be useful to think of the performing people and religious specialists of medieval Japan as members of a particular and special group. These people embodied the gods and spirits in their acrobatics and their dances, their songs, and their mime. Their patron saint was the mysterious figure Shukujin. Konparu Zenchiku identified this Shukujin with the Okina of the Sanbasō performance, so important in drama and puppetry. Zenchiku further claimed descent from Hata no Kawakatsu (sometimes Hata no Kōkatsu), the illustrious seventh-century Korean immigrant from the peninsula, and said that this

man was the earthly embodiment of the Okina and was the ancestor of all performance in Japan.[41]

The key of the Yamato *sarugaku* style, according to Zeami, was dramatic imitation, or *monomane*, the ability to mimetically "channel" various types of characters and effectively bring them to life, bring them into presence on the stage.[42] This is clearly related to the origins of the art in rituals of possession and oracle. One indication of this is the expansive use of *onna kusemai*—a women's dance based on the movements and techniques of shrine dancers and *shirabyōshi* performers—in plays from Kan'ami's time onward. In the original version of *Hyakuman*, called *Saga monogurui* or *Saga no dainenbutsu no onna monogurui no nō* (The Play of the Madwoman at Saga), the *kusemai* is a description of hell. This play is often held to be the work of Kan'ami and was one of his favorite performance pieces. These *kusemai* dancers *(kusemai mai)* were the descendants of the *shirabyōshi* dancer. Similarly, their performance, in male court garb with the accoutrements of a fan and a drum, was based on the ecstatic and sometimes erotic movements of spirit possession. The dances originated by these women were at the very heart of the creative energy of the Noh (fig. 3.1).

In his treatise *Sandō* (The Three Ways), Zeami makes it clear that the pivotal scene in *Hyakuman* is the "Jigoku no kusemai" (Dance of Hell), which his father was said to have been so skilled at performing:

> Then again, there are characters such as Hyakuman or Yamanba who are fairly easy to create because they can be cast as *kusemai* dancers. Of the five *dan* of the play, the *jō* and the *kyū* can then be shortened.

Figure 3.1 *Kusemai mai (kusemai* dancer or *shirabyōshi)* from *Shichijūichi ban shokunin utaawase* (Poetry Competition between Seventy-one Craftspeople, Artisans, Artists, and Performers), original ca. 1500. Line drawing reproduced courtesy of Iwanami shoten from Iwasaki 1993.

dhist priest, where the latter offers successful prayers for the former's salvation, is exemplary of this function. Reenacting or witnessing some old trauma or attachment of the ghost, the priest (and his doubles, the audience) puts to rest old resentments and welcomes a fresh-made world of auspiciousness. This is the power of theater, dance, storytelling, ritual: to calm and to appease the legions of unhappy dead.

The need for such ceremonies was of course related to military disturbances, but also to famine and epidemics. Performance increasingly became a way of managing the danger of the pollution of death, a way, especially, of pacifying and tending to the unaffiliated dead, the *muen,* those without family to care for them and nurture them into ancestorhood or Buddhahood.[54] The choice of places in Kyoto where these performances were staged indicates that they were intended to ward off the dangerous influence of unhappy or resentful spirits. The venues chosen for such performances—Injōji (Senbon Enmadō), Saga Seiryōji Shakadō, Rokudō Chinnōji, Rokuharamitsuji, and so on—were all sites with legends that unambiguously connected them to journeys to the underworld and the court of King Enma. They were also near the large funeral and burial grounds of Toribeno, Rendaino, and Adashino on the outskirts of the capital.[55]

It is important to understand the role of the class of people known as *hinin,* or "nonpersons," at this time in the spread of the Jizō cult, particularly regarding its association with performance in medieval Nara and Kyoto. The role of these marginal populations in the care of the dead, and religious performance is a key to understanding the cultural landscape of that time and place. While often termed "outcastes" in the English-language literature on Japan, they were central and integral to the functioning of medieval society. These polluted and powerful ritual specialists, beggar priests, executioners, gravediggers, mortuary technicians, performers, prostitutes, and the like were called *kawara no mono* (people of the riverbank) as a general term, and those at Kiyomizuzaka in eastern Kyoto, at Narazaka in the Southern Capital, and elsewhere formed themselves into powerful guilds.[56] The traditions of Noh and Kyōgen grew out of the performances staged by members of this social group in the manner described above. One of the main functions of these people was to control the dangerous influences of evil spirits and to clean away the karmic dirt of dangerous places. Thus they were often referred to by the title *kiyome* (purifiers). Mizumoto Masahito maintains that the *sarugaku* actors indeed performed this essential function in the cities, and he further suggests that the given names of Kan'ami and Zeami—"Kiyotsugu" and "Motokiyo," respectively—are evidence of their origins in this profession. Zeami's younger brother Shirō also styled himself as Kiyonobu

in his autobiography. Finally, Nakazawa Shin'ichi notes that Zenchiku
for a time called himself Hata no Ujikiyo.[57] Each name uses the character
"kiyo" (purity), from *kiyome.*

A number of popular temples stood bordering Toribeno, the mas-
sive charnel ground just east of Kyoto in use since ancient times: from
Kiyomizudera (or Shimizudera, as it was known in the medieval period)
and Chi'onin north to Chinnōji, Saifukuji, and Rokuharamitsuji. Here, in
the Higashiyama district, the denizens of medieval Kyoto approached the
world of the dead and experienced religious power at its most palpable.
The whole region was a borderland between this world and the next, a
place where the veil separating the living and the departed was especially
thin.[58] The Chinnōji, a very active venue for the performance of *saru-
gaku* and other arts, has within its precincts a well, said to be the portal
by which Ono no Takamura made his famous entry into hell, and also
statue portraits of King Enma and Jizō attributed to Takamura's hand.[59]
This temple became a central hub of the ancestral ceremonies of late sum-
mer and, by the sixteenth century, was a principal venue for Kyotoites
to witness the fearful cosmology of the next world in sound and image,
through the preaching of the traveling nuns known as Kumano *bikuni* on
a picture of heaven and hell, the *Kumano kanjin jukkaizu* (plate 10).

At the other end of town, in the north, another Jizō site—Injōji (Sen-
bon Enmadō)—similarly emphasized its close connections to Ono no
Takamura and became the premier place to hear the *Tale of the Heike
(Heike monogatari)* performed with the accompaniment of the *biwa* lute;
from the 1440s it also became the main center for *kusemai.* This temple
and Seiryōji, so important to the *Hyakuman* story, are in the Arashiyama
district, adjacent to Kyoto's other great graveyards and funeral grounds,
Rendaino and Adashino.[60] So in proximity to these huge villages of the
dead—the charnel grounds and cemeteries hugging the peripheries of the
capital—citizens of all types came together to witness the spectacle of
performance. The chanting of the story of the fall of the Heike and the
great battles of the twelfth century served to comfort the souls of the
dead. The *kusemai* and the *sarugaku* were also aimed at the pacification
of the restless dead, or *chinkon.* In the case of *sarugaku,* the action of the
play itself often consisted in the salvation of a ghost by a traveling priest.
Similarly popular at these sites were dramatic renditions of the journey of
the soul through the realms of judgment, before Enma's bench. Of course
Jizō played a prominent role in these plays. Dance was an essential part
of the staging of the hell tour and was likewise incorporated into funeral
ceremonies. The tradition of *kangi yuyaku nenbutsu* (leaping-with-joy
nenbutsu) was said in legend to have been created by the ninth-century
"saint of the marketplace," Kūya *shōnin.* This dance and the dancing

rokusai nenbutsu (*nenbutsu* of the six observances) were closely related to the dancing *nenbutsu* held at places like Seiryōji, the setting of *Hyaku-man*. Dōgo, strongly influenced by the *yūzū nenbutsu* movement, started the celebration of the *dainenbutsu* there in 1179.[61] In fifteenth-century Kyoto, dance played an absolutely central role in the development of Jizō worship.

The Jizō Dance

In his diary *Kanmon nikki* (Diary of Things Seen and Heard, popularly called *Kanmon gyoki*), the fifteenth-century prince-of-the-blood Fushimi no miya Sadafusa relates a story of the miraculous events and general uproar surrounding a Jizō statue on the southwestern edge of town, at Seventh Avenue (Shichijō) and the Katsura River (Katsuragawa).[62] The story of this sensational Katsura Jizō (or Katsuragawa Jizō) is worth examining in some detail because it brings together many of the themes central to this chapter—performance, living images, marginality, and stage artifice. In his entry for the sixteenth day of the seventh month of 1416 (Ōei 23), Sadafusa lays out the following story:

> A man of lowly status, living in the province of Awa [on the island of Shikoku], was visited one day by a "little priest" [*kobōshi, sasahōshi*][63] who pleaded with him, "My dwelling, a simple grass hut, has fallen into disrepair and cannot keep out the rain and the dew. I'd like to see it restored to its former state. Please come with me and do this work." The man retorted, "I am a poor man and can barely make ends meet. How can you ask me to abandon my wife and children to follow you to some other place?" The "little priest" said, "They will surely be provided for; please, for now just come along with me." And so the man decided to accompany that "little priest" down the road. When they arrived at the hamlet of Katsura in the province of Yamashiro [on the southwestern outskirts of the capital], there at the crossroads stood a stone Jizō image in a small ruined shrine. "Don't go anywhere; just stay right here," the "little priest" ordered the man, and he disappeared into thin air. Now, there was a bamboo merchant from nearby Nishino'oka who had long felt pained whenever he saw that Jizō in the tumbled-down hut at the crossroads; many had been the time that he had thought to take it on as a project of his own. One day as he passed before the little shrine, he happened to stop for a rest and struck up a conversation with the man from Awa. They began to argue over the future management of the Jizō hall, and the bamboo merchant drew his sword and made to strike the

other man down. As the man from Awa dodged the blow, the bamboo merchant, enraged beyond control, slashed into the stone of the Jizō image and then suddenly collapsed. When this man from Nishino'oka returned to his senses, he begged forgiveness of the Jizō for his offense and vowed that it was his wish to manage and support the shrine. And so the man from Nishino'oka took the tonsure and expressed his intent to cooperate with the man from Awa in attending to the operation of the shrine. News of these events spread through the capital and its environs, and the place became known for such miracles as restoring sight to the blind. High and low, people flocked there in droves, piling up money and other offerings into a veritable mountain and performing all sorts of fancy dances and drumming [shushu furyū no hayashimono].[64]

The diarist expresses some reservations about the veracity of the story but remarks that since it is something that has been widely spoken about of late, he is taking due note of it in his journal. It is corroborated in other sources that this statue (and the spontaneous dances and sideshows that accompanied its sudden fame) attracted a sizable following of faithful from all segments of society in the 1410s. Two close associates of Sadafusa's went to the place and reported back that there was indeed a large gash in the stone image and that the local people said they had noticed that the wound was healing—shrinking bit by bit every day. Some middling retainers of the shogunal Ashikaga family, and of their relatives the Shiba, had visited and offered taue (rice-planting) dances. Yamabushi (shugendō practitioners from the mountains) had come and held a demonstration of their mineiri (peak-entering) purification austerities and rituals. Sadafusa sent officials and enlisted performers from his of retinue and sent them up to Katsura to visit on a number of occasions in the remaining months of that year.[65]

The common people displayed great interest in the site, and we see that those of higher classes and religious professionals also paid obeisance. It is clear from the documentary evidence that courtiers and top-ranking warriors quickly became the patrons of this newly established holy spot. Sadafusa himself had prayers said there for his ailing father, Prince Yoshihito, taking a vow to send offerings for a period of one thousand days. The prominent Shingon sect cleric from Nara, Mansai of Daigoji's Kyoto branch cloister Sanbō'in, visited on the seventeenth day of the eighth month, a few weeks after Sadafusa's first diary entry on the Katsura Jizō. Mansai's diary, an important source for the history of sarugaku, notes, "It was a sign of a wondrous age, cleric and lay attending in great crowds."[66] Mansai was the adopted child of shogun Ashikaga Yoshimitsu and thus surrogate elder brother to Yoshimochi and Yoshinori

(the fourth and sixth Ashikaga shoguns); it is hard to imagine a more exalted visitor to this humble site.[67]

Then we read very surprising news in Sadafusa's diary entry for the fourteenth of the tenth month of the same year, 1416. It seems that the man from Awa was not from Awa at all but from a nearby village and that there had been no "little priest" or any divine command to rebuild the Jizō hall. This "man from Awa" and the bamboo merchant and more than twenty coconspirators had manufactured the whole legend, along with staged miracles involving shills who pretended to be blind or lame. Until their ruse was exposed, they had turned a good profit from the offerings left by the hordes of pilgrims. Sadafusa notes that the ringleader and seventeen others had been arrested by the *bakufu* and were facing investigations. Mansai's diary assures us that the Nishino'oka man had been an innocent, taken in by the story spun by the Awa man.[68]

Sadafusa's reaction to the exposure of the deception is interesting. He claims not to be bothered by the allegations of a hoax and sees it as an issue that only those of little faith would focus on. The diarist insists that regardless of how and with what motives the Jizō hall came to be restored, it had been and would continue to be a source of miraculous sacred power due to the skillful means of the bodhisattva. Sadafusa's faith in the Jizō remains unwavering—remember that he had been skeptical of the reports in his earliest entries on the topic, accepting the miracle only after hearing it from trusted eyewitnesses—and he continued the healing ceremonies for his father, Yoshihito, until the term of the thousand-day vow was up, near the end of the eleventh month of 1416. The last of these was performed a few days after Yoshihito's death. Sadafusa declares that the workings of the sacred are always unfathomable to ordinary mortals (*mottomo fushin no koto nari*). Sadafusa records a later pilgrimage he made to the place in person, in 1433.[69]

Nakamura Teiri suggests that Sadafusa was right to question the motives of the authorities in suppressing the new cult and to view the claims of fraud themselves somewhat skeptically. Part of the accusation was that the gang had been really using foxes to possess people (while claiming Jizō possession) and that the wondrous signs seen by so many were malevolent tricks, a kind of black magic, rather than bona fide miracles. Tanaka Hisao has maintained, based upon evidence in the thirteenth-century *Shasekishū* and elsewhere, that beggar priests *(kotsujiki hōshi)* were the principal disseminators of the Jizō cult to ordinary people.[70] Nakamura's idea is that it would not have been out of the ordinary for such low-ranking self-ordained itinerant priests to also be involved in possession and exorcism of the vulpine variety. It was not any of the specific actions of these folks behind the Katsura Jizō cult that got them into

trouble. Their behavior and techniques were not so remarkable; rather, it was the unprecedented and unexpected wild popularity of the site that spelled trouble with the authorities. Also, after the arrests, the enthusiasm hardly died down.

In fact, the craze for lavish parades and performances dedicated to Jizō actually mounted in intensity over the next few years. At Jizō sites through the capital, crowds of worshippers and dancers and performers came together to do *furyū* and perform music at the "visit to Jizō," or Jizō *mōde*, of the twenty-third and twenty-fourth days of the seventh month. We see this in an entry in Mansai's diary from the year after the miracles of the Katsura Jizō. On a rainy evening in 1426, the twenty-third of the seventh month, he is staying at the Sanbō'in and notes that the next day will be the Jizō *mōde* and that *furyū* troupes will come down from Saga. The next day, standing with his host under the eaves, he watches as float after float passes by the front door of the temple in the rain. The next year, he writes a similar entry: "There is nobody who doesn't know about the Jizō *mōde* today! There will be *furyū* coming down from Kitayama." The next year though, he expresses disappointment that the celebration has shrunken; it was about one-third the size of those in the last couple of years. By 1431, Mansai dismisses it as unexpectedly skimpy. Perhaps it was his memory of earlier decades that made his judgment particularly harsh. It was something he had been watching for a number of years after all, and in 1415 he had written, "This year there will be the usual Jizō *mōde* along with the same *furyū*."[71] Even if Mansai's diary gives an impression that the practice of Jizō *mōde* was diminished by the 1430s, it is important to note that it was really the *furyū* and *hayashimono* that died down, in scale at least, and not the Jizō *mōde* itself.[72]

For the year 1416, though, the Katsura Jizō topped any imaginable display. It is quite clear that Mansai is attending the Jizō *mōde* intent upon seeing large numbers of dancers, musicians, acrobats, and floats. On the ninth day of the eighth month, Sadafusa visits the Katsura Jizō himself and watches the *yamabushi* and the *taue* dancers. He notes, "Nowadays this is done in various places in and around the capital." He also observes that the *hayashimono* was quite similar to the one he had heard at the Jizō *okuri* (Jizō send-off) in Kitayama the previous year. On the fifteenth of the eighth month that year, Sadafusa sets up an association to send a group to offer prayers in the Jizō *mōde*. Two days later he sends a group of some three hundred to accompany sixteen of his retainers (who look splendid, Sadafusa himself must note). There are all sorts of characters in Sadafusa's parade: low-ranking priests carrying *gohei* wands festooned with strips of jagged paper, a man wearing a demon mask and waving a large pole *(bōfuri)*, soldiers, an enormous model of

a sword covered in gold and precious stones. On the thirtieth, he reports a performance of music and dance *(hayashimono)* at Fourth Avenue and Karasuma, featuring clowns dressed as foreign dignitaries entering the capital *(tōjin no juraku)*.[73] Many of these figures, such as the *bōfuri*, became important stock figures in the *dainenbutsu* or *kyōgen* performances of Mibu and Saga Seiryōji.

The seasonal dances known as Bon *odori*, seen in late-summer festivals throughout Japan, are closely related and often traceable to these dances that came to be variously known as Jizō *no hayashimono*, Jizō *no mai* (Jizō's dance), and Jizō *odori* (the Jizō Dance). The arts of *sarugaku*, puppetry, song, chant, dance, and divination were all on display in these marathon affairs, occurring in place after place around town. The dances of the *sarugaku* performers were based on shrine dances, and we have seen that the Kasuga Wakamiya was a Jizō shrine dedicated to performance at a large Buddhist institution, Kōfukuji. The dances they performed became crystallized in key moments of dramatic action and aesthetic communication in the Noh theater.[74] A scene that grew directly out of the sort of festival performance and the ecstatic dances of *furyū* and Jizō *mōde* is the "Jigoku no kusemai."

The climactic scene of the play *Hyakuman*, as it was originally performed under the title *The Play of the Madwoman at Saga*, was a dance set to wild and syncopated percussion and known as "Jigoku no kusemai" (Dance of Hell). It was one of the late-summer dances from the Jizō *mode*, danced as a *furyū* in festivals to appease the hungry ghosts lurking at the entrances to the city.[75] Though Zeami cut this routine when he rewrote the Saga play as *Hyakuman*, he saved the dance and used it for the Noh play *Utaura* (Poetry Diviner). He wrote that the dance had been one of his father's most successful and well loved pieces in performance. It is possible that Kan'ami wrote the "Jigoku no kusemai," but it was more likely written by a senior member of his troupe, Ebina no Na'ami.[76] Whoever it was who wrote this *kusemai*, the piece itself gives us an excellent window onto religious practices of the day. The dance, a journey through hell, was taken from actual rituals on view at Seiryōji, the setting for *Hyakuman*, during the *dainenbutsu* celebrations of late summer when the dead return to dwell with the living.[77] These shows were also sponsored at two other temples in the capital during the Obon (Urabon, or Ghost Festival) season, both important Jizō sites: Mibudera and the Seiryōji Senbon Shakadō.[78]

The performances of the *dainenbutsu kyōgen* at all three places, as we have seen, trace their origins to the Saidaiji monk Dōgo. This particular legend performed in *Hyakuman* has it that the heroine of the play, a woman who has lost track of her son among the festival crowds at the

dainenbutsu of Saidaiji in Nara sets out in search of him and eventually wanders north to the *dainenbutsu* of Seiryōji in Saga and, having gone mad with anxiety and frustration, dons a man's tall *tate'eboshi* hat, takes up some dwarf bamboo, or *sasa*, leaves, and performs an arrhythmic and frenzied dance in the manner of a *shirabyōshi* or *kusemai*. She is a famous shrine dancer from Nara; here, grief transforms her performance into something otherworldly. Her name is said to be a representation that she, Hyakuman, "one million," is the mother of Dōgo, Jūman *shōnin*, the "one hundred thousand saint."[79] It would seem that this etymology is a bit strained, but it is interesting nonetheless. Other sources cast Hyakuman as a venerable *miko* of the Wakamiya *haiden* who had developed a special mode of singing known as Hyakuman *utai*, or tie her to Hyakuman no tsuji, a small crossroads near Sarusawa no ike, the pond where the *uneme* of the Noh play drowned herself. These associations are much later than the original development of the legend into a play, but Zeami in his dramatic treatise *Go'on* (Five Types of Singing) singles out the name of Hyakuman as a *kusemai* in Nara who had first developed the tradition of exchanging auspicious poems, the *kaka*.[80] It could well be that there was such a person; whether or not she was Dōgo's mother is another matter, but speculation regarding this need not detain us here.

Most important for our purposes is the abundant evidence we find for a rich exchange of religious, musical, dramatic, and aesthetic expression tied to the Jizō cult. An overwhelming majority of the plays in the repertoire of the Mibu *kyōgen* directly represent Jizō as the protagonist, and indeed these plays were among those originally staged next to the Jizō'in (Jizō hall) at Mibu as originally ordained by Enkaku *shōnin* Dōgo. Taira no Masahira gave a gong to the proceedings, to be used every year in the *kyōgen*.[81] Tanaka Ryokkō says that the iconographical program on the altar of the Mibu semi-open hall called the *kyōgendō* or *dainenbutsudō* was nearly identical to the configuration in the Injōji (Senbon Enmadō) *kyōgendō,* about five miles away. At Seiryōji: a small wooden seated Enmei (Life-Extending) Jizō image (two *shaku*, a little more than sixty centimeters tall) is placed *behind* a drum directly facing the main stage, where light, flowers, and incense are offered to it. This marks the stage as a transformed spot. Rather than a mere place for performance, it is transfigured into sacred space, the dwelling place of the Buddha. The actors no longer are just demonstrating their skill, cleverness, and speed but are also serving the Buddha.[82]

Many of the plays directly involve Jizō (fig. 3.3). A few of these are *Gakizumo* (Wrestling with Hungry Ghosts); *Gakizeme* (Defeating Hungry Ghosts, formerly mistakenly called *Sai no kawara*, Children's Limbo); *Ōeyama* (here Jizō becomes warrior Raikō's invaluable teacher, ally, and

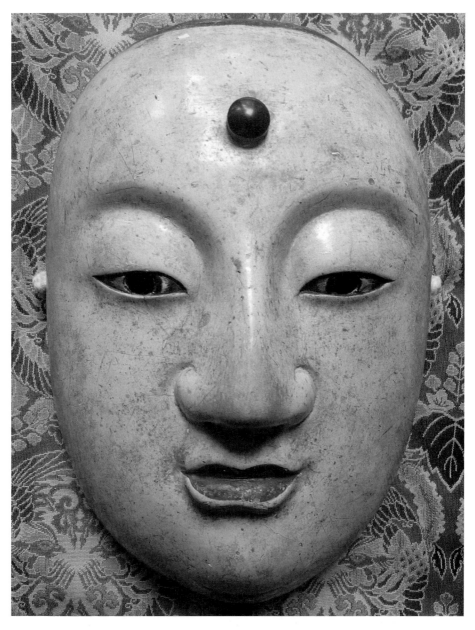

Figure 3.3 Jizō mask used in Mibu *kyōgen,* ca. eighteenth century. Courtesy of Mibudera. Photo by author.

savior in the fight against the drunken demon Shuten *dōji); Daikokugari,* or *Nenbutsu* (a priest attempts to hide his "wife," Daikoku, from the prying eyes of a visitor and shuts her into a shrine wearing a Jizō mask); *Momijigari* (Gathering Autumn Leaves; in the Noh version, Hachiman is the divine figure, but here it is Jizō). The most famous play of the *dainenbutsu,* or Mibu *kyōgen,* is *Oketori* (Carrying the Water Bucket), in which the heroine, Teruko, a beautiful girl with deformed hands, goes to Mibu, tracing out the "ka" *bija* ㋕ of Jizō with her feet every step of the way.[83]

In the later Muromachi period, people at Mibu and Seiryōji began to insist upon their dances being called the *dainenbutsu,* not *kyōgen,* in order to distinguish them from the "frenzied *nenbutsu*" *(rangyō nenbutsu).* The *nenbutsu* of the Mibu and the Seiryōji performances was "the *nenbutsu* correctly performed" *(shōgyō nenbutsu).* These plays were silent, and their simple action was conveyed in gesture and movement. The word *nenbutsu* refers to the invocation of the name of Amida Buddha, "Namu Amida butsu," and also refers to the rowdy dances and festivals sponsored within the Ji sect and other Pure Land sects. As the eighteenth-century haiku poet Tan Taigi, wrote,

kyōgen ha namu to mo iwazu Mibu nenbutsu
[In the *kyōgen* they don't even say *namu*—Mibu *nenbutsu*][84]

It is clear that Jizō worship attracted lavish and often chaotic performances in fifteenth-century Kyoto, and the phenomenon known as Jizō *mōde* is a spectacle much noted in the diaries of the time. This Jizō *mōde* was in fact none other than the "frenzied *nenbutsu*" referred to above. The first half of the fifteenth century was a strange and difficult time in the capital.[85] In addition to the unsettled state of near civil war represented by the split between the northern and the southern courts, even more desperately it was a time of widespread famine.[86] Death and violence were not uncommon, nor were miracles and outlandish displays.

This was the time of the fancy dances, the *furyū.* Huge crowds of people dressed in lavish and extravagant clothes milled about in the streets performing dances and beating out the explosive time. They were organized into krewes and troupes and bands, large and small, to descend upon chosen locales in the capital, where they worked wonders as they created a frenzy within the crowd, who imitated their chanting and ecstatic *nenbutsu* dance.[87] The dances they performed—both the set ones and the improvised—were the inspiration for Na'ami and Kan'ami's "Jigoku no kusemai" onstage as well as for Teruko's winding, meandering Jizō steps.

Their crazy *nenbutsu* dance was also immortalized in the classic

seeing all the fabled Jizō sites, realizes that he had been in the presence of a living Jizō. While seeming to remain in the same spot in her hut, the old nun, an avatar of Jizō, had visited the paddies of all of the different families who had come to her for help. In other words, this is the story of *taue*, or "rice-planting," Jizō. That Jizō here is a woman is particularly interesting. We have already read of Jizō's past lives as women in Chapter One and will soon see that certain Jizō statues were understood to be female as well.

This story is presented as the narrative of Kei'en, who heard it directly from the protagonist—his master, Jizōbō. Jizōbō himself had been the disciple of "the living Jizō" (*shōjin* Jizō). The manuscript ends with a report that in 1267 the faithful came in scores to receive transmission (*kechimyaku*) into this lineage inherited from Jizōbō through his disciple Kei'en and Kei'en's disciple Hōkyō *shōnin*. The lineage chart itself appears after this and names eleven subsequent generations of masters of this tantric Jizō initiation rite. The text was composed by the "child of the Buddha" (*busshi* Shōshun) in 1267, the year of the transmission. This Shōshun would seem to be the current lineage holder; the final two names on the *kechimyaku*, or "blood lineage chart," are Shunshō and Shunjun, and his name naturally grows out of these two. This text seems to have been part of a Jizō transmission ceremony, and according to the manuscript reference *Kokusho sōmokuroku*, it is the same as three other late fifteenth-century manuscripts, *Shōjin Jizō kechimyaku* (Lineage of the Living Jizō), *Shōjin Jizō kanjō engi* (Miracle Tale of the Initiation by the Living Jizō), and *Shōjin Jizōson kanjō shinpi* (The Mysteries of the Living Jizō's Initiation Rite).[98]

The most important point here is that the play seems to be built around the legend of a wandering priest, a Jizō devotee named Jizōbō, as we see in the above story. The connections are unmistakable. Taguchi points out that the earliest version of the play, the Tenshō bon, does not contain the same "Jizō dance" of the later three.[99] The protagonist is Jizōbō, and he does indeed dance, but his dance is not called Jizō *no mai*. In the later versions, the closing dance is completely rewritten into a comic dance scene performed while chanting a short sermon about Jizō. It is perhaps worth noting that at many places throughout Japan a tradition of dancing on the Jizō festival of August 24, called Jizōbon, survives into the twenty-first century. The dances at Katsurabatake village in Tsu, Mie Prefecture, at Dōunji, held on August 23, are perhaps the most popular Jizō *odori* today and boast of origins in the Muromachi period. The composition and choreography of these dances would seem to be the same as the *rokusai nenbutsu* held at the Katsura Jizō outside the capital in late summer.[100] As currently performed, the dance has six singers and

six dancers plus accompanying musicians. At times this might be reduced to six dancers and a couple of musicians. It is also called Jizō *nenbutsu*. These celebrations are of course tied to the kinetic legends of the Katsura Jizō. From these examples and what follows below, it is clear that dance and music were an integral part of Jizō worship in and around Kyoto during the fifteenth century (fig. 3.4).

Jizō Legends and Roads, Bridges, and Borders

In the *Kanmon nikki*'s account of the Katsura Jizō, we find a close relationship between the Jizō cult, performance, images, and the beggar priests of medieval Japan. As Kouchi Kazuo suggests, the large-scale *furyū* spectacles surely received primary economic sponsorship from warrior and courtier elites.[101] The Jizō festivals held at Seventh Avenue and the Katsura River were truly massive events. As with many sacred sites (perhaps we should say all sacred sites), the legends of origin reveal the spot to be decidedly overdetermined. Let us now examine three other contemporaneous yet somewhat contradictory narratives concerning the

Figure 3.4 Six dancers with inscription, "Urabongyō from the eighth to the thirteenth of the seventh month." Urabongyō is the midsummer Ghost Festival known as Obon. Detail of *Chinnōji sankei mandara,* ca. sixteenth century. Courtesy of Chinnōji, Kyoto.

Katsura Jizō. The first of these, the *Katsuragawa Jizōki* (Record of the Katsura River Jizō), survives in a copy dated 1556, but there is internal evidence that it was composed soon after 1416.[102]

We do not know the name of the author of this text, but he seems to have been a scholar monk versed in Chinese and Japanese classics, especially in Confucian texts, and also in Buddhism and Onmyōdō. The date of the work is also unclear, but the year Ōei 23 is mentioned as recent, so the text is probably from around 1417 or so. It is a highly eclectic and digressive text and is valuable for studying the language and customs of the day, especially astrological beliefs. This diary offers considerable retrospective insight into the *sarugaku* and *furyū* of the early Muromachi period, which the author compares to the contemporary performances of the fifteenth century. The Jizō *no hayashimono* was truly the rage of the capital through the first half of the fifteenth century. It was as big as the Gion *matsuri* or the New Year's *matsubayashi* or Obon's *nenbutsu hayashimono*. It was neutral territory, a *harebasho*, for competitions between *furyū* groups. These dances came to be known as *furyū*, from the large umbrella-type markers the dancers carried or wore *(furyū no ōgasa)*. The ones mentioned in the *Kanmon nikki* are described as being covered in mica and gold. In these mummers' shows, the costumes were flashy and expensive, dancers dressed as *shugendō* mountain priests *(yamabushi)*, as Chinese diplomats *(tōjin)*, priests, street actors *(sarugaku hōshi)*, acrobats, and so on. From the early Muromachi period onward, performances had been very much focused on extravagance and competition. In later years the *furyū* also became an ecstatic group dance conducted after a series of lectures and dances offered in the *haiden;* in the latter case, it may be difficult to distinguish from the *odori nenbutsu*.[103]

In terms of the origins of the Katsura Jizō, this source tells us that on the fourth night of the seventh month in 1416 on the occasion of the Ima Shinomiya shrine festival, a man appeared to a *miko* there in her dream and told her to walk to the west on the next day in search of a stone Jizō. Setting out to the west of the shrine on the fifth, she quickly found a stone Jizō image submerged in the Katsura River, glowing with a mysterious light. The date matches Sadafusa's account in the *Kanmon nikki* well, but the idea of the discovery, or translation, of a new image is at odds with the story of the restoration of an existing hall.[104]

Alternatively, in the collection *Jizō bosatsu reigenki ekotoba* (Illustrated Miracles of Jizō Bodhisattva), dated before 1453, in tale six of the second roll we read of a Jizō who makes a similar request for repairs, but the founding of the hall is here a community effort and there are intriguing details concerning the consecration of the statue.[105] Hearing that

if one makes a colossal *(jōroku)* image of Jizō, the tortures of hell will be avoided, a group of people got together and set up a Jizō at Seventh Avenue along the Katsura River. They collected the handprints of some one thousand people and pasted these all over the skin of the Jizō image. Inside the statue—the text states that it is an earthen icon *(tsuchi no zō)*, and here we see it must be hollow—they placed the mandalas of the two worlds and various sutra passages inscribed on paper and on stones. Around this time, a certain lay priest *(nyūdō)* fell ill and went to the underworld, but this Katsura Jizō appeared and pleaded with King Enma on his behalf and he was returned to the world of the living. When the lay priest, who knew the image because he was from that area, asked the Jizō what he could do in return, the response came as a request to grade and repair the road leading to the shrine from the east, the direction of the capital. The Jizō explained that runoff from four or five hamlets often made the road muddy, and it was inconvenient for pilgrims in the winter. The lay priest protested that he was not strong enough to build the road on his own, but Jizō lent him his own *shakujō* staff to give him extraordinary powers. The lay priest went to the corner of Katsuragawa and Seventh Avenue (a bit north of the present location of Katsura Jizō, but most likely the original site and the one that Sadafusa refers to) and, using the story of his salvation from the court of Enma, raised alms and set to fixing the road (fig. 3.5). After that he had a dream of climbing a great steep mountain with five or six monks, each holding a *shakujō* staff and a *mani* jewel.[106]

Finally, in a tale included in the *Reigenki,* "A Person Who Builds Roads Is a Child of Jizō" (Dōro wo tsukuru hito ha Jizō no isshi naru koto), we find the theme of the muddy and ruined road again, but again the details differ considerably. In this tale, a man who lived near Seventh Avenue and the Katsura River in the capital was very poor, without a single grain of millet to his name. He wanted to perform services in filial recognition of his mother but had no means to do so. On the day of the anniversary of her death, he went to the Katsura Jizō and chanted the bodhisattva's name with all his heart. Now, the road in front of that Jizō shrine was damaged, its stones exposed and pitted from heavy rainfalls, and the footing of the pilgrims became unsure and the verandas of all the temple halls were covered in mud. Thinking it a shame, he put aside all thought of self and vowed to rebuild the road, hauling gravel and sand, laying stones, covering the stones with earth, and packing down the road. He was also determined to build a bridge across the river, all so that pilgrims could come and press their hands in prayer before the Jizō image. Every morning he would rise and work on the road, and every night he slept under the veranda of the Jizō hall. With this as his only shelter, he

Figure 3.5 The monk devoted to the Katsuragawa Jizō collects alms for his road-building project. Detail of *Jizō bosatsu reigenki e.* Courtesy of the Nezu Museum.

did not give a thought to food or clothing. And so he continued, barely eking out a living week after week.

At this point in the story, a plump woman appears to him from nowhere. As it happens, she had been sent to find him before but had been unsuccessful in that attempt. And so she tells him the following story behind her first visit and this one: She had been on all-night vigil at Kiyomizudera and had dozed off. A priest came along and poked her with his staff. He told her that he needed help in caring for his one very dear son, and he broke down in tears. Being a compassionate woman, she said she'd do what she could, and the priest, overjoyed, asked her to go to the Katsura Jizō hall and find the son and offer him patronage. The woman had gone to the area indicated in the oracle but had not found the man, so in the next night's dream, she asked the priest how to find him. He asked her for her outer robe and she gave it to him, still in the dream. When she awoke, the robe was gone. The priest also came to the man

in a dream that night and, telling him that someone would be coming to help take care of him, asked him to take the robe. When he rose the next morning, the robe from the dream was there next to him by his makeshift bed under the veranda of the Jizō hall. He dismissed the dream, telling himself that the robe must surely have been dropped by a pilgrim who would come to reclaim it, so he hung it on a stick nearby and went back to work on the road. When the plump woman came and saw her robe hanging by the roadside, she knew that this was indeed the man whom the mysterious priest had called his son. She took him back to live at her home, and that night the same priest appeared to her to reveal his identity as the Katsura Jizō. As a consequence of all of these miraculous occurrences, she became a nun and a fervent practitioner and promoter of the Jizō faith *(Jizō shinkō no gyōnin).*

The tale ends by praising people who operate ferries at river fords and build bridges, saying that they do Jizō's work. The implication here may be that the plump woman who was chosen as Jizō's deputy became a ferry operator just as the man had vowed to build a bridge. The area of western Kyoto near the Katsura River (the village of Katsura was just beyond Kyoto's border west of the river) was by the medieval period a rather impoverished area and known as a gathering place for prostitutes, but also for other female entertainers and religious specialists.[107] I have gone into considerable detail here in relating different tales and eyewitness accounts of the Katsura Jizō, and a similar variety of stories could be offered for any number of Jizō sites or images. What I'd like to stress, though, is that such sites became important loci for religious performance, pilgrimage, and ritual. Many of these sites were new, and their novelty was no disadvantage. That a statue had only come to light recently or that miracles were currently being performed at the hall served only to make the place that much more attractive to the faithful.

In the story of the Katsura Jizō told in *Kanmon nikki,* the prime example of the efficacy of worshipping this statue is that the blind regain their sight. This boon is not uncommon in tales of Jizō, and an example can be found in another story from the *Reigenki,* "A Woman Blind from Birth Regains Her Sight."[108] In this tale of the power of images, or rather the power of faith, a blind woman, living by a river crossing near Nara, is told by a passing priest that she should devote herself single-mindedly to Jizō to overcome her past bad karma. She does this and begins to ask folks if they know where she can obtain a wooden image as a support for her practice of chanting the name. Some local boys, deciding to have some fun, tell her that if she sings them some of her amusing songs, they know where to find her one. Kōdate Naomi has suggested that her dwelling at the ferry station, her blindness, and the fact that she will sing songs

capital, the Tanbaguchi at the Katsura River and Seventh Avenue—site of the famous "hoax" of the Katsura Jizō—had long been home to Jizō statues, and before that to phallic stones representing the crossroads gods of fertility and protection variously known as *sai no kami, sae no kami, kunado no kami, chimata no kami, or dōsojin.*[115]

The *Genpei jōsuiki* (Rise and Fall of the Minamoto and Taira Clans) attributes the establishment of the six Jizōs of Kyōto to Saikō *hōshi*, a participant in the 1177 Shishigatani anti-Taira conspiracy. This source says that Saikō *hōshi* set up six Jizōs at each of the seven entrances to the capital and constructed a stone monument *(tō)* at each of these places, along with a *dōjō*, or hall, for Buddhist practice. Gorai is of the opinion that Saikō merely capitalized on the existing sites of worship associated with the *sai no kami,* which had already begun their conversion into Jizō sites. (These gods of fertility and protection, in large part, constitute the subject of the next chapter.) Gorai characterizes the medieval replacement of the *sai no kami* at the entrances and crossroads of the capital with Jizōs as "a revolutionary transformation for folk belief [*shomin shinkō*]."[116] What Gorai means by "revolutionary" is that the practice demonstrated a clear and ultimate Buddhist co-option of local gods, extending even to the worship of the deepest and most ancient of the gods, the *sai no kami.* A parallel can be noted in the broader participation of the population in ritual and performance, as spectators and as performers; besides the Jizō of Katsura and the dances he inspired, above we have seen the legend of Dōgo and his mother, the entertainer and shamaness Hyakuman, who danced at Saga Seiryōji near the Rendaino. The drama takes place there, near the cremation ground, and seeks to pacify the rough spirits. These rituals are identified in many ways with the gods of the road, the *dōsojin,* themselves. They are gods set up to ward off epidemics and bad influences, but they are also closely related to these dangerous forces. In his adoption at the major entrances to the city, Jizō very clearly took over the role of the god of the limen, *sai no kami.*

Jizō as a Special Savior for Women and the Legend of the Rokuharamitsuji Jizō

The Rokuharamitsuji stands hard by the ancient charnel ground of To-ribeno, close to the crossroads of the six paths of rebirth, *rokudō no tsuji.* This name may as well be translated as "the gates of hell" or "the inter-section of life and death." Rokuharamitsuji is a temple long famous for its Jizō statue, which has generated a great many legends. The main im-age, a wooden statue of Jizō standing with his hands in an unusual posi-

tion, is plausibly attributed to the late-Heian-period sculptor Jōchō and has been designated an Important Cultural Property. As Iwasa Mitsuharu has suggested, though, many of the temple legends may actually concern Jizō images other than the temple's *honzon,* statues on the grounds of the temple or in front of its gates.[117]

The main Jizō image is one of a great many enshrined in the immediate area, and in fact there is another Kamakura-period Jizō statue in the treasury of Rokuharamitsuji—a seated one, also with the distinction of Important Cultural Property—and an illustrated scroll of the *Reigenki,* as well as other statues and paintings of Jizō. The standing image, though, is unique in that, rather than holding the staff and jewel of the standard Jizō iconography, this Jizō forms a mudra with his right hand and grips a bundled length of human hair in his left. It is for this reason that the statue is known as the *katsurakake,* or "wig-holding," Jizō. While the word *katsura,* meaning "wig" or "hair extension," is homophonous with the word for the *katsura* tree, which lends its name to the river and the Katsura Jizō that stood near its banks, this coincidence should not lead us to confuse the two images. One is in the southwest of Kyōto; the other, in the southeast. Still, the strong similarity between the names of the two celebrated images, the Katsura Jizō and the *katsurakake* Jizō, surely led to confusion and probably to a certain synergy in popularity for the two sites. This nickname for the Rokuharamitsuji statue was, after all, adopted well after the Katsura Jizō's discovery or revival and its subsequent fame.[118] None of the many legends about Rokuharamitsuji's renowned Jizō image contained in such earlier sources as the *Konjaku monogatarishū, Hōbutsushū,*[119] and *Jizō bosatsu reigenki ekotoba* mention this surprising attribute, and it is thought that the Jizō image originally held something else, probably a sutra scroll, rather than a hank of hair (fig. 3.6).

This revered icon, just like the Katsura Jizō, has many different origin stories. Iwasa Mitsuharu breaks these stories down into eight varieties, a number of which involve the discovery of the image buried in the mud of a rice paddy in Mutsu Province in the far northeast. In these legends, the statue takes it upon itself to relocate, in an act of autotranslation, to "Kūya's Kannon Hall" at Rokuharamitsuji. Other versions say that the statue was carved by the great sculptor Jōchō at the request of Minamoto no Kunitaka in the 1020s, after the latter died and was restored to life, a boon granted by Jizō. One story says it was a servant of Taira no Takayoshi who dug up the statue in Mutsu; another has it that the image was carved by the sculptor Hakkō *hōgen* for Fujiwara no Hidehira, the third ruler of the northern outpost of Hiraizumi in Mutsu. This last legend tells that the sculptor had a dream in which Jizō flew

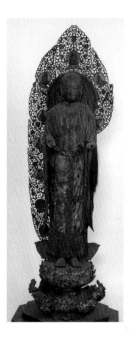

Figure 3.6 Rokuharamitsuji Jizō. Rokuharamitsuji, Kyoto. Courtesy of Rokuharamitsuji.

down to "open the eyes" *(jugan),* or consecrate the statue himself. The statue has, in most temple legends, been attributed to Jōchō's hand, and there is much stylistic evidence to support the idea that it was indeed carved by this master artisan who enjoyed a close relationship with the Kōfukuji and other temples of the Southern Capital.[120] Such a pedigree tells us something about the patrons and clientele of the Rokuharamitsuji during the eleventh century. The three medieval stories about the Rokuharamitsuji Jizō I will focus on below, however, each involve Jizō's intercession on behalf of a person in dire economic straits who needs to redeem a family member in this life or the next.

The first of these tales can be found in the *Jizō bosatsu reigenki ekotoba,* where a poor man from Yamashiro near the capital owes a debt to a man named Toba, who had lent him some rice. The poor man had put up his own daughter as collateral on the loan and, unable to make the payment in time, spent the night in the Rokuharamitsuji Jizō hall to pray for guidance. When he leaves the hall on the morning of the twenty-fourth of the month, Jizō's feast day, he goes to Toba, only to find that his debt has already been settled by a young monk, "about thirty years of age," in black robes. Of course the monk was Jizō himself. As the names of all the actors are given here, the story has the convincing appearance of being based in historical circumstances.[121]

The next story, which appears in Taira no Yasuyori's late twelfth-century collection, *Hōbutsushū,* is quite similar to the previous one, in

that this Rokuharamitsuji Jizō is able to leave his dais to do things in the real world on the behalf of believers.[122] A woman living in extreme poverty in the Higashiyama district of the capital is a Jizō devotee and is especially fervent in her obeisance to the Rokuharamitsuji Jizō. When her aged mother dies, she has no money for a funeral or even a decent burial. An itinerant monk comes upon her and, able to ascertain her situation, kindly takes the mother's body into the mountains, inters the corpse, and performs all the ceremonies himself. Then he disappears into thin air. When she visits the Rokuharamitsuji Jizō, she sees that the feet of the image are caked with mud from his trek into the forested mountains. In some versions of the legend, she has cut off her hair to pay the monk who has helped her (she urges him to sell the hair), and when she enters the hall, she sees that the statue holds the hair. The practice of women cutting off their long hair when making a vow and offering it to this Jizō image explains this surprising attribute and is related to this legend of the origins of the statue. In this legend, which marks the statue as a living Jizō, a poverty-stricken girl in Higashiyama was a devotee of the Rokuharamitsuji Jizō.[123]

It is worth noting that in several of the stories cited here, and in a great many Jizō miracle tales in general, the object of Jizō's salvation is a woman. Of course, as we noted in Chapter One, the past life tales of Jizō tell of when he was the faithful daughter who saved her mother in the next life. The last legend related above—of the "*yama okuri* Jizō," the Jizō who took [the dead] to the mountains—contains echoes of this. In Chapter Two, we read of the aged nun Myōhō, who commissioned the nude Jizō image now in Nara's Denkōji. Another nude Jizō, at Enmeiji in Kamakura, is said to have the body of a woman when the robes are removed.[124] We can also note the important place of annual Jizō rituals in the life of imperial nuns at the Donkeiin convent, a Zen temple for daughters of the imperial line.[125] There are actually a number of Jizō statues that modern and historical believers describe as particularly feminine, and often these are believed to represent Jizō in the form of a nun rather than as a monk. Two of these are the statue at Enichiji in the city of Iwaki in Fukushima Prefecture in the northeast and the *naka no* Jizō, formerly in the Nakanodō at Kannokura on Mount Kumano and now in the Kanfukuji in nearby Kushimoto. From at least the end of the medieval period, female devotees offered small Jizō images to these two with prayers for pregnancy and safe childbirth.[126]

The first of these two statues is said to have been the personal icon of the daughter of the famous tenth-century rebel Taira no Masakado. The legend of this woman was quite widespread in medieval times throughout the Kantō region and in Tōhoku, the northeast. Her story is

included in the fourteenth-century history of Japanese Buddhism, *Genkō shakusho,* and also in the *Konjaku monogatarishū* and the *Reigenki.*[127] This daughter, Masakado's third, was exceptionally beautiful but flatly refused any talk of marriage. Her father disowned her, and she drifted up to Mutsu in the northeast, building a grass hut for herself near the large temple Enichiji.[128] She fell ill and died, traveling in death to the court of King Enma. There she saw a young monk carrying a *shakujō* staff, and knowing him to be no other than the bodhisattva Jizō, went to his side and clung fast to his robe. Jizō told Enma that she was a very devout and chaste woman and should be returned to the world of the living. Enma conceded, and, restored to life, Masakado's daughter took the tonsure and adopted the name "Nyozō *ama,*" indicating her affinity with the bo-dhisattva. Everyone came to call her "Jizō *ama.*" In some early versions of the tale, she is Taira no Masayuki's daughter, but by the late medieval period, she is always described as Masakado's daughter. Many locales in the Kantō region and Tōhoku transmitted her story or stories of other women associated with Masakado, sometimes his mother or one of his consorts. These legends are invariably linked to Jizō worship and often are handed down at sites that promise benefits of pregnancy and safe childbirth.[129] The networks of *shugendō* practitioners *(yamabushi)* and the *bikuni* of Kumano, Ise, and other sacred sites carried these beliefs and practices centering on Jizō throughout Japan. In some cases, these women themselves were transformed into the stuff of legend.

Beginning in the fifteenth century, legends and even eyewitness re-ports told of an immortal nun known as Yao *bikuni,* or Happyaku *bi-kuni,* who preached in the Jizō halls of Kyoto and at other locales. It was said that this nun (also known as Shira *bikuni,* "the white nun") was nearly one thousand years old and that she wandered the highways and byways of Japan, preaching and telling stories from her long and colorful life. Her appearance was bizarre, and she became a spectacle wherever she went. A fourteenth-century grave next to the *rokudō* Jizō image at the Hakone Pass, near the "Pond of Blood" with its group of Jizō images (discussed in Chapter Two), later came to be seen as her burial place. Thus, in the Kantō as in the capital, there was a close association be-tween women and Jizō. As we shall see in the next chapter, the Jizō cult was carried throughout Japan by the female preachers and religious spe-cialists known as the Kumano *bikuni* and was assimilated to ancient cults of fertility and childbirth in these locales.[130]

Stones, Fertility, and the Unconnected Dead

IN THE LAST CHAPTER, we examined the role that performance, possession, and oracle played in the religious lives of the people of medieval Kyoto. We entered into the marginal places, the *muensho* (unconnected places), where people of all classes flocked together through the fifteenth and sixteenth centuries to witness spectacle and performance. Paupers and aristocrats alike came in droves to see and to perform dances for Jizō, dances for Amida, dances for the *Lotus Sutra*. They watched, in rapt amazement, as jugglers, acrobats, preachers, *yamabushi, miko,* and Kumano *bikuni* staged their impromptu or semipermanent shows. In Chapter Three, we saw the great popularity of the Jizō dances in fifteenth-century Kyoto. Amino Yoshihiko in his seminal work on the conceptual and geographic topos of *muen* observes that while it may strike modern sensibilities as odd, the environs of graveyards were important places of exchange and pleasure. Markets were set up in these marginal zones; spectacles like the Katsura Jizō *furyū* craze or early permutations of *sarugaku* flourished there.[1] These performances, large ones like the *dainenbutsu* of Mibu and Seiryōji and also small ones like a Kumano *bikuni* preaching on a mandala at the foot of a bridge, took boundaries and transitional places and phases as their themes as well as their venues.

Like the priests who called themselves *tonseisō* (world-renouncing priests, discussed in Chapter Two), these performers continued a longstanding tradition of the nominally independent charismatic religious figures called *hijiri,* or "holy men" in Hori Ichirō's translation.[2] Perhaps the archetypical model for the institutionally unattached religious seeker is the "saint of the marketplace" *(ichi no hijiri),* Kūya *shōnin,* a man whose legend was closely associated with Rokuharamitsuji.[3] This tenth-century

holy man promoted the ecstatic calling of the name of Amida Buddha, the *nenbutsu,* walked the streets, and stood at the crossroads, chanting out with his own rhythmic self-accompaniment. He is the spiritual ancestor of the Ji sect and of all *nenbutsu* dancing. Surely this is why Kūya became much revered during this period, three centuries after his death in 980, when a noisy and kinetic Pure Land faith began to spread in earnest among the populace. The astounding statue of Kūya in the Rokuharami-tsuji—by Kōshō, son of the renowned sculptor Unkei—depicts him wearing a harness suspending a brass gong *(shōko)* in front of his chest and a striker or mallet in his right hand (fig. 4.1). His left hand holds a staff with a deer antler finial *(rokujō).* Provoking a sort of spiritual synesthesia, Kōshō has brilliantly fashioned six small Buddha figures to proceed from Kūya's mouth arrayed in a line along a thin wire, representing both his voicing of the six-syllable chant *namu Amida butsu* (hail to Amida Buddha) and the six Chinese characters that comprise the *nenbutsu* and often were used as icons in their own right as the *rokuji myōgō honzon* (principal image of the six-character name). This statue, a product of the thirteenth century, can by no means be considered an accurate portrait of a man who lived some three hundred years earlier, but it does bring forth the way in which he was remembered and projected into the future, demonstrating the close connection between his legend and the practices of Rokuharamitsuji. As we shall see, late medieval preachers who modeled themselves directly upon Kūya, down to the details of his dress and accruements, were an important feature of a Rokuharamitsuji satellite, the Kūyadō. While street preachers of this general sort were organized into certain types of guilds by the end of the medieval period, it is important to understand their permanently marginal status.

The people of the *muensho,* the "unconnected places," living in the cities within cities called *shuku* (the same *shuku* used in "Shukujin"), had various and overlapping professions.[4] Among these were classes of beggar priests *(kotsujiki hōshi)* and their female counterparts and partners, some sedentary, some traveling; these were performers with a wide variety of names, liturgies, and dress. Among the women were the Kumano *bikuni,* whom we met in Chapter Three, as well as *aruki miko* and *yūjo, shirabyōshi, katsurame, etoki, tsujiko* (corner girl), *shirame* (white woman), and so on; among the males, all dressed in some sort of Buddhist clerical garb, were *kobōshi, boro* (player of the shakuhachi, or bamboo flute), *zatō (biwa,* or lute, player and bard), *hōka* (juggling and conjuring peddler), *oshi (shugendō* guide), et cetera.[5] Two such figures, Kyoto's *hachitataki* (bowl-beating) chanters and the Kumano *bikuni* traveling out from Wakayama Prefecture, played particularly important roles in developing and spreading the idea of an otherworldly *muensho,* the marginal,

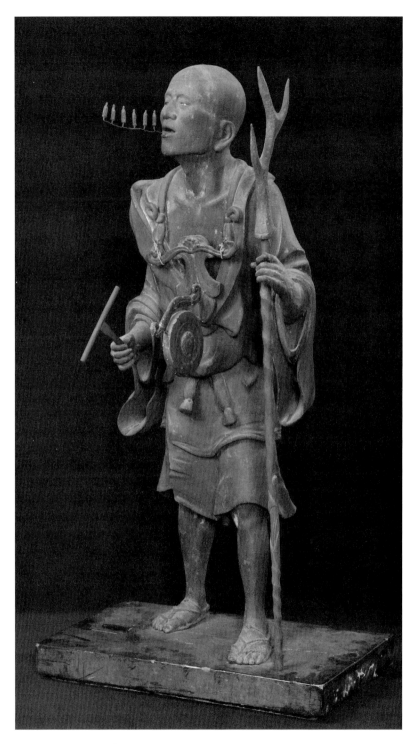

Figure 4.1 Kūya *shōnin* statue, ca. thirteenth century. Rokuharamitsuji, Kyo-to. Courtesy of Rokuharamitsuji.

liminal, and riparian place called *sai no kawara*. It was these two groups of performers who permanently fixed the relationship between Jizō worship and the memorialization of dead infants and children.[6] For the time being, we will remain in the Higashiyama area of Kyoto, especially the environs of the Rokuharamitsuji, examined in Chapter Three, and the nearby Rokudō Chinnōji. This small corner of the city was an essential locus in the formation of the idea of the collective dead in late medieval Japan.

It makes sense at this juncture to briefly explain the idea of the *muen botoke* (unconnected dead) as it developed in the Muromachi period. We have seen in the last chapter the importance of performance in the practice of pacifying souls *(chinkon)* in the free zones in the northwest of the capital and near the massive graveyard of Toribeno in Higashiyama. Perhaps no single temple is more closely associated with the topos "the crossroads of the six paths of rebirth" *(rokudō no tsuji)* than Chinnōji, the site of a major annual ritual throughout the late medieval and the early modern periods.[7] The ritual I refer to is one that Kyotoites came to know as *rokudō mairi* (pilgrimage of the six paths), a somewhat ambiguous term referring simultaneously to a visit to the temple known as Rokudō Chinnōji and to a trip through the six paths of rebirth. Crowds would descend upon this temple to take part in welcoming the ancestors from the otherworld, a rite known as *shōryō mukae* ("welcoming the spirits"—in Kyoto dialect, these visiting *shōryō* are known as *oshorai*), and also to observe the festival for feeding the hungry ghosts, the *segakie*.[8] We can take the hungry ghosts named here *(gaki)* as the functional equivalent of *muen botoke*—that is, these are the spirits of those who have died without the descendants required to nurture them into ancestorhood. They are those spirits without connections, and also those who are unsaveable by reason of attachment or resentment created through a violent or unjust death; propitiating these ghosts became an important concern in late medieval Kyoto. We have evidence of many types of performance aimed at *chinkon,* including *heikyoku, sarugaku,* and *kagura,* as well as more orthodox Buddhist ritual. While it may seem quite ancient to modern participants, the annual *segakie* was in fact an innovation of the early fifteenth century. Before this, it had been performed sporadically in response to major disasters such as famines and earthquakes to appease the spirits of the dead. It is in the 1410s that we first begin to have documentary evidence for the regular observance of the *segakie* rite just before the yearly rituals for Urabon (Obon, the "Ghost Festival"). As Nishiyama Mika has demonstrated, members of the Zen sect were instrumental in reintroducing the ceremony from Song China and employing it to gain

the patronage of successive generations of shogunal support.[9] These were priests with direct experience of Chinese practice such as Enni Ben'en (1202–1280) of Tōfukuji in Kyoto, Rankei Dōryū (Ch. Lanxi Daolong; 1213–1278) of Kenchōji in Kamakura, and their successors like Musō Sōseki (1237–1351), abbot of Nanzenji and founder of Tenryūji. The Zen figures of the thirteenth and fourteenth centuries were, like the Ritsu monks of the day, much in demand for their skill at managing funerals. The land under the great Zen institution Kenchōji, founded with the sponsorship of the powerful Kamakura regent Hōjō Tokiyori, had originally been a potter's field and execution grounds, with a Jizō statue presiding over the scene. Jizō thus also became the *honzon* of Kenchōji.[10] The *segakie*, once it was closely associated with the celebrations of Obon by Zen priests, became widespread through various sects after the Kamakura period. Still, through the Muromachi period, it was exclusively at the select group of "Five Mountain," or *gozan*, Zen temples that generations of Ashikaga shogun observed the late-summer rite.[11]

It was not until the end of the Muromachi period, however, that the *segakie* became a mass event, performed in a public and open way. This ceremony, aimed primarily at the pacification of dangerous spirits, at the war dead, and at the dead of famines and natural disasters, emphasized the hungry ghosts and also the misfortunes of the dead being tortured in hell. During the late medieval period, the topographical features of that realm were being made increasingly available to the populace in lurid new formats and multimedia performances. The *segakie* was the ideal time for these shows. Chinnōji was a very important site for the celebration of large public *segakie* from the sixteenth century forward and still receives throngs of visitors in the second week of August. Indeed, the *segakie* of the early modern period and beyond became so much a part of the ceremony of Urabon as to be part of a fixed set. The Obon story is the story of Mokuren *sonja*, the disciple of the Buddha who crossed to the otherworld to save his mother; it was an important part of the dramatic offerings, as was *chi no ike jigoku* or the Blood Pool Hell, a hell reserved for women as a punishment for the "sin" of childbirth and menstruation and, especially, death in childbed. To illustrate how closely enmeshed these ceremonies and beliefs were, Nishiyama Mika cites the 1599 text *Ketsubonkyō jikidanshi* (Straight Talk on the Blood Bowl Sutra), by the Tendai prelate Shunjō:

> Mokuren's mother fell into the Avici hell [*mugen jigoku*]. Following the Buddha's teaching, he performed the *segakie* and his mother was freed from the Avici hell. However, since she had tainted the gods and bud-

dhas with the pollution of her menstrual flow and the blood of a diffi-
cult labor, she fell from there into the Blood-pool hell [*ketsubon jigoku*].
The Buddha preached the *Ketsubonkyō* and the mother was born into
the Tuṣita heaven.[12]

I'd like to suggest that we can see the *segakie*, like the *Ketsubonkyō* cult,
as an expansion of the central drama celebrated at Urabon, the descent

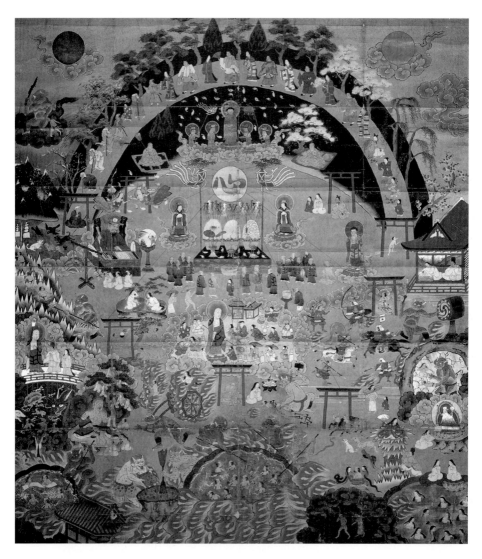

Figure 4.2 *Kumano kanjin jikkai mandara,* ca. seventeenth century. Courtesy of
Daienji and Mie kenritsu hakubutsukan.

of Mokuren to the otherworld to save his wicked mother. The expansion of the net of salvation to include the nonancestral dead, as can be seen in the rise of the children's limbo *sai no kawara,* has everything to do with the popularization of the *segakie.*

By the medieval period the *segakie* had actually long been celebrated at Chinnōji, but it took on new dimensions with the late medieval popularity of the rite. One prominent feature of the celebration of the all-souls festival of *segakie* or *shōryō mukae* at Chinnōji was the preaching of Kumano *bikuni* on the *Kumano kanjin jikkai mandara* (The Kumano Mandala for Viewing the Ten Worlds within the Heart/Mind; hereafter *Jikkai mandara*), and in fact it was there that I first saw this striking image on a midsummer visit in 1985.[13] This mandara displays at its very center a large offerings table for *segakie* attended by a small crowd of monks, and below this appears a scene of Jizō ministering to the children's ghosts on *sai no kawara* (figs. 4.2 and 4.3). The image is a complex one, with the steeply arched bridge depicting the stages of life at the top and the many fires of hell commanding our attention below and up the edges, but clearly the primary impact of the painting is from these central areas, rendered in a larger size than the rest of the scenes.

There is an older Chinnōji *Jikkai mandara,* probably from the early or mid-seventeenth century, with a compositional structure very different from that of the great majority of the fairly substantial numbers of *Jikkai mandara* that survive. One might imagine that it was preached differently

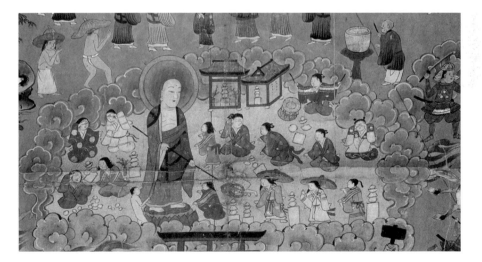

Figure 4.3 Detail of *Kumano kanjin jikkai mandara,* ca. seventeenth century, showing *sai no kawara.* Courtesy of Daienji and Mie kenritsu hakubutsukan.

as well, but this we will not likely come to know. We have no complete text of the preaching of the *Jikkai mandara,* only fragments of the type of language the Kumano *bikuni* preached in.[14] In this earlier visual program (fig. 4.4), the *segakie* does not take center stage and also the *sai no kawara* has a significant but not pivotal place (plate 11). It is one area among many. It is likely that as preachers came to emphasize the role of *segakie* and the theme of *sai no kawara,* the mandara was redesigned for maximum multimedia effect. This image is one that has lost its voice, but we can begin to imagine the sort of things the *bikuni* must have said about these marginal beings, these *gaki,* children's ghosts on the *sai no kawara* (fig. 4.5).

While it is a difficult fact to grasp (for this author and for you readers likely from modern, "first world" countries), the death of a child was an incredibly common occurrence before the advent of antibiotics, immunization, and a whole host of medical interventions. Although this is an obvious and well-known fact, I think we do well to stretch and try to envision the anxiety and grief that was a natural background to everyday life in such an environment. Some of us may be close to people who have lost children, some of us may have lost children ourselves, but imagine a world and a life where so many small children were dying all the time, in nearly every family. We are wrong to imagine that the ubiquity of the experience of child loss made it an easy thing to bear. It is important to remember that those affected were not just the mothers, as is often implied, or even just both parents, but brothers and sisters, cousins, and grandparents would all be deeply saddened by the death of a sweet young child, by the abrupt removal of that innocent presence from their web of daily associations. The establishment of this new place in the otherworld during the seventeenth century and its subsequent propagation and popularization through the Jizō cult preyed upon the intense emotions of these bereaved relatives. It could be argued that a much-needed outlet was thus created for the mourning of dead children, something that had not formally played any part of Buddhist practice up until this point, but the advent of this belief could also be viewed more cynically, as an attempt to capitalize on the raw emotions of family members by representing the desperate plight of the infants and small children now gone from their midst. Below, I will argue that in fact the introduction of the *segakie* to a broad public in the sixteenth century (and the related expansion of the category of the *muen botoke* to the multitudes who died young), created a new idea of the collective dead over the two centuries spanning the transition from medieval to early modern.[15]

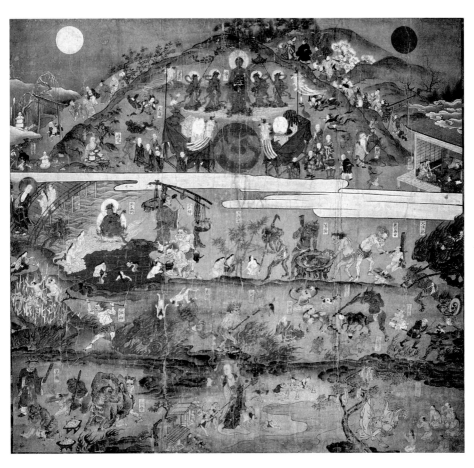

Figure 4.4 *Kumano kanjin jikkai mandara,* ca. sixteenth century. Courtesy of
Chinnōji, Kyoto.

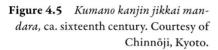

Figure 4.5 *Kumano kanjin jikkai man-*
dara, ca. sixteenth century. Courtesy of
Chinnōji, Kyoto.

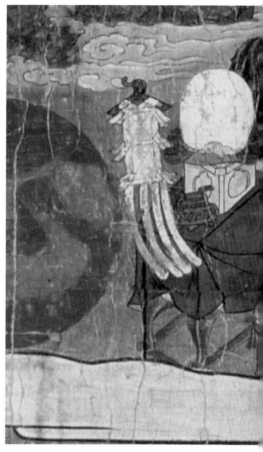

The Unconnected Dead and the Creation of a Buddhist "Children's Limbo"

No aspect of the Jizō cult is more familiar or well known today than
that of the ceremonies for aborted or stillborn fetuses *(mizuko kuyō),*
ceremonies enthusiastically promoted by certain temples since the early
1970s, as we saw in Chapter One. It is clear that this practice and Jizō's
role therein grow out of belief in *sai no kawara,* the place most closely
associated with Jizō in the modern imagination. Here the souls or ghosts
of dead children are condemned to pile up stones, creating small stupas
(tōba) in an attempt to generate merit for their parents. Every evening at
sunset, though, a demon (or demons) appears to knock down the towers
and threaten the children. Jizō intervenes to save them, but their work or
play of building the pebble stupas begins again the next day as the cycle
repeats. There is no description of the *sai no kawara* in any Buddhist

scripture, and it seems that it was known only in Japan. Belief in this desolate and heartbreaking place was conceived, fostered, and disseminated by various kinds of itinerant preachers during the late medieval period.[16]

Over the course of the Edo period, the *sai no kawara* was one of the most often represented scenes in paintings of hell. It is important to note that this is a departure from the medieval period, when no such place was known. It was during the seventeenth century that *sai no kawara*, became a noted spot on the tour of hell, just as iconic as Enma's court with its truth-telling mirror. In addition to paintings such as these, a central tool in the propagation of the *sai no kawara* was a hymn *(wasan)*, the *Sai no kawara Jizō wasan*. More than ten versions of this song survive with slight variations, but the most standard and widespread is the one attributed to Kūya *shōnin*, the tenth-centu-

ry "saint of the marketplace." Here follows a translation by Lafcadio
Hearn of the *wasan,* as briefly introduced by his young guide Akira, a
former Shingon acolyte:

> "Now there is a *wasan* of Jizō," says Akira, taking from a shelf in the
> temple alcove some much-worn, blue-covered Japanese book. "A *wasan*
> is what you would call a hymn or psalm. This book is two hundred
> years old: It is called Saino-Kawara-kuchi-zu-sami-no-den, which is, lit-
> erally, 'The Legend of the Humming of the Sai-no-Kawara.'" And this is
> the *wasan;* and he reads me the hymn of Jizō—the legend of the murmur
> of the little ghosts, the legend of the humming of the Sai-no-Kawara—
> rhythmically, like a song:

> Not of this world is the story of sorrow.
> The story of the Sai-no-Kawara,
> At the roots of the Mountain of Shide;
> Not of this world is the tale; yet 'tis most pitiful to hear.
> For together in the Sai-no-Kawara are assembled
> Children of tender age in multitude,
> Infants but two or three years old,
> Infants of four or five, infants of less than ten:

> In the Sai-no-Kawara are they gathered together.
> And the voice of their longing for their parents,
> The voice of their crying for their mothers and their fathers—
> *"Chichi koishi! haha koishi!"*—
> Is never as the voice of the crying of children in this world,
> But a crying so pitiful to hear
> That the sound of it would pierce through flesh and bone.
> And sorrowful indeed the task which they perform—
> Gathering the stones of the bed of the river,
> Therewith to heap the tower of prayers.
> Saying prayers for the happiness of father, they heap the first tower;
> Saying prayers for the happiness of mother, they heap the second
> tower;
> Saying prayers for their brothers, their sisters, and all whom they
> loved at home, they heap the third tower.
> Such, by day, are their pitiful diversions.
> But ever as the sun begins to sink below the horizon,
> Then do the Oni, the demons of the hells, appear,
> And say to them—"What is this that you do here?
> "Lo! your parents still living in the Shaba-world

"Take no thought of pious offering or holy work:
"They do nought but mourn for you from the morning unto the
 evening.
"Oh, how pitiful! alas! how unmerciful!
"Verily the cause of the pains that you suffer
"Is only the mourning, the lamentation of your parents."

And saying also, "Blame never us!"
The demons cast down the heaped-up towers,
They dash the stones down with their clubs of iron.
But lo! the teacher Jizō appears.
All gently he comes, and says to the weeping infants:—
"Be not afraid, dears! be never fearful!
"Poor little souls, your lives were brief indeed!
"Too soon you were forced to make the weary journey to the Meido,
"The long journey to the region of the dead!
"Trust to me! I am your father and mother in the Meido,
"Father of all children in the region of the dead."
And he folds the skirt of his shining robe about them;
So graciously takes he pity on the infants.
To those who cannot walk he stretches forth his strong shakujō;
And he pets the little ones, caresses them, takes them to his loving
 bosom.
So graciously he takes pity on the infants.

Namu Amida Butsu![17]

While it is unclear exactly when the *wasan* was composed or first known,
Watari Kōichi has argued convincingly that its origins can be traced to
Higashiyama in the first half of the seventeenth century.[18] This *wasan*
emphasizes the suffering of parents in mourning. It depicts the children's
futile attempts to make merit on their parents' behalf by building small
stone stupas, trying in vain to fulfill their filial duty. It is important to
note that we have no evidence that there was any ritual by which parents
could create merit, *tsuizen kuyō*, for the dead children. It was in the con-
text of the *segakie*, ceremonies for *muen botoke*, that this idea developed.
It was in the chanting and dancing of the Kūyasō (*hachitataki* chant-
ers) and the preaching of the Kumano *bikuni* and others that the *sai no
kawara* took hold in the Japanese religious imagination. As others have
noted, the image of children playing at building stupas on a beach and
thus accruing merit is a famous scene from the *Lotus Sutra* and likely had
some influence on the iconography of *sai no kawara*.[19] In his translation,

Hearn includes the cries of the children in transliteration of the original Japanese for effect: *"haha yo, chichi yo."*

Hearn, writing in the late nineteenth century, is shown this book and told it is some two hundred years old; this estimate by Hearn's guide Akira is likely not far off. The text that Akira refers to as the *Sai no kawara kuchi zusami no den* no doubt shared the same content as the 1757 book usually known as the *Sai no kawara kugō den* (both titles mean "The Legend of the Humming of the Sai-no-Kawara").[20] It is this work that first attributes the *wasan* to Kūya and is the basis for the legend that the *wasan* was spread by Kūya *shōnin*. The Kūya legend was very important in late medieval Kyoto and closely associated in the popular imagination with a charismatic thirteenth-century ascetic—Ippen *shōnin*—who encouraged dancing and loud vocalization with rhythm. Kūya's connection to Rokuharamitsuji is also essential to remember in this context. The Kūyadō near this temple was home to the striking "chanting" statue portrait of him, naturally an object of cultic worship, and also to a small guild of performers and artisans. They made bamboo tea whisks and actively promoted the benefits of green tea for good health, but, more importantly for our purposes, they also walked through the streets and cemeteries of eastern Kyoto on winter nights, chanting and playing percussion. These were the Kūyasō, also known as the *hachitataki*, or "bowl beaters" (Fig. 4.6).[21]

Taking the illustrated seventeenth-century hagiography *Kūya shōnin ekotoba den* (The Illustrated Biography of Kūya shōnin) as their holy text and origin story, the Kūyasō claimed to be the blood descendants of a hunter named Sadamori, who shot and killed Kūya's favorite deer in the forests of Mount Kurama, to the north of the capital.[22] It was the death of this deer that moved Kūya so profoundly that he took its hide to wear as his only garment and placed one of its antlers on the end of his staff. Thus, the iconography of saint Kūya and the appearance of his latter-day followers, the *hachitataki,* was set. Sadamori, witnessing Kūya's grief, renounced hunting and took the Buddhist name "Jōami" to wander the countryside beating out rhythm on a dried gourd *(hyōtan)* and chanting the *nenbutsu.* Although this type of performer, the inheritor of Jōami's legend, the Kūyasō, was known as a "bowl beater," he actually beat the *hyōtan* he wore tied to his waist, tapping out a rhythm for his chanting with a bamboo stick. Or he wore a gong suspended in front of his chest, like Kūya of the Rokuharamitsuji image, striking it with a little wooden mallet. He sang out the name of Amida and danced the dances known as the *kangi yuyaku nenbutsu* (leaping-with-joy *nenbutsu,* also known as Kūya *nenbutsu*) and the *rokusai nenbutsu.*[23] There was much stigma attached to these performers, and *sarugaku* players made attempts to dis-

Figure 4.6 *Hachitataki,* from *Shichijūichi ban shokunin utaawase.* Line drawing reproduced courtesy of Iwanami shoten from Iwasaki 1993.

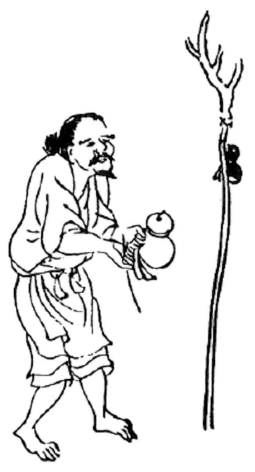

tinguish themselves from the *hachitataki* and others, like the *shōmonji* ("chanters," another type of marginal beggar or ritual drama specialist). One way the *sarugaku* troupes did this was by lampooning the art of other sorts of performers in their own works. In 1464 a parodic play called *Hachitataki* was staged at a large fund-raising show *(kanjin)* organized by Kanze On'ami, head of the prominent Noh family and star to the shogunal court.[24]

Gorai Shigeru, in his monumental study of *odori nenbutsu,* or the dancing of *nenbutsu,* argues that the *rokusai nenbutsu* and the so-called Kūya *nenbutsu* were originally funerary dances, to be performed as a requiem at funeral processions and at burials.[25] Eventually, these dances became a seasonal event. The Kūyasō were thus from the start closely connected to death ritual; the members of this community of outcaste religious specialists nightly wove their way through the graveyards and

streets of the capital for the final seven weeks of every year—starting on
the thirteenth day of the eleventh month, Kūya's memorial day—chant-
ing verses of impermanence *(mujō no jumon)* and dancing their dances
as they begged for alms.[26] Sometime during the seventeenth century,
they came to tie the idea of *sai no kawara* and its *wasan* to their patron
saint and to Jizō, the *honzon* of Rokuharamitsuji and the bodhisattva
of the dead. As Watari Kōichi has conclusively demonstrated, it was the
Kūyasō, these *hachitataki,* who created the scene of Jizō at the children's
limbo on *sai no kawara.*[27] In a poem written in the fifth year of Genroku,
1692, Matsuo Bashō reveals the degree to which they had become a fix-
ture of life in Kyoto by his day:

> *karazake mo Kūya no yase mo kan no uchi*
> Salmon jerky and the emaciated Kūyasō, both arrive in the dead of
> winter[28]

A number of decades earlier, the poet Chōshōshi had composed the
following:

> *hachitataki akatsukigata no hitokoe ha fuyu no yoru sae mo naku*
> *hototogisu*
> The lone voice of the *hachitataki* just before dawn, a cuckoo that
> sings even of a winter night[29]

There was a variety of similar performers who walked about collecting
alms, chanting, and playing percussion, the *munetataki* (breast beater),
or *kanetataki* (bell beater), being another type. It is quite possible that
they also spread the *wasan,* and there can be no doubt that the hymn
found its way into the sermons of the Kumano *bikuni* as they explicated
this central scene of the *Jikkai mandara.* The *wasan* also appears in vari-
ous pieces of literature during the Edo period. For example, in his late
seventeenth-century *Honchō suibodai zenden* (A Complete Collection
of the Legends of Drunken Enlightenment in Japan), Santō Kyōden in-
cludes a rendition of the Kūya version of the *Sai no kawara wasan,* com-
bined with elements from the *Fuji no hiotana sōshi,* calling it the "Sai no
kawara sekkyō bushi."[30]

 The *wasan* was clearly an important vehicle for the dissemination
of belief in *sai no kawara,* as was the *Jikkai mandara,* but there were
other media (textual, visual, and dramatic) that seized upon the evoca-
tive and poignant imagery of this place. The *sai no kawara* is described in
such Edo-period works as *Mokurenki* (Record of Mokuren—the chant-
ed *sekkyō bushi* version of the Obon story); the *kojōruri* ballad entitled

Suwa no honji Kane'ie; Chikamatsu's play *Kako Kyōshin nanahaka meguri*; and elsewhere.[31] These texts emphasize Jizō's loving protection of the children who cling to his sleeves and seek shelter in the folds of his robes. In this sense, we are reminded of Jizō's care for the Kōfukuji monk Shōen in the hell under Mount Mikasa at Kasuga, discussed in Chapter Two. The *oshi* of Mount Fuji, the *shugendō* adherents who acted as guides to the pilgrims who came to visit and to scale this holy peak, seem to have had an important role in the inception of the *sai no kawara*. Below, we will consider the *otogizōshi* called *Fuji no hitoana sōshi* (The Tale of the Fuji Cave), a text composed at the turn of the seventeenth century. In this tale, the fabled twelfth-century warrior Nitta no Tadatsuna enters a deep cave at Mount Fuji (the *hitoana* of the title), meets the bodhisattva Sengen, the *honji* of the god of the mountain Asama *gongen* (manifestation), and is given an extensive tour of hell.[32] It is likely that the *oshi* and their female counterparts, in their fund-raising campaigns around the country, preached about this portal to the netherworld and about *sai no kawara* and the Blood Pool Hell, which also figures prominently in the text. Their sermons seem to have played an important role in shaping *Fuji no hitoana sōshi*. Miyazaki Fumiko, writing on women's religion at Mount Fuji, points out that the language used in this text's description of women's hells is extremely similar to that employed by the Yoshida *oshi* (the *shugendō* guides of Mount Fuji) in their *Bukkiryō*. The latter document, dated 1612, is a rulebook and sort of catechism for this *shugendō* confraternity that so long and so staunchly forbade women to enter the mountain.[33]

The oldest dated copy of the *Fuji no hitoana sōshi* carries an inscription dating it to 1603. It is here we find the oldest evidence for *sai no kawara*.[34] The text describes the children piling the stones to build towers for their parents, and the demons that come to knock down these stupas and threaten the children. In this earliest-known version of the text, it is said the children will suffer nine thousand years of torment for the pain they cause their mothers during pregnancy and for the grave emotional suffering they inflict on their parents by dying young. Jizō, however, is nowhere to be found in this particular scene. I say "this particular scene" because, as the consummate savior from hell, he naturally appears at many other junctures in the text. In fact the 1603 text explicitly recommends that people worship Jizō for birth in the Pure Land and succor from hell. However, in this early version he is conspicuously absent at *sai no kawara*. As Nitta approaches the entrance to hell, this children's limbo is the first place he encounters; his guide, Sengen *bosatsu*, orders him, "Now regard the *sai no kawara*!" *(mazu sai no kawara o misen)*. And when he looks, this is what he sees:

Seven- and eight-year-old children held hands with three- and four-year-olds, all of them stricken with inexpressible grief. "What's the meaning of this?" Nitta asked, taking in the sight. The Bodhisattva explained: "These are children who died without compensating their mothers for the pain they caused them during their nine months in the womb. They're to suffer on the riverbed like this for nine thousand years." A blazing fire swept the expanse, and the stones all burst into flames. As the children had nowhere to run, they were burned up until only their ashen bones remained. Soon, a number of demons arrived. Shouting "Arise! Arise!" and beating the ground with iron staves, they restored the children to their former selves.[35]

The printed version of 1627, which is the basis for later hand-copied and printed versions, prominently features Jizō. As Watari has shown, there is a moment during the early seventeenth century where we find images of *sai no kawara* without Jizō present, but by midcentury the fixed cast of the children, Jizō, and the ogre *(oni)* is set. In early twentieth-century Japan, children still played a game called *hiku hikume,* a sort of tag based upon Jizō's face-off with the *oni.* The child who is "it" (the *oni*) tries to get around the leader of a short train of children who hold onto each other. The leader, O-Jizōsan, may be touched by the *oni,* but if the *oni* touches another child further back in the line, the round ends and the tagged child becomes "it."[36] It is interesting that while Jizō does become important in the text of *Fuji no hitoana sōshi* at this juncture, he is still excluded from accompanying visual representations of the *sai no kawara,* which clearly are closely based on earlier drawings (fig. 4.7; plate 11). In this later version, it is not a demon but Jizō who revives the children. While the demon restored their bodies only so that they could be tortured again, Jizō is there to save them. Comparing these two versions, separated by a quarter century or so, we can hear the voice of the street preacher and note a new register of vocality in the text, adding a magical spell. Here we enter the text at the moment of the children's resurrection, and the white bones *(hakkotsu)* of the children remain, littering the ground.

> After quite some time, Jizō bosatsu arrived and, waving his ringed staff, intoned a spell: *genzai mirai shu, hakkotsu onkon fusoku, nyorai ichgon, fujō dazai shoakudō.*[37]

This version of *Fuji no hitoana sōshi* also explicitly ties the *sai no kawara* to the Blood Pool Hell *(chi no ike jigoku),* a place prominently featured in the *Jikkai mandara* and the preaching of the Kumano *bikuni.* The tears of the grieving mothers are transformed into the pond of blood.

Figure 4.7 *Sai no kawara,* from Fuji no hitoana no sōshi printed version (1627) in the Spencer Collection. Reproduced by permission of the Spencer Collection, the New York Public Library, Astor, Lenox, and Tilden Foundations.

And those are the ones who when in the Shaba world, dwelt in their mother's bellies, causing them nine months of pain and then faded away without repaying the debt *(hō'on)* of having become mother and child. They will suffer for nine thousand years there, and the tears their mothers cry will become the Blood Pond.[38]

This passage reveals the cruelty of the emotionally coercive method of fund-raising employed by the Kumano *bikuni* and other itinerant preachers. At the death of a child, not only will that baby be sorely missed, but he will fall into a world of endless torture where his only desire will be to somehow redeem himself and repay a debt to his parents by building small stupas out of pebbles. Beyond this, because of the attachment a dead little boy or girl created in a mother's heart, the mother herself will cry hot tears of blood that will become her torment in the next dwelling place. In this, it is much like the language of the *wasan.* It is a heart-wrenching scene that is described in the *Fuji no hitoana sōshi:*

The little ones struggle weakly in their attempts to escape the cruel suffering. But they cannot escape. They call out, "Mommy! Daddy!" But to no avail.[39]

Above, we considered the importance of Chinnōji for the establishment of the idea of the marginal category of dead known as *muen botoke* and the relationship between these beneficiaries of the *segakie* and the care of dead children and infants. The Chinnōji was also a crucial place for the preaching of the *sai no kawara* by the Kumano *bikuni* using their *Jikkai mandara*.[40] As we have seen, the area of Higashiyama, adjacent to the massive burial ground of Toribeno, had long been associated with death ritual and memorial services. The Kūyasō of the late medieval and early modern period were clearly an important aspect of this ambience. Watanabe Shōgo has suggested that they in fact inherited the mantle of the Jishū, Ippen's wandering, dancing ascetic order, whose influence waned with the Edo period. As half-lay, half-clerical beggar priests, as self-ordained *nenbutsu* practitioners, as masters of ecstatic dance, and as funerary specialists, they do indeed share many characteristics with the Jishū.[41] Also important for our purposes is their role as the producers of dioramic performances in the form of puppet shows. The Jishū were noted for their engaging spectacles that brought to life the horrors of hell, the pathos of human tragedy, and the heat and excitement of the battlefield. Watanabe argues that the Kūyasō were also puppeteers and that these people who lived in the marginal spaces *(sanjo)* were the ancestors of the puppet performers of the Edo period who created the classical Bunraku puppet theater of the eighteenth century.[42]

During the late medieval and early modern periods, Chinnōji was seen as the entrance to hell itself and was called *rokudō no tsuji*.[43] In the *michiyukibun,* or traveling narrative, of the Noh play *Yuya,* we are presented with the thoughts of the heroine as she travels along the Kamo River and into Higashiyama:

> Passing along beside the river-beach
> They hasten on and almost at once
> Come to the Great Carriage-way.
> "Ah! The Rokuhara Jizō Hall," the lady says
> And bows towards it.
> Kannon too is enshrined there.
> . . .
> As Yuya offers up this prayer
> They pass the
> Temple of Otagi

And come to what must surely be
The crossroads at Rokudō
Oh! dreadful, indeed—for from here
The road leads into Hell!
I shudder too at Toribe-yama over there
Where the rising smoke drifts away
Into thin mist.[44]

The temple referred to here as "the temple of Otagi," Otagidera, is none other than Chinnōji. This name, written with the same characters as Mount Atago in Arashiyama, to the northwest of the capital, is associated with death and burial. Passing by such a place, Yuya, who is preoccupied with the grave illness of her mother, is understandably shaken.

The fame of this temple was tied to the annual late-summer pilgrimage there to welcome back the dead and say prayers for them, the so-called *rokudō mairi*. As we have noted, this meant both "visiting the Rokudō temple" and "journeying through the six paths of rebirth." A trip to Chinnōji at this time of year offered the faithful a variety of performances describing the tribulations and tortures of hell. In the late medieval *Chinnōji sankei mandara* (Chinnōji Pilgrimage Mandara), we see a number of huts dedicated to different exhibitions, set up in the temple precincts as people welcome ancestors and spirits before the Obon festival (fig. 4.8). Among these exhibitions are the *Kumano kanjin jikkai mandara*, the six dancers of the *rokusai nenbutsu*, the miraculous Zenkōji Amida triad from the mountains of Japan's "snow country," the six Jizōs, the legend of young fallen warrior Atsumori from the *Tale of the Heike (Heike monogatari)*, the tribunal of the Ten Kings, and so on.[45] One of these small booths houses a diorama of the *sai no kawara*, where a statue of Jizō presides over the babies and small children and also their handiwork, diminutive stupas *(gorin no tō)* (plate 12). Here a puppeteer, perhaps a *hachitataki*, would perform the story of *sai no kawara* using puppets and statues. There are two booths dedicated to *sai no kawara*, on opposite sides of the precincts—the one just described, with the Jizō image; and another, with a masked man writing on small wooden slats for the ceremony and with a number of *sai no kawara* dolls next to him (fig. 4.9). Perhaps a parent who had lost a child would buy one of the effigies and take it over to the other booth, the diorama of the *sai no kawara*.

A major focus of the Obon festival as celebrated at Rokudō Chinnōji in the late medieval and early modern period was the care of the unattached dead, the *muen botoke*. This included the children of *sai no kawara* and also those dead whose lineage had been broken, those with-

Figure 4.8 *Chinnōji sankei mandara,* ca. seventeenth century. Courtesy of Chinnōji, Kyoto.

Figure 4.9 The selling of dolls for *sai no kawara*. Detail of *Chinnōji sankei mandara,* ca. seventeenth century. Courtesy of Chinnōji, Kyoto.

out descendants to remember them and care for their graves. The tradition of stacking old abandoned gravestones into towers called *muentō* developed out of this desire to pacify the souls of the unconnected dead. Such assemblages are often called *sentai* Jizō (one thousand Jizōs), though many of the stones are not in fact Jizō images. These groupings of old, broken, and worn images and graves are seen at sites throughout Japan (figs. 4.10 and 4.11). They may be pieces of *gorin no tō* or graves carved with the two buddhas of the *Lotus Sutra,* Śākyamuni and Prabhūtaratna (Tahō) sitting side by side. Often these stones wear red bibs, marking them (at least for the modern viewer) as stand-ins for Jizō. The little *gorin no tō* are seen repeatedly in representations of *sai no kawara* and are analogous to the pebble towers built by the children's ghosts. Examples of real miniature towers like this (built of rock or cast in clay) can also be found, and an especially large number have been discovered at the Rokuharamitsuji.[46]

At the time of Obon, a table holding offerings for the *segakie* festival is set up in front of the *muentō* of Chinnōji, to welcome the spirits of the dead, in the rite known as *shōryō mukae* (see figs. 4.4 and 4.5). The

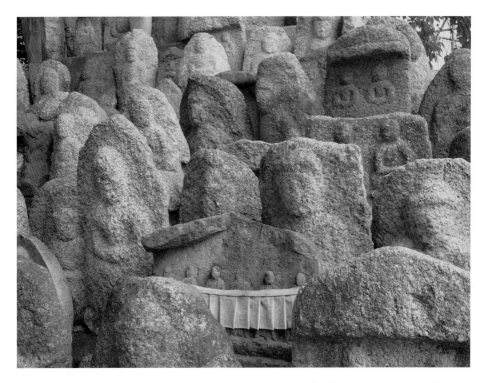

Figure 4.10 *Sentai* Jizō at Mibudera. Courtesy of Mibudera. Photo by author.

ancestral tablets set up on the table read "the spirits of all generations of the ancestors of all families" and "the myriad spirits of the three worlds" (plate 13). The ascendancy of the *segakie* represents a new idea of the "collective dead" in late medieval Japan, and the *sai no kawara* is an extension of this notion.[47] The red bibs on these stones are reminiscent of the red bibs worn by the children in some representations of *sai no kawara*, and one belief had it that by tying the bib of a dead child to a Jizō statue, a mother could hope that Jizō would, in bloodhound fashion, sniff out her child to help him or her in the otherworld.[48] Any visitor to Japan will have seen the stacks of bibs tied to stone Jizō images and to other stone figures. Red is a protective color in East Asia, a prophylactic against harm or illness; thus it was a popular color for children's clothing. In this sense, it partakes of the apotropaic character of fertility images, a topic explored in more detail below.

Since the red bib is a feature of Jizō iconography often remarked upon by visitors to Japan but one that has not been studied in any detail, I will briefly note a few connections that suggest a symbolism that ties the blood of death to the blood of regeneration and birth.[49] As we have seen

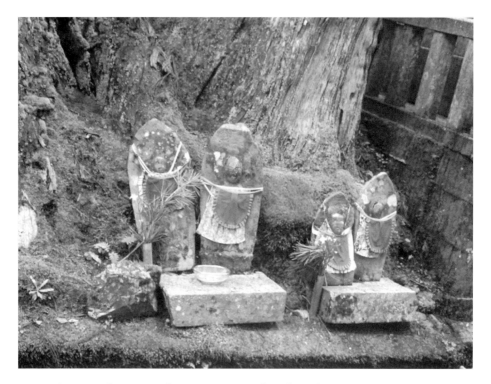

Figure 4.11 In the graveyard at Mount Kōya. Photo by author.

above, the Zen sect in the late medieval period was under the influence of
the mainland Ch'an sect during the sixteenth and seventeenth centuries,
and Nishiyama Mika sees this as one important reason for the explo-
sion of the *segakie*'s popularity around this time. It was already suggested
above that the belief in *sai no kawara* is closely related to the late medi-
eval cult of the Blood Pool Hell. In the practice known as *kawa segaki*
and also as *arai zarashi*, when a woman died in childbed, a piece of red
cloth, either dyed or actually stained with the blood of the dead woman,
was anchored between two sticks, placed in a flowing river, and left until
the elements had bleached it white again. This was a measure for saving
the deceased from punishment in the Blood Pool.[50] It is possible that one
of the meanings of Jizō's red bib can be found here. There is an associa-
tion with the blood-stained bedclothes and white clothing from a birth
and with the placenta itself.

Sawada Mizuho has written about a seventeenth-century gazetteer
entry from Zhejiang Province in southeastern China in which women
who have had children make skirts out of red paper, one for each child,
and wrap them around a Dizang (Jizō) image on Dizang's birthday, the

thirtieth day of the seventh month, and when they remove these later in
the ceremony, it is said to expiate the pollution of childbirth.[51] (On the
same day, there are ceremonies centering on the village storehouse and
directed at making deposits to King Enma, who provides the soul of the
child on loan.) It is quite possible that the practice of wrapping Jizō im-
ages in red bibs is related to this ceremony. Others have suggested that it
represents the donation of monastic robes to the monastic community,
since Jizō is a monk, or even that this piece of red cloth represents the
placenta.[52] If this latter notion seems somewhat far-fetched, we might
note that a number of representations of children at *sai no kawara* show
them with placentas atop their heads.[53] There is also a possible connec-
tion to the idea expressed in the loan from Enma in the Dizang rite from
Zhejiang; Tanaka Takako has noted that in the late medieval story *Tengu
no dairi* (A Goblin Visits the Imperial Palace), it is said that Datsueba
(the "clothes stripping hag" of Sanzu River, sometimes understood to be
Enma's wife) lends each baby/fetus a "placenta jacket," or *enagi*, which
must be returned to her on the fateful day when they meet again.[54]

It is worth noting in this context that this figure of the terrifying
crone who sits on the banks of the Sōzu (or Sanzu) River at the bor-
derline of this world and the next is a Japanese innovation. She is not
known in the hell tour literature of the continent, but first appears in
the Japanese apocryphon *Jizō juō kyō* (Jizō Ten Kings Sutra).[55] Makita
Shigeru has suggested that the Japanese name "Sōzuka" (given to the
Chinese characters for this river that marks the crossing into the realm of
the dead) derives from the rivers that worshippers at mountains like Fuji
used to purify themselves before the climb. These were often named the
Shōjin kawa or Shōjigawa and served as a boundary between the human
and the divine realms. (Recall that the pond by the *roku* Jizō of Hakone
is called Shōjin ike.) The Japanese Styx is called the Shōzu or the Sōzu.
Makita continues, "Dwelling at such borders were the *sae no kami* who
protected small children and the *ubagami* [old woman goddess] of the
crossings [*seki*] who ensured pregnancy and safe childbirth. Buddhism
borrowed this, tied it to Jizō, and invented the idea of the hag of the
Sōzu river [*Sōzuka no baba*]."[56] This river, also called the Sanzu or the
Mitsuse, is mentioned in the tenth-century *Kagerō nikki* (Kagerō Diary),
and references to it with descriptions proliferate from the thirteenth cen-
tury, along with a sharpening vision of the landscape of the otherworld,
the place of judgment, and its denizens.[57] It seems likely that the "river-
beach" *(kawara)* of *sai no kawara* would conjure up an image of the des-
olate gravelly banks of this infernal river, strewn with rocks and pebbles.

In his seminal essay "Ishigami mondō" (A Dialogue on the Stone
Gods), written in 1909, ethnographer Yanagita Kunio suggested conti-

nental origins for the stone gods of the borders, comparing them to the Korean *sottae*, tall pillars guarding villages in the form of male and female gods and decorated with the sexual imagery of turtles and snakes, and to the Okinawan *sai no kan*.[58] The name given to these gods—*sae no kami*, or *sai no kami*—is written with a great variety of Chinese characters, and since the Nara period, the characters for *dōsojin* (literally, "road-ancestor-god") have most commonly been read (that is, pronounced) as *sae no kami*. Yanagita maintains that the prevalence of the toponym *shōjin*, given to rivers and lakes throughout Japan, is derived from two characters, "sawari" and "kami." These characters, meaning "god of obstacles," are usually read as *sae no kami* but also can be pronounced as *shōjin*.[59] The name of the children's limbo is clearly related to the cult of the stone gods. Various etymologies have been suggested. Among these is the name of the river beach near the confluence of the Katsura and Kamo rivers, a spot known as "the riverbed of the western cloister," or *sai(in) no kawara*, that had become designated as a burial ground or place for the disposal of corpses in the ninth century. Though this "potter's field" moved south from Shijō (Fourth Avenue) to Shichijō (Seventh Avenue) in later years, it is said that the bodies of children were still placed here near the Kōzanji temple. There is still a station stop by this name in western Kyoto, variously pronounced as Sai'in, Sa'in, and Sai.[60]

Stone Fertility Images and the Jizō Cult: Generative Power and the Limen

We have seen above that old and discarded gravestones were often massed together to serve as monuments to the *muen botoke*, the unconnected, forgotten dead. In some places, particularly on Mount Kōya, such stones or fragments of graves are wrapped in red bibs and placed in the crotches at the roots of ancient trees. These function as Jizō images and are evocative of an idea of the stone as a guarantor of fertility. This observation takes us into our next subject here. Leaving the specific landscape of Higashiyama behind for the time being, we will explore the process by which stone images of Jizō came to replace border stones and fertility images in villages throughout Japan. That is, Jizō's popularity in the late medieval period and beyond owes much to the incorporation or assimilation of a more ancient cult, that of the *dōsojin* or *sae (sai) no kami*.[61]

The *sae no kami* were, from the beginning, gods of sexuality and fertility and retained this character throughout their history.[62] Phallic stones began to appear in Japan by the early Jōmon period and by the mid- and late Jōmon were quite widespread. It is clear in the various local his-

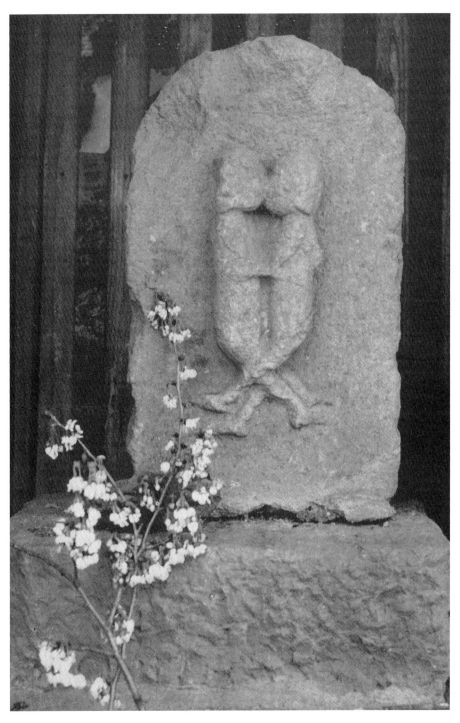

Figure 4.14 *Himegoto* (secret) *dōsojin.* Photo by Ashıda Ei'ichi, ca. 1960.

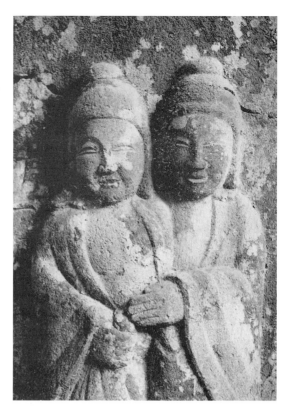

Figure 4.15 Smiling *dōsojin*. Photo by Ashida Ei'ichi, ca. 1960.

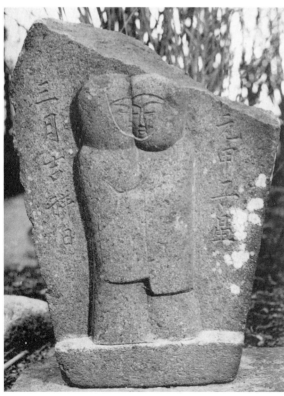

Figure 4.16 Monk and nun *dōsojin*. Photo by Ashida Ei'ichi, ca. 1960.

in which these old practices influenced the character of the Jizō cult in Japan. The *ishigami* were closely tied to sexuality, and their cult was one of dynamic action and ritual, dance and song. The *ishigami* are gods of ecstasy; their cult is not philosophical in nature. It was by tapping into the long tradition of village and neighborhood festivals centered around these gods that Buddhism gained widespread popularity. One subtext of this chapter is to cast light on the role of often overlapping categories of religious specialists and performers—the Kūyasō, the Kumano *bikuni*, *tonseisō, hijiri, shugenja, jikkyōja* ("sutra carriers," or itinerant preachers), and so on—in the transformation of Japanese folk belief toward Buddhism. As practiced in Japan, this new faith always remained deeply tied to the autochthonous, to old customs and beliefs anchored in particular to places—Jizō was a pivotal figure in this process of the incorporation of Buddhism into local cults. His care of dead children and babies at *sai no kawara,* as we saw above, and his assimilation to the stone fertility gods were essential to his role in shepherding the people in cities and villages throughout Japan snugly into the Buddhist fold.

It is his connection to these gods of child granting and child loss that ultimately led to Jizō's modern identity as the protector of children and also as the patron saint of the unborn, the role for which he is so familiar in Japan and abroad. In the madness of Dōgo's mother, Hyakuman, as she searches in vain for her lost child, we hear the echoes of real mothers grieving the loss of their children. We see, played out onstage and in legend, the very real fears of the painful separation of parent and child through the "out of sequence" and "unfilial" death of the child. For those who had lost a child, or more than one—surely in the majority during this age of high infant mortality—the drama might have provided some measure of catharsis. Similarly, the idea that Jizō might look after and care for the children in their own special corner of hell may have been a comforting thought. On the other hand, the cult of *sai no kawara* was clearly one of the many ways in which the Buddhist clergy manipulated believers, playing on their deep fears and their heartbreak to gather donations. Many stories, like that of *Karukaya dōjin* (The Initiate Karukaya) and the Dōgo legend that inspired the Noh play *Hyakuman,* make a Jizō image the occasion of a parent and child reunion.

We might note an ironic parallel between the reunion of Hyakuman and her child and the tale of a mother and son brought together by the *dōsojin* of Kyoto's Gōjō bridge. In the latter case, two strangers, the poet Izumi Shikibu and the monk Dōmyō *ajari,* come to realize that they are mother and son only after they have already had sex. Izumi had abandoned her baby boy on the bridge with a small dagger as a keepsake. When she sees the knife in the monk's possession, she has her shocking

realization.[69] While there is no doubt little relationship between the two stories, the overlapping details of an abandoned baby who becomes a monk, the mother and son reunion, and the mediating role of Jizō (or the *dōsojin*) are intriguing. Incest and fertility are closely associated in Japanese mythology and in the origin stories of the *sae no kami*.

As indicated above, the cult of the *dōsojin* or *sae no kami* stretches back to the earliest period of Japanese myth.[70] As Kojima Yoshiyuki wrote in his study of the marriage of the originary pair of gods in the Japanese creation story, the brother and sister Izanami and Izanagi:

> Among all of the cults [*shinkō*] of the Japanese people, the *dōsojin* are the most widespread and also the oldest. The character of the cult is various and complex, but its most basic aspects are that it seeks to ward off evil and that it bears similarities to the legend of Izanami and Izanagi. The identity of Izanami and Izanagi as the gods of union [*musubi no kami*] and the gods of couples [*fūfu no kami*] is closely related to this connection of the *dōsojin* to the story of Izanami and Izanagi. The role of the *dōsojin* as the gods of birth [*osan no kami*] and the gods of children [*kodomo no kami*] is no doubt a reflection of the narrative of the birthing of the land. Also, the fact that these gods are the first to demarcate the separation between the world of the living and the world of the dead reveals the close connection to the *dōsojin* of popular legend.[71]

In fact, the earliest mention of the term *sae no kami* occurs in the *Kojiki*, in a compelling scene in which Izanagi follows his wife to the next world. Izanagi has descended, Orpheus-like, to the underworld land of Yomi (Yellow Springs) in pursuit of his wife/sister after she died giving birth to their youngest child, the god of fire. By looking at her corpse, he breaks a taboo, doing what he has been explicitly warned against, and is chased from the land of the dead. Crossing to safety, he flings a staff down into the ground, forming a gate or barrier; this staff itself is called *funato no kami* and serves as a boundary marker between the land of the living and the land of the dead.[72] As it is clear that in the real world *dōsojin* or *sae no kami* were, from the beginning, employed as the boundary stones marking the line between the living and the dead—the so-called hill of Yomi (Yomi *no saka*), the assimilation of the Jizō cult to their worship was quite natural. Some scholars see here a reference to actual practice and hold that when people disposed of their dead on hillsides, they often placed stone gods, the *sae no kami* and so on, at the base of these hills to mark the separation.[73] As stone gods *(ishigami)* presided over birth as well as death, so the role of Jizō as a god of birth *(ubugami)* became increasingly emphasized. By affinity to the worship of *sae no kami*, the Jizō

cult in Japan through the medieval period became ever more closely tied to sexuality and childbirth, while the connection to death and the underworld also remained strong. A key to Jizō's transformation in Japan lay in these stone gods, markers of physical and metaphysical boundaries.

The cult of *dōsojin* or *sae no kami* is, as we have seen, both ancient and geographically widespread, so it is incredibly diverse and varied. It is very difficult to make any generalizations that will hold beyond those above offered by Kojima—that is, that these gods are involved in warding off baleful influences, especially death, and that they are connected to sexuality and fertility through the legend of Izanami and Izanagi, the first couple. With these two poles of Eros and Thanatos in mind, let us continue our exploration of the *dōsojin* cult. While these two functions may at first seem to be at odds with one another, or at least unrelated, the earliest records of the worship of these gods make it clear that the display of sexuality or the exposing of sexual organs was seen as the best way to drive away dark or evil influences and invite good fortune and blessings. One is reminded of Ame no Uzume's sexual dance that amused the gods and lured Amaterasu out of her seclusion in the rock cave.

In the *Honchō seiki* (A History of Japan through the Ages) entry for the second day of the ninth month in the year 938, a description is given of the worship of a pair of male and female gods in effigy, here called the *kunato no kami*. (This resonates with the name for the boundary gods in the *Kojiki*: *kunato sae no kami*.) These effigies are set up at crossroads in the east and the west of the capital and are wooden statues painted red with cinnabar (mercury sulfide, or *tan*) and carved "in the fashion of yin and yang below the waist."[74] The same incident is recorded for the entry on this date in the *Fusō ryakki* (Short History of Japan), compiled by the Tendai monk Nōen in 1094.

> They set up at the roads into the capital in the east and the west wooden statues of a female goddess and a male god. They placed a crown upon the man's head, hung a necklace about his neck, and painted his body with cinnabar. The woman held a cup in her hands and had her pudenda carved into the lower torso, below her waist. Children gathered to make offerings of cut paper, flowers, and incense. They call these the *funato no kami*. They also call them the *goryō*. Just what sort of gods they might be is unclear.[75]

The two sources cited here alternate between the pronunciations *funado* or *funato* and *kunato* or *kunado*, as do many sources. The root of the latter is the verb *kunagu*, "to have sexual intercourse." The name of the god means both the sex act and genitalia. Also, the word *funato*, "the place

at the fork in the road," was slang for the sexual organs from as early as the Nara period. This derives from the similarity between a road splitting in two and the relationship between the human torso and the legs.[76] These gods of the crossroads are also called *chimata no kami.* Until at least the Edo period, it was very common throughout Japan for people, both in cities and in villages, to set up *sae no kami* or *dōsojin* images at crossroads and liminal spaces. Most of these were made of wood, bamboo, or straw and so have not survived. Besides their tendency to rot or fall apart, they were often burned annually in the *dōsojin* bonfire ritual known as *dondo yaki.*

However, there was also a tradition of setting up "male" and "female" stones that were naturally phallic or vaginal in shape.[77] In some locales, sexually explicit relief carvings of couples in sexual union or of phalli were used. It is precisely these sorts of images, placed at crossroads, village borders, mountain passes, entrances to burial grounds, and so on, that came to be replaced by stone Jizō statues throughout the medieval period. It is clear that Buddhist preachers and wandering holy men sought to appropriate this cult from an early date. The logic of *honji suijaku* that made the worship of Jizō so central to the Kasuga cult in Nara also was employed here in a more casual way as the local gods were converted to Buddhist deities and enlisted into the cause of the Dharma. An example of this sort of hierarchical scheme of conversion is expressed in the story of the *dōsojin* of the Minabe province of Kii, collected in the eleventh-century *Hokke genki* (Miracles of the *Lotus Sutra*) and in *Konjaku monogatari,* to which we now turn.[78]

Here a Buddhist priest, while traveling to the sacred mountains of Kumano to spend his summer retreat there made his bed for the night under a tree by the shore of the ocean. His name was Dōkō, and he was of the Shintennōji, an important and powerful Tendai temple near the capital. He was awakened in the middle of the night by riders yelling, *"Sae! sae!"* as they approached a nearby tree. They were calling out the *dōsojin* whose small shrine was there, telling him to get on his horse and accompany them. The god appeared as an old man *(okina)* and begged off, saying that his horse had gone lame and that he was too aged and frail to walk on his own. The riders moved on but said they would return the next day. Dōkō was intrigued by all this and visited the spot in question the next morning. He found there a neglected and broken shrine to a male *sae no kami.* The text specifically tells us that there was a male but no female, revealing an expectation that there would often be a yin image as well as a yang image at a shrine to *sae no kami.* Also, he found an *ema,* a votive plaque with a painting of a horse on it, lying in front of the statue. The wooden plaque was broken in half at the horse's forelegs,

making it clear what the old man had meant by saying his horse was lame. The priest used some string he had in his bag to mend the plaque and replaced it. He was, as one might imagine, curious to see what would happen that night, so he delayed his departure by a day.

That night, as expected, the riders came again, and this time the *dōsojin* rode out with them. The following day, the old man came to the priest and thanked him for his help. He explained that the gang of riders were gods of epidemics and that it was his job to guide them on the local roads, but he could not do it because of the broken *ema*.[79] If unable to perform his function, he would be beaten and abused by the epidemic deities. He revealed to the priest his status as a lowly local deity and said that he hoped to change out of his present "vulgar" form, presumably as a phallus, and to be born into a higher state. To this end, he requested the priest's help, asking him to stay for three more days and chant the *Lotus Sutra* under that tree. Dōkō did so, and on the fourth day the *dōsojin* announced that he would be going to join the bodhisattva Kannon in the land of Fudaraku. He asked the priest to build a boat of boughs and set his statue afloat on it. Doing so, Dōkō saw the little boat sail off rapidly to the south and watched as the statue transformed into a radiant bodhisattva, floating up into the clouds.[80]

Whether wood or straw effigies, carved stones, or natural stones that brought to mind human sexual organs, it is clear that the *dōsojin* were statues with stories. That is, they were visual reminders of legends; their worship was closely connected to these legends, and the rituals dedicated to them also invoked these stories. They are not silent stones. As the Jizō cult spread throughout the Japanese countryside and expanded in urban areas during the fourteenth and fifteenth centuries, Buddhist priests connected these images, often stone roadside statues housed in small shrines, with stories as well. As we have seen in the cases of the Chisokuin Jizō, the Yata Jizō, and others, the connection of a statue to the story of its miraculous origins was already a well-established tradition.

As regards the *dōsojin*, their origin stories almost invariably involve the transgressive motif of incest. In this sense, the local legends of *sae no kami* or *dōsojin* told over the centuries mimicked the foundational myth of the birth of the Japanese people, or of humankind itself, from the union of the brother-sister pair of Izanami and Izanagi. We will have occasion below to revisit this myth, but here it is sufficient to note that Izanami and Izanagi are a brother and a sister descended from on high, the first inhabitants of the earthly realm, who learn about sex by watching the mating dance of the wagtail *(inaōse dori* or *sekirei, niwakunaburi)* and go on to populate the earth with the first generation of Japanese gods.[81]

Within the considerable regional and local variation in *dōsojin* leg-

ends, the forbidden act of incest is a constant. While most often the incest is between a brother and a sister—sometimes living isolated from others as castaways, sometimes separated at birth and ignorant of their relationship, sometimes possessed of comically outsized genitals and thus suitable only for each other—many locales have a legend of a father-daughter pair.[82] There are a great many examples of parent and child reunion, or tragic final separation, in medieval Japanese literature. Many of these cases involve Jizō. As two of the most well loved, *Karukaya* and *Sanshō dayū* (Sanshō the Bailiff) might be mentioned.

Koyasu monogatari: The Safe-Childbirth Jizō of Kiyomizuzaka and Dōsojin

We will complete our exploration of the Jizō cult with a tale that brings together many of the themes discussed above, including childbirth, child loss and reunion, and also sexual connection. It is called *Koyasu monogatari* (The Tale of Safe-Childbirth) and is preserved in a beautiful illustrated book held by the Spencer Collection of the New York Public Library. It is here in the seventeenth century that we first find a new "surname" for Jizō, *koyasu* Jizō.[83] This tale will take us back to Higashiyama in Kyoto, to Kiyomizuzaka, the area surrounding Kiyomizudera, or Shimizudera as it was known at the time. It was a very popular and bustling place, mentioned in many tales and stories. Discussing the *kōwakamai* ballad text entitled *Kagekiyo*, Abe Yasurō writes, "The setting of the story, Kiyomizuzaka, was not only a place frequented by the heroes of the world of legend and an area for prostitutes to ply their trade. It was also a border zone that was home to beggar outcastes, *hinin, sakanomono* (people from the hill), and performers, as well as *hijiri*."[84] A fascinating and in some ways shocking tale, it was probably written by a *rengashi*, a professional poet, possibly one with a priestly background.[85] It has beautiful illustrations, richly decorated with gold leaf, but in the manuscript held in the New York Public Library, one of only a handful of surviving copies, they are pasted into the text out of order.[86] It is set just before the outbreak of the Genpei wars in the late twelfth century and tells the story of an old nun, a former aristocrat tricked by a man when she was young, now living in poverty in Kiyomizuzaka, an area populated by beggar priests, performers, and outcastes. The text, as we shall see, is a very complicated one, but it clearly demonstrates the fusion between the worship of Jizō and the cult of the *sae no kami*. In this story, we see the emergence of Jizō as a bestower of children and a guardian of women in childbirth, rivaling the Kannon of Kiyomizudera, so famous for granting these benefits.

The story is exciting and entertaining; it is also magical. Like so many pieces of late medieval religious fiction, it offers efficacy through its narration. It guarantees certain boons to the audience. It promises romantic fulfillment and safe childbirth to those who hear it and to those who walk up Kiyomizudera's Sannenzaka and visit the "pagoda for safe delivery" *(koyasu no tō)*, which stood at the very top, before the entrance to Kiyomizudera. These two features, sexual connection and safe childbirth, are the principal themes of *Koyasu monogatari*. An intricately complicated and literary work, it is also a reworking of the mythic themes of the *sae no kami* for an early modern audience. *Koyasu monogatari* is an example of the appropriation of a historical narrative for a liturgical purpose. It is set in the Japanese past of the twelfth century but uses the recitation of history as a sort of incantation or spell to create effects in the present.

Below we will first look at this complex tale in broad strokes and delve into a few of its details. Then we will consider a few possible sources, textual and otherwise. Finally, we will reflect on the challenges faced by the host temple of the *koyasu no tō*, Taisanji, during the seventeenth century, when the tale was written, and indulge in speculation on the circumstances of the creation of this little book, which purports to relate the wondrous origins of what it calls "the *koyasu* Jizō of Kiyomizuzaka."

In an example of so-called medieval myth *(chūsei shinwa)*, our tale begins with a retelling of the Japanese cosmogonic myth, familiar from the eighth-century *Nihon shoki*.[87] Here, however, the focus is less on the creation of the land and the generation of the deities than on the discovery of sex by the original male and female pair, Izanami and Izanagi, under the tutelage of the wagtail. It attributes a poem to their daughter Amaterasu:

> *au koto wo inaosedori no, oshiezuba, hito ha koiji ni*
> *mayowazamashi*
> Had not the wagtail taught them how to "do it," people would
> never wander lost upon the road of love today.[88]

It is thus that these two are known as "the gods most dear to couples" *(fūfu sai'ai no mikami)*, and it is through the technique they introduced that all, high and low, come into the world. We are told that from the age of the gods to the reign of Emperor Jinmu, all sorts of wondrous things happened and that the Buddhist texts are also full of strange events:

> As these are all manifestations of the appearance of the buddhas and
> bodhisattvas in our world and are intended as skillful means for the sal-

vation of sentient beings, they are recorded in histories that they might be read with the eyes or fall upon the ears. Thus today, before our very eyes, their wondrousness is revealed. Because the tale of the safe-child-birth Jizō of Kiyomizuzaka is so surpassingly wondrous I have undertaken to set it down in words.[89]

As we have noted, the story that follows this invocation or introduction is an exceedingly complex one, but let us continue, focusing on the essential parts of the narrative. Here the story opens on an aged nun named Ichinen *bikuni* living to the west of the Sanjūsangendō (Hall of Thirty-three Bays, Rengeō'in temple) in the neighborhood of Kiyomizuzaka[90] One night she has a dream of a beautiful couple sitting at her bedside. They tell her that they are the emissaries of King Enma. They bring her an elegant jar and a folded piece of paper. The letter contains a poem to her from Enma; opening it, she reads:

> *yo naka no, mayou shimeshi no, sashimogusa, roku no chimata no, michi shirube sen*
> The guide to all the sentient beings wandering lost in the world; let him be your signpost at the crossroads of the six paths![91]

After declaring Jizō and Enma to be identical, or "of the same body" *(on ittai)*, the following text carefully explains and interprets the poem, glossing *sashimogusa*, a name for the plant mugwort, as "all sentient beings"—a traditional interpretation, also found in the *Nippo jisho* (a Japanese-Portuguese dictionary produced in 1603).[92] The nun understands the meaning of the poem and is deeply moved by the compassion and skillful means of Jizō. Echoing the language of Enma's poem in her praise of Jizō, she calls him "the teacher in the six paths, who temporarily manifests his form to lead the sentient beings wandering lost in the world" *(yo no naka no mayou shujō o, rokudō no, nōge no Jizō, kari ni, katachi o arawashi, michibiki)*. Still dreaming, Ichinen listens as the man and the woman exchange poems rich in Buddhist allegory, and then she offers her own poem. The narration also explains these poems, demonstrating how their imagery is drawn from the *Lotus Sutra* and revealing their meanings. Then the man disappears into the nun's left sleeve and the woman into her right. When she wakes, Ichinen *bikuni* finds the beautiful jar from the dream sitting before her Buddhist altar along with the folded sheet of paper, King Enma's poem (plate 14).

Not long after this strange dream, the nun realizes that she is pregnant. On the seventh day of the sixth month of 1165 she gives birth, painlessly, to a pair of Siamese twins. They share a torso but have two

heads, four arms, and four legs. We might note that, despite the specificity of the text on this point, the illustrations depict them with two heads and a total of four limbs. Ichinen is shocked and embarrassed that she, past seventy, and a nun besides, should have somehow become pregnant and given birth. She considers abandoning the twins before anyone finds out, but within a day or two she finds herself deeply bonded to them. (The text says nothing about her reaction to their deformity.) At this point a thick liquid begins to bubble forth out of the jar left by Enma's messengers. At first it tastes like *amazake,* a sweet, pulpy, and mildly alcoholic drink made from rice that, during the Edo period, was drunk cold to fortify the body in the summer. It replenishes itself no matter how much she ladles out, and the next day it becomes an ambrosial *nigorizake,* a cloudy and full-bodied rice wine traditionally consumed in the winter months. By the third day it has developed into a fine, dry, mature clear sake. She calls together over a hundred monks and nuns, all fellow *nenbutsu* practitioners, to have a party, but no matter how much they drink, the jar remains full.[93]

This, as one might imagine, inspires the nun to go into business selling the sake. She names her sake shop "Izumi no sakaya" (Brewery of the Source) and begins turning a very nice profit.[94] Her product instantly gains wide renown, and well it might, given that it has a reputation for restoring youth to the aged, making the foolish wise, and relieving all manner of suffering. Additionally, news travels through the area that if a woman in difficult labor takes even one drop of this miraculous draught, both mother and child will be easily delivered without incident. With this sort of advertising, it is no surprise that the warriors of the Taira clan, who control the capital, begin drinking it. In fact, Taira clan leader Kiyomori, the tyrant Rokuharadono himself (well known to the tale's audience through the vocal performance of the *Tale of the Heike,* and associated with this area of eastern Kyoto), puts in an enormous order. Though she becomes a very wealthy woman, the old nun remains as humble and devout as ever. Behind this image of the rich brewer nun stands the historical situation in late medieval and early modern Kyoto, where a great many breweries functioned as financial institutions, turning a large margin on moneylending as well as sake sales. Many of these *sakagura* (literally, "sake storehouses," breweries that acted as banks) were in fact operated by Buddhist nuns.[95]

The twins, a boy and a girl, are respectively given the names "Shureki" and "Shuekihime."[96] They are lovely and docile, and a great help around the shop. However, in a case of mistaken identity, they are arrested at age seven and taken into custody by the authorities. It seems that that year there had been a number of strange natural phenomena, includ-

ing the cessation of the famous Otowa falls at Kiyomizudera temple as well as the simultaneous blossoming of a variety of flowers out of season. The political and military disturbances that would lead to the Genpei wars were also beginning to ferment. An astrologer had established that the birth of four demon children in the capital was the cause of all the troubles. Finally, it is determined that the twins are to be beheaded at the riverbank execution grounds at Sanjō Kawara. However, just as promised in the *Lotus Sutra*'s *Kannon Sutra*, because of their deep faith in Kannon, the sword of the executioner breaks into three pieces as it strikes their necks (fig. 4.17). The twins are released, and the real culprits, a set of quadruplets one year older than the twins, are apprehended and beheaded. Their heads are hung in a tree before the prison for all to see.

The nun has been beside herself with worry and is overjoyed that her prayers to the Kannon of Kiyomizudera proved efficacious and saved her dear children. In an illustration in the book, we find her at prayer on the *butai*, Kiyomizudera's unique elevated platform stage, when the twins are magically returned to her (fig. 4.18). In this reunion, we are reminded of the legends of mothers and fathers finding their lost children in Noh plays

Figure 4.17 The twins are saved by the Kiyomizudera Kannon at the moment of their execution. From *Koyasu monogatari,* ca. seventeenth century. Reproduced by permission of the Spencer Collection, the New York Public Library, Astor, Lenox, and Tilden Foundations.

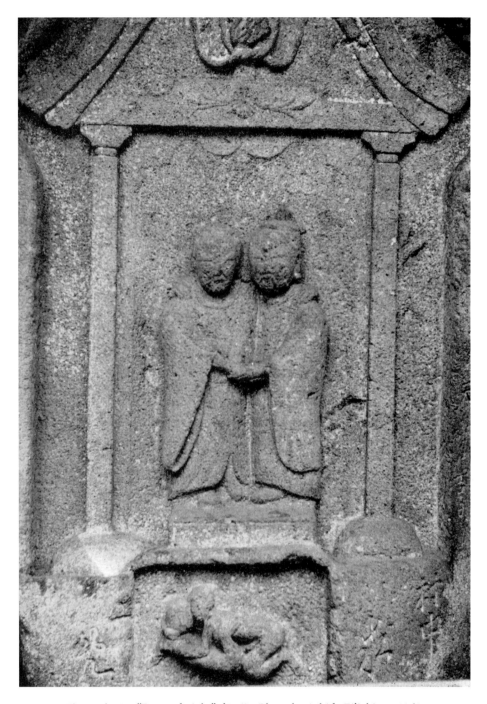

Figure 4.19 "Day and night" *dōsojin*. Photo by Ashida Ei'ichi, ca. 1960.

a central place in any number of *otogizōshi*, here there is an incantatory function to the bookend passages that initiate and conclude the auspicious tale. We cannot help but note the pervasive influence of the cult of the *dōsojin* in this story of loving twins.

While we can know nothing conclusive about the tale's authorship, one interesting aspect of *Koyasu monogatari* is its historical setting. Many *otogizōshi* bolster their verisimilitude through the use of names, dates, and events gleaned from *Heike monogatari*, *Gikeiki* (Record of Yoshitsune), or other popular military tales, the close attention to specific dates in *Koyasu monogatari* is striking. Hamanaka Osamu has demonstrated that many of the events in the story, along with their dates, are drawn directly from the early fourteenth-century historical work *Hyakurenshō* (Book of One Hundred Exercises), written in classical Chinese, *kanbun*.[100] These events include the birth of Siamese twins in the capital in 1165, the appearance of a miraculous fount of sake west of Sanjūsangendō, the cessation of the Otowa falls, the unseasonable blooming of flowers, and, finally, the birth of quadruplets in the capital around 1164. Since each of these anomalies actually appears in *Koyasu monogatari,* the similarities are too striking to be discounted, yet the tale was composed some three hundred years after *Hyakurenshō* was written and several centuries after the reported events themselves. Hamanaka points out that *Hyakurenshō* was not available in a printed edition until the nineteenth century, and deems it highly unlikely that the author of our tale would have had access to a handwritten copy. Thus he posits an intervening text, now lost, based on the *Hyakurenshō* that our author used in constructing his or her story. I do not think that we need to assume with Hamanaka that the author of *Koyasu monogatari* could not have had access to *Hyakurenshō* or that an *otogizōshi* could not be based on a *kanbun* source. However, in the absence of concrete evidence in either direction, the point is moot. Either way, the similarities between the events in *Koyasu monogatari* and those recorded in *Hyakurenshō* are too remarkable to allow us to attribute them to coincidence.

What is fascinating here is the creative act of an author weaving a narrative out of chronicles of discrete and unrelated weird happenings around the capital during the second half of the twelfth century. This is where liturgy is created out of history. *Koyasu monogatari* fuses together several incidents from the *Hyakurenshō* to make something new. And thus a meaningful framework is constructed from random historical events to create a story that holds magic and efficacy in the telling. Similarly, it ties the Jizō cult to a thriving and long-established tradition of Kiyomizudera as a place to pray for a mate or, as in the case of the play *Kiyomizu zatō* (The *Biwa* Player at Kiyomizudera) and other works,

to actually find a partner. It was similarly a place to ask for a child and pray for its safe delivery. *Koyasu monogatari* distances Jizō from a focus on death and the underworld to recast his cult as a source of fertility and sexual fulfillment, tying him to the *dōsojin* or *sae no kami* through the image of the conjoined twins and their incestuous marriage (fig. 4.19).[101]

Before moving on to the topic of Sannenzaka's Taisanji, I'd just like to mention one more fascinating aspect of *Koyasu monogatari*. That is the connection to sake (plate 15). The nun invites her fellow men and women of the cloth over to sample the fine wine that issues from the jar left by Enma. That tippling by monks and nuns is not remarked upon might indicate that it was not particularly exceptional. The *Jizō bosatsu reigenki* also contains a story about a nun who is a sake brewer. Records indicate, furthermore, that the neighborhood of Kiyomizuzaka was, over the centuries, home to quite a number of breweries doing a brisk trade. As the name would indicate, Kiyomizudera (literally, "Pure Water Temple," and also read as Shimizudera) was famous for the purity of its water. A number of local sake brewers listed in the fifteenth-century *Sakaya kōmyō,* a register of *sakaya* names, incorporate "Kiyomizu" into their shop names to make it clear that the water used to brew their sake comes from the renowned source.[102] Thus the plot element of a new brewery named Izumi no sakaya (Brewery of the Source) opened outside the gates of Kiyomizudera would also seem convincing.

Taisanji in the Seventeenth Century and the Composition of *Koyasu monogatari*

The name of the steep stone staircase ascending to Kiyomizudera from the west is written with the characters for either "three-years hill" or "peaceful-birth hill." Formerly, the temple Taisanji (literally, "the temple of serene birth") stood at the top of this hill at the end of this staircase, just before the entrance to Kiyomizudera, next to the *koyasu no tō* (pagoda for safe delivery), which it operated (figs. 4.20 and 4.21; plate 16).[103] The name "Sannenzaka" (or "Sanneizaka") is said to derive from this connection to Taisanji's *koyasu* Kannon, or "Kannon guaranteeing safe childbirth." And yet *Koyasu monogatari,* a text scholars associate with Taisanji and one that mentions the *koyasu no tō* repeatedly, is the story of the *koyasu* "Jizō" of Kiyomizuzaka. In fact, an alternate title, "Koyasu no Jizō," appears on the inner cover of the manuscript. It seems surprising that Kannon has been replaced with Jizō. The text's omission of any mention of either Taisanji or Sannenzaka is a possible clue. It could be that *koyasu no tō* and Taisanji indicate the same site, so there is no need

Figure 4.20 *Kiyomizudera sankei mandara,* ca. sixteenth century. Courtesy of Kiyomizudera.

Figure 4.21 A *miko* dances on the *butai* of Kiyomizudera. Detail of *Kiyomizudera sankei mandara,* ca. sixteenth century. Courtesy of Kiyomizudera.

to specify the name of the temple, but this still does not explain the shift from Kannon to Jizō.

Koyasu monogatari was written in the latter half of the 1600s. The *koyasu no tō* burnt down in the great fire of 1629 and was rebuilt in the early 1630s under the patronage of the third Tokugawa shogun, Iemitsu.[104] However, this fire was just the beginning of Taisanji's troubles. The history of Taisanji and the *koyasu no tō* in the latter seventeenth century is an incredible one. Could it be that the controversies that embroiled the temple for some twenty years have something to do with the circumstances of the composition of *Koyasu monogatari* and might this explain why this story does not mention Taisanji?

Taisanji had always been a convent. Legend has it that the founder was Kōmyō *kōgō*, and in the sixteenth-century pilgrimage painting *Kiyomizudera sankei mandara* (Kiyomizu Temple Pilgrimage Mandara) we see two nuns collecting alms at the gate to the *koyasu no tō* (plate 16). In the middle of seventeenth century, however, it began to be mismanaged after a nun put her uncle, a monk named Rissei, in charge. After Rissei's death the temple was passed to his relative Seichō. This Seichō was a ne'er-do-

well, and, by his own father's account in a letter reporting him to the authorities, he would use the temple's income to go on sprees in the gay quarters of Fourth Avenue near Kawaramachi, where he would stay four or five nights at a stretch, getting into sword fights and all other sorts of mischief. In 1675, Seichō hit a new low when he sold someone the temple for ten *kan*, or about eighty-three pounds, of silver. One would think that things could not get much worse, but the person who took over from Seichō—a monk named Jukyō from the competing temple, Jōjuin—was also, it seems, something of a bon vivant. He started off his tenure with a bang, holding a tremendously successful public exhibition *(kaichō)* of the main image of the *koyasu no tō* in 1679. Jukyō showed the image all over Kyoto. It was a painting of Senju (Thousand Armed) Kannon seated on a crag, an icon that was usually sealed from view within the pagoda. People were excited to behold the secret image. He collected a great deal of money from the faithful, but this resulted in a dispute with his parent institution and with his master, who disowned him as a disciple, bringing a suit against him to the civil authorities. Jukyō, however, had friends in high places, and the case against him was dismissed. These allies, however, could not make good his mounting gambling debts, and in 1684 he put the temple in hock for a term of ten years and left town.[105]

The monk to whom Jukyō had pawned the temple in exchange for covering his debts, one Kyōin, was already involved in a dispute with the powerful neighboring institution, Jōjuin, and when he took up residence at Taisanji, he refused to be subordinate to Jōjuin's claims on the temple, which he saw as his property. Around this time, a rumor began to circulate through the capital that the *honzon* of the *koyasu no tō* was missing. It turned out that this was no rumor at all, and according to the report from the civil authorities, when they questioned the suspected thief, a painter from Osaka named Ikkan, they found that the burglary had been an inside job. The former abbot Jukyō had in fact *given* Ikkan the miraculous Kannon image in payment for some land, and then Ikkan had sold the painting to someone else. The image was finally recovered in 1695 and restored to its rightful place, but it seems that the Taisanji had been bereft of its miraculous *honzon* for some ten years.

After an absence of twelve years from the temple, the same Jukyō who had not only put the *koyasu no tō* into hock but had also sold its main image, returned, using a new name, "Gensei," to reclaim his possession. A document sent to the civil police explained that he had been away for a period, but now the "Koyasudera" would revert to his control. Jōjuin of course protested vehemently and was, in the end, successful in getting Gensei (a.k.a. Jukyō) banished from the capital and also from nearby Yamashiro and Ōtsu. Thereafter, from 1698 on, Taisanji became

a branch temple of the Jōjuin. The important point here is that Taisanji and its *koyasu no tō* were plagued by serious administrative problems during the latter half of the seventeenth century, after it fell under male management, and, especially interesting for our purposes, these reports confirm that its miraculous icon was *not* a Jizō image but rather a painting of Kannon.

And yet the *Koyasu monogatari* purports to relate the miraculous origins of the "Jizō Hall of Kiyomizu Hill." The two or three scholars who have written about this work have assumed that it was a product of the Taisanji. I would suggest that it is rather from a nearby Jizō hall that intended to capitalize on its proximity to Kiyomizudera and the famous *koyasu no tō*. Perhaps this Jizō hall was a small shrine at the Rokuhara Jizōdō, or at the nearby Enmadō, or possibly at Saifukuji around the corner, which was already famous for the legend of healing the grave illness of a child emperor in the Nara period.[106] I do not think it is going too far to speculate that the author of this version of *Koyasu monogatari* consciously took advantage of generations of profligate Taisanji abbots or of the rumors that the *koyasu no tō* no longer contained the miraculous image of Kannon that guaranteed safe childbirth. This is exactly the kind of opportunity that could inspire a clever and enterprising author to pick up his brush and compose a tall tale like *Koyasu monogatari*. Just as the narrative has religious efficacy for those who read it or hear it, it also would have had the real-world effect of filling the coffers of the "Jizōdō of Kiyomizuzaka," wherever that may have been.

The reader will remember the comments a century earlier of the princely diarist Sadafusa seen in the previous chapter. Sadafusa insisted that the apparently fraudulent circumstances surrounding the great enthusiasm for the Katsura Jizō did not diminish either its efficacy or its holiness. It would be best to adopt the same philosophy here. When I suggest that the tale was written in order to promote a small Jizō hall as an ideal pilgrimage spot for couples seeking fertility and singles seeking each other, I do not mean to imply that the author of the tale was inspired by cynical motives of profit or that the believers who gathered to hear the tale were credulous or foolish. Indeed, they were only playing their important roles in the long and varied history of the transformation of Jizō from a lord of the hells to the patron saint of lovers, children, and travelers.[107]

There is a strong possibility that the author of *Koyasu monogatari* in fact based the tale on the origin legend of a Jizō image located not too far away at Ōe no saka (now usually called Oi no saka), a hill that marked the border between Tanba and Yamashiro—that is, close to the Tanbaguchi entrance to the capital, near the location of the Katsura Jizō.

This is the very *koyasu no* Jizō (safe-childbirth Jizō) who admonished Minamoto no Yorimitsu (also called Raikō) not to bring the head of the demon Shuten *dōji* (a figure associated with a different peak called Ōeyama, a bit to the south) into the capital but rather to bury it there at Ōe no saka in the place now known as Kubitsuka (Tomb of the Severed Head).[108] This safe-childbirth Jizō of Ōe no saka was thus a known site, easily recognizable to those who heard the Shuten *dōji* story. In fact, there is another text called *Koyasu monogatari* that uses different characters in its title and tells a somewhat different story; this other text could be related to the site in Tanba.[109] Although there are a few points of similarity beyond the title, this is most decidedly not the same tale. First of all, this *Koyasu monogatari* begins by discussing the pains and dangers of childbirth, describing cases where a difficult labor might go on for days, the afterbirth might fail to appear *(hōe kudarazu shite)*, and so on. It says that Jizō, seeing the tribulations of childbirth, has taken compassion upon the women of the world and made a great vow to protect women and children in childbirth *(koyasu heisan no daigan)* and that "in this very country of Japan" blessings of the vow can be obtained.[110] Then it launches into the tale. This text places considerable emphasis throughout on the experience of childbirth and the anxiety and pain of the mother, an aspect that makes it markedly different from the text examined above.

This other *Koyasu monogatari* survives in a very rare printed edition from the mid-seventeenth century and tells the story, set in the seventh century, of a wealthy but childless old couple living near Ōe no saka who pray for progeny. An old man appears to them and gives each a small box. Ten months later, the woman gives birth to conjoined twins with "two heads and eight legs," and they are given the names "Tamamatsumaru" and "Tamawakahime." The capital is at this time plagued by strange signs and events, and a monstrous birth is said to be the cause. The twins are, as in the other tale, falsely accused, arrested, and saved from execution when the sword blade shatters across their necks. In this case, a voice from the sky announces that the twins are Jizō and Kannon, two deities who were often associated, as we have seen. The real culprit, here the infamous demon Shuten *dōji*, is apprehended, and the children are returned to their aged parents. In this version of the story, it is the twins themselves who later discover a miraculous fount of sake that restores youth to the aged. The emperor, in recognition of this boon, gives them rank and grants their request to marry one another. At this point, they remember their purpose in coming into the world and make a vow to rescue any woman experiencing difficulty in childbirth. They carve a wooden Jizō image and disappear into thin air. Their parents then build a small hall and enshrine the statue in their home village of Ōe no

saka. Responding to a dream, the old couple cut down a cherry tree and from it carve an exact duplicate of the miraculous image, setting it up in a hall that they build at the village of Otowa, the site of the (future) Kiyomizudera. The story continues, explaining that it was in fact this small Jizō shrine that inspired the legendary eighth-century general Sakanoue no Tamuramaro to build Kiyomizudera and erect a pagoda, the *koyasu no tō,* at that spot. According to this tale, it was Taira no Kiyomori who rebuilt the *koyasu no tō* after it had been destroyed in a fire. The text tells us that he did so to ensure the birth of an imperial son to his daughter Kenreimon'in, whose pregnancy had been made difficult by the resentment of the spirits of the bishop Shunkan and the other exiles of the Shishigatani affair. Thus, the text follows the *Tale of the Heike* to provide quite a bit of historical detail while insinuating the *koyasu* Jizō at every turn. It describes the burning of Kiyomizudera as follows:

> During the reign of Retired Emperor Takakura, in the second year of Kaō [i.e., 1170], the monks of Mount Hiei, prompted by some resentment of the Kōfukuji, set fire to Kiyomizudera [a Kōfukuji subsidiary]. The flames eventually traveled down, and the *koyasu no tō* also caught fire. It was completely lost to the flames in a matter of moments. At this juncture, there was nobody who could go into the building to rescue Jizō bosatsu. However, Jizō himself leapt out through the smoke and settled himself in the middle of a rice paddy to the south of Rokuharamitsuji.[111]

Hearing of Jizō's own initiative to rescue himself from the conflagration at Kiyomizudera and of his destination, we think of the rice-planting *(taue)* Jizō and other images that move of their own accord. This is a statue that rescues itself, reaffirming the notion we encountered earlier of mobile images, of Jizō statues as living entities. In this case Jizō flies to safety for a gentle landing in a rice paddy.

Seeing this miracle, Kiyomori decided to build a pagoda *(tō).* Actually, the text is rather ambiguous. Did Kiyomori rebuild the *koyasu no tō* in its original location, or did he erect a new pagoda in the spot that the *koyasu no* Jizō had chosen for himself, in the rice paddy to the south of Rokuharamitsuji? In the latter reading, this text would also seem to suggest another temple, one devoted to Jizō in the Kiyomizuzaka area and not the Taisanji. (In this tale, the *honzon* of the *koyasu no tō* would seem to be Jizō, not Kannon, suggesting that it was a different *koyasu no tō* from Taisanji's.)

The tales have a number of similar motifs and yet are developed in very different directions. As we have seen, the emphasis on safe childbirth is much stronger in the printed text of 1661, which proclaims in its intro

ductory section that Jizō will appear to save the life of any woman about to die in childbirth, and then in its final pages offers a fail-safe prescription for easy childbirth:

> And so, in order to receive the blessings of the great vow for ease and safety in childbirth [koyasu heisan no daigan] from this Jizō bosatsu, do as follows. Put on an obi [cloth sash worn as a belt] about five feet in length—it matters not if it be silk or hempen—and pray, "Hail to Jizō bodhisattva, of great mercy and great compassion, of ease and safety in childbirth, I humbly beseech your protection" [Namu kimyō chōrai, daiji daihi, koyasu heisan Jizō bosatsu]. Take a strip of paper and write the prayer upon it to use as an amulet, a talisman to be worn against your skin. Diligently chant the holy name of Jizō without slacking a bit. If you do these things, you will never again have anything to fear regarding difficult childbirth.[112]

The Jizō hall of Ōe no saka in this version is called Daifukuji. Two gazetteers from the Edo period have revealing entries on this place. The first is the 1711 work Sanshū meisekishi (Famous Historical Places in Yamashiro), a guidebook, that notes that the temple was called the koyasu Jizō and that the main image was carved by Genshin. It describes the statue as a seated Jizō less than a meter tall. The other reference is found in the Miyako meisho zue (Illustrated Map of the Famous Sites of the Capital) of 1780, which relates the following origin story for the image. In this tale, Genshin is traveling when the ghost of a woman who had died in childbirth appears to him and begs to be saved from hell. He performs various rituals to save her, and she begs him to endeavor to prevent other women from suffering her fate. He cuts down the cypress tree (kaya) growing from her grave and fashions this small Jizō image from it.[113] The temple that currently claims the mantle of "the koyasu Jizō of Ōe no saka" is Chōrakuji, which houses a small seated image seventy-one centimeters tall, designated an Important Cultural Property and formerly a National Treasure.

This unusual fourteenth-century image, representing a decidedly relaxed Jizō holding the shakujō staff in his left hand instead of in his right, is also linked in the temple's legend to rescuing Kenreimon'in from a difficult childbirth and causing her to safely deliver the baby who would become Emperor Antoku.[114] Antoku, by the time he was five, had ascended the throne, championed by the Taira clan. The heart-wrenching story of Kenreimon'in and Antoku is immortalized in the Tale of the Heike. At the sea battle of Dan no ura in 1185, the final dramatic confrontation in the Genpei wars, Kenreimon'in leapt from a boat carrying the fleeing

burg's notions of Apollonian and Dionysian, there is something of a dual nature to Jizō, between the young sweet-faced Buddhist monk and the ancient phallic stone wrapped with deeply stacked votive bibs. It is the latter I am placing at the "pagan" pole. This dangerous ecstatic power of Jizō, the master of death and birth, as a stone god—a raw and untamed power—stands in opposition to the doctrinal sophistication and artistic subtlety of the Kamakura-era statues. One might imagine the dressing of a stone Jizō in a bib as the sublimation of the wild god *shaguji;* with the gift of the robe, he is enfolded into the sangha. This autochthonous god of unbridled creativity who dwells in and manifests through the ancient stones is thus transformed into the controlled and hermetic body of the monk (fig. 4.22).

In Jizō's cult and iconography there is a fascinating tension, or rather oscillation, between motion and stillness. The story behind a late Tokugawa-period standing Jizō image at Jizō-in in Seki, Mie Prefecture, illustrates this well (fig. 4.23). The Tokugawa house requested an audience with the seated Jizō image from the venerable Seki no Jizō-in (Jizō of the barrier) and ordered that the statue be brought to the capital Edo

Figure 4.22 Natural stones representing the *shaguji,* inside a small stone shrine. Photo by Ashida Ei'ichi, ca. 1960.

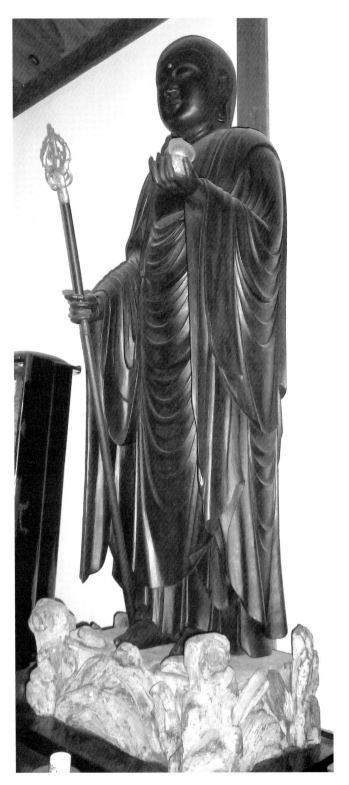

Figure 4.23 Standing Jizō, eighteenth century. Courtesy of Seki Jizō-in. Photo by author.

Figure 4.24 *Dokuson raigō Jizō*, by Kanō Tan'yu, ca. seventeenth century. Courtesy of the Mary and Jackson Burke Foundation, New York. Photo by Sheldan C. Collins.

(modern-day Tokyo) in a *degaichō* (religious procession). The standing image, set atop a replica of the original image's unique craggy base, was created in response to this shogunal summons. Temple officials, reluctant to send the holy icon, created a proxy. The surprised *bakufu* officials were told that the temple's *honzon* had risen from his meditation seat to stand upon the dais in preparation for the journey.[120] Another iconographical expression of stillness in motion can be found in the cloud-borne descent of the *dokuson raigō* Jizō, which, as we saw, flourished for many centuries in Kōfukuji circles. We close our exploration here, with a seventeenth-century rendering of this theme by Kanō Tan'yu (fig. 4.24). Here, in a composition Tan'yu used more than once in a hanging scroll, Jizō flies down, merrily playing a flute and wearing as a hat the inverted lotus leaf so often seen on the heads of hungry ghosts *(gaki)* in the *Kumano kanjin jukkaizu*.[121] This painting expresses, as well as any other, the combined qualities of motion, connection to the marginal, and performance we have seen associated with Jizō. It takes up the *dokuson raigō* iconography and offers more than one new twist.

Abbreviations

DNBZ	*Dai Nihon bukkyō zensho.* 大日本 佛教 全書. 1912. Ed. Bussho kankōkai. 150 vols. Tokyo: Bussho kankōkai.
MJMS	*Muromachi jidai monogatarishū* 室町時代物語集. 1940. Ed. Ōta Takeo 太田武夫 and Mori Takenosuke 森武之助. Tokyo: Ōokayama shoten.
MJMT	*Muromachi jidai monogatari taisei* 室町時代物語大成. 1973–1985. Ed. Yokoyama Shigeru 横山重 and Matsumoto Ryūshin 松本隆信. 13 vols. Tokyo: Kadokawa shoten.
NKBT	*Nihon koten bungaku taikei* 日本古典文學大系. 1957–1967. Ed. Takagi Ichinosuke 高木市之助 et al. Tokyo: Iwanami shoten.
Reigenki	*Jūyonkanbon Jizō bosatsu reigenki* 一四卷本地蔵菩薩霊驗記. 2002–2003. Ed. Ōshima Takehiko 大島建彦, Enomoto Chika 榎本千賀, et al. 2 vols. Tokyo: Miyai shoten.
SNEZ	*Shinshū Nihon emakimono zenshū* 新修日本絵巻物全集. Ed. Kameda Tsutomu 龜田孜 et al. 1975–1977. Tokyo: Kadokawa shoten.
T	*Taishō shinshū Daizōkyō* 大正新修大蔵経. 1979. Ed. Takakusu Junjirō and Watanabe Kaikyoku 高楠順次郎, 渡邊海旭. Tokyo: Taishō issaikyō kankōkai.

Notes

Translations are mine unless otherwise noted. It has been my policy to use the translations of others where they exist.

Chapter 1: The Iconology of Jizō

1. Sakamoto et al. 1965, 68:100–104 (10th month winter 552). Also see Como 2008b, 18. The phrase "countenance of severe dignity" is from Aston's 1894 translation (Aston 1993, book 2, 66).

2. Translation from Deal 1995, 218, with slight modification. Deal's "face of extreme solemnity" renders the same phrase as Aston (1993): *mikao kirakirashi*.

3. On the origins of this term and its use by Warburg, beginning in 1912, see Heckscher 1967. For a concise accounting of Warburg's method, see Burucúa 2003, 28–34.

4. Faure 1998a, 791.

5. See the article by Agamben (1999) on the "nameless science," or in, its original Italian title, "la scienza senza nome." The original reference is R. Klein 1970, 224. Also see Ginzburg 1989 and Woodfield 2001.

6. For reflection on and critique of "visual culture" or "visual studies" as a discipline, see Morra and Smith 2006; Mitchell 2002; Elkins 2003; and Jay 2005. For a particularly useful exploration from the field of religious studies, see Morgan 2005. Also see Warburg's disciple Edgar Wind (1993) on the concept of *Kulturwissenschaft*.

7. For an accounting of Warburg's ideas and influence, see Gombrich 1970; Ginzburg 1989; and Rampley 1997.

8. Haskell 1993, 382–383. For a detailed treatment of Warburg's historiographical stance, see Mali 2003. In many ways, Warburg's project was more centered in cultural history than in art history; see Bialostocki 1981 and

Foster 1976. Georges Didi-Huberman (2003) has written eloquently about the "problem" of history and anachronism in Warburg. Warburg's work was also driven by fantasy and creativity regarding the nature of the archive and the interpretation of sources. See the encyclopedic meta-scrapbook *Mnemosyne* (Spinelli and Venutti 1998).

9. Agamben 1999, 102. For further reflections on the nature of Warburg's method, also see Ginzburg 1989; Schmidt and Wuttke 1993; and Woodfield 2001.

10. On Warburg's approach to historical inquiry, see Burke 1991. Also see Cieri Via 1994 and Diers 1995.

11. Davis 1997; Swearer 2004; Campany 1993; Kinnard 1999, 25–44. Also see the essays collected in Maniura and Shepherd 2006 and Freedberg 1989.

12. On living icons in Japanese Buddhism, see Sharf and Sharf 2001 and Horton 2007.

13. Faure 1998a, 790–791.

14. On Panofskian iconology as opposed to Warburgian, see Katō Tetsuhiro 1992; Iversen 1993; and Agamben 1999, 99–100. Also see Ferretti 1989; Gombrich 1970, 307–324; Holly 1993; and R. Klein 1979, 143–160.

15. On the problem of viewing religious painting and sculpture as art and on the category of art as a culturally and historically specific notion, see Belting 1994, 1–16; Dean 2006; Silver 1993; and Pitelka 2008.

16. On this aspect of Buddhist images, see Campany 1993, 258–259; and Faure 1998a, 784, 799–807.

17. Zhiru (2007, 7) has pointed out that this label is also somewhat of an oversimplification in the Chinese case.

18. It would be incorrect to think of non-Buddhist gods in Japan as exclusively "Shintō" and thus native to Japan; many deities found in early Japanese myth have continental origins (see Como 2008b). On the problematic nature of the term and the very idea of Shintō as an indigenous religion, see Kuroda Toshio 1981. However, at various points in this work I will hint at autochthonous aspects of Japanese religion. Perhaps it is better to say "pre-Buddhist," but there is no history in Japan before Buddhism. My intent in invoking the category of the autochthonous is to create a loose parallel to what Warburg referred to as *Nachleben* (lit. "afterlife"), the persistence of ancient motifs, myths, and beliefs even as cultural paradigms undergo major transformation. As Warburg was interested in the use and transformation of classical tropes in the Christian art of the Renaissance, I will argue that the Jizō image has at times been the locus of synergy between Buddhism and "folk religion." On *Nachleben* in Warburg's thought, see Didi-Huberman 2002.

19. On *honji suijaku*, see Yoshida 2006; Teeuwen and Rambelli 2003; Murayama 1974; Grapard 1986; Matsunaga 1969; S. C. Tyler 1989; Kamata 1995; and Moerman 2004.

20. This idea was a prominent one in the Chinese cult of Jizō (Dizang); see Zhiru 2007, 48–49. It continued to receive emphasis in Japan.

21. Zhiru 2007, 55–57. The Korean monk Sinbang, a disciple of the famous pilgrim-monk Xuanzang and an important Yogācāra thinker who later became a Sanjie jiao follower, said that Jizō (Dizang) is the most important bodhisattva for beings in this third and final stage of the world's decline (Yabuki 1927, 638–639). For more on Sinbang and the Jizō cult, see Zhiru 2007, 61–68. Also see Hubbard 2001 on Sanjie jiao.

22. In the present book, "Pure Land" refers either to the sect dedicated to the worship of Amida Buddha or to his paradise, Gokuraku, and the low-ercased "pure land" is a general designation for a heavenly abode of a deity.

23. See Fowler 2005, 180–189, for examples of images of and rituals dedicated to this pair of bodhisattvas in China, Korea, and Japan. Also see Shimizu 1999b.

24. Tanaka Hisao 1989, 24–52; Tanaka 1983?

25. Pinotti (2001, 24–25) sees the role of polarities and conflict in War-burg's theories of art as the legacy of Goethe. On the idea of the image as the place where opposing ideas clash, also see Agamben 1999, 102; and Rampley 1997, 49–50.

26. Warburg 1932.

27. Ōshima in *Reigenki* 1:iv. In subsequent chapters we will have occasion to explore the links between these gods and their relationship to other small stone gods—the *mishakuchi,* the *shakujin,* the *shukujin,* and so on.

28. Iversen 1993. Also see Didi-Huberman 1996.

29. Horiguchi Sōzan was the former owner of the statue I refer to as the Rockefeller Jizō in the next chapter. In the book he wrote on the image, Horiguchi closes his introduction with a heartfelt wish that we, each of us, cultivate our own "Jizō face" and thereby make our families, our society, and our world truly peaceful and compassionate (1955, 2–3). The phrase is also used in other common expressions, such as "Borrowing money, Jizō's face; repaying the debt, Enma's" *(kariru toki no Jizōgao, nasu toki no Enmagao).* Furthermore, in her famous Heian-period miscellany *Makura no sōshi* (The Pillow Book), Sei Shōnagon confesses her strong attraction to the teenaged monk Ryūen *sōzu,* whom she describes as having a face as beautiful as Jizō's *(NKBT,* vol. 19, 278).

30. For an overview of Jizō iconography, see Mōri Hisashi 1974. On the *mani* jewel *(cintāmāni)* and the *shakujō,* or *khakkara,* see Saunders 1985, 154–156 and 179–181, respectively.

31. McCullough 1988, 68. " 'Ikaniya,' to notamaheba, sono toki mitsu-ketatematsuri, urishige ni oboharetaru keshiki, jigoku nite zainin domo ga Jizō bosatsu wo mitatematsuramu mo, kakuya to oboete ahare" *(NKBT,* vol. 32, 159).

32. Watari 1997, 132, in a book review of Ishikawa Jun'ichirō 1995.

33. On the identity of the Northern Fujiwara, the Ōshū Fujiwara of Hiraizumi, see Yiengpruksawan 1998, 160–166; and Walker 2001, 23–25.

34. In the mandala, however, he appears nowhere in the guise of a monk. Ishida Hisatoyo 1978, 1:115–122.

35. Hayami 1975b, 60–63.

36. Mochizuki 1989, 55–60; cf. Asai 1986.

37. Hayami 1975a, 32.

38. Zhiru 2007, esp. 50–77 and 169–172. Zhiru's fascinating study is required reading for anyone interested in the cult of Dizang in China.

39. Zhiru (2007, 13–16) has argued that while this is the modern perception of Dizang, historically his role was broader. Wang-Toutain (1998) thoroughly explores this view of Dizang as savior of the dead seen in the texts and wall paintings from Dunhuang.

40. *Shasekishū, NKBT,* vol. 85, 314. Translation from Mujū 1985, 210 ("Yada" altered to "Yata").

41. Tani 1939, 93. Also see Sugawara (1966), who suggests the late Heian period; and Watari 1980.

42. Mochizuki 1989, 191–192; Manabe 1981, 45–47.

43. Hayami 1975b, 59–74.

44. I have placed an asterisk next to Dizang's Sanskrit name since there is some evidence that this bodhisattva, portrayed as a celestial divinity rather than as a monk, was in fact introduced into the Indian Buddhist pantheon through Chinese or Central Asian influence. See Zhiru 2007, 229–239.

45. T262:9:57c21–c22. See Yü 2001 on the cult of Guanyin. For a wide range of articles addressing the figure of the bodhisattva in Mahayana Buddhism, see Kawamura 1981.

46. For the question of Dizang's origins in India or Central Asia, see Zhiru 2007, 229–239. Many popular Japanese studies on Jizō, and even encyclopedia entries, point to his origins in the ancient Indian earth goddess Pṛthivī, but there is no historical evidence for any connection. There are tantalizing hints that Dizang's popularity is at least in part connected to Uygur influence and quite possibly related to Manicheanism. See von Gabian 1973; J. Williams 1973, 131–132; and Russell-Smith 2005, 223–227.

47. On the iconography of hell in Japan, see Hirasawa 2008; Peschard-Erlih 1991; and Wakabayashi 2009.

48. For the early Japanese Jizō cult at Yōkawa, see Hayami 1975b, 57, 89–95; and Takahashi Mitsugu 1983. Genshin (1971), in his *Kanjin ryaku yōshū,* also mentions Jizō's ability to substitute his own body for the bodies of sinners undergoing torture in hell.

49. For the Mulian legend, see Teiser 1988a; Sawada 1968; and Mair 1983, 87–122.

50. On filial piety in Indian Buddhism, see Schopen 1984; Strong 1983; and Holt 1981.

51. On the idea of the period of "semblance" or "image" dharma *(saddharma-pratirūpaka)* in Buddhist theories of historical decline, see Nattier 1991, 66–89.

52. *Dizang benyuan jing,* T412:13:778b18–c11; Śikṣānanda 2000, 6–8.

53. On apocryphal sutras, see Makita Tairyō 1989 and Buswell 1990.

54. Shimizu 2002. On the marginality of Dizang in the written text of

the sutra, see Teiser 1994, 167–179. For a list of more than ten visual representations of Dizang with the ten kings found in the Dunhuang caves of western China, see Teiser 1994, 230–232 (reproductions of two of these appear on 36–38).

55. In a story in the *Nihon ryōiki*, a man named Fujiwara no Hirotari journeys to the underworld; inquiring about the status of the imposing judge-king Enma, he is told, "In your country he is called Jizō bosatsu." *Nihon ryōiki* 3:9, *NKBT*, vol. 70, 338–342, trans. in K. Nakamura 1973, 233–234. The full title of the *Jizō jūō kyō* is *Bussetsu Jizō bosatsu hosshin in'nen jūō kyō* (The *Ten Kings Sutra* as Preached by the Buddha on the Causes and Conditions That Lead to the Bodhisattva Jizō's Aspiration for Enlightenment). For a concise discussion of this sutra in English, see Teiser 1994, 57–61. Also see Manabe 1960, 124–131. The identity of Jizō and Enma was all but unknown in Korea and China. For hints that a similar equivalence between Dizang and Yanlo Wang may have been drawn in China, see Zhiru 2007, 187; and Hirasawa 2008, 24.

56. On the iconography of the ten kings and Jizō in medieval Japan, see Hayashi Masahiko and Watari 1990; Nakano Teruo 1992; and Wakabayashi 2009.

57. See Glassman 1999, 137; and Iwamoto 1979, 110. Also see Hirasawa 2008, 15–16.

58. See Matsushima 1986; and Nakano Teruo 1992, 84 plate 65.

59. Yiengpruksawan 1998, 122–158; on Jizō, see esp. 130, 141. On the Konjikidō Jizō statues, also see Mochizuki 1989, 71–72.

60. There is some controversy over the historicity of the claims that Chōgen went to China three times, and some scholars doubt that he went at all. Nevertheless, the tradition that he went multiple times was an important one in Nara Buddhist circles, and the epistolary and material exchange with the continent he conducted was extensive. See Yamamoto Eigo 1983.

61. On the special merit of creating Jizō images as described in Kamakura-period miracle tales, see Narita 1993.

62. The definitive edition of the text is *Reigenki* (Ōshima et al. 2002–2003). Some of the tales are translated in Dykstra 1978. The earliest mention of Jitsuei's *Jizō bosatsu reigenki* is in the mid-Kamakura period *Kakuzenshō*, in relation to a discussion of the iconography of the six Jizōs (*DNBZ*, vol. 48, 205–206 [1435–1436]). For the purposes of our discussion, it is best to think of both the fourteen-fascicle version edited by Ōshima and the thirteen-fascicle version collected in *Gunsho ruijū* 1959–1960 and in Jitsuei 1964 as a product of the developed Jizō cult of the later medieval period, though many parts of the text are much older.

63. *Reigenki* 13. For more on Mr. Wang, see *Reigenki* 4:3, 184–186, and 5:6, 252–253. For a translation of this—"the earliest Dizang miracle tale," according to Zhiru—see Zhiru 2007, 170–172. The hell-smashing verse is as follows (in Zhiru's translation): "If a person seeks to apprehend all of the Buddhas of all three realms, he or she should contemplate thus: It

is the mind that creates all *tathāgatas."* The tale originally appears in the early eighth-century *Huayan jing zhuanji,* by the famous Huayan patriarch Fazang. The verse reflects the mind-only teachings of his school. On this legend, also see Watari 1994.

64. The *Zongjinglu* was compiled by the tenth-century Chan (Zen) master Yongming Yanshou. The annotation in Ōshima et. al 2003 refers the reader to chapter 91 of the *Zongjinglu,* but this seems to be a misprint for "chapter 9," which contains the relevant passage. See *Zongjinglu, T2016:48:461b08.*

65. *Reigenki* 16–32. It is likely that this section was added at a later date (it does not appear at all in the *Gunsho ruijū* 1959–1960 version of the text), but it serves as a useful overview of some important features of Jizō's characteristics and iconography. Reference to him as the "hopeless sinner," or *icchantika,* appears on 18 and 19. The *icchantika* (J. *issendai*) is a class of beings who cannot be saved, because they possess none of the seeds of Buddhahood. In Jizō's case the term indicates that he chooses to be born again and again in the hells where he labors to save beings, postponing his own enlightenment indefinitely.

66. For an insightful analysis of the way these details from the real world, often culled from rumors, or *sekkenbanashi,* serve to lend an aura of verisimilitude to such tales, see Minobe 1988.

67. For a textual history of the *Reigenki,* see Watari and Kōdate in Ōshima et al. 2003, 2:345–395. On the circumstances of Miidera (Onjōji) in early medieval Japan, see Wakabayashi 2002. An illustrated version can be found in Umezu 1980.

68. *Reigenki* 33–35. Also see *Konjaku monogatarishu* 17:12 (*NKBT,* vol. 24, 519), which ends a bit differently, by urging people to respect sculptors, even if they are faithless swindlers.

69. *Reigenki* 62–64. The fact that Shōrenbō, likely a self-ordained holy man, or *hijiri,* was married is not surprising given the customs of the time, though his reference to "breaking the precepts" may give us cause to wonder how this lifestyle was viewed by the authors of the tale. (A similar but not identical story appears at *Konjaku monogatarishū* 17:31.)

70. This language of marginality, *hendo gesen no kyō,* is usually used to refer to Japan's distance from the holy land of India, but here it is turned to a different purpose.

71. This is a stock expression to describe a life of radical asceticism. Rather than literally "eating wood and wearing grass," it implies renouncing grains to subsist on berries, roots, and leaves, while also eschewing cultivated fibers like cotton, hemp, or silk in one's clothing. The following "dwelling under trees and atop rocks" is a similar sort of phrase.

72. *Reigenki* 86. The Dharmakāya, *hōshin,* is one of the three bodies of the Buddha. In this context, it refers to the universal, all-pervading, and primordial nature of the buddha Vairocana, or Dainichi.

73. *Reigenki* 85–86. This story also appears in *Konjaku monogatarishū*

17:16, where the protagonist is called Zōkai. It is clear that members of the *shugen* confraternities were important advocates of the Jizō cult (see Tanaka Hisao 1983), so this story is very interesting in that regard, as is the one that follows here. That next story takes place in Yoshino, another *shugen* center, and mentions Nichizō *shōnin*, who was involved in such practices and whose name shares the character "zō" (storehouse) with "Kaizō *shōnin*" as well as, of course, "Jizō."

74. *Reigenki* 167–171. "Tangerine" here translates *kōji*, a smaller relative of the mandarin orange, or *mikan*. Often the word was used to refer to the *mikan* itself. The tale was rather famous and also appears in the *Jizō bosatsu kan'ō den* and several other texts; it is even mentioned in the *sekkyō bushi* version of *Sanshō dayū*, see the note by Kōdate Naomi in *Reigenki* 171.

75. His prayer refers to the particular soteriological difficulties Japanese Buddhism posed for women: the "five obstacles and three subjugations," *goshō sanjū*. See Glassman 2002 and Kamens 1993.

76. Other texts also draw a connection between Jizō and Fudō, emphasizing Jizō's benignity and Fudō's fearsomeness. The *Shasekishū* says that both are manifestations of Dainichi, Jizō revealing his gentleness and Fudō his strength. The *Bodaishin bekki*, by thirteenth-century Zen master Yōsai, explains in similar terms that Jizō is like a mother and Fudō like a father: Jizō a rice pot, and Fudō a hatchet. *Reigenki* 171.

77. The role of dreams is prominent in these miracle tales; dream communication and oracles are indeed at the heart of the Jizō cult.

78. On traveling Jizō images, see Matsuzaki 1983, 1985. Lisa Ann Pluth (2004, 44–74) has written about the "royal ease" seated posture, or *lalitāsana*, and the strong sense of motion it conveys in Tang-period cave images of Dizang. This observation certainly applies equally to such seated images in Japan; many appear on the verge of rising from their lotus seats.

79. Faure 1998a, 770.

80. Warburg (1992, 18) used the term *bewegtes Beiwerk* (elements of movement, accessories in motion) to describe this frozen animation as expressed in quattrocento art through blowing tresses and ribbons, billowing robes, or fluttering blossoms; see Rampley 1997, 42, 50. He was at the same time interested in the power of certain bodily attitudes of gestures, which he called *Pathosformel*, to carry culturally encoded emotional content (Agamben 1999, 90). For Warburg's ideas about motion, also see Michaud 2004, 67–91; Tanaka Jun 2001, 127–155; and Didi-Huberman 2004.

81. Michaud 2004, 96. The portion quoted by Michaud appears in Warburg 1999, 187, and the second bracketed interpolation is present in Michaud's original. On the naïveté of the art historian who would think that the modern person can have access to the lost world of the past because the image, as read by the expert eye, lays it bare, see Didi-Huberman 2005, 51–52.

82. This is clear in the phenomenon known as "Jizō's surname," *Jizō no myōji*, whereby Jizō images tend to be called the "nail-pulling Jizō" (*kuginuki* Jizō), the "taro potato Jizō" (*satoimo* Jizō), the "night crying Jizō" (*yo-*

naki Jizō), the "sweating Jizō" (*asekake* Jizō), the "bound Jizō" (*shibari*, or *shibarare*, Jizō), and so on. See Yanagita 1999 and Shimizu 2000. For an extensive catalog of these names, including location and temple name, see Motoyama and Okumura 1989, 447–477. Also see Horton 2007, 129.

83. Mochizuki 1989, 74–77. For an amusing story, from twentieth-century Japanese fiction, of Jizō's refusal to move a large stone until asked politely, see Natsume 2002, 503–510.

84. The meaning of *nōge* is somewhat ambiguous here. While Tendai priests with permission or certification to teach students were known as *nōge*, and the term is also applied to eminent clerics in other sects, it can also mean a buddha or bodhisattva. In Jizō's case it would seem to point to his ability to travel to and teach ("ge/ke," the character for "transform," short here for *kyōge*, "to teach") in any of the six realms of existence; the bodhisattva sends "transformation bodies" of himself *(keshin)* to teach *(kyōge)* into each of the six realms in order to save the sentient beings.

85. See Hayami 1975b, 63–71; and Manabe 1981, 90–105.

86. Manabe 1981, 90. Also see Hoshino 1961 and Takasu 2006.

87. Mochizuki 1989, 26.

88. Hayami 1975b, 63, 70. There is an early and pristine image of six Jizōs in a mid-thirteenth-century scroll, Manuscript 21 of the New York Public Library's Spencer Collection, *Sanjū butsu nijūgo bosatsu roku Jizō zu*. On six Kannons, see Fowler 2007.

89. See Zhiru 2007, 69–70, for the six Jizōs; 68–75, for Jizō and the six paths.

90. See, e.g., *Kakuzenshō* 1979 (*DNBZ*, vol. 48, 204–206; 1434–1436 in alternate pagination). On the six Jizōs, see Matsushima 1986, 48–53.

91. *Reigenki* 95–97. The tale also appears in *Konjaku monogatarishū* 17:23; *Genkō shakusho* 17, "Koretaka"; and *Jizō bosatsu kan'ōden*, 2:26. For a different story of Jizō/Dizang imposing an iconographical correction on a visitor in hell, see Teiser 1988b; Zhiru 2007, 125, 175–177; and Pluth 2004, 81–83.

92. On Mahākāśyapa and the legend that he will wait, ensconced in a mountain, to transmit the robe of Śākyamuni to the future Buddha Maitreya, see Adamek 2000, 73–75.

93. On young boys in Japanese religion, see Guth 1987; Lin 2003; Murray 2000, 70–96; Faure 1998b, 241–278; and Nakazawa Shin'ichi 2003, 61–67.

94. Faure 1998a, 768. On the idea of the capacity for vision in Buddhist icons, also see Gell 1998, 148–150. On the gaze of images and their animated nature more generally, see Gell 1998, 96–154; and Eck 1981. A different exploration of how idols and icons stop or return the gaze can be found in Marion 1991.

95. See, for example, his article on the Piazza Schifanoia (Warburg 1932).

96. There is a large bibliography on *mizuko kuyō*, the modern Buddhist memorial service for the unborn dead, in English; inter alia, see Harri-

son 1996; LaFleur 1992; Bargen 1992; and Hardacre 1997. Also see LaFleur 1999 for a thoughtful critique of Hardacre and a reframing of the debate. On *mizuko kuyō* in the United States, see Wilson 2009 and Bays 2002.

97. I would like to suggest, as I do in Chapter Four, that Jizō in this context is closely related to the "autochthonous" *kosōteki*, Japanese stone gods of fertility and generative power described in Nakazawa Shin'ichi 2003. On the autochthonous deities of Japan, see Tanaka Takako 1995 and Kokubu 1992.

98. See Hayashi On 1998, figs. 1:12, 1:13, and plate 3. Photographs of the image also appear in the first pages of *Bukkyō geijutsu* 241, plates 9–13. In any case Hayashi counts exactly one thousand Jizō images in the painting. Of course the number one thousand usually simply signifies a great number. Readers may want to try to count the Jizō images in plate 3.

99. On the division bodies of Jizō numbering "tens of thousands of millions" and more, see *Dizang pusa benyuan jing*, chap. 2, T412:13779a29–c13. On the Fukuchi'in image, see Matsushima 1986, 14 plate 17, 42 plate 66; Hayashi 1988, 97n. 20. On a late medieval mutual aid society formed around the image, see Asuwa 1998.

100. Hayashi On 1998, 93 plate 10. The *kushōjin* is an important topic that cannot be treated in detail here, but there is an extremely close connection between these deities who perch on the shoulders (akin to the angel and devil or twin genii of Western lore) and the two boy "acolytes" of Jizō. See *Reigenki* 1:4, vol. 1, 45–48; 1:8, vol. 1, 58–61; Soymié 1966–1967; and Faure 2006, 262–263.

101. See Ishida Mosaku 1964, 30; 117–119 plates 67–71. Also see Ishida 1960.

102. On the Cologne Jizō, see Goepper 1984. For other examples, such as those found in the body of a 1239 Jizō statue at Nara's Ōkuraji, see Sugiyama 1962; Ōta Koboku 1974; Shibata Minoru 1974; Ishida Mosaku 1964, 116 plate 65; and fig. 2.13 in this book.

103. *Reigenki* 2:1, vol. 1, 68; also in *Konjaku* 17:21. Also see Horton 2007, 151–152.

104. See Hayashi On 1998 on this image in Nara National Museum collection.

Chapter 2: Monastic Devotion to Jizō

1. Horiguchi 1955, 1. I have scoured Fenollosa's oeuvre for these words of praise, but they prove illusive. I have asked around and have received much help from colleagues and archivists in looking through his letters and other materials, but still have found nothing. As these words of praise appear on the first page of this book by the statue's former owner, Horiguchi Sōzan, I will take it as part of the legend of the work and accept it as true. (It by no means seems unlikely.) Fenollosa knew of the show and was in the Midwest that year, but his impressions of it apparently were not recorded. My thanks

go to Scott Johnson and Yamaguchi Seiichi, to Rachael Woody of the Freer and Sackler Archives at the Smithsonian Institution, to the Missouri State Archives, and to others for help in my search for Fenollosa's reactions. On the Japan pavilion at the fair, its curatorial agenda, and its public reception, see Christ 2000.

2. Ibid.; Kuno 1966, 13ff.

3. On the practice of placing objects inside statues, see Kurata 1973 and Ikoma 2001. Also see Belting 1994 for European parallels.

4. Horiguchi 1955, 13.

5. Ibid., 4.

6. On Jizō's mantra, see Manabe 1981, 8–11, 143–147. On the magical properties of Sanskrit letters and text and their use in image cults, see Gimello 2004. Gimello skillfully reminds us that when elite and learned scholars of Buddhist doctrine were involved in the creation of meaning through image, their philosophical commitments naturally informed their ritual practice.

7. *Jizō bosatsu hongankyō*, T30:789c. Translation in Śikṣānanda 2003, 90. While Chōken's inscription matches the sutra as it appears in the Taishō canon, Jōkei's *Jizō kōshiki* renders it slightly differently; see Yamada Shōzen 2000, 104. In the *Jizō kōshiki* this stanza is followed by a prayer to meet with Jizō in lifetime after lifetime, a prayer that also appears inside the statue and is repeated in the *Jizō kōshiki* (ibid., 143) and elsewhere with variation in the wording.

8. Significantly, Jisshin originally took ordination under Ryōhen, who is discussed in some detail later in the chapter (Horiguchi 1955, 21). Also see Inagi 2005, 300–302. For the background of Kōfukuji during this period, see Motoki 2006.

9. Horiguchi 1955, 21. For background on Murōji's Dragon Cave and its rituals, see Fowler 2005, 15–41.

10. R. Tyler 1989.

11. On the history of the *kaihōgyō*, see Hiramatsu 1982.

12. On this lineage of sculptors and their involvement with Ritsu monks, see Groner 2001, 117–120; and Kobayashi Takeshi 1965. Also see Matsushima 1986, 67–68 and plate 12, for a beautiful Jizō statue in Yakushi-ji carved by Zen'en in 1240. Yamamoto Tsutomu (1982) also attributes the seated image of Jizō at Ōkuraji to the En school; cf. Sugiyama 1962.

13. Kuno 1966, 16.

14. See Nedachi 2006 on the social and religious milieu of the Nara *busshi*, or sculptors of Buddhist images.

15. Horiguchi 1955, 7.

16. Yamada Shōzen 2000, 210.

17. Ibid., 104.

18. See Ford 2006 for a study of Jōkei's life and thought. Also see Ueda 1977.

19. On the place of Jizō in Jōkei's program of worship, see Shimizu 1995; Taira Masayuki 1992; and Ford 2006, 96–97. For Jōkei's faith in the Kasuga deity, see Takei 1980.

20. On scholarly misuses of Jōkei's petition, see Ford 2006, 30.

21. R. Tyler 1990, 115–118; Grapard 1992, 74–82. For a ceremony (performed by one Insho *sōzu*) dedicated to the five *honji* of the Kasuga shrine in 1194, with Jizō worshipped as the god of the third sanctuary, Amenokoyane (Hiraoka *daimyōjin*), see Kujō Kanezane's diary, *Gyokuyō* (1969), 884. Kanezane notes that he has not before heard of Jizō's being worshipped in this context.

22. Yamada Shōzen 2000, 208. Here Jōkei draws from the *Dizang pusa benyuan jing*, T412:13:779bc and 789ab. For more on Jōkei and the Kasuga cult, see Fujimoto 1985 and Chikamoto 1998, 1999a.

23. Noma Seiroku 1978, 11:4 (72 plate 93), 12:3 (75 plate 94); Takashina 2005; Gomi 1998; R. Tyler 1990. Also see Motoi Makiko in Shibata Yoshinari et al. 2005.

24. Gomi (1998, 120) says that Jizō was the personal deity of the *warabe;* Grapard 1992, 100–106) discusses the role of the Kasuga *jin'nin* and mentions a group of blind *jin'nin* who were especially dedicated to Jizō (105). On *warabe* in medieval handscrolls, or *emaki*, see Tsuchiya 2001, 158–166. A ritual shrine dancer with the continental-sounding name of Koma Yukimitsu is taken on a tour of hell and then restored to life by the Kasuga god in *Kasuga gongen genki* 6:1 (61 plate 70). Though his manner of dress seems quite close to that of the *warabe*, there is no clear connection. The Kasuga *myōjin* guides him dressed in court clothing, not in the guise of Jizō.

25. On the Chisokuin Jizō and its legends, see S. C. Tyler 1992, 168–169; Sugiyama 1965, 33–44; Shimizu 1995, 38 n. 5; 1996; and R. Tyler 1990, 122.

26. This legend appears in a number of sources, including *Gaun nikkenroku*, Zuikei and Ikō 1961, 30 (Bun'an 5 [1448], 8/30). Also see *Daijōin jisha zōjiki*, Jinson 1978, vol. 27, 182–183 (Chōroku 5 [1461] 7/24).

27. It would be no easy feat to go out and find some sandalwood in Japan's temperate climate. The discovery of such a rare wood no doubt adds to the miraculous nature of the story. On the woods used in Japanese Buddhist sculpture, see Nedachi 2008.

28. For sculptures by Ono no Takamura of the ten kings and Jizō, see Wakabayashi 2009.

29. R. Tyler 1990, 122.

30. Suzuki Ryōichi suggests that the firm and consistent identification of Jizō with the third shrine (when the *honji butsu*—root deities—associated with the other shrines vary considerably) reveals the strong influence of popular cults on the aristocratic religion of the southern capital. Suzuki 1983, 50, cited in S. C. Tyler 1992, 166.

31. The Kasuga deity said that Myōe was his Tarō, his number one son, and Jōkei his Jirō, his second son. *Shasekishū* 1:5, *NKBT,* vol. 85, 70–71; Mujū Ichien 1985, 84–85. Also see Yamashita 1974; Fukushima 1976; and Tsutsui 1999.

32. Glassman 2002. On the Denkōji image as a "living Jizō," see Ikoma 2002.

33. Sugiyama 1965, 32. Also see Morse 1994.

34. Horiguchi 1955, 13.

35. Hayashi On 1998, 89. For more on Jōkei's *Jizō kōshiki* and those written by others, see Hoshino 1958.

36. Kuno 1966, 12–17. The Kannon statue is in the Nara National Museum collection. This seems to have been part of a set of five, three of which are known. Subsequent to the publication of Kuno's article, another statue—the Kasuga Wakamiya's *honji,* Monju bosatsu, now held by the Tokyo National Museum—was identified as the work of Zen'en. For a photograph of the Monju statue, see Fowler 2005, 195 fig. 5.9. Why the Wakamiya, a subsidiary shrine under Kōfukuji's jurisdiction, was excluded from Myōhō's project is an interesting question to ponder.

37. On this statue, see Guth 1981.

38. See Morse 2002b.

39. Sugiyama 1965, 25. The first two are Takemikazuchi no mikoto and Futsunushi no mikoto, the Kashima god and the Katori god, respectively. The fourth is the goddess Himegami. See Grapard 1992, 23, 82–93.

40. On *miya mandara*, see Sasaki Kōzō 1999; on the Kasuga mandara more specifically, see ten Grotenhuis 1999, 142–162; Kageyama 1973, 79–94; and especially Gyōtoku 1996.

41. See Hayashi On 1998; S. C. Tyler 1992.

42. On the relationship between celestial and terrestrial pure lands, see Moerman 2005, 42–91. As mentioned earlier, I have used the lower-cased "pure land" as a general designation for a heavenly abode of a deity, whereas "Pure Land" refers to the sect dedicated to the worship of Amida Buddha or to his paradise, Gokuraku. For images, see Nara kokuritsu hakubutsukan 1983.

43. *Shasekishū* 1:5, *NKBT,* vol. 85, 70; Morrell 1985, 84. For studies of Myōe in English, see Morrell 1987, 44–65; Kawai 1992; Tanabe 1992; Unno 2004; and Abé 2006.

44. For a translation and study of the play, see Morrell 1982.

45. See Brock 1988; Kusunoki 1989, 238; and Shimizu 1995, 31–32. Also see Nattier 1988 and Fujimoto 1983.

46. There are three buddhas in this painting: Amida, Yakushi, and Shaka. This work is analyzed in Motoi Makiko in Shibata Yoshinari et al. 2005. On the origins of this legend in rumor, see Matsushima 1986, 64–65; Kageyama 1973, 91–92; Hayashi On 1998, 88–89; ten Grotenhuis 1999, 148–149; and Minobe 1988. (This image is misidentified as a painting of Amida's Gokuraku in Pilgrim 1998, 14–15. Also, ten Grotenhuis [1999, 149] indicates that the monk led by Jizō is Jōkei, but it is his disciple Shōen.)

47. *Kasuga gongen genki e* 16.4 (82 plate 110); R. Tyler 1990, 266–267. A version of the tale is also in the *Reigenki* 8:1, "Honji suijaku shiru beki no koto," vol. 2, 14–20. Also see *Shasekishū* 1:6, Mujū 2001, vol. 85, 70–71; and Mujū 1985, 85–87. For a fascinating study of this story as it appears in *Shasekishū,* see Minobe 1988. For more on Shōen, see Shibata

Yoshinari et al. 2005. The same story appears in the *Sangoku denki* 10:27 (Ikegami 1982), but the monk is called Chin'en.

48. Minobe 1988, 50–52; Meeks 2003, 96–99; Hosokawa 1987b, 113ff. Also see Abé 2003. For more on the identification of Kasuga and Jizō, see *Reigenki* 7:7, vol. 1, 423–426, where a shrine maiden, or *shinnyo*, becomes a nun after a visit to hell, where she learns of this connection. Kōdate Naomi's note on page 426 there is particularly useful.

49. On the *fukusha*, see Motoi 2001. On this place in Chinese Dizang legends, see Zhiru 2007, 182–185.

50. On Mount Karada (Karadasen), see Manabe 1960, 12–14. On Jizō in the Maitreya cult and rebirth in Tuṣita heaven in China, see Zhiru 2005.

51. This story is the second tale in the first volume of the Tōji edition of the *Jizō bosatsu reigenki e*, but functionally it is the lead story, as the initial section consists in a general introduction to Jizō.

52. *Shasekishū* 2:5, *NKBT*, vol. 85, 104 (The relevant passage is not translated in Morrell's summary on 110–111 in Mujū 1985.) See Motoi 2001, 43–46. Mount Karada is Jizō's pure land to the south, and Mount Fudaraku is Kannon's pure land, in Japan usually understood to be an island to the southwest. On Mount Fudaraku (Fudarakusen), see Moerman 2005, 63, 92ff.

53. Zhiru 2007, 71–75.

54. See Mair 1989.

55. On the origins of *raigō*, see Yamamoto Kōji 1974.

56. Traditionally, this statue was called the Kagekiyo Jizō and held a bow rather than the ringed monk's staff it surely originally carried. The name (and the bow) refers to its later association with the legend of the famous twelfth-century warrior of the Taira clan. (See the *Tale of the Heike* [i.e., *Tale of the Taira House*] for the story of Kagekiyo and his bow. *Heike monogatari*, *NKBT*, v. 32, 309–310; McCullough 1988, 369.) The somewhat crude name "*otama* Jizō" refers to the unusual realism of the rendering of the pudenda on the long-hidden nude statue. For the modern day context of this image, see Horton 2007, 137–138, 154–155. Other nude images such as the Denkōji Jizō or the standing Jizō at Enmeiji in Kamakura are carved in an ambiguous fashion between the legs. (On the Enmeiji image, see Horiguchi 1960, 46–70; and deVisser 1915, 135, 142.) This is called the "horse penis *guna*," or *meionsō*, by twentieth-century art historians. The name is taken from the list of bodily marks of a Buddha and refers to the ability of the awakened ones to withdraw their male members into their bodies like a horse. It does not seem likely that this is what the sculptors were trying to convey in leaving the hidden genitalia vague. On possible meanings for this difference, see Kimura 2009, 159. (Note that another nude standing Jizō image, a Kamakura-period work at Ise's Kongōshōji has an underskirt carved as part of the lower half of the statue; Mori Ichirō 1986, plate 73.) Based on this unique feature and a line of the votive text *(ganmon)*, Kimura suggests that the monk Sonpen may have been the lover of his master, Jisson. Mizuno Keizaburō (1996, 415–416) points out that the other nude statues seen in di-

1959. It is also useful in this regard to remember the role of the monk at the bedside of the dying as a *zenchishiki,* a "good friend," a guide and support in the final important moments. On this important figure in deathbed rituals of medieval Japan, see Stone 2008.

83. In fact, by the early modern period, we find the belief that certain entrances to field mouse burrows lead to a place of treasures called "the Jizō pure land" *(Jizō jōdo).* See Inada Kōji and Inada Kazuko 2003, 85–89.

84. On Ritsu monks in the Kantō during the Kamakura period, see Tsutsumi 1992 and 1999. Also see Ōishi 2000. For the impact of these developments on the fortunes of Buddhist sculptors from Nara, see Drogin 2000. For a similar statue in another American collection, see Morse 2002a, 57.

85. While the Ritsu sect relied heavily on Jizō for its mission in eastern Japan, the central cult image for this sect remained the Seiryōji-style Shaka image, which the sect installed in many temples. While the main image is usually the Seiryōji-style Shaka, Jizō's ubiquity in other iconographic and ritual contexts is remarkable. See McCallum 1998. Also see Kawakatsu 1933.

86. On Jizō worship in medieval Zen, see Shimizu 1999a on Rinzai Zen; Ishikawa Rikizan 1986 on Sōtō Zen. The relationship between Jizō and warriors, though mentioned in the next chapter, deserves much fuller treatment in another study. From Jizō's iconographical echoes in the *sōgyō* Hachiman (the "monk form" of the Minamoto clan god, Hachiman), to the importance of the *shōgun* Jizō in the founding legends of Kiyomizudera, to his cult at Mount Atago, to personal devotion by generations of samurai leaders such as Hōjō Tokiyori, Ashkaga Takauji, Takeda Shingen, and others, the "warrior Jizō" is a major theme awaiting thorough investigation. See Conlan 2003, 188–190; Morisue 1939; and deVisser 1915, 98–104.

87. On the emergence of new sectarian consciousness during the Kamakura period, see Bielefeldt 1997.

88. This incident appears in the *Chokushū goden,* 13. See *Hōnen shōnin den zenshū,* 59; Coates and Ishizuka 1930, vol. 2, 267–268; Shimizu 1993, 43; and Okazaki 1969, 78, 91–92. The temple was called Ungōji and is given a new name, "Injōji," by Hōnen. The text tells us that the Jizō image was moved back behind a Seishi image and still stood there at the time of the writing.

89. As mentioned in Chapter One, Jizō and Kannon were often seen as a pair and called the light-emitting bodhisattvas, or *hōkō bosatsu.* The *Shasekishū* says that Jizō is "of the same body" *(dōtai)* with Amida and Kannon (*NKBT,* vol. 85, 183–184).

90. See Wakamori 1951.

91. Ryōhen 1971, 567–568; Shimizu 1996, 165. For a legend describing Ryōhen's particularly close personal connection to Jizō, see Motoi 2001, 35–36.

92. Sugiyama 1965, 33–34.

93. For the reassessment of Kamakura New Buddhism in English, see Foard 1980; Payne 1998; and Morrell 1987.

94. This idea is stressed throughout Matsuo's work. See, for example, Matsuo Kenji 2001. For a critique of Matsuo's approach, see Oishio 2006.

95. For more on Chōgen, see Kobayashi Takeshi 1971. On official sponsorship of *tonseisō*, see Matsuo Kenji 2002; and Goodwin 1994, 67–106.

96. Horiguchi 1955, 21–22.

97. This is an iconographical choice that is most significant: a clan god in monkish guise. As Ross Bender (1980, 90–149) notes, Hachiman was not primarily a war god to the Minamoto, though he was also that. Also see Christine Guth's fascinating work on the development of statues of this deity and the *sōgyō* Hachiman of the Kamakura period (1985, 44–50). In 1202, Chōgen instructed Kaikei to make a Hachiman image "in the form of Jizō" for Tōdaiji (Hirabayashi 1981, 206).

98. Matsuo Kenji 1995; Hosokawa 1997.

99. Tsutsumi 1999, 223; Miyazaki 2005, 232.

100. On deathbed rituals, see Stone 2004.

101. The ministry of Ritsu monks to lepers and their activities in leper communities are well documented. See Quinter 2007; Matsuo Kenji 1995; and Hosokawa 1993.

102. Yamakawa 2006; Okamoto 2003.

103. Sanford 1997; Sawayama 1998.

104. Shimizu 1995, 36–37. Also see Tsutsumi 1992.

105. Hosokawa 1987a. I follow Hosokawa in reading the name as Dōgo rather than Dōgyo. The strong association of Dōgo to Seiryōji is noteworthy.

106. On the Hakone images, see Murano et al. 1993; Yamakawa 2006, 65–70; and Kuno 1957. Also see Kobanawa 1985, 20–22; Kuno 1975, 18, 62–63, 81–82; plate 12; Saitō Masatoshi et al. 1990; and Kyūbi 1967. For other stone Jizō images of the late Heian and Kamakura periods, see Kawakatsu 1974; and Kuno 1975, 117–118. These sculptors associated with the Ritsu sect also carved many Jizō images at or near temples off the mountain roads of Ikoma and Tōno between Kyoto and Nara.

107. These lanterns may have been the remains of a Jizō *nagashi* ritual, in which small paper or gourd boats carry souls away across the water. This ritual began in the city of Edo in the eighteenth century. For a report on a recent celebration of this ceremony, see Arai 1998, 107–109. On Jizō *nagashi*, also see Manabe 1960, 49.

108. Fenollosa and Fenollosa 1913, 149.

109. On the *gorin no tō*, see Aoki et al. 2001 and Suitō 1991. This proliferation of this style of grave monument in medieval Japan is the topic of my next project.

110. The phrase *shishū kengaku*, "combined study of the four sects," was used to describe the practice of many monks, especially in the Nara region, of combining the doctrine and rituals of Tendai, Zen, Shingon, and Pure Land Buddhism. For more on the cooperative nature of early Kamakura Buddhism, see Morrell 1985, 1–68.

111. These are held in a great many museums and private collections. See Yamaji Sumi 2002, 22. Besides the ones included in illustrations here, paintings of the Jizō *dokuson raigō* are very common, and examples can be found in Kyoto's Chōfukuji, Meitokuji in Shiga Prefecture, Kakurinji in Tokushima, and the Honolulu Academy of Arts, to name just a few. There is a rare sculptural representation of the theme at Nara's Yakushiji. Matsushima 1986, 67–68 plate 12.

112. Yamaji Sumi 2002, 28, 30.

113. See Tamamuro 2004. Also see Bodiford 1993; Hosokawa 1987a; Ishikawa Rikizan 1986; and Hayashi Mikiya 1974.

114. See Kobayashi Yasushi 1989; and Harima 1989, 135, 146–147. For the six Jizō motifs as represented on three-dimensional stone monuments, see Miyoshi 1958; and Daigō Hachirō in the appendix to Matsushima 1986, 92–94 plates 1–7.

115. Matsuo Kenji 2002, 32.

Chapter Three: The Jizō Dance

1. Ishikawa Rikizan 1986.

2. Shimizu 1999a.

3. See Teeuwen 1996 and Andreeva 2006.

4. Eishun 1978, 4:38–42.

5. Ibid., 1:390–393, 407. *Sarugaku*, or "monkey music," was the forerunner of Noh theater and was a type of dramatic performance often used in religious alms-raising campaigns.

6. For an exploration of shamanism in *sarugaku* with a review of pioneering Japanese scholarship on the subject, see Ortolani 1984.

7. Chikamoto 1999b, 168. There is an interesting parallel or inversion of the idea of a hell under Kasuga seen in the legend of Jōkei's disciple Shōen (see Chapter Two) and in a story where a Kasuga shrine maiden falls into hell and is told of a special Kasuga hell by the Myōjin himself (*Reigenki* 7:7, vol. 1, 423–426).

8. On the theme of women's suicide by drowning in the Noh, see Torii 1989, 21–85.

9. For a reading of the Uneme legend as a sacrifice aimed at the protection of the nation and the ruler through the pacification of souls *(chinkon)*, see Torii 1989, 137–158.

10. Chikamoto 1999b, 169.

11. Abe Yasurō 1988, 190–191.

12. On the Dragon Cave, see Fowler 2005, 34ff.

13. See Chikamoto 1999b, 170–171, citing *Gen'yōki* 16. Also see Itō Mamoru 1999; and Komine 1991. The original myth, in which Ame no Uzume performs a sexual dance to entice Amaterasu to exit the rock cave can be found in the *Nihon shoki*. This work, *Gen'yōki*, says she is the original *sa-*

rume ("monkey woman," a shamanistic shrine performer), making clear the prominent place of women in religious performance in early Japan (*Nihon shoki, NKBT,* vol. 67, 111–113, cf. 145–146; Aston 1993, 42–45, cf. 76–78).

14. See Hashimoto Naoki 1985 for a study of the Hyakuman legend onstage and in prose fiction *(otogizōshi).* A transcription of the 1670 printed edition of this *otogizōshi* version of *Hyakuman* appears in *MJMT,* vol. 11, 281–297. On the theme of reunion of mother and child in the Noh, see Torii 1989, 224–257. On the issue of genre, see Gorai 1995.

15. Hare 1986, 13.

16. Ibid., 21–28.

17. See S. B. Klein 2006, 233–234, on the importance of efficacy in performance. On the origins of *sarugaku* in performance aimed at ritual purification, see Mizumoto 1996, esp. 43–78, 131–166. Also see Rath 2004, 39–47.

18. Nakazawa Shin'ichi 2003, 10–11. Also see Takahashi Yūsuke 2009 on the *Meishukushū.*

19. There is a large bibliography on the important role of the Okina in the Noh theater; see Honda 1958 and Amano 1995. On the religious functions of the *okina* more generally, see Orikuchi 1965a. In English, see Pinnington 1998 and Rath 2000. On the Okina, and on the Okina as the character Sanbasō in Awaji puppet theater, see Law 1997, 176ff; it is especially interesting that in this ritual, the puppet dons a mask (178, 184–185). On shamanistic elements in the folk performance of the Okina, see Hoff 1977.

20. The *Meishukushū* notes the identity of the Okina and Jizō, specifying Jizō as the *honji* for the Kasuga deity (Zenchiku 1974, 414).

21. *Meishukushū* stresses that the Kasuga deity and the Okina are "of the same body" *(on ittai)* (Zenchiku 1974, 408). On Sanbasō, the Okina, and their relationship to the Kasuga shrine, see Nakazawa Shin'ichi 2003, 20–25.

22. Morisue 1971, 3–68.

23. The characters meaning "stone god(s)," often read as *ishigami,* can also be pronounced as *shakujin* or *shakushi, shakuji, shaguji,* and so on. (Yanagita Kunio's seminal essay on this subject is discussed later in the chapter.) Nakazawa Shin'ichi (2003) writes of the site and the moment of religious ritual, dramatic performance, or physical feats (such as *kemari* ball games and acrobatics) as "the space of the *shaguji*" (17–18). On the Shukujin, see Hattori 1974–1975, 2009; and Mizumoto 1996, 79–130. On the creation of piled stone towers *(shakutō),* the six Jizōs of Shinomiya Kawara, liminality, performance, spectacle, and blindness, see Ōshima 1992b; an explanation of the term *shakutō* is offered on page 346, and page 351 tells of a performance of the *Tale of the Heike (kanjin no Heike)* at which a Jizō image in the hall became animated and shook his ringed *shakujō* staff at the peak of the tale's action.

24. On the difficulties and ironies of manifesting possession in the modern performance of these "folk arts," see Hashimoto Hiroyuki 2006, 20–22. Also see Law 1997 and Averbuch 1998.

25. On Shukujin and the *aragami,* see Nakazawa Shin'ichi 2003, 40–46, 143–147; and Faure 2006. Nakazawa (2003) emphasizes the "embryological" *(taijigakuteki)* aspects of the Shukujin's transformation out of the *aragami* and Zenchiku's exposition of it (for example, p. 43). It must be emphasized that the populations who worshipped the Shukujin were marginal people and were discriminated against in important ways, even as they were deemed essential to the spiritual health of the larger society (see Rath 2004, 37–47; and Law 1997, 49–88). For the uses of marginal populations in the center's program of control—i.e., the imperial system's reliance on the beggars and performers of the *shuku,* "dwellings"—see Yamaguchi 1989 and Wakita Haruko 2003.

26. On these performers, see Wakita Haruko 2001. Also see Honda 1977 for the relationship between these shrine dancers and what became Noh.

27. See O'Neill 1958a. This festival is still celebrated, albeit with a different emphasis; see Kasano'in 1991.

28. On dances and rituals on the veranda at the Kasuga Wakamiya *haiden,* see Matsuo Kōichi 2003, 16–17.

29. Ōkawa and Ueda 1992, 99. For a seventeenth-century Jizō hall whose restoration was sponsored by *yūjo,* in this case clearly prostitutes, see Hosokawa 1997, 266–270; the list of their names, painted on a pillar in the Jizō hall on the twenty-fourth of the eighth month in 1684, appears on page 273.

30. Ōkawa and Ueda 1992, 102.

31. O'Neill 1958a, 411 n. 12. Ōkawa and Ueda 1992, 103.

32. The name "Jizōnyo," or "Jizō *onna*" (Jizō woman), appears fairly frequently (more than ten times) in the *Heian ibun,* suggesting that it was not an uncommon name.

33. *Kasuga gongen genki e* (Noma 1978) 13:3, 75 plate 97.

34. Ibid., 11:4, 72 plate 92; 12:3, 75 plate 94, 32–33 plate 40. For an analysis of these scenes and the stories behind them, see Gomi 1998, 120–126; and Meeks 2010. Also see R. Tyler 1990, 232–234, 236–237.

35. Ōkawa and Ueda 1992, 105. The author wishes to express his thanks to Prof. Ōkawa Naomi, emeritus of Tsukuba University, for kindly responding to a letter to clarify several points regarding this hall.

36. The terms *yūjo* and *asobi* are ambiguous and overlap with many other categories of entertainer and sex worker. Perhaps a useful working definition would be a woman who plays music, sings, and is available for sexual encounters. (It is possible that in some instances, the term indicated just this liberty, rather than a profession.) A common thread would be the worship of the deity Hyaku *dayū* among such women. See Law 1997. Oe no Masafusa, in his late-Heian works *Yūjoki* (Record of Prostitutes) and *Kairaishi* (Puppeteers), attempts to draw a firm distinction between *asobi* and *kugutsu,* or "puppeteers," but it seems that they shared many qualities. See Goodwin 2007, esp. 18–21, 27–28. On the relationship between shrine maidens, or shamanesses *(miko),* and *asobi/yūjo,* see Goodwin 2007, 84–119. On *asobi*

as shamanesses, see Bialock 2007, 135ff. Also see Amino 1994; Kuly 2003; and Pandey 2007.

37. On the problems involved in attributing the aesthetics of Noh to Zen Buddhist influence, see Hare 1986, 31–32, 233–235. If anything, the influence was mutual; Noh performance seems to have had considerable impact upon the poetry and other writings of the fifteenth-century Zen figure Ikkyū Sojun (see Taguchi 1997, 252–280).

38. The use of female mediums by male exorcists *(genja)* played an important part in Heian-period Buddhist ritual, and spontaneous possession of women by malevolent sprits was also common. See Bargen 1997; and Bowring 1982, 43–99.

39. See Abe Yasurō 1987, 72–74; and Meeks 2003, 159–160, 365–376.

40. "Shinmyō jihi no koto," *Zōdanshū* 10, Mujū 1973, 307–309; Abe Yasurō 1987, 76–77.

41. See Nakazawa Shin'ichi 2003, 37–44. Also see Kim 2008.

42. Hare 1986, 227.

43. Hare 1986, 131–132. The word *dan* refers to sections of the play, and *jō*, *kyū*, and *ha* refer to the tempo and rhythm of those sections. On the authorship of "Jigoku no kusemai," see *Go'on*, Zeami 1974, 225–226 (also see 487–488); on the success of it in Kan'ami's performance of *Sarugaku dangi*, see Zeami 1974, 264. Also see Hare 1986, 240; and O'Neil 1958b.

44. Gorai 1988b, 272–279; Foard 1998. The *kyōgen* has a close relationship to Jizō, to the *kagura* of the Wakamiya, and to the comic traditions of *okashi hōshi*, "funny priest" (Morley 1993, 25–28).

45. Tanaka Ryokkō 1954, 8; Yagi Seiya 1981.

46. On Dōgo and his career, see Hosokawa 1987a; on the Jizō statue and the Hyakuman legend, see ibid., 175–179. For the Jizō cult of Mount Atago, see Hinata 1981.

47. Possession has also been very much associated with Jizō at Mount Osore in northeastern Japan. See Blacker 1975 and Ivy 1995. As Ivy points out, the historical depth of the practices of the mediums there is not as great as is often assumed. However, it is clear that the traditions of mediumship and ecstatic trance are generally very old indeed and that these are often related to Jizō worship.

48. On Jizō possession as a children's game during the modern period, see Ōshima 1992a, 159–190. On pages 178–190, Ōshima provides long lists of different formulae that were chanted to invite "possession" by Jizō in these games and also offers detailed charts of sources keyed to different locales. It is clear that many of the formulae demonstrate strong Shugendō influence.

49. See ibid., 159–190; and Sakurai 1983a. It remains somewhat ambiguous whether Jizō represents the possessed or the possessing god. Abe Yasurō notes a historical reference in *Towazugatari* to the performances at the Wakamiya *haiden* as a case of *honji suijaku*. It is important to understand this context for possession, where the buddhas help the gods enter people to

solve problems or pronounce oracles. The interaction between the Buddhist priests, or exorcists, with the *shirabyōshi* or other shrine maidens is said to be like the cooperation of gods and buddhas (Abe Yasurō 1988, 209). Also see the translation in Nakanoin Masatada no Musume 1973, 202–203.

50. See Matsuzaki 1983, 1985; and Ōshima 1992a, 357–413.

51. There are also examples of father-and-child Jizō legends, such as *Karukaya*, but the mother-and-son theme is much more prevalent. On the Karukaya legend, see Matisoff 2002.

52. Bialock 2007; Watson 1982.

53. Goodwin 2007, 150–151; Ogasawara 1992, 47.

54. It is important here to distinguish between the geographical (and institutional) *muen* that is the topic of Amino Yoshihiko's influential book (1987) and the soteriological category of *muen*. The *muen botoke* are the dead with no family ties, particularly those who die without surviving children to nurture them into ancestorhood.

55. On burial grounds in medieval Kyōto, see Katsuda 2004. On religious institutions and performance in these areas, see Ogasawara 1992 and Wakabayashi 2009.

56. Amino 1987, 45–50.

57. Mizumoto 1996, 140–149; Nakazawa Shin'ichi 2003, 39. On *kiyome* and the closely related *inujinin* (dog god people), see Onozawa 2007, 255; and Amino 1994, 199–206.

58. On Higashiyama, especially Gojō-Kawara near Kiyomizu, as a liminal zone, see Ogasawara 1992, 95–96. On dangerous spirits and their pacification, see Yamada Yūji 2007. On the religious environment of Rokuharamitsuji and environs, see Hirabayashi 1981, 126–144.

59. Wakabayashi 2009.

60. On the association of *heikyoku* with the pacification of the dead and with Enmadō in particular and on the eventual primacy of *kusemai* over *heikyoku*, see Ogasawara 1992, 73–91.

61. See Gorai 1988b, 58–62; Ōmori 1986; and Bukkyō daigaku 1966. This is the beginning of the *rokusai nenbutsu*. The *yūzū nenbutsu* sect was begun by the *tonseisō* Ryōnin in 1117. Ryōnin, who had been trained on Mount Hiei, combined Tendai, Kegon, and Pure Land doctrine and practice and based his teachings on the idea that the combined practice of people chanting the *nenbutsu* (and dancing and drumming) would compound the benefits and yield merit greater than the sum of the parts.

62. On this Katsura Jizō, see Nakamura Teiri 1999 and Kouchi 1975. On the Katsura Jizō as "living image," see Ikoma 2003.

63. This word *kobōshi* (or *kohōshi*, "little priest") is very ambiguous and could easily mean either a young priest or a low-ranking priest of the wandering, self-ordained type or even a short-statured priest.

64. *Kanmon nikki*, Gosukōin 2002, vol. 1, 49–50 (7/16). My rendering here is more paraphrase than translation. Note that the pronunciation *furyū* is correct for this sort of dancing or parade, while the older and more

orthodox pronunciation of the characters, *fūryū,* means "elegance" or "sophisticated beauty."

65. Ibid., vol. 1, 57–62 (Ōei 23, 8/9, 8/17, 8/20–9/6).

66. Mansai 1959, vol. 1.

67. Nakamura Teiri 1999, 195.

68. *Kanmon nikki,* Gosukōin 2002, vol. 1, 69 (Ōei 23, 10/14). Mansai 1959, vol. 1, 85. On the problem of suspicion and belief in Sadafusa's diary, see Haruta 1985, 357–362.

69. For events surrounding Yoshihito's death and funeral, see *Kanmon nikki,* Gosukōin 2002, vol. 1, 76–83 (Ōei 23, 11/20–11/26). Also see Bodiford 1992, 153–154; 1993, 193–194. There was a pilgrimage to the Katsura Jizō that same year, 1416, on 11/24 (Gosukōin 2002, vol. 1, 81). Sadafusa visited again in 1433 (Eikyo 5, 3/18) (ibid., vol. 4, 163).

70. Nakamura Teiri 1999, 195; Tanaka Hisao 1989, 89.

71. Kouchi 1975, 27; Mansai 1959, vol. 1, 370–371 (also see vol. 1, 24, 26, 72, 78, 442, 510, 518).

72. Kouchi 1975, 28. Mansai 1959, vol. 2, 270–271. Often, for his entry for the twenty-fourth of the month, especially the seventh month, Mansai offers some variation of the formula, "the usual Jizōkō" or "Jizō *mode* as usual."

73. Ibid., 23; *Kanmon nikki,* Gosukōin 2002, vol. 1, 58–59 (Ōei 23, 8/9, 8/15, 8/17).

74. For a vivid account of the wild and uncontrollable aspects of performance in medieval Japan—*sarugaku, fūryū,* and otherwise—see Hashimoto Hiroyuki 2003. It seems that much of what we see in folk performance reconstructions is analogous to a sort of freeze-frame. The speed and the power of the original are removed.

75. On *chinkon* and performance at the seasonal offerings for hungry ghosts, the *segakie* held at the capital's margins, see Ogasawara 1992, 58, 95, 98–99. On the shamanic mother paired with a child deity, a motif related to the action of *Hyakuman,* see Ouwehand 1964, 160–163.

76. Next to nothing is known about Na'ami, but this may well have been his dance. For a brief sketch of the artist's life, see Hare 1986, 257 n. 2. "Ebina no Na'ami" is also the name of the protagonist of the comical work of medieval fiction *Saru Genji no sōshi* (The Tale of Monkey Genji). For a translation of this *otogizōshi,* see Putzar 1963. Scholars of the text have suggested that the two are likely one and the same; see Tokuda 2002, 269–270.

77. Abe Yasurō 1988. Watanabe Shōgo (1999, 234) has suggested that the "Jigoku no kusemai" that appears in *Utaura* was in fact based on *sarugaku* Noh dances that were performed at the preaching, or *etoki,* about paintings of hell. Also see Kanei 1971, 15–18.

78. On the Mibu *kyōgen,* see Tanaka Ryokkō 1954; and Chaney 1997.

79. Tanaka Ryokkō 1954, 4–8. Having founded the Shakadō performance, Dōgo later moved it to the Injōji (Senbon Enmadō).

80. Abe Yasurō 1988, 216. In a record of the special Kasuga Wakami-

ya festival in 1349 a woman named Otozuru *gozen* dances a frenzied dance *(ranbyōshi),* "dressed as she was for *Okina omote,* the role of the 'old man' " (O'Neill 1958a, 415). On the male dress of the *shirabyōshi* as a marker of difference and power in medieval Japan—and a form of resistance—see Tabata and Hosokawa 2002, 222–227. Also see Hashimoto Naoki 1985, 215–218.

81. Tanaka Ryokkō 1954, 4.

82. Ibid., 15–16. This placement of the Jizō image connects him to the so-called *ushirodo no kami* (backdoor god), or Matarajin (the god Matara). See Yamamoto Hiroko 2003; Nakazawa Shin'ichi 2003, 124–129; and Mizumoto 1996, 55–60.

83. Tanaka Ryokkō 1954, 24–56, esp. 29–30. For masks and costumes relating to the Mibu *kyōgen,* see Kyōto bunka hakubutsukan 1992, in which the mask illustrated here (fig. 3.3) appears on page 68, and the *engi* of the performances and a photograph of the *shakujō* used by the Jizō actor can be found on page 42.

84. Tanaka Ryokkō 1954, 7–8.

85. On the meaning of the dances of *furyū* in a slightly later period, see Berry 1994, 248–259. Berry cites several instances of officials nervously placing a temporary ban on the dances. These sorts of events often got quite chaotic, involved great numbers of people, and had a history of sometimes going very wrong from the beginning. Of course it worried the authorities. In 1349 there had been a famously catastrophic incident (known as the *saijiki kuzure*) in which numbers of stands set up for spectators collapsed, killing many people.

86. On the response of the *bakufu* to the repeated famines and the religious innovations adopted at that time, see Nishio 1985. These innovations included the regularization of the "feeding of the hungry ghosts," *segakie.* On the development of the *segakie,* see ibid., 76–80.

87. Moriya 1988; Hashimoto Hiroyuki 2003; Matsuoka Shinpei 2009.

88. *Jizō no mai, NKBT,* vol. 43, 256–262; Taguchi 1997, 609–626; Hashimoto Asao 1974; translated in R. Tyler 1978. Also see Kanei 1971, 18–22; Ikeda 1978; and Andō and Nomura 1974.

89. Taguchi (1997, 643) proposes there may be a connection between the *kasa* here and the beloved legend of the Kasa Jizō in which an old man sweetly places six hats he has been unable to sell upon the snowy heads of six stone Jizō images and is granted a boon.

90. See *Jizōbō* 1963. Taguchi (1997, 619) notes that the Tenri bon text variant of *Jizō no mai* (Jizō's Dance) specifies that the lead Jizōbō should be played by a child, as in the Kyōgen play *Kanazu no Jizō* (The Jizō of Kanazu). On Jizō as a child, see Shimizu 2005. On *Kanazu no Jizō,* see Fujioka 2000. On the theme of sculptors of Jizō images as protagonists in Kyōgen, see Inada Hideo 2009.

91. Taguchi 1997, 610–612.

92. *Jizō no mai, NKBT,* vol. 43, 262.

93. Taguchi 1997, 614.

94. See Kanei 1972 and Hashimoto Hiroyuki 2003.

95. Taguchi 1997, 616.

96. Ibid., 617.

97. Ibid., 624–625.

98. For a list of variant texts and locations of copies in manuscript form, see *Kokusho sōmokuroku* 1990, vol. 4, 429.

99. Taguchi 1997, 626.

100. See Ta'i 2006 on the relationship between traditional and modern performances of this dance. Also see Hashimoto Hiroyuki 2006 and Okuno 1986. On a legend of Ono no Takamura as the originator of Jizō *odori* and a record of a Jizō *odori* confraternity discovered inside a sixteenth-century statue at Saidaiji in Nara, see Hoshino 1958, 123–124.

101. Kouchi 1975, 23–28.

102. Nakamura Teiri 1999, 196; Murayama 1953, 402.

103. Ueki (1974, 356) in his introduction makes it clear that these dances were performed, sometimes by hundreds of people, at various other spots, such as the *roku* Jizō near Daigoji, during the later Ōei years.

104. Ibid., 357.

105. Manabe and Umezu 1957, 31–33. Also see Haruta 1985.

106. Manabe 1964; *Reigenki* 7:3, vol. 1, 396–401.

107. On the *katsurame* (women who worked running ferries) and the associations between river ferry operators, shamanesses, and prostitutes, see Amino 1984, 392–429. It seems that the *katsurame* commonly adopted the name "Jizōnyo" (ibid., 414). On the presence of prostitutes and female performers near riverbanks or on boats, also see Watanabe 1979, 144–146.

108. *Shōjin mōmoku hiraku koto, Reigenki* 5:11, vol. 1, 269–271. In her notes (ibid., 271), Kōdate Naomi cites other examples of Jizō's curing blindness and also mentions the prevalence of blind performers in premodern Japan. Also see Manabe and Umezu 1957, 31, for the tale of the blind girl from Tanba and the Jizō Hall of Seventh Avenue and Horikawa.

109. For an analysis of the crazed woman, or *monogurui*, in *Hyakuman* and other Noh plays, see Torii 1989, 234–235. Also see Kanei 1972. On the transformation of ritual of divine possession into Noh performance, see Yamaji Kōzō 1987. Also see Morisue 1971, 273–301, on *sarugaku* performed by women.

110. Bialock 2007, 238.

111. For lyrics from Bon *odori* emphasizing rescue from the Blood Pool and Jizō, see Matsuoka Hideaki 1988, 278–280.

112. On this topic, see Ogasawara 1992, esp. 14–15, 47, 50–51, 71, 96–100.

113. On the development of the Kyoto *roku* Jizō pilgrimage circuit during the Muromachi period, see Murayama 1953, 96, 98, 156. Also see Manabe 1981, 90–104, 311–312.

114. There are various alternate lists of seven entrances, but these are the most applicable for our purposes. This list overlaps only in part with the

modern *roku* Jizō *meguri* in Kyoto, but the latter is a roster of six popular Jizō temples rather than a list of places where six Jizō statues were set up.

115. On the six Jizōs around Kyoto, see Nakamura Teiri 1999, 197ff. Imatani Akira says that the Katsura Jizō does not date from much earlier than 1416 ("Jizōdō," in *Kyōtoshi no chimei* 2001, 1123). Competing legend has it that Ono no Takamura established all six sites. Still other sources have Kiyomori as the originator of the Kyoto six Jizōs. Writing nearly a century ago, Marius Willem deVisser (1915, 89) notes, "This reminds us of the Six Jizō's of Roku Jizō mura, distributed by Kiyomori among six villages near Kyoto. Further, we have here the first instance of the cult of Jizō as a deity of the roads, a protector of travelers, in which function he superseded the ancient phallic gods of the roads, the Sae no kami."

116. Gorai 1980, 2. The *roku* Jizō pilgrimage circuit of fifteenth-century Kyoto is noted by Sadafusa in *Kanmon nikki*, Gosukōin 2002, vol. 1, 68–69 (Ōei 23, 10/11–10/16); vol. 1, 127 (Ōei 24, 4/8).

117. On Rokuharamitsuji's main images and subsidiary images, see Iwasa 1984 and Mōri Hisashi 1964. Also see Yiengpruksawan 1998, 135–142.

118. It is unclear how old the tradition of making offerings of cut hair may be, but Iwasa (1984, 22) notes that it is mentioned in the 1702 guidebook *Sanshū meiseki shi*.

119. *Hōbutsushū* (Taira Yasuyori 1993), 199–120. There are many surviving variant versions of *Hōbutsushū* with additions, but it is clear that this appeared in Yasuyori's original (Iwasa 1984, 36–37).

120. Iwasa 1984, 26. Rokuharamitsuji holds some of the most remarkable statues of the Kamakura period, including an emotionally affecting and lifelike portrait statue of Taira no Kiyomori as a monk holding a sutra scroll, as well as striking portraits of two famous sculptors, Unkei and Tankei, and another beautiful statue of the seated Jizō, among others.

121. Manabe and Umezu 1957, 36–37; see page 37 for legal documents relating to the event. The tale does not appear in roll 14 of *Reigenki*.

122. *Hōbutsushū* (Taira Yasuyori 1993), 199–120. This tale is called "The Jizō Who Took [the Dead] to the Mountains" *(yama okuri no Jizō).*

123. Nakamura Teiri (1999, 197) discusses a very similar story from the miracle tale collection *Sankoku in'nen Jizō bosatsu reigenki* of 1684.

124. For the fascinating story of this image, the *maedashi* Jizō, see Glassman 2002, 395–397; deVisser 1915, 141; and Horiguchi 1960.

125. See Amamonzeki 2009, 124–126 plate 65. The nuns of this convent and their lay followers created a great number of small Jizō images in miniature shrines during the seventeenth century. I extend my heartfelt gratitude to Prof. Manabe Shunshō for sharing his survey of these materials at an early stage in the research.

126. For photographs of these offerings, see Hagiwara 1983, 203 plate 61, 281 plate 70. The Nakanodō with its *naka no* Jizō was so named because it was the midpoint *(naka)* on the climb up 538 stone steps to the Kannokura shrine. A photograph of this image is in ibid., 202 plate 60.

127. *Konjaku* 17:29, *NKBT,* vol. 24, 543 (though here she is Taira no Masayuki's third daughter, not Masakado's); *Genkō shakusho, Kokushi taikei,* 9, 99; *Reigenki* 14:8, vol. 2, 340–342. It is the final tale in the *Reigenki.* Also see Hirose 2003.

128. There are two temples named Enichiji in Fukushima Prefecture that claim to be the one she wandered to, but Hagiwara (1983, 279–282) provides evidence that the one in Iwaki has the more legitimate case. It should be noted that a small hall at Masakado shrine in the city of Abiko, Chiba Prefecture, also contains "Nyozō's Jizō image," said to have been set up by the Taira woman.

129. Hagiwara 1983, 280–281, 285. In Edo-period culture she became celebrated as the character Taki Yasha *hime* in the popular culture of Kabuki theater, the cheap and popular books called *yomihon,* and so on.

130. In many legends, Happyaku *bikuni*'s immortality is linked to her eating goji berries (wolfberries, *Lycium barbarum*), or *kuko.* (At the time of this writing, these fruits are something of a craze in the United States, being much vaunted for their antioxidant properties.) Much work remains to be done on the fascinating topic of Happyaku *bikuni* and her relationship to the Jizō cult (see Hagiwara 1983, 272–278, 289–295; Tokuda 1990; Tanaka Hisao 1998; and Glassman 2008, 182–186). The Happyaku, or Yao, *bikuni* legend begins in the fifteenth century but is related to older and newer stories about a mysterious nun called Jizō *ama.* In 2005 the Art Institute of Chicago acquired a painting by Ike no Taiga (eighteenth century), depicting crowds in Mikawa gathering to see the Jizō *ama* (see *Group Pilgrimage to the Jizō Nun,* ca. 1755–1765 at http://www.artic.edu/aic/collections/artwork/185222/print/).

Chapter Four: Stones, Fertility, and the Unconnected Dead

1. Amino 1987, 52, 56.

2. On Kūya, see Chilson 2007; Hori 1958; Ishii 2003; and Itō Yuishin 2005b.

3. Though some scholars prefer the pronunciation "Kōya" for this monk's name, I will call him Kūya, following popular practice and Ishii. Below, we will have occasion to consider the early modern confraternity associated with him, the Kūyasō, or Kūya monks. For a brief entry on Kūya, see the fifteenth-century *Sangoku denki* (Gentō 1976), vol. 3, 90–91.

4. On the *shuku,* see Itō Takeshi 1996.

5. For an accounting in English of the Kumano *bikuni,* as well as others, and their religious functions, see Ruch 1977. Also see Ruch 1991, 103–134; and Moerman 2005, 213–231. On the *hōka* and the *boro,* see Harada 1990. On the *shirame* and the *shirabyōshi,* see Watanabe 1999, 130–131 and 142–143, respectively.

6. It would be incorrect to portray the *sai no kawara* as the exclusive property of these performers. Although they were the ones who developed

of rhythmic chanting of the seventeenth century, and the term also refers to the texts associated with its performance. Hagiographies of the eccentric and charismatic late Edo-period "exorcist" Yūten *shōnin* can help us imagine how gripping these must have been. See Hardacre 1997, 28–45; and Takada 1991, 18–42, 150–169.

31. Watari 2005, 77.

32. Sengen and Asama are written with the same Japanese characters. This bodhisattva is not known in the pantheon and was created by religious leaders at Mount Fuji as a custom-made *honji* for Asama *gongen*. For a modern setting of a trip to the Fuji Cave inspired by Jules Verne, see Okuizumi 2004.

33. See Miyazaki 2005. It is also worth noting that any number of tales in the *Reigenki* concern *shugenja* (adepts of esoteric mountain religion, *shugendō*) who are Jizō devotees.

34. William LaFleur has suggested that the idea of *sai no kawara* was widespread in the medieval period, but it seems that the concept does not appear until the Edo period. He also posits that there is some evidence that the place is based on pre-Buddhist Japanese ideas of hell, but he does not offer details. See LaFleur 1992, 58 and 230 n. 28. Whatever the source of the imagery of *sai no kawara*, it seems clear that this children's limbo developed in Japan and is not of continental origin.

35. Translation from Kimbrough 2006b, 9. This is from the 1603 manuscript text (*Fuji no hitoana sōshi*, *MJMT*, vol. 11, 429–451). The passage in question appears on page 436; see page 438 (pages 10–11 in Kimbrough's translation) for the general recommendation of Jizō worship.

36. On the topic of *hiku hikume*, also called *kotoro kotoro*, see Watari 2001b; and Manabe 1960, 49–51.

37. My translation from the printed text of 1627. *Fuji no hitoana sōshi*, *MJMT*, vol. 11, 452–475. The passage translated here appears on 461. ("Dakuten" marking voiced consonants added.) Hayami (1975b, 153) offers Chinese characters for this magical formula, which appears in kana in the original text, though it is better understood as a *dharani*, or magical spell, spoken for efficacy rather than meaning. This formula is in part based on the *Dizang benyuan jing* and is part invention. If one were to ascribe meaning, it might be something like, "The Tathāgata spoke, earnestly entrusting [to me] the beings of the present and future along with their white bones: 'now undo their set [karma] of falling into the [three] evil paths.'"

38. *MJMT*, vol. 11, 461.

39. Ibid.

40. On the Kumano *bikuni* at *rokudō no tsuji*, see Komatsu Kazuhiko 2007.

41. On Higashiyama Jishū and funerals, see Watanabe 1999, 235–248; and Onozawa 2007. For the Shōtoku *taishi* cult of Higashiyama and its relationship to funerary ritual, especially in the Zen and Ritsu sects, see Hayashi Mikiya 1970, 1974.

42. On puppet shows featuring the tortures of hell during the fifteenth and sixteenth centuries, see Watanabe 1999, 238–239; and Tokuda 1984.

43. The Saga Shakadō, next to the Seiryōji, was also seen as an entrance to hell, and it too was known as *rokudō no tsuji*. A neighborhood in Saga still has the name "Rokudōchō." Thus, as we have already seen, the connections in this regard between northwestern and southeastern Kyoto are strong.

44. Translation from O'Neill 1954, 220 (notes omitted).

45. See Fukuhara 1987, 154–156. On *sankei mandara* (pilgrimage mandalas) more generally, see Nishiyama Masaru 2008 and Formanek 2000. For images, see Osaka Shiritsu Hakubutsukan 1987.

46. A photo of a few of the tens of thousands of small cast clay *gorin no tō* that were discovered in 1966 in an excavation below the main hall of Rokuharamitsuji can be found in Kawasaki and Taki 2007, 76–77. Others made of small pieces of stone fixed together have also been found. An example of each type—the clay cast and the assembled type—is held in the Sylvan Barnet and William Burto Collection in Cambridge, Massachusetts. It is also noteworthy that, as the abbot revealed to me, a great many of the stone *sentai* Jizō images at the Rokudō Chinnōji were brought there from construction sites when they were accidentally unearthed. Rev. Sakaida Kōdō, pers. comm., June 2009.

47. See Harrison 1996 for the idea of the *mizuko* ("water child," or aborted fetus) as the collective dead for the modern age.

48. Mochizuki 1989, 37–88.

49. On the color symbolism of death and fertility in Chinese ritual, see Watson 1982.

50. See D. R. Williams 2008; 2005, chap. 3; and Hardacre 1997, 26–27.

51. Sawada 1968.

52. I would like to thank Bernhard Scheid for initiating a stimulating discussion of the question of Jizō's red bib on the e-mail list Premodern Japanese Studies (PMJS, http://www.pmjs.org/pmjs-listserve) and also to thank the participants in that exchange. For the robe as placenta, see Faure 2003, 241–244. Also see Formanek 2006, 76–77.

53. Watari 1999, 202.

54. Tanaka Takako 1995. The *enakin (enagi)* is a jacket worn over the birth clothes *(ubugi)* on the first shrine visit. On the placenta and Datsueba, see Kōdate 2006. Also see Nakazawa Shin'ichi 2003. A legend of Mibudera tells of a maid who burned a set of *ubugi* with an iron, and how then the Mibu Jizō fixed it. The ritually charged sand of Mibudera was said to help women have a safe delivery (deVisser 1915, 74). On folkloric practices related to Jizō and birth and the birth god, *ubugami*, see Ishigami 1976, 14–22.

55. For a study of the sources of Datsueba, see Seidel 2003.

56. Makita Shigeru 1965, 133, quoted in Daigo 1977, 534.

57. On the Sōzu, Sanzu, Shōzu, or Mitsuse in Japanese literary and religious sources, see Iwamoto 1979, 312–333.

58. Yanagita 1998, 564–565. This fascinating and wide-ranging work takes the form of an exchange of letters between Yanagita and several of his contemporaries. Also see Daigo 1977, 531–532.

59. Daigo 1977, 135. Yanagita (1998, 564–565, 602) also draws a connection between the twin elephant god Shōten, or Kangiten, and the "god of obstacles." Also see Faure 2009. On twin Jizō *dōsojin* images, see Yamazaki 1995, 57–64.

60. Yanagita (1998) also suggests that the idea of a border or boundary is indicated throughout Japan, indeed throughout East Asia, by words like *saku, soko,* and *seki* and, further, that the name *shakujin* or *sakuji,* meaning "gods of the boundary" or "gods of obstacles," was transformed into *shakujin,* "stone gods." This is a point that Yanagita returns to repeatedly throughout the essay; see, for instance, pp. 504, 507, 530, 533. On this point, also see Ouwehand 1964, 199–200; and Nakazawa Shin'ichi 2003, 56–58. For a book-length study on stones in Japanese religion, see Gorai 1988a. Also see Nakazawa Atsushi 1978. For more on village borders and their religious significance, see Yasuyuki Yagi 1988.

61. Nakazawa Shin'ichi (2003) has suggested similar functions for gods called the *shakujin* (a homophone with the Chinese reading of *ishigami*) and the *shukujin.* We might also note that, like Jizō, the *dōsojin* is sometimes represented as a child (Iijima 1987).

62. On the *ishigami* (stone gods) as gods of sexuality, see Daigo 1977, 369–383; and Muraoka 1976, 18–26.

63. Takamure 1956, 343–344.

64. Daigo 1977, 525–526. On a stone Jizō as village "protector god" (Shugojin), see Sasaki Satoshi et al. 2005, 54–55.

65. Tanaka Hisao 1983; Kuraishi 1990; Ōshima Takehiko 1992a. Here and below, I will be using *dōsojin* and *sae no kami* interchangeably, and many scholars have treated them as identical. However, there is debate on this issue and some have insisted that they should be distinguished. See Kuraishi 2005, 11–12 n. 2. *Sae no kami* can be written many ways (see glossary). One significantly common rendering is with the Chinese characters for *dōsojin* ("road ancestor god"), simply read as *sae no kami*. See Orikuchi 1965b.

66. Daigo 1977, 7, 13–15; Tanaka 1986a; Ōshima 1992a.

67. For photo essays containing such images see, Ashida 1963 and Czaja 1974. Also see Katō Genchi 1924; Itō Kenkichi 1966; Kawakatsu 1974; and Ōshima 1992a. On the connection between Jizō and agricultural as well as biological fecundity, see Nakamura Teiri 1999, 201–202. On sexual elements of the Jizō cult, see Muraoka 1975, 93–121. On phallicism and fertility cults in South Asia, see Miyaji 1999, 89–109.

68. Daigo 1977, 525.

69. Kimbrough 2008, 76–101; Faure 1998b, 131–132; Cranston 1969, 20–21.

70. Ōshima 1992a, 81. For a wide-ranging study of the theme of incest in Buddhist myth, literature, and legend, see Silk 2009. The stories examined in Silk, fascinating though they are, have little or nothing to do with the *dōsojin*.

71. Kojima 1962, 15.

72. Ōshima 1992a, 79. *Kojiki, NKBT,* vol. 1, 68, has *funato no kami. Nihon shoki, NKBT,* vol. 67, 98, offers *funato no kami* but says that the original name was *kunato sae no kami.*

73. Matsumae 1971, cited in Ōshima 1992a, 80.

74. See Ōshima 1992a, 66; and Abe Yasurō 1995, 132–134.

75. Daigo 1977, 535. Daigo remarks that it is odd that an erudite man like Nōen would not know the name of this god and suggests that he would surely know of the *sae no kami,* since a figure named the Kasajima *sae no kami* appears in the *Tale of the Heike* narrative with no particular gloss or explanation.

76. Ibid.

77. See Ōshima 1992a, 59ff.

78. *Hokke genki* 2:68; *Konjaku monogatari* 13:34, 252–254. The former is translated in Dykstra 1983, 143–145.

79. On the *sae no kami* as gods of the roads and their relationship to gods of epidemics, see Daigo 1977, 359–363. Also see Como 2008a.

80. For an analysis of this story in terms of *honji suijaku,* see Abe Yasurō 1995, 138–140.

81. *Nihon shoki, NKBT,* vol. 67, 84–85. Also see Murakami 1988.

82. On incest in *dōsojin* legends, see Wakita Masahiko 1980; and Ōshima 1992a, 59–91. On pages 71–78, Ōshima provides a chart comparing the details of eighty-five different incest legends.

83. On Jizō's surnames, or "Jizō *no myōji,*" see Yanagita 1999 and Shimizu 2000.

84. Abe Yasurō 2002, 22. For the establishment of outcaste *(hinin)* groups around Kiyomizuzaka and Rokuharamitsuji and the relationship of these populations to purification and performance, see Amino 1994, 34–39.

85. Tokuda Kazuo, pers. comm., March 2003.

86. *MJMS,* vol. 4, 454–476; *MJMT* vol. 5, 141–162. There are two different texts, both illustrated and hand-copied books, but the content is largely the same. There is a third text with the same title, though written with different characters, that tells a very different story. We will examine this third version, which takes place at Ōeyama rather than in the capital, in the pages that follow. For a brief introduction to *Koyasu monogatari,* see Komatsu Kazuhiko 1992. There is also a seventeenth-century handscroll version of the text in the Baelz Collection at the Linden-Museum in Stuttgart, Germany. I have not yet had a chance to see this in person, but I thank Prof. Melanie Trede of the University of Heidelberg for bringing it to my attention. It is described in Linden-Museum et al. 1998, vol. 1, 265; plates, vol. 2, 30–31 (color), 406–407 (monochrome). Also see Hirayama and Kobayashi 1994, 148–149 and plate 3.

87. On the transformation of ancient myths in the medieval period *(chūsei shinwa),* see Yamamoto Hiroko 1998 and Funada 2004.

88. *MJMS,* vol. 4, 454.

89. Ibid., 455.

90. On the character of the neighborhood of Kiyomizuzaka during the late medieval period, see Shimosaka 2003, 224–256.

91. Ibid.

92. Doi et al. 1980, 564.

93. On drinking by Jishū in Higashiyama, see Onozawa 2007, 248–249.

94. For another *koyasu* Jizō with two variant legends, one involving a Jizō image that issues up from the earth in a rush of water to open a new source and another about a lake of magical water, see Abe Mika 2009. This image, at Tōsen'in (Temple of the Eastern Source) in the foothills of Mount Fuji, still has an active following of female devotees who come to chant at the monthly Jizōkō (Jizō confraternity meeting) for safe childbirth. Here we note a strong resonance with the Izumi no sakaya and its magic jar.

95. On women, including nuns, as brewers (and moneylenders) in fifteenth- and sixteenth-century Kyoto, see Gay 2001, 40–46. There is also a well-known story of the "sake malt" *(sakekasu)* Jizō of Suruga, told in the *Reigenki* (3:5, vol. 1, 160–165). This is the tale of a poor old woman, a Jizō devotee, who borrows rice to start brewing sake so that she can earn cash to hold a memorial service for her dead mother. With Jizō's help she becomes a rich woman by selling the delicious and miraculous sake she has brewed. It is translated in Dykstra 1978, 197–200.

96. While the Chinese characters are not given for the twins' names, it is safe to assume that the *"shu"* given to each of them would be written with the character for *sake*.

97. Besides the Noh, above we have mentioned *Karukaya* and *Sanshō dayū* in this connection. For an exploration of this theme of reunion in *Mii-dera*, see Torii 1989, 224–257.

98. Yanagita (1998) identifies the *honji* of *dōsojin* as stone Jizōs (527, 595) and also says the *dōsojin* is called *enmusubi no kami*, or the "god of connections," the one who brings male and female pairs together (527, 574, 588).

99. See Goepper 1993 on the iconography and cult of this deity.

100. Hamanaka 1996, 133.

101. It is instructive to compare *Koyasu monogatari* with other texts on Kiyomizudera. One such text is the *Kiyomizudera engi emaki* of 1517, created by personages at the very pinnacle of Japanese society. Another is the *Kiyomizudera sankei mandara* of 1548, a visual guide to Kiyomizudera. See plate 16 and figs. 4.20–4.21 in this book.

102. *Kiyomizudera shi* 2000, vol. 1, 247–249.

103. Taisanji no longer exists, and the *koyasu no tō* was moved to a location on the other side of the Otowa falls during the Meiji period. Ibid., vol. 1, 315. For an overview of the site as offered by the late medieval pilgrimage mandara, see Kuroda Hideo 1987.

104. *Kiyomizudera shi* 2000, vol. 1, 342–344. For images of the pagoda in the *sankei mandara,* see Ōsaka Shiritsu Hakubutsukan 1987, 122 and plate 16.

105. Ibid., vol. 2, 47–57.

106. These places, along with the Koyasu no tō, can be found along the right-hand edge of the *Yasaka Hōkanji tō mandara*. See Osaka Shiritsu Hakubutsukan 1987, 152 and plate 32.

107. deVisser (1915, 178–181) also describes this historical transformation in the closing pages of his valuable study.

108. See Komatsu Kazuhiko 1997, 37–55, on this demon and his role in defining boundaries, inhabiting a liminal space between the inside and the outside.

109. *MJMT*, vol. 5, 163–178. This is a work in two volumes; the first carries the interior title *(naidai)* of *Ōi no saka koyasu monogatari* (The Story of Safe Childbirth of Oi no saka), and the second, *Kiyomizu koyasu monogatari* (The Story of Safe Childbirth of Kiyomizu). The colophon in the printed text of 1661 says that the work was written in 1624. Also see Seto 1999.

110. *MJMT*, vol. 5, 164.

111. Ibid., vol. 5, 176.

112. Ibid., vol. 5, 177.

113. Seto 1999, 53–54.

114. See Matsushita 1942, 59 plate 19, plate 97, for an explanation of this iconography. Also see Morse 2002a, 55 fig. 2.

115. On the Jakkōin Jizō and the items inside it, see Oku 1997.

116. See Akata 2007 on animism in medieval Nara and Yamato no kuni (73–91) and on the herd of deer that wander the precincts of Kasuga and their connection to these traditions (92–115). On animism and animate images, see Freedberg 1989, 32.

117. Yamakami 1981.

118. In a certain sense, I do not mean to draw Japan as a limit around the autochthonous. I am referring really to something truly ancient and ancestral, the worship of stones. The cult of stone gods or holy stones is widespread across the continents, east to west and north to south. On medieval Japanese Buddhist notions of materiality and the sacredness of things, see Rambelli 2007.

119. Michael Steinberg, "Aby Warburg's Kreuzlingen Lecture: A Reading," in Warburg 1995, 99–101. For more on the performative dimension of ritual and the communication between the numinous and the human, see Yamamoto Hiroko and Sakayori 2006.

120. Rev. Sakai Sūga, abbot of Seki no Jizō-in, pers. comm., June 2009.

121. For an interpretation of this painting, see Nakanishi 1990.

Glossary

Adashino 化野
aitade 藍蓼
Aizen myōō 愛染明王
Aki no hōin Ninsai 安芸の法印任済
akunin shōki 悪人正機
Ama 海女
amanyūdō 尼入道
amazake 甘酒
Amenokoyane 天児屋
Amenouzume 天鈿女
An'ami 安阿弥
An'yō 安養
aragami 荒神
arai zarashi 洗い晒し
aruki miko 歩き巫女, 歩き神子
Asama gongen 浅間権現
asobi (asobu, asobasu) 遊び
Atago 愛宕
Atsumori 敦盛
Awa 阿波
Bai Juyi 白居易
bakufu 幕府
bettō 別当
bikuni 比丘尼
Bingzhou 幷州
bōfuri 棒振
Bon odori 盆踊り
bonji 梵字
boro 暮露

Bunraku 文楽
bunshin 分身
busshi 仏子
butai 舞台
Byakukōji 白毫寺
Chang hen ge 長恨歌
changxing sanmei 常行三昧
Chi no ike 血の池
chi no ike jigoku 血の池地獄
chimata no kami 岐の神
chinkon 鎮魂
Chinnōji 珍皇寺
chinsō 頂相
Chōken 重賢
Chōshōshi 長嘯子
Chūjōhime 中将姫
chūsei shinwa 中世神話
chū'u 中有
dai bosatsu 大菩薩
Daifukuji 大福寺
daihi sendai no bosatsu 大悲闡提ノ
　菩薩
Daikokugari 大黒狩
dainenbutsu 大念仏
Dainichi Nyorai 大日如来
Dairokuten 第六天
daishi 大士
daisōjō 大僧正
Datsueba 奪衣婆

dengaku 田楽

Dizang 地蔵

Dōgo 導御

dōji 童子

Dōkō 道公

dokuson raigō 独尊来迎

Dōmyō *ajari* 道命阿闍梨

dōsojin 道祖神

dōtai 同体

Dōunji 洞雲寺

Ebina no Na'ami 海老名南阿弥

Eison 叡尊

ema 絵馬

enagi 胞衣着

Enichiji 恵日寺

Enma (-ō) 閻魔（王）

Enmei Jizō 延命地蔵

enmusubi no kami 縁結びの神

Enni Ben'en 円爾弁円

Enraō 閻羅王

etoki 絵解き

Fazang 法蔵

fuda 札

Fujiwara no Fuhito 藤原不比等

Fujiwara no Hidehira 藤原秀衡

Fujiwara no Kanezane 藤原兼実

fukube 福部

fukusha 福舎

fun 分

funado or *funato* 船戸、 岐、岐処

funato no kami 岐神、船戸神

furyū 風流

furyū no hayashimono 風流の拍子
物

furyū no ōgasa 風流の大傘

Fushimi no miya Sadafusa 伏見宮
貞成

fushoku 付嘱

Fusō ryakki 扶桑略記

Fu'unpu 浮雲峰

gaki 餓鬼

Gakizeme 餓鬼責め

Gakizumo 餓鬼角力

ganmon 願文

geinō 芸能

Genpei jōsuiki 源平盛衰記

gense riyaku 現世利益

Gensei 元清

Genshin 源信

Gen'yōki 元要記

Gikeiki 義経記

giki 儀軌

Gion *matsuri* 祇園祭

gohei 御幣

gokuraku 極楽

gorin no tō 五輪塔

goryō 御霊

goshō sanjū 五障三従

gozan 五山

goze 瞽女

Guangmu 光目

Guanyin 観音

Hachiman 八幡

hachitataki 鉢叩

haiden 拝殿

hajigoku ge 破地獄偈

Hakkō *hōgen* 白河法眼

Happyaku *bikuni* 八百比丘尼

harebasho 晴れ場所

Hasedera 長谷寺

Hata no Kawakatsu (Kōkatsu) 秦
河勝

Hata no Ujikiyo (Zenchiku) 秦氏清
（禅竹）

hayashimono 拍子物

Heike monogatari 平家物語

heikyoku 平曲

hendo gesen no kyō 辺土下賤ノ境

hibutsu 秘仏

Higashiyama 東山

hijiri 聖

hihikume 比々丘尼

hinin 非人

hinoki 檜

Hiraoka 平岡

hitoana 人穴

hiyoku renri 比翼連理

Hōbutsushū 宝物集

hōe kudarazu shite 胞衣[はうゑ]く
だらすして

hōgen 法眼
hōin 法印
hōka 放下
hōkō bosatsu 放光菩薩
Hōkyō 宝篋
hōkyōin tō 宝篋印塔
Honchō seiki 本朝世紀
Honchō suibodai zenden 本朝酔菩
 提全伝
hongan 本願
honji suijaku 本地垂迹
honza 本座
honzon 本尊
hō'on 報恩
hōshi 法師
hōshin 法身
Hosshin in'nen jūō kyō 発心因縁十
 王経
Hossō 法相
Huayan jing zhuanji 華厳経伝記
Hyakuman 百万
Hyakuman no tsuji 百万の辻
Hyakuman *utai* 百万謡
Hyakurenshō 百練抄
hyōtan 瓢箪
I Gyōkichi 伊行吉
I Gyōmatsu (Yi Xingmo) 伊行末
I Yukiuji 伊行氏
ichi no hijiri 市の聖
Ichinen *bikuni* 一念比丘尼
Iha 伊派
Ikkan 一閑
Ima Shinomiya 今四ノ宮
imayō 今様
inaōse dori 稲負鳥
inbutsu 印仏
injō bosatsu 引接菩薩
injō Jizō 引接地蔵
Injōji (Senbon Shaka Enmadō) 引接
 寺（千本釈迦閻魔堂）
inujinin 犬神人
ishigami 石神
"Ishigami mondō" 石神問答
issendai 一闡提
itabi 板碑

Izanagi 伊邪那岐
Izanami 伊邪那美
Izumi Shikibu 和泉式部
Jakkōin 寂光院
"Jigoku no kusemai" 地獄の曲舞
Jikkai mandara 十界曼荼羅
jikkyōja 経持者
jimotsu 持物
Jindai no maki shikenbun 神代巻私
 見聞
jin'nin 神人
Jishū 時衆
Jissan 實算
Jitsuei 実睿
Jizō ama 地蔵尼
Jizō juō kyō 地蔵十王経
Jizō mōde 地蔵詣
Jizō no mai 地蔵の舞
Jizō odori 地蔵踊り
Jizō okuri 地蔵送り
Jizō shinkō no gyōnin 地蔵信仰の
 行人
Jizōbō じざう坊
Jizōbō 地蔵坊
Jizōgao 地蔵顔
Jizōnyo 地蔵女
Jōami 定阿弥
Jōchō 定朝
jōgō 定業
jōgyō zanmai 常行三昧
Jōjuin 成就院
jōroku 丈六
jugan 入眼
Jukyō 寿教
Jūman *shōnin* 十万上人
Junkō 順高
Jūzenji 十禪時
kagura 神楽
kagura'o 神楽男
kaichō 開帳
kaihōgyō 回峰行
Kaizō 海蔵
kaka 賀歌
kakai 歌垣
kami 神

kan 貫

Kan'ami 観阿弥

kanbun 漢文

kanetataki 鉦叩き

Kanfukuji 観福寺

kangi yuyaku nenbutsu 歓喜踊躍
念仏

Kangiten 歓喜天

kanjin 勧進

kanjin jikkai mandara 観心十界曼
荼羅

kanjin no Heike 勧進の平家

Kanmon gyoki 看聞御記

Kanmon nikki 看聞日記

Kannokura 神ノ倉

Kannon 観音

kansō 官僧

Kanze Kojirō Nobumitsu 観世小次
郎信光

kaō 花押

*kariru toki no Jizōgao, nasu toki no
Enmagao* 借りる時の地蔵顔、済
す時の閻魔顔

Karukaya 苅萱

Karukaya dōjin 苅萱道心

kasa 笠

Kasuga gongen genki e 春日権現験
記絵

katsura 桂

katsura 鬘

Katsurabatake 桂畑

Katsuragawa Jizō 桂川地蔵

katsurakake 鬘掛

katsurame 桂女

kawa segaki 川施餓鬼

Kawachi 河内

kawara no mono 河原の者

kaya 栢

kechien 結縁

kechien kōmyō 結縁交名

kechimyaku 血脈

Kei'en 慶円

Kenchōji 建長寺

kengyō 検校

Kenreimon'in 建礼門院

Kenjōbō Gyōhan 顕定房尭範

keshin 化身

ketsubon jigoku 血盆地獄

Ketsubonkyō jikidanshi 血盆経直
談私

kirikane 切金

Kitayama 北山

kiyo 清

kiyome 清目

Kiyomizudera 清水寺

Kiyomizuzaka 清水坂

Kiyomizuzaka no koyasu Jizō 清水
坂の子安地蔵

Kiyonobu (Shirō) 清信（四郎）

Kiyotaki no miya 清滝の宮

Kiyotsugu (Kan'ami) 清次（観阿
弥）

kō 講

kobōshi 小法師

kodomo no kami 子どもの神

kōji 柑子

Kōjin 荒神

kojōruri 古浄瑠璃

Koma Yukimitsu 狛行光

Kōmyō kōgō 光明皇后

Kongōhō Jizō 金剛寳地蔵

Kongōnyo 金剛如

Konparu Zenchiku 金春禅竹

Konzōin 金蔵院

kōshiki 講式

Kōshō 康勝

kosōteki 古層的

kotoro kotoro 子取ろ子取ろ

kotsujiki hōshi 乞食法師

kōwakamai 幸若舞

Kowataguchi 木幡口

koyasu heisan no daigan 子易平産の
大ぐはん

koyasu Jizō 子安地蔵

Koyasu monogatari 子安物語、子
易物語

koyasu no kami 子安神

koyasu no tō 子安塔

Koyasudera 子安寺

Kubitsuka 首塚

Kudara 百済

kugutsu 傀儡子

kuko 枸杞

Kumano *bikuni* 熊野比丘尼

Kumano kanjin jikkai mandara 熊野
観心十界曼荼羅

kun 訓

kunado (*kunato*) *no kami* 久那斗
神、岐神、来名戸神、来名戸の
祖神

kunagu 婚ぐ

Kuramaguchi 鞍馬口

Kuritaguchi 栗田口

Kurokawa Dōyū 黒川道祐

kuse 曲

kusemai 曲舞

kusemai mai 曲舞舞

Kushimoto 串本

kushōjin 倶生神

Kūya 空也

Kūya *nenbutsu* 空也念仏

Kūya shōnin ekotoba den 空也上人
絵詞伝

Kūyasō 空也僧

kyōge 教化

kyōgen 狂言

Kyōin 教胤

ling 霊

magai butsu 磨崖仏

mandara 曼荼羅

mani 摩尼

Mansai 満済

mappō 末法

matsubayashi 松囃子

mawari Jizō 廻り地蔵

meionsō 馬陰相

Meishukushū 明宿集

Mibudera (Hōdō sanmaiji) 壬生寺
（法幢三昧寺）

michiyukibun 道行き文

Miidera 三井寺

mikan 蜜柑

mikao kirakirashi 相貌端厳

Mikasa 三笠

mikkyō 密教

miko 巫女

Minamoto no Kunitaka 源国挙

mineiri 峰入り

minkan shinkō 民間信仰

Miwa 三輪

miya mandara 宮曼荼羅

miya no ichi 宮一

Miyako meisho zue 都名所図会

mizuko kuyō 水子供養

mokujiki sōe 木食草衣

Mokuren *sonja* 目連尊者

Momijigari 紅葉狩

mono no ke 物の怪

monomane 物真似

mōshigo 申し子

Motokiyo (Zeami) 元清 （世阿弥）

mubutsu sekai 無仏世界

muen 無縁

muen botoke 無縁仏

muen no jihi 無縁の慈悲

muensho 無縁所

muentō 無縁塔

mujō no jumon 無常の頌文

Mujū Ichien 無住一円

mukaegane 迎え鐘

Mulian 目連

munetataki 胸叩き

Musō Sōseki 夢窓疎石

musubi no kami 結の神

Mutsu 陸奥

myōjin 明神

Myōsan 明讃

nagashi 流し

naidai 内題

naka no Jizō 中の地蔵

Nakanodō 中ノ堂

Nanto 南都

Nanzenji 南禅寺

Narazaka 奈良坂

nenbutsu 念仏

nenji butsu 念持仏

Nichizō 日蔵

nigorizake 濁り酒

nijūgo bosatsu 二十五菩薩

ninniku no hadae 忍辱の肌

Ninshō 忍性
Nishino'oka 西岡
Nitta no Tadatsuna 仁田忠綱
Nōen 皇円
nōge 能化
nyoi hōju 如意宝珠
Nyozō *ama* 如蔵尼
nyūdō 入道
Obon お盆
odori nenbutsu 踊り念仏
Ōe no saka 大江の坂、大枝の坂
Ōeyama 大江山
Ōhara 大原
Oi no saka 老の坂
Ōjōyōshū 往生要集
Oketori 桶取
Okina 翁
Ōkura Yasukiyo 大蔵安清
Ōkura Yasu'uji 大蔵安氏
Ōkuraha 大蔵派
okurigane 送り鐘
oni 鬼
onmatsuri 御祭り
onna kusemai 女曲舞, 女久世舞
onnade 女手
Ono no Takamura 小野篁
onryō 怨霊
osan no kami お産の神
oshi 御師
Ōshima 大島
oshorai お精霊
Ōshū Fujiwara 奥州藤原
Otagidera 愛宕寺
otogizōshi 御伽草子
Otowa 音羽
Paekche 百済
raigō 来迎
raise riyaku 来世利益
rangyō nenbutsu 乱行念仏
Rankei Dōryū (Lanxi Daolong) 蘭
 渓道隆
rei 霊
rengashi 連歌師
Renge zanmai kyō 蓮華三昧経
Rissei 立清

Ritsu 律
rō 漏
roku Jizō 六地蔵
Rokudō Chinnōji 六道珍皇寺
rokudō no tsuji 六道の辻
rokudō nōge Jizō bosatsu 六道能化
 地蔵菩薩
Rokuharamitsuji 六波羅蜜寺
Rokuharamitsuji Jizōdō 六波羅蜜寺
 地蔵堂
rokuji myōgō honzon 六字名号本
 尊
rokujō 鹿杖
rokusai nenbutsu 六斎念仏
Ryōgen 良源
Ryōhen 良遍
Ryōnin 良忍
Ryōzen *jōdo* 霊山浄土
Ryūketsu 龍穴
Sadamori 貞盛
sae no kami 斉の神　佐比神　障神
 斎神　塞神　賽神　道祖神
Saga 嵯峨
Saga monogurui 嵯峨物狂い
*Saga no dainenbutsu no onna
 monogurui no nō* 嵯峨の大念仏の
 女物狂能
Saga Seiryōji 嵯峨清凉寺
Sai 西院
sai no kami 塞神, 道祖神, 賽神
sai no kan 才神
sai no kawara 賽の河原, 西院の河原
Sai no kawara Jizō wasan 賽の河原
 地蔵和讃
*Sai no kawara kuchi zusami no den
 (kugō den)* 賽の河原口号伝
Saidaiji 西大寺
Saifukuji 西福寺
Sai'in 西院
Saikō 西光
Sa'in 西院
Saishō *no kimi* 宰相の君
sakagura 酒蔵
sakaki 榊
sakanomono 坂者

Sakanoue no Tamuramaro 坂上田
　村麻呂
sakekasu 酒粕
Sanbasō 三番叟
Sandō 三道
Sanjie jiao 三階教
sanjo 散所
Sanjūsangendō 三十三間堂
Sannenzaka 三年坂、産寧坂
Sanshū meisekishi 山州名跡志
Sanzu 三途
sarugaku 猿楽
Sarusawa no ike 猿沢池
sasahōshi 小法師
sawari 障
segakie 施餓鬼会
Seichō 清長
seino 細男、才男
Seiren 西蓮（尼西蓮）
Seiryōji 清凉寺
Seishi 勢至
Seki 関
sekirei, niwakunaburi 鶺鴒
sekkyō bushi 説経節
Senbon Shakadō 千本釈迦堂
Sengen *bosatsu* 浅間菩薩
sentai Jizō 千体地蔵
setsuwa 説話
Shaba 娑婆
shaku 尺
shakubyōshi 笏拍子
shakujō 錫杖
Shakushi 石神
shakutō 石塔
shamon 沙門
shamon no goku 沙門の獄
Shiba 柴
Shilunjing 十輪經
Shimizudera 清水寺
Shin Yakushiji 新薬師寺
Shin Yakushiji engi 新薬師寺縁起
Shin'a 心阿
shinchū shogan ketsujō enman 心中
　所願決定円満
shinkō 信仰

Shinnyo 信如
Shinnyokaku 真如覚
Shintennōji 四天王寺
Shira *bikuni* 白比丘尼
shirabyōshi 白拍子
shirame 白女
Shirō 四郎
Shishigatani 鹿ヶ谷
shishū kengaku 四宗兼学
shite 仕手
Shizhi 勢至
Shōbōji 正法寺
shōgun Jizō 勝軍地蔵
shōgyō nenbutsu 正行念仏
shōjin 生身
shōjin 精進
Shōjin ike 精進池
shōjin Jizō 生身地蔵
Shōjin Jizō bosatsu engi 生身地蔵菩
　薩縁起
Shōjin kawa or Shōjigawa 精進川
shōjin no zō 生身の像
shōju raigō 聖衆来迎
shōko 鉦鼓
shomin shinkō 庶民信仰
shōnin 上人
Shōrenbō 祥蓮房
shōryō mukae 精霊迎
Shōshun 秀舜
shōten 聖天
Shōzu 葬頭
shu 酒
Shuekihime 酒えき姫
shugen 修験
shugendō 修験道
shugenja 修験者
Shugojin 守護神
Shugūjin 守宮神
shugyōja 修行者
shūji 種子
shuku 宿
Shukujin 宿神
Shukurenbō 宿蓮房
Shunjō 舜貞
Shunjun 俊舜

Akata Mitsuo 赤田光男. 2007. *Seirei shinkō to girei no minzoku kenkyū: Animizumu no shūkyō shakai* 精霊信仰と儀礼の民俗研究：アニミズムの宗教社会. Tokyo: Kinokuniya shoten.

Amamonzeki 尼門跡. 2009. *Amamonzeki jiin no sekai: Miko-tachi no shinkō to gosho bunka* 尼門跡寺院の世界：皇女たちの信仰と御所文化 (Amamonzeki: A Hidden Heritage; Treasures of the Japanese Imperial Convents). Ed. Institute for Medieval Japanese Studies, Tōkyō Geijutsu Daigaku. Tokyo: Sankei shinbunsha.

Amano Fumio 天野文雄. 1995. *Okina sarugaku kenkyū* 翁猿楽研究. Osaka: Izumi shoin.

Amino Yoshihiko 網野喜彦. 1984. "Ukai to Katsurame" 鵜飼と桂女. In *Nihon chūsei no hinōgyōmin to tennō* 日本中世の非農業民と天皇, 392–429. Tokyo: Iwanami shoten.

———. 1987. *Muen, kugai, raku: Nihon chūsei no jiyū to heiwa* 無縁・公界・楽：日本中世の自由と平和. Tokyo: Heibonsha.

———. 1994. *Chūsei no hinin to yūjo* 中世の非人と遊女. Tokyo: Akashi shoten.

Andō Tsunejirō 安藤常次郎 and Nonomura Kaizō 野々村戒三, eds. 1974. *Kyōgen shūsei* 狂言集成. Tokyo: Nōgaku shorin.

Andreeva, Anna. 2006. "Saidaiji Monks and Esoteric Kami Worship at Ise and Miwa." *Japanese Journal of Religious Studies* 32 (3): 349–377.

Aoki Tadao 青木忠雄, Ishii Susumu 石井進, and Suitō Makoto 水藤真. 2001. *Sekibutsu to sekitō* 石仏と石塔. Tokyo: Yamakawa shuppansha.

Arai, Paula Kane Robinson. 1998. *Women Living Zen: Japanese Sōtō Buddhist Nuns*. Oxford: Oxford University Press.

Asai Kazuharu 浅井和春. 1986. "Heian zenki Jizō bosatsuzō no kenkyū" 平安前期地蔵菩薩像の研究. *Tōkyō kokuritsu hakubutsukan kiyō* 22 (1): 5–125.

Ashida Eiichi 芦田栄一. 1963. *Shashinshū: Dōso no kamigami* 写真集：道祖の神々. Fujisawa: Ikeda shoten.

Aston, W. G., trans. 1993. *Nihongi: Chronicles of Japan from the Earliest Times to A.D. 697*. Rutland, VT: Tuttle.

Asuwa Harumi 阿諏訪青美. 1998. "Muromachiki ni okeru Nara Fukuchiin Jizōdō no saikō to 'Kanjin tanomoshi'" 室町期における奈良福智院地蔵堂の再興と「勧進憑支」. *Shi'en* 58/2 (160): 66–85.

Averbuch, Irit. 1998. "Shamanic Dance in Japan: The Choreography of Possession in Kagura Performance." *Asian Folklore Studies* 57 (2): 293–329.

Bargen, Doris G. 1992. "Ancestral to None: Mizuko in Kawabata." *Japanese Journal of Religious Studies* 19 (4): 337–377.

———. 1997. *A Woman's Weapon: Spirit Possession in the Tale of Genji*. Honolulu: University of Hawai'i Press.

Bashō [Matsuo Bashō] 芭蕉 [松尾芭蕉]. 1962. *Teihon Bashō taisei* 定本芭蕉大成. Ed. Ogata Tsutomu. Tōkyō: Sanseidō.

———. 1995. *Matsuo Bashō shū* 松尾芭蕉集. Ed. Nōichi Imoto. Tokyo: Shōgakkan.

Bays, Jan Chozen. 2002. *Jizō Bodhisattva: Modern Healing and Traditional Buddhist Practice*. Boston: Tuttle.

Belting, Hans. 1994. *Likeness and Presence: A History of the Image before the Era of Art*. Chicago: University of Chicago Press.

Bender, Ross. 1980. "The Political Meaning of the Hachiman Cult in Ancient and Medieval Japan." Ph.D. diss., Columbia University.

Berry, Mary Elizabeth. 1994. *The Culture of Civil War in Kyoto*. Berkeley and Los Angeles: University of California Press.

Bialock, David T. 2007. *Eccentric Spaces, Hidden Histories: Narrative, Ritual, and Royal Authority from "The Chronicles of Japan" to "The Tale of the Heike."* Stanford, CA: Stanford University Press.

Bialostocki, Jan. 1981. "Aby M. Warburgs Botschaft: Kunstgeschichte oder Kulturgeschichte?" In *Übergabe des Aby-M.-Warburg-Preises für das Verleihungsjahr 1980 im Kaisersaal des Rathauses am 16. April 1981*, ed. Verein für Hamburgische Geschichte, 25–43. Hamburg: Hans Christians.

Bielefeldt, Carl. 1997. "Kokan Shiren and the Sectarian Uses of History." In *The Origins of Japan's Medieval World: Courtiers, Clerks, and Peasants in the Fourteenth Century*, ed. Jeffrey P. Mass, 295–319. Stanford, CA: Stanford University Press.

Blacker, Carmen. 1975. *The Catalpa Bow: A Study of Shamanistic Practices in Japan*. London: Allen and Unwin.

Blum, Mark Laurence. 2002. *The Origins and Development of Pure Land Buddhism: A Study and Translation of Gyōnen's "Jōdo Hōmon Genrushō."* Oxford: Oxford University Press.

Bodiford, William M. 1992. "Zen in the Art of Funerals: Ritual Salvation in Japanese Buddhism." *History of Religions* 32 (2): 146–164.

———. 1993. *Sōtō Zen in Medieval Japan*. Honolulu: University of Hawai'i Press.

Bowring, Richard. 1982. *Murasaki Shikibu: Her Diary and Poetic Memoirs*. Princeton, NJ: Princeton University Press.

Brock, Karen. 1988. "Awaiting Maitreya at Kasagi." In *Maitreya, the Future Buddha*, ed. Alan Sponberg and Helen Hardacre, 214–247. Cambridge: Cambridge University Press.

Buckley, Edmund. 1895. *Phallicism in Japan*. Chicago: University of Chicago Press.

Bukkyō daigaku minkan nenbutsu kenkyūkai 仏教大学民間念仏研究会, ed. 1966. "Rokusai nenbutsu" 六斎念仏 and "Rousai nenbutsu to sono keitō ni zoku suru nenbutsu" 六斎念仏とその系統に属する念仏. In *Minkan nenbutsu shinkō no kenkyū: Shiryōhen* 民間念仏信仰の研究：資料編, 122–131, 263–286. Tokyo: Ryūbunkan.

Burke, Peter. 1991. "Aby Warburg as Historical Anthropologist." In *Aby Warburg: Akten des internationalen symposions, Hamburg 1990*, ed. Horst Bredekamp, Michael Diers, and Charlotte Schoell-Glass, 39–44. Weinheim, Germany: VCH, Acta Humaniora.

Burucúa, José E. 2003. *Historia, arte, cultura: De Aby Warburg a Carlo Ginzburg*. Buenos Aires: Fondo de Cultura Económica de Argentina.

Buswell, Robert E., ed. 1990. *Chinese Buddhist Apocrypha*. Honolulu: University of Hawai'i Press.

Campany, Robert F. 1993. "The Real Presence for Joseph M. Kitagawa." *History of Religions* 32 (3): 233–272.

Chaney, Sally E. 1997. "Mibu Kyōgen: A Living Tradition of Folk Theatre." Ph.D. diss., University of Kansas.

Changjin 常謹. 1967. *Dizang pusa xiang langyan ji* 地蔵菩薩像靈驗記. In *Xu zang jing* 続蔵経 149:177–185. Hong Kong: Ying yin Xu zang jing wei yuan hui.

Chikamoto Kensuke 近本謙介. 1998. "'Kasuga gongen genki'e seiritsu to Gedatsubō Jōkei" 「春日権現験記絵」成立と解脱房貞慶. *Chūsei bungaku* 43:69–80.

———. 1999a. "Kasuga o meguru in'nen to gensetsu: Jōkei to 'Kasuga gongen genki e' ni kansuru shinshiryō'" 春日をめぐる因縁と言説：貞慶と「春日権現験記絵」に関する新資料. *Kanazawa bunko kenkyū* 302:20–36.

———. 1999b. "Nanto o meguru nō to Nihongi: Fudaraku no minami no kishi ni tenkai suru bungei sekai" 南都をめぐる能と日本紀—補陀落の南の岸に展開する文芸世界. *Kokubungaku: Kaishaku to kanshō* 64 (3): 165–173.

Chilson, Clark. 2007. "Eulogizing Kūya as More than a Nenbutsu Practioner: A Study and Translation of the *Kūyarui*." *Japanese Journal of Religious Studies* 34 (2): 305–327.

Christ, Carol. 2000. "The Sole Guardians of the Art Inheritance of Asia: Japan and China at the 1904 St. Louis World's Fair." *Positions: East Asia Cultures Critique* 8 (3): 675–709.

Cieri Via, Claudia. 1994. *Nei dettagli nascosto: Per una storia del pensiero iconologico*. Rome: La Nuova Italia Scientifica.

Coates, Harper Havelock, and Ryūgaku Ishizuka, trans. 1930. *Honen, the Buddhist Saint: His Life and Teaching; Compiled by Imperial Order*. 5 vols. Tokyo: Kōdōkaku.

Como, Michael. 2008a. "Of Temples, Horses, and Tombs: Hōryūji and Chūgūji in Heian and Early Kamakura Japan." In *Hōryūji Reconsidered*, ed. Dorothy C. Wong, 263–288. Newcastle, UK: Cambridge Scholars.

———. 2008b. *Shōtoku: Ethnicity, Ritual, and Violence in the Japanese Buddhist Tradition*. Oxford: Oxford University Press.

Conlan, Thomas. 2003. *State of War: The Violent Order of Fourteenth-Century Japan*. Ann Arbor: Center for Japanese Studies, University of Michigan.

Cranston Edwin, trans. 1969. *The Izumi Shikibu Diary: A Romance of the Heian Court*. Cambridge, MA: Harvard University Press.

Czaja, Michael. 1974. *Gods of Myth and Stone: Phallicism in Japanese Folk Religion*. New York: Weatherhill.

Daigo Hachirō 大護八郎. 1977. *Ishigami shinkō* 石神信仰. Tokyo: Mokujisha.

Davis, Richard H. 1997. *Lives of Indian Images.* Princeton, NJ: Princeton University Press.

Deal, William E. 1995. "Buddhism and the State in Early Japan." In *Buddhism in Practice,* ed. Donald Lopez, 216–227. Princeton, NJ: Princeton University Press.

Dean, Carolyn. 2006. "The Trouble with (the Term) Art." *Art Journal* 65 (2): 24–33.

deVisser, Marius Willem. 1915. *The Bodhisattva Ti-Tsang (Jizō) in China and Japan.* Berlin: Oesterheld and Co. Verlag.

Didi-Huberman, Georges. 1996. "Pour une anthropologie des singularites formelles: Remarque sur l'invention warburgienne." *Genesis: Sciences Sociale et Histoire* 24:145–163.

———. 2002. "The Surviving Image: Aby Warburg and Tylorian Anthropology." *Oxford Art Journal* 25:59–70.

———. 2003. "History and Image: Has the 'Epistemological Transformation' Taken Place?" In *The Art Historian: National Traditions and Institutional Practices,* ed. Michael F. Zimmermann, 128–143. Williamstown, MA: Sterling and Francine Clark Art Institute.

———. 2004. "Knowledge: Movement (the Man Who Spoke to Butterflies)." Foreword to *Aby Warburg and the Image in Motion,* by Philippe-Alain Michaud, trans. Sophie Hawkes, 7–19. New York: Zone Books.

———. 2005. *Confronting Images: Questioning the Ends of a Certain History of Art.* Trans. John Goodman. University Park: Pennsylvania State University Press.

Diers, Michael. 1995. "Warburg and the Warburgian Tradition of Cultural History." *New German Critique* 65:59–73.

Doi Tadao 土井忠生, Morita Takeshi 森田武, and Chōnan Minoru 長南実, eds. 1980. *Hōyaku Nippo jisho* 邦訳日葡辞書. Tokyo: Iwanami Shoten.

Drogin, Melanie Beth. 2000. "Images for Warriors: Unkei's Sculptures at Ganjōjuin and Jōrakuji." Ph.D. diss., Yale University.

Dunhuang wenwu yenjiu suo 敦煌文物研究所, ed. 1999. *Zhongguo shiku: Dunhuang Mogao ku* 中国石窟：敦煌莫高窟. Beijing: Wen wu chu ban she.

Dykstra, Yoshiko Kurata. 1978. "Jizō, the Most Merciful: Tales from *Jizō bosatsu reigenki.*" *Monumenta Nipponica* 33 (2): 179–200.

———, trans. 1983. *Miraculous Tales of the Lotus Sutra from Ancient Japan: The Dainihonkoku Hokkekyōkenki of Priest Chingen.* Honolulu: University of Hawai'i Press.

Eck, Diana L. 1981. *Darśan: Seeing the Divine Image in India.* Chambersburg, PA: Anima Books.

Ecke, Gustav. 1959. "Carved Images of Jizō as a Priest in Late Fujiwara and Early Kamakura Interpretations." *Artibus Asiae* 22 (1/2): 41–47.

Eishin 栄心. 1979. *Hōkkekyō jikidanshō* 法華經直談鈔. Ed. Ikeyama Issaien 池山一切圓. Kyoto: Rinsen shoten.

Eishun 英俊. 1978. *Tamon'in nikki* 多聞院日記. *Zōho zoku shiryō taisei,* vols. 38–42, ed. Takeuchi Rizō and Tsuji Zenosuke. Kyoto: Rinsen shoten.

Elkins, James. 2003. *Visual Studies: A Skeptical Introduction.* New York: Routledge.

Ennin 円仁. 1955. *Ennin's Diary: The Record of a Pilgrimage to China in Search of the Law.* Trans. Edwin O. Reischauer. New York: Ronald Press Co.

———. 1990. "Nittō guhō junrei gyōki" 入唐求法巡礼行記. In *Daijō butten: Chūgoku, Nihon hen; Saichō, Ennin* 大乗仏典 : 中国・日本篇 ; 最澄、円仁, vol. 17, ed. Kiuchi Gyōō, 145–242. Tokyo: Chūō Kōronsha.

Faure, Bernard. 1998a. "The Buddhist Icon and the Modern Gaze." *Critical Inquiry* 24 (3): 768–813.

———. 1998b. *The Red Thread: Buddhist Approaches to Sexuality.* Princeton, NJ: Princeton University Press.

———. 2003. "Quand l'habit fait le moine: The Symbolism of the *kāṣāya* in Sōtō Zen." In *Chan Buddhism in Ritual Context,* ed. Bernard Faure, 211–249. London: RoutledgeCurzon.

———. 2006. "The Elephant in the Room: The Cult of Secrecy in Japanese Tantrism." In Scheid and Teeuwen 2006, 255–268.

———. 2009. "Nihon shūkyō no 'shin/butsu' kōzō saikō: 'Yasei no kami' no kōsatsu o tōshite" 日本宗教の「神／仏」構造再考 : 「野生の神」の考察をとおして. *Bungaku* 10 (1): 225–236.

Fenollosa, Ernest Francisco, and Mary Fenollosa. 1913. *Epochs of Chinese and Japanese Art: An Outline History of East Asiatic Design.* New and rev. ed. New York: Frederick A. Stokes, 1963.

Ferretti, Silvia. 1989. *Cassirer, Panofsky, and Warburg: Symbol, Art, and History.* New Haven, CT: Yale University Press.

Foard, James H. 1980. "In Search of a Lost Reformation: A Reconsideration of Kamakura Buddhism." *Japanese Journal of Religious Studies* 7 (4): 261–291.

———. 1998. "Pure Land Belief and Popular Practice: The Odori Nembutsu of Ippen Shōnin." In *Engaged Pure Land Buddhism: Studies in Honor of Professor Alfred Bloom,* ed. Kenneth K. Tanaka and Eisho Nasu, 189–200. Berkeley, CA: Wisdom Ocean Publications.

Ford, James L. 2006. *Jōkei and Buddhist Devotion in Early Medieval Japan.* Oxford: Oxford University Press.

Formanek, Susanne. 2000. "Shaji sankei mandara—Pilger-Bilder zwischen Heilsobjekt und religiösem Werbeplakat und ihre Beziehungen zum Edo-zeitlichen Pilgerwesen." In *Informationssystem und kulturelles Leben in den Städten der Edo-Zeit,* ed. Shiro Kohsaka and Johannes Laube, 97–120. Wiesbaden: Harroswitz Verlag.

———. 2006. "Mizuko kuyō: Moderne Ausprägungen und historische Hintergründe der buddhistischen Totenrituale für Ungeborene in Japan." In *Buddhismus in Geschichte und Gegenwart 11,* 51–97. Universität Ham-

burg, Asien-Afrika-Institut, Abteilung für Kultur und Geschichte Indiens und Tibets.

Formanek, Susanne, and William R. LaFleur. 2004. *Practicing the Afterlife: Perspectives from Japan.* Vienna: Verlag der Österreichischen Akademie der Wissenschaften.

Foster, Kurt. 1976. "Aby Warburg's History of Art: Collective Memory and the Social Mediation of Images." *Daedalus* 105:169–176.

Fowler, Sherry Dianne. 2005. *Murōji: Rearranging Art and History at a Japanese Buddhist Temple.* Honolulu: University of Hawai'i Press.

———. 2007. "Between Six and Thirty-three: Manifestations of Kannon in Japan." In *Kannon, Divine Compassion: Early Buddhist Art from Japan* (*Kannon Göttliches Mitgefühl Frühe buddhistische Kunst aus Japan*), ed. Katharina Epprecht, 59–77. Zurich: Rietberg Museum at the University of Zürich.

Freedberg, David. 1989. *The Power of Images: Studies in the History and Theory of Response.* Chicago: University of Chicago Press.

Fuji Masaharu 富士正晴. 1974. *Nihon no Jizō* 日本の地蔵. Tokyo: Mainichi shinbunsha.

Fujikake Shizuya 藤懸静也. 1941. "Jizō bosatsu zu" 地蔵菩薩図. *Kokka* 610:280–281.

Fujimoto Bun'yu 藤本文雄. 1983. "Jōkei 'Gedatsu shōnin shōshōshū' ni okeru jōdogi" 貞慶「解脱上人小章集」における浄土義. *Tendai gakuhō* 25:134–137.

———. 1985. "Gedatsu shōnin Jōkei to Kasuga shinkō" 解脱上人貞慶と春日信仰. *Tendai gakuhō* 27:94–98.

Fujioka Michiko 藤岡道子. 2000. "Kyōgen to Jizō shinkō: 'Kanazu Jizō' no baai" 狂言と地蔵信仰 : 「金津地蔵」の場合. *Tōyō tetsugaku kenkyū kiyō* 16:3–31.

Fukuhara Toshio 福原敏男. 1987. *Shaji sankei mandara: E wa sasou reijō no nigiwai* 社寺参詣曼荼羅 : 絵は誘う霊場のにぎわい. Osaka: Ōsaka shiritsu hakubutsukan.

Fukushima Kimihiko 福島公彦. 1976. "*Shakekishū, Zōdanshū* to *Jizō bosatsu reigenki*" 「沙石集」、「雑談集」 と 「地蔵菩薩霊験記」. *Chūsei bungaku ronsō* 1:59–67.

Funada Jun'ichi 舩田淳一. 2004. "Jōkei 'Kasuga gongen kōshiki' no shinkō sekai: Kasugasha, Kōfukuji no okeru chūsei shinwa no seisei o megutte" 貞慶「春日権現講式」の信仰世界 : 春日社・興福寺における中世神話の生成をめぐって. *Nihon bungaku* 53 (6): 21–32.

Gay, Suzanne. 2001. *The Moneylenders of Late Medieval Kyoto.* Honolulu: University of Hawai'i Press.

Gell, Alfred. 1998. *Art and Agency: An Anthropological Theory.* Oxford: Clarendon Press.

Genshin 源信. 1971. *Eshin sōzu zenshū* 恵心僧都全集. Sakamotomura: Hieizan tosho kankōjo.

Gentō 玄棟. 1976. *Sangoku denki* 三国伝記. Ed. Ikegami Jun'ichi. Tokyo: Miyai shoten.

Gimello, Robert. 2004. "Icon and Incantation: The Goddess Zhunti and the Role of Images in the Occult Buddhism of China." In *Images in Asian Religions: Texts and Contexts,* ed. Phyllis Granoff and Shinohara Kōichi, 225–256. Vancouver: University of British Columbia Press.

Ginzburg, Carlo. 1989. "From Aby Warburg to E. H. Gombrich: A Problem of Method." In *Clues, Myths, and the Historical Method,* ed. Carlo Ginzburg, 17–59. Baltimore: Johns Hopkins University Press.

Glassman, Hank, trans. 1999. "*Mokuren no sōshi:* The Tale of Mokuren." *Buddhist Literature* 1:120–161.

———. 2002. "The Nude Jizō at Denkōji: Notes on Women's Salvation in Kamakura Buddhism." In *Engendering Faith: Women and Buddhism in Premodern Japan,* ed. Barbara Ruch, 383–413. Ann Arbor: Center for Japanese Studies, University of Michigan.

———. 2008. "At the Crossroads of Birth and Death: The Blood-Pool Hell and Postmortem Fetal Extraction." In Stone and Walter 2008, 175–206.

Goepper, Roger. 1984. *Die seele des Jizō: Weihegaben im Inneren einer buddhistichen Statue.* Cologne: Museum fur Osasiatische Kunst.

———. 1993. *Aizen-Myōō: The Esoteric King of Lust; An Iconological Study.* Zurich: Artibus Asiae, Museum Rietberg Zurich.

Gombrich, E. H. 1970. *Aby Warburg: An Intellectual Biography.* Chicago: University of Chicago Press.

Gomi Fumihiko 五味文彦. 1998. "*Kasuga genki e" to chūsei: Emaki o yomu aruku* 「春日験記絵」と中世：絵巻を読む歩く. Tokyo: Tankōsha.

Goodwin, Janet R. 1994. *Alms and Vagabonds: Buddhist Temples and Popular Patronage in Medieval Japan.* Honolulu: University of Hawai'i Press.

———. 2007. *Selling Songs and Smiles: The Sex Trade in Heian and Kamakura Japan.* Honolulu: University of Hawai'i Press.

Gorai Shigeru 五来重. 1980. "Heiankyō to roku Jizō" 平安京と六地蔵. *Tanbō Nihon no koji geppō* 2:1–2.

———. 1988a. *Ishi no shūkyō* 石の宗教. Tokyo: Kadokawa shoten.

———. 1988b. *Odori nenbutsu* 踊り念仏. Tokyo: Heibonsha.

———. 1995. *Jisha engi kara otogibanashi e* 寺社縁起からお伽話へ. Tokyo: Kadokawa shoten.

Gosukōin 後崇光院. 2002. *Kanmon nikki* 看聞日記. Ed. Kunaicho shoryobu. Tokyo: Meiji shoin.

Grapard, Allan G. 1986. "Lotus in the Mountain, Mountain in the Lotus: *Rokugō kaizan nimmon daibosatsu hongi.*" *Monumenta Nipponica* 41 (1): 21–50.

———. 1992. *The Protocol of the Gods: A Study of the Kasuga Cult in Japanese History.* Berkeley and Los Angeles: University of California Press.

Groner, Paul. 2001. "Icons and Relics in Eison's Religious Activities." In *Living Images: Japanese Buddhist Icons in Context,* ed. Robert H. Sharf and Elizabeth Horton Sharf, 114–150. Stanford, CA: Stanford University Press.

Gunsho ruijū. 1959–1960. 25 vols. Zoku Gunsho Ruijū Kanseikai.

Guth, Christine (also Kanda, Christine Guth). 1981. "Kaikei's Statue of Hachiman in Tōdaiji." *Artibus Asiae* 43 (3): 190–208.

———. 1985. *Shinzō: Hachiman Imagery and Its Development.* Cambridge, MA: Harvard University Press.

———. 1987. "The Divine Boy in Japanese Art." *Monumenta Nipponica* 42 (1): 1–23.

Gyōtoku Shin'ichirō 行徳真一郎. 1996. "Kasuga miya mandara no fūkei hyōgen: Busshō to shinsei no katachi" 春日宮曼荼羅図の風景表現：仏性と神性のかたち. *Museum* 541:13–42.

Hagiwara Tatsuo 萩原龍夫. 1983. *Miko to bukkyōshi: Kumano bikuni no shimei to tenkai* 巫女と仏教史：熊野比丘尼の使命と展開. Tokyo: Yoshikawa kōbunkan.

Hamada Takashi 濱田隆. 1967. "Kōyasan "shōshū raigōzu" no rekishiteki haikei: Jōgyō zanmai kara shōshū raigō e 高野山「聖衆来迎図」の歴史的背景：常行三昧から聖衆来迎. *Museum* 190:22–27.

Hamanaka Osamu 濱中修. 1996. " 'Koyasu monogatari' to minkan denshō" 「子安物語」と民間伝承. In *Muromachi monogatari ronkō* 室町物語論攷, 128–147. Tokyo: Shintensha.

Harada Masatoshi 原田正俊. 1990. "Hōkasō, boro ni miru chūsei zenshū to minshū" 放下僧・暮露にみる中世禅宗と民衆." *Historia* 129:25–54.

———. 1999. "Gozan zenrin no butsuji hōe to chūsei shakai: Chinkon, segaki, kitō o chūshin ni" 五山禅林の仏事法会と中世社会：鎮魂・施餓鬼・祈祷を中心に. *Zengaku kenkyū* 77:59–92.

Hardacre, Helen. 1997. *Marketing the Menacing Fetus in Japan.* Berkeley and Los Angeles: University of California Press.

Hare, Thomas Blenman. 1986. *Zeami's Style: The Noh Plays of Zeami Motokiyo.* Stanford, CA: Stanford University Press.

Harima Sadao 播麿定男. 1989. *Chūsei no itabi bunka* 中世の板碑文化. Tokyo: Tōkyō bijutsu.

Harrison, Elizabeth G. 1996. "Mizuko Kuyō: The Re-production of the Dead in Contemporary Japan." In *Religion in Japan: Arrows to Heaven and Earth,* ed. Peter F. Kornicki and James McMullen, 250–266. Cambridge: Cambridge University Press.

Haruta Akira 春田宣. 1985. " 'Kanmon nikki' to 'seken kōsetsu' to setsuwa: Katsuragawa Jizō odō shūzō no hanashi o chūshin ni." 『看聞日記』と「世間巷説」と説話：桂川地蔵御堂修造話を中心に. *Kokugakuin zasshi* 86 (11): 352–363.

Hashimoto Asao 橋本朝生. 1974. "Tenshō Kyōgen bon no shukke zatō: Kyōgen no kesei yōsetsu" 天正狂言本の出家座頭：狂言の形成序説. *Kokugo to kokubungaku* 56 (6): 28–41.

Hashimoto Hiroyuki 橋本裕之. 2003. *Engi no seishinshi: Chūsei geinō no gensetsu to shintai* 演技の精神史：中世芸能の言説と身体. Tokyo: Iwanami shoten.

———. 2006. *Minzoku geinō kenkyū to iu shinwa* 民俗芸能研究という神話. Tokyo: Shinwasha.

Hashimoto Naoki 橋本直紀. 1985. "Yōkyoku sōshika no ichitenkei: 'Hya-kuman' to 'Hyakuman monogatari' no baai" 謡曲草子化の一典型：「百万」と「百万物語」の場合. In *Otogizōshi* お伽草子, ed. Nihon Bun-gaku Kenkyū Shiryō Kankōkai, 204–219. Tokyo: Yūseidō.

Haskell, Francis. 1993. *History and Its Images: Art and the Interpretation of the Past.* New Haven, CT: Yale University Press.

Hattori Yukio 服部幸雄. 1974–1975. "Shukujinron: Geinōgami shinkō no kongen ni aru mono" 宿神論：芸能神信仰の根源に在るもの. Parts 1, 2, and 3. *Bungaku* 42 (10): 64–79; 43 (1): 54–63; 43 (2): 188–209.

———. 2009. *Shukujinron: Nihon geinōmin shinkō no kenkyū* 宿神論：日本芸能民信仰の研究. Tokyo: Iwanami shoten.

Hayami Tasuku 速水侑. 1975a. *Heian kizoku shakai to bukkyō* 平安貴族社会と仏教. Tokyo: Yoshikawa kōbunkan.

———. 1975b. *Jizō shinkō* 地蔵信仰. Tokyo: Hanawa shobō.

———. 1983. "Nihon kizoku shakai ni okeru Jizō shinkō no tenkai" 日本貴族社会における地蔵信仰の展開. In Sakurai Tokutarō 1983b, 75–138.

Hayashi Masahiko 林雅彦 and Watari Kōichi 渡浩一. 1990. "Rinzan bunko zō "Jūō santan" 林山文庫蔵「十王讃嘆」. *Meiji daigaku kyōyō ronshū* 232:135–198.

Hayashi Mikiya 林幹弥. 1970. "Higashiyama no Taishidō" 東山の太子堂. *Nihon rekishi* 260:70–80.

———. 1974. "Ritsusō, zensō, sanmaisō to Taishi" 律僧・禅僧・三昧僧と太子. *Shōtoku Taishi kenkyū* 8:13–27.

Hayashi On 林温. 1998. "Sentai Jizō bosatsu zō ni tsuite: Nanto butsuga kō, go" 千体地蔵菩薩図について：南都仏画考、五. *Bukkyō geijutsu (Ars Buddhica)* 241:77–99.

Hearn, Lafcadio. 1894. *Glimpses of Unfamiliar Japan.* Vol. 1. Boston and New York: Houghton, Mifflin, and Co.

Heckscher, William S. 1967. "The Genesis of Iconology." In *Stil und Uber-lieferung in der Kunst des Abendlandes, Akten des 21, Internationalen Kongresses für Kunstgeschichte in Bonn 1964,* 3:239–262. Berlin: Gebr. Mann.

Hinata Kazumasa 日向一雅. 1981. "Atago Jizō no honji" 愛宕地蔵の本地. *Kokubungaku: Kaishaku to kanshō* 46 (11): 48–49.

Hirabayashi Moritoku 平林盛得. 1981. *Hijiri to setsuwa no shiteki kenkyū* 聖と説話の史的研究. Tokyo: Yoshikawa kōbunkan.

Hiramatsu Chokū 平松澄空. 1982. *Hieizan kaihōgyō no kenkyū* 比叡山回峰行の研究. Tokyo: Miraisha.

Hirasawa, Caroline. 2008. "The Inflatable, Collapsible Kingdom of Retribu-tion: A Primer on Japanese Hell Imagery and Imagination." *Monumenta Nipponica* 63 (1): 1–50.

Hirayama Ikuo 平山郁夫 and Kobayashi Tadashi 小林忠. 1994. *Hizō Nihon bijutsu taikan. 12, Yōroppa shūzō Nihon bijutsu sen* 秘蔵日本美術大観, vol. 12, ヨーロッパ蒐蔵日本美術選. Tōkyo: Kōdansha.

Hirose Fumiko 広瀬文子. 2003. "Saitama densetsu kō: Happyaku bikuni to Taira Masakado densetsu ni miru bunka tokusei" 埼玉伝説考—八百

比丘尼と平将門伝説にみる文化特性. *Saitama daigaku kokugo kyōiku ronso* 6:17–40.

Hirota Tetsumichi 広田哲通. 2000. *Chūsei bukkyō bungaku no kenkyū* 中世仏教文学の研究. Osaka: Izumi shoin.

Hōbutsushū. Kankyo no tomo. Hirasan kojin reitaku 宝物集. 閑居友. 比良山古人霊託. 1993. In *Shin Nihon koten bungaku taikei* 新日本古典文学大系, vol. 40, ed. Koizumi Hiroshi. Tokyo: Iwanami shoten.

Hoff, Frank. 1977. "The 'Evocation' and 'Blessing' of Okina: A Performance Version of Ritual Shamanism." *Alcheringa: Ethnopoetics* 3 (1): 48–60.

Holly, Michael Ann. 1993. "Unwriting Iconology." In *Iconography at the Crossroads: Papers from the Colloquium Sponsored by the Index of Christian Art, Princeton University, 23–24 March 1990*, ed. Brendan Cassidy, 17–25. Princeton, NJ: Princeton University Press.

Holt, John C. 1981. "Assisting the Dead by Venerating the Living." *Numen* 28:1–28.

Honda Yasuji 本田安次. 1958. *Okina sono hoka: Nō oyobi kyōgenkō no ni* 翁そのほか：能及狂言考之貳. Tokyo: Meizendō shoten.

———. 1977. "Nō no hassei: Mikomai kara nō e" 能の発生：巫女舞から能へ. *Bungaku* 45 (3): 13–25.

Hōnen. 1998. *Hōnen's Senchakushū: Passages on the Selection of the Nenbutsu in the Original Vow*. Trans. and ed. Senchakushū English Translation Project. Honolulu: Kuroda Institute, University of Hawai'i Press.

Hori, Ichirō. 1958. "On the Concept of Hijiri (Holy-Man)." Parts 1 and 2. *Numen* 5 (2): 128–160; 5 (3): 199–232.

Horiguchi Sōzan 堀口蘇山. 1955. *Jizō bosatsu ryūzō* 地蔵菩薩立像. Tokyo: Geien junreisha.

———. 1960. *Kantō no ragyōzō* 關東の裸形像. Tokyo: Geien junreisha.

Horton, Sarah J. 2007. *Living Buddhist Statues in Early Medieval and Modern Japan*. New York: Palgrave Macmillan.

Hoshino Toshihide 星野俊英. 1958. "Jizō kōshiki no shurui" 地蔵講式の種類. *Toyama gakuhō* 4:112–125.

———. 1961. "Roku Jizō shinkō ni okeru zōzō no sho keishiki" 六地蔵信仰に於ける造像の諸形式. *Taishō daigaku kenkyūkiyō* 46:1–42.

Hosokawa Ryōichi 細川涼一. 1987a. "Hōkongōin Dōgo no shūkyō katsudō" 法金剛院導御の宗教活動. In *Chūsei no Risshū jiin to minshū* 中世の律宗寺院と民衆, 169–234. Tokyo: Yoshikawa kōbunkan.

———. 1987b. "Kamakura jidai no ama to amadera: Chūgūji, Hokkeji, Dōmyōji" 鎌倉時代の尼と尼寺：中宮寺・法華寺・道明寺. In *Chūsei no Risshū jiin to minshū* 中世の律宗寺院と民衆, 100–168. Tokyo: Yoshikawa kōbunkan.

———. 1993. *Itsudatsu no Nihon chūsei: Kyōki, tōsaku, ma no sekai* 逸脱の日本中世：狂気・倒錯・魔の世界. Tokyo: JICC shuppankyoku.

———. 1997. "Nobukata Fumon'in no funakoshi Jizō to Ninshō" 延方普門院の船越地蔵と忍性. In *Chūsei jiin no fūkei: Chūsei minshū no seikatsu to shinsei* 中世寺院の風景：中世民衆の生活と心性, 257–273. Tokyo: Shin'yōsha.

Hubbard, Jamie. 2001. *Absolute Delusion, Perfect Buddhahood: The Rise and Fall of a Buddhist Heresy.* Honolulu: University of Hawai'i Press.

Iijima, Yoshiharu. 1987. "Folk Culture and the Liminality of Children." *Current Anthropology* 28 (4): 41–48.

Ikawa Jōkei 井川定慶, ed. 1978. *Hōnen Shōnin den zenshū* 法然上人傳全集. Kyoto: Hōnen shōnin den zenshū kankōkai.

Ikeda Eigo 池田英悟. 1978. "Kyōgen ni okeru Jizō bosatsu" 狂言における地蔵菩薩. *Chūō daigaku kokushi* 21:12–19.

Ikegami Jun'ichi 池上旬一. 1982. *Sangoku denki* 三国伝記. Tokyo: Miyai shoten.

Ikoma Tetsurō 生駒哲郎. 2001. "Tainai nōnyūbutsu ni miru chūsei bukkyō shinkō: Denkōji ragyō Jizō bosatsuzō o chūshin ni" 胎内納入物にみる中世仏教振興：伝香寺裸形地蔵菩薩像を中心に. *Risshō shigaku* 90:80–82.

———. 2002. "Chūsei ni okeru butsuzō no busshō: Denkōjizō ragyō Jizō bosatsuzō tainai nōnyūbutsu no kentō o chūshin ni" 中世における仏像の仏性：伝香寺蔵裸形地蔵菩薩像胎内納入物の検討を中心に. *Risshō shigaku* 91:31–53.

———. 2003. "Muromachiki no shōjin shinkō: Katsura Jizō no reigentan o megutte" 室町期の生身信仰：桂地蔵の霊験譚をめぐって. *Yamawaki gakuen tanki daigaku kiyō* 41:1–19.

Imahori Taietsu 今堀太逸. 1979. "Jōkei no minshū kyūsai: Sono shūkyō katsudō no shisōteki kiban" 貞慶の民衆救済：その宗教活動の思想的基盤. *Indogaku bukkyōgaku kenkyū* 27 (2): 148–149 (650–651).

Inada Hideo 稲田秀雄. 2009. "Kyōgen busshi mono kō: 'Busshi' 'Roku Jizō' 'Kanazu'" 狂言仏師物考：「仏師」「六地蔵」「金津」. *Yamaguchi kenritsu daigaku gakujutsu jōhō* 2:14–27.

Inada Kōji 稲田浩二 and Inada Kazuko 稲田和子, eds. 2003. *Nihon mukashibanashi hyakusen* 日本昔話百選. Tokyo: Sanseidō.

Inagi Nobuko 稲城信子. 2005. *Nihon chūsei no kyōten to kanjin* 日本中世の経典と勧進. Tokyo: Hanawa shobō.

Ishida Hisatoyo 石田尚豊. 1978. *Mandara no kenkyū* 曼荼羅の研究. 2 vols. Tokyo: Tōkyō bijutsu.

Ishida Ichirō 石田一郎. 1956. *Jōdokyō bijutsu: Bunka shigakuteki kenkyū joron* 淨土教美術：文化史學的研究序論. Kyoto: Heirakuji shoten.

Ishida Mosaku 石田茂作, ed. 1960. *Kodai hanga* 古代版画. Vol. 1 of *Nihon hanga bijutsu zenshū* 日本版画美術全集. Tokyo: Kōdansha.

———. 1964. *Japanese Buddhist Prints.* English adaptation by Charles S. Terry. New York: H. N. Abrams.

Ishigami Katashi 石上堅. 1976. *Sei to shi no minzoku* 生と死の民俗. Tokyo: Ōfūsha.

Ishii Yoshinaga 石井義長. 2003. *Amida hijiri Kūya: Nenbutsu o hajimeta heiansō* 阿弥陀聖空也：念仏始めた平安僧. Tokyo: Kōdansha.

Ishikawa Jun'ichirō 石川純一郎. 1995. *Jizō no sekai* 地蔵の世界. Tokyo: Jiji tsūshinsha.

Ishikawa Rikizan 石川力山. 1986. "Chūsei bukkyō ni okeru bosatsu shikō: Toku ni Sōtōshū ni okeru Jizō bosatsu shinkō o chūshin to shite" 中世仏教における菩薩思考：特に曹洞宗における地蔵菩薩信仰を中心として. *Nihon bukkyō gakkai nempō* 11:473–488.

Itō Kenkichi 伊藤堅吉. 1966. *Sei no ishigami: Sōtai Dōsojin kō* 性の石神：双体道祖神考. Tokyo: Yamato keikokusha.

Itō Mamoru 伊藤聡. 1999. "Ōkura seishin bunka kenkyūjo, Sakakibara bunkozō 'Gen'yōki' honkoku 大倉精神文化研究所・榊原文庫蔵「元要記」翻刻." *Ōkurasan ronshū* 43:429–473.

Itō Takeshi 伊藤毅. 1996. "'Shuku' no ni ruikei 「宿」の二類型." In *Toshi to shōnin, geinōmin: chūsei kara kinsei e* 都市と商人・芸能民：中世から近世へ, ed. Gomi Fumihiko and Yoshida Nobuyuki, 147–165. Tokyo: Yamakawa Shuppansha.

Itō Yuishin 伊藤唯真, ed. 1986. *Bukkyō nenjū gyōji* 仏教年中行事. Vol. 6 of *Bukkyō minzokugaku taikei* 仏教民俗学大系, ed. Bukkyō Minzokugaku Taikei henshū iinkai. Tokyo: Meicho shuppan.

———, ed. 2005a. *Jōdo no shōja Kūya* 浄土の聖者空也. Tokyo: Yoshikawa kōbunkan.

———. 2005b. "Kūya no shōgai: Shami o tsuranuku" 空也の生涯：沙弥を貫く. In Itō Yuishin 2005a, 17–49.

Iversen, Margaret. 1993. "Retrieving Warburg's Tradition." *Art History* 16 (4): 541–553.

Ivy, Marilyn. 1995. *Discourses of the Vanishing: Modernity, Phantasm, Japan.* Chicago: University of Chicago Press.

Iwamoto Yutaka 岩本裕. 1979. *Jigoku meguri no bungaku* 地獄めぐりの文学. Tokyo: Kaimei shoin.

Iwasa Mitsuharu 岩佐光晴. 1984. "Rokuharamitsuji Jizō bosatsu ryūzō ni tsuite" 六波羅蜜寺地蔵菩薩立像について. *Bijutsu shigaku* 6:1–48.

Iwasaki Kae 岩崎佳枝, ed. 1993. *Shichijūichiban shokunin utaawase* 七十一番職人歌合. Shin Nihon koten bungaku taikei, 61, Tōkyō: Iwanami shoten.

Jay, Martin. 2005. "Introduction to Show and Tell." *Journal of Visual Culture* 4 (2): 139–143.

Jinson 尋尊. 1978. *Daijōin jisha zōjiki* 大乗院寺社雑事記. In *Zōho zoku shiryō taisei* 増補續史料大成, vols. 26–37, ed. Tsuji Zennosuke. Kyoto: Rinsen shoten.

———. 1983. *Daijōin jisha zōjiki: Aru monbatsu sōryo no botsuraku no kiroku* 大乗院寺社雑事記：ある門閥僧侶の没落の記録. Ed. Suzuki Ryōichi. Tokyo: Soshiete.

Jitsuei 実睿. 1964. *Sangoku innen Jizō bosatsu reigenki* 三國因緣地蔵菩薩霊驗記. Ed. Manabe Kōsai. Tokyo: Koten bunko.

Jizōbō 地蔵坊. 1963. In *Kyōgenshū* 狂言集, vol. 3, ed. Nonomura Kaizō and Furukawa Hisashi. *Nihon koten zensho* 日本古典全書, 43–45. Tokyo: Asahi shimbunsha.

Kageyama Haruki 影山春樹. 1973. *Shintō bijutsu: Sono shosō to tenkai* 神道美術：その諸相と展開. Tokyo: Yūzankaku shuppan.

Kakuzenshō 覚禅鈔. 1979. *DNBZ*, vols. 45–51, ed. *Bukkyō kankōkai*. To-
 kyo: Meicho hukyūkai.

Kamata Tōji 鎌田東二. 1995. "Kami to hotoke no topogurafii" 神と仏のト
 ポグラフィー. In *Kami no shigen* 神の始原, vol. 1 of *Nihon no kami* 日
 本の神, ed. Yamaori Tetsuo, 209–252. Tokyo: Heibonsha.

Kamens, Edward. 1993. "Dragon-Girl, Maidenflower, Buddha: The Trans-
 formation of a Waka Topos, 'The Five Obstructions.'" *Harvard Journal
 of Asiatic Studies* 53 (2): 389–442.

Kamibeppu Shigeru 上別府茂. 2005. "Kūya, Kūyasō to sōsō: Sanmai hijiri
 kenkyū no shiten kara 空也・空也僧と葬送：三昧聖研究の視点から."
 In Itō Yuishin 2005a, 185–208.

Kaminishi, Ikumi. 2006. *Explaining Pictures: Buddhist Propaganda and* Eto-
 ki *Storytelling in Japan*. Honolulu: University of Hawai'i Press.

Kanei Kiyomitsu 金井清光. 1971. "Monogurui no kyōgen kara kyōgengeki
 e" 物狂いの狂言から狂言劇へ. *Kokugo to kokubungaku* 48 (6): 15–27.

———. 1972. "Kyōgen no shagiri to oikomi" 狂言のシャギリと追い込み.
 Kokugo to kokubungaku 49 (7): 38–46.

Kasano'in Chikatada 風山院親忠. 1991. "Kasuga Wakamiya Onmatsuri no
 'furyū'" 春日若宮おん祭りの「風流」. In *Inori no mai: Kasuga Waka-
 miya Onmatsuri* 祈りの舞：春日若宮おん祭, ed. Nagashima Fututarō
 et al., 139–159. Osaka: Tōhō Shuppan.

Katō, Genchi. 1924. *A Study of the Development of Religious Ideas among
 the Japanese People as Illustrated by Japanese Phallicism*. Tokyo: Asi-
 atic Society of Japan.

Katō Tetsuhiro 加藤哲弘. 1992. "Mō hittotsu no ikonorojii: Aby Warburg to
 imeiji no kaishakugaku" もう一つのイコノロジー：アビ・ヴァールブ
 ルクとイメージの解釈学. *Bigaku* 43 (2): 25–35.

Katsuda Itaru 勝田至. 2004. "Chūsei Kyōto no sōsō" 中世京都の葬送. *Reki-
 shi to chiri: Nihonshi no kenkyū* 577:56–64.

Kawai Hayao. 1992. *The Buddhist Priest Myōe: A Life of Dreams*. Ed. and
 trans. Mark Unno. Venice: Lapis Press.

Kawakatsu Seitarō 川勝政太郎. 1933. "Shinshiryō: Seiryōji Jizō bosatsu
 ryūzō no ganmon" 新資料：清凉寺地蔵菩薩立像の願文. *Shisetsu to bi-
 jutsu* 4 (32): 93–94.

———. 1974. "Sekizō Jizō 石造地蔵." *Bukkyō geijutsu (Ars Buddhica)*
 97:25–44.

Kawamura, Leslie S., ed. 1981. *The Bodhisattva Doctrine in Buddhism*. Wa-
 terloo, Ontario: Wilfred Laurier University Press.

Kawasaki Junshō 川崎純性 and Taki Shūzō 高城修三. 2007. *Rokuharami-
 tsuji* 六波羅蜜寺. Kyoto: Tankōsha.

Kim Hyŏn-uk 金賢旭. 2008. *Okina no seisei: Tōrai bunka to chūsei no kami-
 gami* 翁の生成：渡来文化と中世の神々. Tokyo: Shibunkaku shuppan.

Kimbrough, R. Keller. 2006a. "Preaching the Animal Realm in Late Medi-
 eval Japan." *Asian Folklore Studies* 65 (2): 179–204.

———. 2006b. "The Tale of the Fuji Cave." *Japanese Journal of Reli-*

gious Studies 33 (2) [online suppl.]: 1–22. http://nirc.nanzan-u.ac.jp/publications/jjrs/pdf/748a.pdf /.

———. 2008. *Preachers, Poets, Women, and the Way: Izumi Shikibu and the Buddhist Literature of Medieval Japan.* Ann Arbor: Center for Japanese Studies, University of Michigan.

Kimura Saeko 木村朗子. 2009. *Koisuru monogatari no homosekushuaritei: Kyūtei shakai to kenryoku* 恋する物語のホモセクシュアリティ：宮廷社会と権力. Tokyo: Soeisha.

Kinnard, Jacob N. 1999. *Imaging Wisdom: Seeing and Knowing in the Art of Indian Buddhism.* Richmond, UK: Curzon Press.

Kino Shūshin 紀秀信. 1972. *Butsuzō zui* 仏像図彙. Tokyo: Kokusho kankōkai.

Kitagawa Tadahiko 北川忠彦 and Yasuda Akira 安田章, eds. 1972. *Kyōgen-shū* 狂言集. Tokyo: Shōgakkan.

Kiyomizudera shi 清水寺史. 2000. Ed. Kiyomizudera shi hensan iinkai 清水寺史編纂委員会. 3 vols. Kyoto: Hōzōkan.

Klein, Robert. 1970. *La forme et l'intelligible: Écrits sur la Renaissance et l'art moderne.* Paris: Gallimard.

———. 1979. *Form and Meaning: Essays on the Renaissance and Modern Art.* Trans. Madeline Jay and Leon Wieseltier. New York: Viking Press.

Klein, Susan Blakeley. 2006. "Esotercism in Noh Commentaries and Plays: Konparu Zenchiku's *Meishukushū* and *Kakitsubata.*" In Scheid and Teeuwen 2006, 229–254.

Kobanawa Heiroku 小花波平六. 1985. *Sekibutsu kenkyū handobukku* 石仏研究ハンドブック. Tokyo: Yūzankaku.

Kobayashi Naoki 小林直樹. 2000. "*Shasekishū* Jizō setsuwa kō: Uragaki kiji no kentō kara 「沙石集」地蔵説話考：裏書記事の検討から. *Setsuwa bungaku kenkyū* 35:75–84.

Kobayashi Takeshi 小林剛. 1965. "Busshi Zen'en, Zenkei, Zenshun" 仏師善圓・善慶・善春. *Bukkyō geijutsu (Ars Buddhica)* 31:67–76.

———. 1971. *Shunjōbō Chōgen no kenkyū* 俊乗房重源の研究. Yokohama: Yūrindō.

Kobayashi Yasushi 小林靖. 1989. "Chūsei roku Jizō shinkō no ichi sokumen: Itabi ni miru roku Jizō shinkō" 中世六地蔵信仰の一側面：板碑にみる六地蔵信仰. *Nihon bukkyō shigaku* 23:88–96.

Kōdate Naomi 高達奈緒美. 2004. "Aspects of the *Ketsubon* Cult." In Formanek and LaFleur 2004, 121–143.

———. 2006. "Datsueba shōkō" 奪衣婆小考. In Yamada Itsuko 2006, 56–60.

Kojima Yoshiyuki 小島瓔禮. 1962. "Izanaki, Izanami no kon'in" イザナキ・イザナミの婚姻. *Shūkyō kenkyū* 35 (4): 15.

Kokubu Naoichi 國分直一. 1992. *Nihon bunka no kosō: Rettō no chiriteki isō to minzoku bunka* 日本文化の古層：列島の地理的位相と民族文化. Tokyo: Daiichi shobō.

Kokusho sōmokuroku (Hoteiban) 国書総目録（補訂版）. 1990. Tokyo: Iwanami shoten.

Komatsu Kazuhiko 小松和彦. 1992. "'Koyasu monogatari' no miryoku" 「子安物語」の魅力. *Shin Nihon kotenbungaku taikei geppō* 55:4–7.

———. 1997. *Shuten Dōji no kubi* 酒呑童子の首. Tōkyō: Serika Shobō.

———. 2007. "Rokudō no tsuji: Kumano bikuni no etoki basho" 六道の辻：熊野比丘尼の絵解き場所. In *Rokuharamitsuji*, ed. Kawasaki Junsho and Taki Shūzō, 126–130. Kyoto: Tankōsha.

Komatsu Shigemi 小松茂美, ed. 1992. *Yūzū nenbutsu engi* 融通念仏縁起続. In *Zoku Nihon no emaki*, vol. 21. Tokyo: Chūō kōronsha.

———, ed. 1994. *Kiyomizudera engi, Shin'nyodō engi* 清水寺縁起・真如堂縁起. In *Zoku zoku Nihon emaki taisei*, vol. 5. Tokyo: Chūō kōronsha.

Komine Kazuaki 小峯和明. 1991. "Noboranakatta ryū: Denshō to modoki" 昇らなかった龍：伝承ともどき. In *Setsuwa no mori: Tengu, tōzoku, igyō no dōke* 説話の森：天狗・盗賊・異形の道化, 164–186. Tokyo: Taishūkan shoten.

Kouchi Kazuo 木内一夫. 1975. "Kanmon gyōki ni mietaru Jizō mōde: nenbutsu odori to furyū" 看聞御記に見えたる地蔵詣：念仏躍と風流. *Kokugakuin zasshi* 76 (5): 22–33.

Kujō Kanezane 九條兼實. 1969. *Gyokuyō* 玉葉. Tokyo: Kokusho kankōkai.

Kuly, Lisa. 2003. "Locating Transcendence in Japanese Minzoku Geinō: Yamabushi and Miko Kagura." *Ethnologies* 25 (1): 191–208.

Kuno Takeshi 久野健. 1957. "Kantō no sekibutsu" 関東の石仏. *Bukkyō geijutsu (Ars Buddhica)* 30:72–84.

———. 1966. "Daibusshi Zen'en to sono sakuhin" 大仏師善円とその作品. *Bijutsu kenkyū* 240:1–17.

———. 1975. *Sekibutsu* 石仏. *Nihon no bijutsu* 36. Tokyo: Shōgakkan.

Kuraishi Tadahiko 倉石忠彦. 1990. *Dōsojin shinkōron* 道祖神信仰論. Tokyō: Meichō shuppan.

———. 2005. *Dōsojin shinkō no keisei to hatten* 道祖神信仰の形成と発展. Tokyo: Taiga shobō.

Kurata Bunsaku 倉田文作. 1973. *Zōnai nōnyūhin* 像内納入品. *Nihon no bijutsu* 86. Tokyo: Shibundō.

Kuroda Hideo 黒田日出男. 1987. "Sankei mandara to bungei: Kiyomizudera sankai mandara no dokkai" 参詣曼荼羅と文芸：清水寺参詣曼荼羅の読解. *Kokubungaku: Kaishaku to kanshō* 52 (9): 131–138.

———. 1989. "*Kumano kanjin jikkai mandara* no uchū" 熊野観心十界曼荼羅の宇宙. In *Sei to mibun: Jakusha, haisha no seisei to hiun* 性と身分：弱者・敗者の聖性と非運, vol. 8 of *Taikei Bukkyō to Nihonjin* 大系仏教と日本人, ed. Miyata Noboru, 206–273. Tokyo: Shunjūsha.

———. 2004. "The *Kumano kanshin jikkai mandara* and the Lives of the People in Early Modern Japan." In Formanek and LaFleur 2004, 101–120.

Kuroda, Toshio. 1981. "Shinto in the History of Japanese Religion." Trans. James C. Dobbins and Suzanne Gay. *Journal of Japanese Studies* 7 (1): 1–21.

Kurokawa Dōyū 黒川道祐. 1997. *Kundoku "Yōshū fushi"* 訓読「雍州府志」. Ed. Tachikawa Yoshihiko 立川美彦. Kyoto: Rinsen shoten.

Kusunoki Junshō 楠淳證. 1986. "Jōkei no jōdokan to sono shinkō (ni): Mida jōdo shinkō no umu ni tsuite" 貞慶の浄土観とその信仰（二）：弥陀浄土信仰の有無について. *Ryūkoku daigaku daigakuin kiyō* 7:1–14.

———. 1989. "Jōkei no Hōnen Jōdokyō hihan ni kansuru ichi kōsatsu" 貞慶の法然浄土教批判に関する一考察. *Ryūkoku daigaku ronshū* 434/435:231–245.

———. 2002. "Jōkei no Mida jōdo shinkō no umu ni tsuite no saikentō" 貞慶の弥陀浄土信仰の有無についての再検討. *Indogaku bukkyōgaku kenkyū* 57:1–36.

Kūya shōnin ekotoba den 空也上人絵詞伝. 1966. In *Minkan nenbutsu shinkō no kenkyū: Shiryōhen* 民間念仏信仰の研究：資料編, ed. Bukkyō Daigaku Minkan Nenbutsu Kenkyūkai, 495–504. Tokyo: Ryūbunkan.

Kyōto bunka hakubutsukan 京都文化博物館. 1992. *Mibudera ten: Dainenbutsu kyōgen to Jizō shinkō no tera* 壬生寺展：大念仏狂言と地蔵信仰の寺. Kyoto: Kyōto bunka hakubutsukan.

Kyōtoshi no chimei 京都市の地名. 2001. *Nihon rekishi chimei taikei* 日本歴史地名大系, vol. 27. Tokyo: Heibonsha.

Kyūbi Eisaburō 九尾影三郎. 1967. "Hakoneyama no sekibutsu" 箱根山の石仏. In *Hakone chōshi* 箱根町誌, ed. Hakone Machi, 127–139. Tokyo: Kadokawa shoten.

LaFleur, William R. 1992. *Liquid Life: Abortion and Buddhism in Japan.* Princeton, NJ: Princeton University Press.

———. 1999. "Abortion, Ambiguity, and Exorcism." Review of *Marketing the Menacing Fetus in Japan,* by Helen Hardacre. *Journal of the American Academy of Religion* 67 (4): 797–808.

Law, Jane Marie. 1993. "Of Plagues and Puppets: On the Significance of the Name Hyaku-dayū in Japanese Religion." *Transactions of the Japan Asiatic Society,* 4th ser., 8:107–131.

———. 1997. *Puppets of Nostalgia: The Life, Death, and Rebirth of the Japanese Awaji Ningyō Tradition.* Princeton, NJ: Princeton University Press.

Lin, Irene. 2003. "From Thunder Child to Dharma-protector: Dōjō hōshi and the Buddhist Appropriation of Japanese Local Deities." In *Buddhas and Kami in Japan: Honji suijaku as a Combinatory Paradigm,* ed. Mark Teeuwen and Fabio Rambelli, 54–76. New York: Routledge.

Linden-Museum (Stuttgart), Doris Croissant, Misako Wakabayashi, and Klaus J. Brandt. 1998. *Japanese Paintings in the Linden-Museum Stuttgart: A Selection from the Baelz Collection.* 2 vols. Tokyo: Kōdansha; Stuttgart: Linden-Museum.

Mair, Victor H. 1983. *Tun-Huang Popular Narratives.* Cambridge: Cambridge University Press.

———. 1989. *T'ang Transformation Texts: A Study of the Buddhist Contribution to the Rise of Vernacular Fiction and Drama in China.* Cambridge, MA: Council on East Asian Studies, Harvard University.

Makita Shigeru 牧田茂. 1965. *Jinsei no rekishi* 人生の歴史. Tokyo: Kawade shobō shinsha.

Makita Tairyō 牧田諦亮. 1989. *Gikyō kenkyū* 疑経研究. Kyoto: Rinsen shoten.

Mali, Joseph. 2003. *Mythistory: The Making of a Modern Historiography.* Chicago: University of Chicago Press.

Manabe Kōsai 真鍋広済. 1960. *Jizō bosatsu no kenkyū* 地蔵菩薩の研究. Kyoto: Sanmitsudō shoten.

———. 1964. "Yoritaka bon *Jizō bosatsu reigenki ekotoba* ni tsuite" 頼隆本「地蔵霊験記繪詞」について. In *Sangoku innen Jizō bosatsu reigenki* 三國因緣地蔵菩薩霊験記, 165–179. Tokyo: Koten bunko.

———. 1981. *Jizō son no kenkyū* 地蔵尊の研究. Kōyasan: Yoshida shoin.

Manabe Kōsai 真鍋広済 and Umezu Jirō 梅津次郎, eds. 1957. *Jizō bosatsu reigenki ekotoba shū* 地蔵霊験記繪詞集. Tokyo: Koten bunko.

Maniura, Robert, and Robert Shepherd, eds. 2006. *Presence: The Inherence of the Prototype within Images and Other Objects.* Aldershot, England: Ashgate.

Mansai 満済. 1959. "Mansai jūgō nikki" 満済准后日記. In *Zoku Gunsho ruijū* 續群書類從, suppl. 1, part 1, 2 vols.

Marion, Jean-Luc. 1991. *God without Being: Hors-Texte.* Chicago: University of Chicago Press.

Matisoff, Susan. 2002. "Barred from Paradise? Mount Kōya and the Karukaya Legend." In *Engendering Faith: Women and Buddhism in Premodern Japan,* ed. Barbara Ruch, 463–500. Ann Arbor: Center for Japanese Studies, University of Michigan.

Matsumae Takeshi 松前健. 1971. *Nihon shinwa no shinkenkyū: Nihon bunka keitōron josetsu* 日本神話の新研究：日本文化系統論序説. Tokyo: Ōfūsha shuppan.

Matsunaga, Alicia. 1969. *The Buddhist Philosophy of Assimilation: The Historical Development of the Honji-Suijaku Theory.* Rutland, VT: Tuttle.

Matsuo Kenji 松尾剛次. 1995. *Kamakura shin Bukkyō no tanjō: Kanjin, kegare, hakai no chūsei* 鎌倉新仏教の誕生：勧進・穢れ・破戒の中世. Tokyo: Kōdansha.

———. 2001. "Official Monks and Reclusive Monks: Focusing on the Salvation of Women." *Bulletin of the School of Oriental and African Studies, University of London* 64 (3): 369–380.

———. 2002. "Chūsei Rissō to wa nani ka: Kōfukuji Daijōin to Saidaiji matsuji" 中世律僧とは何か：興福寺大乗院と西大寺末寺. In *Chūsei no jiin taisei to shakai* 中世の寺院体制と社会, ed. Nakao Takashi, 30–47. Tokyo: Yoshikawa kōbunkan.

Matsuo Kōichi 松尾恒一. 2003. "Jinja kairō no saigi to shinkō: Kasugasha orō o chūshin to shite" 神社回廊の祭儀と信仰：春日社御廊を中心として. In *Sairei to geinō no bunkashi* 祭礼と芸能の文化史, ed. Sonoda Minoru and Fukuhara Toshio, 5–28. Kyoto: Shibunkaku shuppan.

Matsuoka Hideaki 松岡秀明. 1988. "Wagakuni ni okeru Ketsubonkyô shinkô ni tsuite no ichikôsatsu" わが国における血盆経信仰についての

一考察. In *Shûkyô to josei* 宗教と女性, ed. Sôgô Joseishi Kenkyûkai, 257-280. Tokyo: Yoshikawa Kôbunkan.

Matsuoka Shinpei 松岡心平, ed. 2009. *Kanmon nikki to chūsei bunka* 看聞日記と中世文化. Tokyo: Shinwasha.

Matsushima Ken 松島健. 1986. *Jizō bosatsuzō* 地蔵菩薩像. *Nihon no bijutsu* 293. Tokyo: Shibundō.

Matsushita Takaaki 松下 隆章. 1942. "Jizō shinkō to Kasuga jinja" 地蔵信仰と春日神社. *Mita bungaku* 17 (11): 62-73.

Matsuzaki Kenzō 松崎憲三. 1983. "Mawari Jizō no engi to shūzoku no denpa ni tsuite: Kinki no mawari Jizō o chūshin ni" 廻り地蔵の縁起と習俗の伝播について：近畿の廻り地蔵を中心に. In Sakurai Tokutarō 1983b, 225–254.

———. 1985. *Meguri no fōkuroa: Yugyōbutsu no kenkyū* 巡りのフォークロア：遊行仏の研究. Tokyo: Meicho shuppan.

McCallum, Donald F. 1998. "The Replication of Miraculous Images: The Zenkōji Amida and the Seiryōji Shaka." In *Images, Miracles, and Authority in Asian Religious Traditions*, ed. Richard H. Davis, 207–226. Boulder, CO: Westview Press.

McCullough, Helen Craig, trans. 1988. *The Tale of the Heike*. Stanford, CA: Stanford University Press.

Meeks, Lori Rachelle. 2003. "Nuns, Court Ladies, and Female Bodhisattvas: The Women of Japan's Medieval Ritsu-School Nuns' Revival Movement." Ph.D. diss., Princeton University.

———. 2010. "The Disappearing Medium: Reassessing the Place of Miko in the Religious Landscape of Premodern Japan." *History of Religions* 51 (1): 208–260.

Michaud, Philippe-Alain. 2004. *Aby Warburg and the Image in Motion*. Trans. Sophie Hawkes. New York: Zone Books.

Minobe Shigekatsu 美濃部重克. 1988. "Seken banashi to hanashi: 'Shasekishū' ni okeru 'kindai no koto' 'tashika naru koto'" 世間話とはなし：「沙石集」における「近代ノ事」「慥ナル事」. In *Chūsei denshō bungaku no shosō* 中世伝承文学の諸相, ed. Minobe Shigekatsu, 45–63. Osaka: Izumi shoin.

Mitchell, W. J. T. 2002. "Showing Seeing: A Critique of Visual Culture." *Journal of Visual Culture* 1 (2): 165–181.

Miyaji Akira 宮治昭. 1999. *Bukkyō bijutsu no ikonorojii: Indo kara Nihon made* 仏教美術のイコノロジー：インドから日本まで. Tokyo: Yoshikawa kōbunkan.

Miyazaki, Fumiko. 2005. "Female Pilgrims and Mount Fuji: Changing Perspectives on the Exclusion of Women." *Monumenta Nipponica* 60 (3): 339–391.

Miyoshi Tomokazu 三吉朋十. 1958. "Shiryō hōkoku: Shimentō to rokumentō 資料報告: 四面塔と六面塔." *Bukkyō to minzoku* 2:56–60.

Mizumoto Masahito 水本正人. 1996. *Shukujin shisō to hisabetsu buraku: Hisabetsumin ga naze sairei, kadozuke ni kakawaru no ka* 宿神思想と

被差別部落：被差別民がなぜ祭礼・門付にかかわるのか. Tokyo: Aka-ishi shoten.

Mizuno Keizaburō 水野敬三郎. 1996. "Shin Yakushiji Jizō bosatsu zō (Kage-kiyo Jizō) ni tsuite" 新薬師寺地蔵菩薩像（影清地蔵）について. In *Ni-hon chōkokushi kenkyū* 日本彫刻史研究, ed. Mizuno Keizaburō, 412–424. Tokyo: Chūō kōron bijutsu shuppan.

Mochizuki Shinjō 望月信成. 1989. *Jizō bosatsu: Sono minamoto to shinkō o saguru* 地蔵菩薩：その源と信仰をさぐる. Tokyo: Gakuseisha.

Moerman, D. Max. 2004. "Paradigm Regained: Taking Syncretism Serious-ly." *Monumenta Nipponica* 59 (4): 525–533.

———. 2005. *Localizing Paradise: Kumano Pilgrimage and the Religious Landscape of Premodern Japan.* Cambridge, MA: Harvard University Press.

Morgan, David. 2005. *The Sacred Gaze: Religious Visual Culture in Theory and Practice.* Berkeley and Los Angeles: University of California Press.

Mōri Hisashi 毛利久. 1964. *Rokuharamitsuji* 六波羅蜜寺. Tokyo: Chūō kōron bijutsu shuppan.

———. 1974. "Jizō bosatsuzō no keisō" 地蔵菩薩像の形相. *Bukkyō geijutsu (Ars Buddhica)* 97:14–24.

Mōri Ichirō 毛利伊知郎, ed. 1986. *Mieken no bijutsu fūdo o saguru: Kodai, chūsei no shukyō to zōkei* 三重県の美術風土を探る：古代・中世の宗教と造形. Tsu: Mie kenritsu bijutsukan.

Morisue Yoshiaki 森末義彰. 1939. "Shōgun Jizō kō 勝軍地蔵考." *Bijutsu kenkyū* 91:1–16.

———. 1971. *Chūsei geinōshi ronkō: Sarugaku no nō no hatten to chūsei shakai* 中世芸能史論考：猿楽の能の発展と中世社会. Tokyo: Tōkyōdō shuppan.

Morita Tatsuo 森田竜雄. 2000. "Hachitataki" 鉢叩. In *Geinō, bunka no sekai* 芸能・文化の世界, ed. Yokota Fuyuhiko, 153–190. Tokyo: Yoshi-kawa kōbunkan.

Moriya Takeshi 守屋毅, ed. 1988. *Geinō to chinkon: Kanraku to kyūsai no dainamizumu* 芸能と鎮魂：歓楽と救済のダイナミズム. Tokyo: Shunjūsha.

Morley, Carolyn Anne. 1993. *Transformation, Miracles, and Mischief: The Mountain Priest Plays of Kyōgen.* Ithaca, NY: East Asia Program, Cor-nell University.

Morra, Joanne, and Marquard Smith, eds. 2006. *Visual Culture: Critical Concepts in Media and Cultural Studies.* 4 vols. London: Routledge.

Morrell, Robert E. 1982. "Passage to India Denied: Zeami's Kasuga Ryūjin." *Monumenta Nipponica* 37 (2): 179–200.

———. 1987. *Early Kamakura Buddhism: A Minority Report.* Berkeley, CA: Asian Humanities Press.

Morse, Samuel C. 1994. "Kyūsai e no yosoi" 救済への装い (Dressed for Sal-vation—the Hadaka Statues of the Twelfth and Thirteenth Centuries). In *Hito no "katachi," hito no "karada": Higashi Ajia bijutsu no shiza*

人の ＜かたち＞・人の ＜からだ＞：東アジア美術の視座 (The Human Form and the Human Body), ed. Tōkyō Kokuritsu Bunkazai Kenkyūjo, 31–46. Tokyo: Heibonsha.

———. 2002a. "Jizō in Mediaeval Japan: Three Works from the Ruth and Sherman Lee Institute." *Orientations* 33 (7): 52–59.

———. 2002b. "Kaikei saku Jizō bosatsu ryūzō" 快慶作地蔵菩薩立像." *Kokka* 1286:23–34.

Motoi Makiko 本井牧子. 2001. "Jizō bosatsu no fukusha: Setsuwa kara umareta shinkō" 地蔵菩薩の福舎：説話から生まれた信仰. *Kokugo kokubun* 70 (5): 35–52.

Motoki, Yasuo. 2006. "Kofukuji in the Late Heian Period." Trans. Mikael Adolphson. In *Capital and Countryside in Japan, 300–1180: Japanese Historians in English*, ed. Joan Piggot, 298–325. Ithaca, NY: East Asia Program, Cornell University.

Motoyama Keisen 本山桂川 and Okumura Hirosumi 奥村寛純, eds. 1989. *Shinpen Nihon Jizō jiten* 新編日本地蔵辞典. Tokyo: Murata shoten.

Mujū Ichien 無住一円. 1973. *Zōdanshū* 雑談集. Ed. Yamada Shōzen and Miki Sumito. Tokyo: Miyai shoten.

———. 1985. *Sand and Pebbles (Shasekishū): The Tales of Mujū Ichien, a Voice for Pluralism in Kamakura Buddhism*, trans. and annotated by Robert E. Morrell. Albany: State University of New York Press.

———. 2001. *Shasekishū* 沙石集. Ed. Kojima Takayuki. Tokyo: Shōgakkan.

Murakami, Fuminobu. 1988. "Incest and Rebirth in Kojiki." *Monumenta Nipponica* 43 (4): 455–463.

Murano Hiroshi 村野浩. 1993. "Moto Hakone sekibutsu, sekitō gun no chōsa" 元箱根石仏・石塔群の調査. *Hakonechō bunkazai kenkyū kiyō* 25:38–91.

Muraoka Kū 村岡空. 1975. *Ai no shinbutsu* 愛の神仏. Tokyo: Daizō shuppan.

Murayama Shūichi 中村修一. 1953. *Nihon toshi seikatsu no genryū* 日本都市生活の源流. Tokyo: Kanshoin.

———. 1974. *Honji suijaku* 本地垂迹. Tokyo: Yoshikawa kōbunkan.

Murray, Stephen O. 2000. *Homosexualities*. Chicago: University of Chicago Press.

Nakamura, Kyoko Motomochi, trans. 1973. *Miraculous Stories from the Japanese Buddhist Tradition: The "Nihon ryōiki" of the Monk Kyōkai*. Cambridge: Harvard University Press.

Nakamura Teiri 中村禎里. 1999. "Katsura Jizō jiken to chūsei shūsho shinkō" 桂地蔵事件と中世衆庶信仰. *Ōzaki gakuhō* 155:193–207.

Nakanishi, Gratia Williams. 1990. "The Boddhisattva Jizō Playing a Flute by Kanō Tan'yū: A New Interpretation." *Orientations* 21 (12): 36–45.

Nakano Masaki 中野政樹. 1975. "Kyōzō gaisetsu" 鏡像概説. In *Kyōzō* 鏡像, 109–124. Tokyo: Tōkyō kokuritsu hakubutsukan.

Nakano Masaki 中野政樹, Hirata Yutaka 平田寛, and Sekiguchi Masayuki 関口正之, eds. 1991. *Mandara to raigōzu: Heian no kaiga, kōgei* 曼荼羅と来迎図：平安の絵画・工芸. Vol. 1. Tokyo: Kōdansha.

Nakano Teruo 中野照男, ed. 1992. *Enma, Jūōzō* 閻魔・十王像. *Nihon no bijutsu* 313. Tokyo: Shibundō.

Nakanoin Masatada no Musume. 1973. *The Confessions of Lady Nijō*. Trans. Karen Brazell. Garden City, NY: Anchor Books.

Nakazawa Atsushi 中沢厚. 1988. *Ishi ni yadoru mono: Kai no ishigami to sekibutsu* 石にやどるもの：甲斐の石神と石仏. Tokyo: Heibonsha.

Nakazawa Shin'ichi 中沢新一. 2003. *Seirei no ō* 精霊の王. Tokyo: Kōdansha.

Nara kokuritsu hakubutsukan 奈良国立博物館. 1983. *Jōdo mandara: Gokuraku jōdo to raigō no roman* 浄土曼荼羅：極楽浄土と来迎のロマン. Nara: Nara kokuritsu hakubutsukan.

Narita Mikikazu 成田樹計. 1993. "'Konjaku monogatari' dai jūnana ni okeru Jizō zōzō no kudoku" 「今昔物語集」第十七における地蔵造像の功徳. *Taishō daigaku daigakuin kenkyū ronshū* 17:193–203.

Natsume, Soseki. 2002. *I Am a Cat*. Trans. Aiko Ito and Graeme Wilson. North Clarendon, VT: Tuttle.

Nattier, Jan. 1988. "The Meanings of the Maitreya Myth: A Typological Analysis." In *Maitreya, the Future Buddha*, ed. Alan H. Sponberg, 23–50. Cambridge: Cambridge University Press.

———. 1991. *Once upon a Future Time: Studies in a Buddhist Prophecy of Decline*. Berkeley: Asian Humanities Press.

Nedachi Kensuke 根立研介. 2006. *Nihon chūsei no busshi to shakai: Unkei to Kei-ha Shichijō busshi o chūshin ni* 日本中世の仏師と社会：運慶と慶派七条仏師を中心に. Tokyo: Hanawa shobō.

———. 2008. "Nihon no mokuchōzō no zōzō gijutsu hō: Ichi boku warihagi zukuri to yosegi zukuri o chūshin ni" 日本の木彫像の造像技法・一木割矧造りと寄木造りを中心に. In *Ki no bunka to kagaku* 木の文化と科学, ed. Itō Takao, 135–154. Ōtsu: Kaiseisha.

Nishio Kazumi 西尾和美. 1985. "Muromachi chūki Kyōto ni okeru kikin to minshū: Ōei nijū nen oyobi Kanshō ninen no kikin o chūshin to shite" 室町中期京都における飢饉と民衆：応永二十年及び寛正二年の飢饉を中心として. *Nihonshi kenkyū* 275:52–80.

Nishiyama Masaru 西山克. 1998. *Seichi no sōzōryoku: Sankei mandara o yomu* 聖地の想像力：参詣曼荼羅を読む. Kyoto: Hōzōkan.

Nishiyama Mika 西山美香. 2006a. "Gozan Zenrin no segakie ni tsuite: Suirikue kara no eikyō" 五山禅林の施餓鬼会について：水陸会からの影響. *Komazawa daigaku Zen kenkyūjo nenpō* 17:31–55.

———. 2007. "Ashikaga Yoshimitsu no 'hōzō' to shite no Hōdōji Rokuōin: Hōju to butsuga shari o megutte" 足利義満の＜宝蔵＞としての法幢寺鹿王院：法珠と仏牙舎利をめぐって. *Zeami: Chūsei no geijutsu to bunka* 4:120–133.

Noma Hiroshi 野間宏 and Okiura Kazuteru 沖浦和光. 1985. *Nihon no sei to sen: Chūsei hen* 日本の聖と賤：中世編. Tokyo: Jinbun shoin.

Noma Seiroku 野間清六, ed. 1978. *Kasuga gongen genki e* 春日権現験記絵. In *SNEZ*, vol. 16.

Ogasawara Kyōko 小笠原恭子. 1992. *Toshi to gekijō: Chūkinsei no chinkon, yūraku, kenryoku* 都市と劇場：中近世の鎮魂・遊楽・権力. Tokyo: Heibonsha.

Ōhashi Toshio 大橋俊雄. 1959. "Hōnen shōnin narabi ni sono monryū no honzonkan ni tsuite" 法然上人並びにその門流の本尊観に就いて. *Kenshin gakuen ronshū* 50 (10): 142–157.

Ōishi Masaaki 大石雅章. 2000. "Kōfukuji Daijōin monzeki to Risshū jiin" 興福寺大乗院門跡と律宗寺院. *Nihonshi kenkyū* 456:1–27.

Oishio Chihiro 追塩千尋. 2006. *Chūsei Nanto no sōryo to jiin* 中世南都の僧侶と寺院. Tokyo: Yoshikawa kōbunkan.

Okamoto Satoko 岡本智子. 2003. "Ōkura ha hōkyōintō no kenkyū" 大蔵派宝篋印塔の研究. *Kairitsu bunka* 2:73–94.

Ōkawa Naomi 大河直躬 and Ueda Tetsuji 植田哲司. 1992. "Bunkazai repōto: Shinyakushiji Jizōdō no fukugen shūri to munagi sumigaki: Kasuga miko, asobime no Jizō shinkō to no kankei" 文化財レポート：新薬師寺地蔵堂の復元修理と練木墨書：春日巫女、遊女の地蔵信仰との関係. *Nihon rekishi* 530:97–105.

Okazaki Jōji 岡崎譲治, ed. 1969. *Jōdokyō ga* 浄土教画. *Nihon no bijutsu* 43. Tokyo: Shibundō.

Oku Takeo 奥健夫. 1997. "Seiryōji, Jakkōin no Jizō bosatsuzō to 'gokyō no ryōyaku': Zōnai nyūhin ron no tame ni" 清凉寺・寂光院の地蔵菩薩像と「五境の良薬」：像内納入品論のために. *Bukkyō geijutsu (Ars Buddhica)* 234:87–116.

Okuizumi Hikaru 奥泉光. 2004. *Shin, chitei ryokō* 新・地底旅行. Tokyo: Asahi shinbunsha.

Okuno Yoshio 奥野義雄. 1986. "Jizōbon to nenbutsu kō: Jizōbon ni miru nenbutsu kō no shosō to Jizōbon no genshi keitai o chūshin ni" 地蔵盆と念仏講：地蔵盆にみる念仏講の諸相と地蔵盆の源初形態を中心に. In Itō Yuishin 1986, 119–142.

Ōmori Keiko 大森惠子. 1986. "Kūya to rokusai nenbutsu" 空也と六斎念仏. In Itō Yuishin 1986, 267–285.

———. 2005. "Denshō no naka no Kūyazō: Reigen kyōge tan, odori nenbutsu, daifukucha, Kūyasō nado" 伝承の中の空也像：霊験教化譚・踊念仏・大福茶・空也僧など. In Itō Yuishin 2005a, 153–184.

O'Neill, P. G. 1954. "The Nō Plays *Koi no Omoni* and *Yuya*." *Monumenta Nipponica* 10 (1/2): 203–226.

———. 1958a. "The Special Kasuga Wakamiya Festival of 1349." *Monumenta Nipponica* 14 (3/4): 408–428.

———. 1958b. "The Structure of Kusemai 曲舞." *Bulletin of the School of Oriental and African Studies, University of London* 21 (1/3): 100–110.

Onozawa Makoto 小野澤眞. 2007. "Chūsei tojō ni okeru hijiri no hatten: Higashiyama, Ryōzen Jishū ni okeru igi" 中世都城における聖の発展：東山、霊山時衆における意義. In *Chūsei no jiin to toshi, kenryoku* 中世の寺院と都市・権力, ed. Gomi Fumihiko and Kikuchi Hiroki, 218–255. Tokyo: Yamakawa shuppansha.

Orikuchi Shinobu 折口信夫. 1965a. "Okina no hassei" 翁の発生. In *Orikuchi Shinobu zenshū* 折口信夫全集, 2:371–415. Tokyo: Chūō kōronsha.

———. 1965b. "Sae no kami matsuri o chūshin ni" さへの神祭りを中心に. In *Orikuchi Shinobu zenshū* 折口信夫全集, 15:265–270. Tokyo: Chūō kōronsha.

Ortolani, Benito. 1984. "Shamanism in the Origins of the Nō Theatre." *Asian Theatre Journal* 1 (2): 166–190.

Osaka Shiritsu Hakubutsukan 大阪市立博物館, ed. 1987. *Shaji sankei mandara* 社寺参詣曼荼羅. Tokyo: Heibonsha.

Ōshima Takehiko 大島建彦. 1992a. *Dōsojin to Jizō* 道祖神と地蔵. Tokyo: Miyai shoten.

———, ed. 1992b. "Jizō, mōsō, Ono shi" 地蔵・盲僧・小野氏. In *Minkan no Jizō shinkō* 民間の地蔵信仰, ed. Ōshima Takehiko, 339–374. Tokyo: Keisuisha.

Ōshima Takehiko 大島建彦, Enomoto Chika 榎本千賀, et al., eds. 2002–2003. *Jūyonkanbon Jizō bosatsu reigenki* 一四卷本地蔵菩薩霊験記. 2 vols. Tokyo: Miyai shoten.

Ōta Koboku 太田古朴. 1974. *Suributsu, inbutsu: Zenkyōji, Hannyaji, Ōkuraji* 摺仏、印仏：善教寺・般若寺. Kyoto: Sōgeisha.

Ouwehand, Cornelis. 1964. *Namazu-e and Their Themes: An Interpretative Approach to Some Aspects of Japanese Folk Religion.* Leiden: Brill.

Pak, Youngsook. 1995. "The Role of Legend in Koryō Iconography (I): The Kṣitigarbha Triad in Engakuji." In *Function and Meaning in Buddhist Art*, ed. K. R. van Kooij and H. van der Veere, 157–165. Groningen, Netherlands: Egbert Forsten.

———. 1998. "The Korean Art Collection in the Metropolitan Museum of Art." In *Arts of Korea*, ed. J. G. Smith, 402–449. New York: Metropolitan Museum of Art.

Pandey, Rajyashree. 2007. "Performing the Body in Medieval Japanese Narratives: Izumi Shikibu in *Shasekishū*." *Japan Forum* 19 (1): 111–130.

Payne, Richard Karl, ed. 1998. *Re-visioning "Kamakura" Buddhism.* Honolulu: University of Hawai'i Press.

Peschard-Erlih, Erika. 1991. "Les mondes infernaux et les peintures des six voies dans le Japon bouddhique." Ph.D. diss., Institut national des langues et civilisations orientales Paris 3.

Pilgrim, Richard B. 1998. *Buddhism and the Arts of Japan.* New York: Columbia University Press.

Pinnington, Noel J. 1998. "Invented Origins: Muromachi Interpretations of *okina sarugaku*." *Bulletin of the School of Oriental and African Studies, University of London* 61 (3): 492–518.

Pinotti, Andrea. 2001. *Memorie del neutro: Morfologia dell'immagine in Aby Warburg.* Milan: Mimesis.

Pitelka, Morgan. 2008. "Wrapping and Unwrapping Art." In *What's the Use of Art? Asian Visual and Material Culture in Context*, ed. Jan Mrázek and Morgan Pitelka, 1–20. Honolulu: University of Hawai'i Press.

Pluth, Lisa Ann. 2004. "The Xumishan Grottos and the Iconography of Tang Dynasty Dizang." Ph.D. diss., University of Kansas.

Putzar, Edward D. 1963. "The Tale of Monkey Genji: Sarugenji-zōshi" 猿源氏草子. *Monumenta Nipponica* 18 (1/4): 286–312.

Quinter, David. 2007. "Creating Bodhisattvas: Eison, Hinin, and the 'Living Mañjuśrī'" *Monumenta Nipponica* 62 (4): 437–458.

Rambelli, Fabio. 2007. *Buddhist Materiality: A Cultural History of Objects in Japanese Buddhism.* Stanford, CA: Stanford University Press.

Rampley, Matthew. 1997. "From Symbol to Allegory: Aby Warburg's Theory of Art." *Art Bulletin* 79 (1): 41–55.

Rath, Eric C. 2000. "From Representation to Apotheosis: Nō's Modern Myth of Okina." *Asian Theatre Journal* 17 (2): 253–268.

———. 2004. *The Ethos of Noh: Actors and Their Art.* Cambridge, MA: Harvard University Press.

Ruch, Barbara. 1977. "Medieval Jongleurs and the Making of a National Literature." In *Japan in the Muromachi Age,* ed. John Whitney Hall and Toyoda Takeshi, 279–309. Berkeley and Los Angeles: University of California Press.

———. 1991. *Mō hitotsu no chūseizō: Bikuni, otogizōshi, raise* もう一つの中世像：比丘尼・御伽草紙・来世. Kyoto: Shibunkaku Shuppan.

Russell-Smith, Lilla. 2005. *Uygur Patronage in Dunhuang: Regional Art Centres on the Northern Silk Road in the Tenth and Eleventh Centuries.* Leiden: Brill.

Ryōhen 良遍. 1971. "Nenbutsu ōjō ketsushin ki" 念仏往生決心記. In *Jōdoshū zensho: Zoku* 浄土宗全書：続, ed. Jōdoshū Kaishū Happyakunen Kinen Keisan Junbikyoku, 15:557–573. Tokyo: Sankibō busshorin.

Saitō Ken'ichi 斉藤研一. 2003. *Kodomo no chūseishi* 子どもの中世史. Tokyo: Yoshikawa kōbunkan.

Saitō Masatoshi 斉藤昌利, Murano Hiroshi 村野浩, Ono Michitaka 小野迪孝, et al. 1990. "Moto Hakone sekibutsu no chōsa, kenkyū (kiyō)" 元箱根石仏の調査・研究(概要). *Tōkai daigaku kiyō, koyō gakubu* 21:189.

Sakamoto Tarō 坂本太郎 et al., cds. 1965. *Nihon shoki* 日本書紀. In *NKBT,* vols. 67 and 68.

Sakurai Tokutarō 桜井徳太郎. 1983a. "Honbō shamanizumu no henshitsu katei: Toku ni Jizō shinkō to sono shūgō ni tsuite" 本邦シャマニズムの変質過程：とくに地蔵信仰との習合について. In Sakurai Tokutarō 1983b, 225–254.

———, ed. 1983b. *Jizō shinkō* 地蔵信仰. Tokyo: Yūzankaku shuppan.

Sanford, James. 1997. "Wind, Waters, Stupas, Mandalas: Fetal Buddhahood in Shingon." *Japanese Journal of Religious Studies* 24 (1–2): 1–38.

Sasaki Kōzō 佐々木剛三. 1999. *Shintō Mandara no zuzōgaku: Kami kara hito e* 神道曼荼羅の図像学：神から人へ. Tokyo: Perikansha.

Sasaki Satoshi 佐々木聡, Shimizu Kunihiko 清水邦彦, Yoshikawa Yoshihisa 吉川嘉久, and Shibutani Mayuko 渋谷真悠子. 2005. "Kyū Shiramine

mura no itabi, sekibutsu" 旧白峰村の板碑・石仏. Special issue, *Hikaku shisō kenkyū* 32:52–55.

Saunders, Dale. 1985. *Mudrā: A Study of the Symbolic Gestures in Japanese Buddhist Sculpture*. Princeton, NJ: Princeton University Press.

Sawada Mizuho 澤田瑞穂. 1968. *Jigokuhen: Chūgoku no meikaisetsu* 地獄変：中国の冥界説. Kyoto: Hōzōkan.

Sawayama Mikako 沢山美果子. 1998. *Shussan to shintai no kinsei* 出産と身体の近世. Tokyo: Keisō shobō.

Scheid, Bernhard, and Mark Teeuwen, eds. 2006. *The Culture of Secrecy in Japanese Religion*. London: Routledge.

Schmidt, Peter, and Dieter Wuttke. 1993. *Aby M. Warburg und die Ikonologie*. Wiesbaden: Harrassowitz.

Schopen, Gregory. 1977. "Sukhāvatī as a Generalized Religious Goal in Sanskrit Mahāyāna Sūtra Literature." *Indo-Iranian Journal* 19 (3–4): 177–210.

———. 1984. "Filial Piety and the Monk in the Practices of Indian Buddhism: A Question of Sincization Viewed from the Other Side." *T'oung pao* 52:110–126.

Seidel, Anna. 2003. "Datsueba." In *Hobogirin: Dictionnaire encyclopédique du bouddhisme d'aprés les sources chinoises et japonaises; Daisho Kongo-Den'e*, ed. Jacques Gernet and Hubert Durt, 1159–1170. Paris: Maisonneuve; Tokyo: Maison franco-japonaise.

Seto Yumi 瀬戸友美. 1999. " 'Koyasu monogatari' ron: Jizō shinkō o chūshin ni" 「子安物語」論：地蔵信仰を中心に. *Aichi daigaku kokubungaku* 49:50–72.

Sharf, Robert H., and Elizabeth Horton Sharf, eds. 2001. *Living Images: Japanese Buddhist Icons in Context*. Stanford, CA: Stanford University Press.

Shibata Minoru 紫田実. 1974. *Gangōji Gokurakubō: Inbutsu, shōbutsu, suributsu, itae, sentaibutsu* 元興寺極楽坊：印仏・摺仏・刷仏・板絵・千体仏. Tokyo: Chūō kōron bijutsu shuppan.

Shibata Yoshinari 柴田芳成, Hashimoto Masatoshi 橋本正俊, and Motoi Makiko 本井牧子. 2005. " 'Kasuga gongen genki e' no shakaiteki, ningenteki haikei" 「春日権現験記絵」の社会的・人間的背景. In *Kasuga gongen genki e chūkai* 春日権現験記絵注解, ed. Ikegami Jun'ichi, 307–322. Osaka: Izumi shoin.

Shibusawa, Keizō 澁澤敬三. 1984. *Shinpan Emakimono ni yoru Nihon jōmin seikatsu ebiki* 新版絵卷物による日本常民生活絵引. Tokyo: Heibonsha.

Shimizu Kunihiko 清水邦彦. 1993. "Hōnen Jōdokyō ni okeru Jizō hibō" 法然浄土教における地蔵誹謗. *Nihon shisōshigaku* 25:43–54.

———. 1995. "Jōkei no Jizō shinkō" 貞慶の地蔵信仰. *Rinrigaku* 12:29–40.

———. 1996. "Ryōhen no Jizō shinkō" 良遍の地蔵信仰. *Indogaku bukkyōgaku kenkyū* 43 (1): 164–167.

———. 1999a. "Chūsei Rinzaishū no Jizō Shinkō" 中世臨済宗の地蔵信仰. *Indogaku bukkyōgaku kenkyū* 45 (2): 637–639.

———. 1999b. "Kenkyū nōto: Nihon ni okeru hōkō bosatsu shinkō no hatten" 研究ノート：日本における放光菩薩信仰の展開. *Hikaku minzoku kenkyū* 16:175–183.

———. 2000. "Jizō no myōji, saikō" 地蔵の名字・再考. *Hokuriku shūkyō bunka* 12:1–22.

———. 2002. "'Jizō juō kyo' kō" 「地蔵十王経」考. *Indogaku bukkyōgaku kenkyū* 51 (1): 189–194.

———. 2003. "Jitsuei hen 'Jizō bosatsu reigenki' saikō: Kōdate setsu o dō shiyō suru ka" 実睿編「地蔵菩薩霊験記」再考—高達説をどう止揚するか. *Nihon bukkyō sōgō kenkyū* 2:49–63.

———. 2005. "Jizō ga kodomo no sugata o toru koto ni tsuite" 地蔵が子どもの姿を取ることについて. *Hokuriku shūkyō bunka* 17:1–13.

Shimosaka Mamoru 下坂守. 2003. *Egakareta Nihon no chūsei: Ezu bunsekiron* 描かれた日本の中世：絵図分析論. Kyoto: Hōzōkan.

Shinpen kokka taikan 新編国歌大観. 1991. Tōkyō: Kadokawa Shoten.

Śikṣānanda. 2000. *Sutra of the Past Vows of Earth Store Bodhisattva*. Trans. Buddhist Text Translation Society. Burlingame, CA: The Society, Dharma Realm Buddhist University, Dharma Realm Buddhist Association.

Silk, Jonathan A. 2009. *Riven by Lust: Incest and Schism in Indian Buddhist Legend and Historiography*. Honolulu: University of Hawai'i Press.

Silver, Larry. 1993. *Art in History*. New York: Abbeville Press.

Soejima Hiromichi 副島弘道, Nagasawa Ichirō 長沢市郎, Mizuno Keizaburō 水野敬三郎, and Yabuuchi Satoshi 藪内佐斗司. 1986. "Shin Yakushiji Jizō bosatsuzō shūri kenkyū hōkoku" 新薬師寺地蔵菩薩像修理研究報告. *Tōkyō geijutsu daigaku bijutsu gakubu kiyō* 22:1–65.

Soymié, Michel. 1966–1967. "Notes d'iconographie chinoise: Les acolytes de Ti-tsang (I)." Parts 1 and 2. *Arts Asiatiques* 14:45–78; 16:141–170.

Spinelli, Italo, and Roberto Venuti, eds. 1998. *Mnemosyne: L'Atlante della memoria di Aby Warburg*. Rome: Artemide.

Stone, Jacqueline I. 2004. "By the Power of One's Last Nenbutsu: Deathbed Practices in Early Medieval Japan." In *Approaching the Land of Bliss: Religious Praxis in the Cult of Amitābha*, ed. Richard K. Payne and Kenneth K. Tanaka, 77–119. Honolulu: University of Hawai'i Press.

———. 2008. "With the Help of 'Good Friends': Deathbed Ritual Practices in Early Medieval Japan." In Stone and Walter 2008, 61–101.

Stone, Jacqueline I., and Mariko Namba Walter, eds. 2008. *Death and the Afterlife in Japanese Buddhism*. Honolulu: University of Hawai'i Press.

Strong, John. 1983. "Filial Piety and Buddhism: The Indian Antecedents to a 'Chinese' Problem." In *Traditions in Contact and Change*, ed. Peter Slater and Donald Wiebe, 171–186. Waterloo, Ontario: Wilfred Laurier University Press.

Sugawara Ikuko 菅原征子. 1966. "Heian makki ni okeru Jizō shinkō" 平安末期における地蔵信仰. *Shichō* 96:31–52, 75.

Sugiyama Jirō 杉山二郎. 1962. *Ōkuraji Jizō bosatsu zazō* 大蔵寺地蔵菩薩座像. *Museum* 141:19–22.

———. 1965. "Denkōji hadaka Jizō bosatsuzō ni tsuite" 伝香寺裸地蔵菩薩像について. *Museum* 167:23–34.

Suitō Makoto 水藤真. 1991. *Chūsei no sōsō, bosei: Sekitō o zōritsu suru koto* 中世の葬送・墓制 : 石塔を造立すること. Tokyo: Yoshikawa kōbunkan.

Suzuki Ryōichi 鈴木良一. 1983. *Daijōin jisha zōjiki: Aru monbatsu sōryo no botsuraku no kiroku* 大乗院寺社雑事記 : ある門閥僧侶の没落の記録. Tokyo: Soshiete.

Swearer, Donald K. 2004. *Becoming the Buddha: The Ritual of Image Consecration in Thailand*. Princeton, NJ: Princeton University Press.

Tabata Yasuko 田端泰子 and Hosokawa Ryōichi 細川涼一. 2002. *Nyonin, rōjin, kodomo* 女人、老人、子ども. Tokyo: Chūō kōron shinsha.

Tachikawa Yoshihiko 立川美彦. 1996. *Kyōtogaku no koten "Yōshū fushi"* 京都学の古典「雍州府志」. Tokyo: Heibonsha.

Taguchi Kazuo 田口和夫. 1997. *Nō, kyōgen kenkyū: Chūsei bungei ronkō* 能・狂言研究 : 中世文芸論考. Tokyo: Miyai shoten.

Ta'i Ryūichi. 田井竜一. 2006. "Katsura Jizō mae rokusai nenbutsu: Sono tokushitsu to denshō o megutte" 桂地蔵前六斎念仏 : その特質と伝承をめぐって. *Nihon dentō ongaku kenkyū* 3:41–66.

Taira Masayuki 平雅行. 1992. "Gedatsu Jōkei to akunin shōki" 解脱貞慶と悪人正機. In *Nihon chūsei no shakai to bukkyō* 日本中世社会と仏教, 266–284. Tokyo: Hanawa shobō.

Taira Yasuyori 平康頼. 1993. *Hōbutsushū to sakuin: Kyūsatsubon* 宝物集と索引 : 九冊本. Ed. Fukuhara Shōgo. Tokyo: Kindai bungeisha.

Takada Mamoru 高田衛. 1991. *Edo no ekusoshisuto* 江戸の悪霊祓い師. Tōkyō: Chikuma shobō.

Takahashi Mitsugu 高橋貢. 1983. "*Jizō bosatsu reigenki* seiritsu no ichi haikei" 「地蔵菩薩霊験記」成立の一背景. In Sakurai Tokutarō 1983b, 33–44.

Takahashi Yūsuke 髙橋悠介. 2009. "Sarugaku ni okeru kōjin shinkō: Konparu Zenchiku *Meishukushū* o chūshin ni" 猿楽における荒神信仰―金春禅竹「明宿集」を中心に. *Kokubungaku: Kaishaku to kanshō* 74 (10): 69–78.

Takamure Itsue 高群逸枝. 1956. "Kazoku seikatsu" 家族生活. In *Zusetsu Nihon bunkashi taikei* 図説日本文化史大系, ed. Kodama Kōta, 2:342–349. Tokyo: Shōgakkan.

Takashina Takakane 高階隆兼. 2005. *Kasuga Gongen genki e chūkai* 春日権現験記絵注解. Osaka: Izumi shoin.

Takasu Jun 鷹巣純. 2006. "Idemitsu bijutsukan bon Rokudō jūōzu ni miru dentō to chiikisei" 出光美術館本六道十王図に見る伝統と地域性. *Shūkyō minzoku kenkyū* 16:42–61.

Takei Akio 竹居明男. 1980. "Gedatsu shōnin Jōkei to Kasuga shinkō" 解脱上人貞慶と春日信仰. *Kikan Nihon shisōshi* 15:3–12.

Tamamuro Taijō 圭室諦成. 2004. *Sōshiki bukkyō* 葬式仏教. Tokyo: Daihōrinkaku.

Tanabe, George J., Jr. 1992. *Myōe the Dreamkeeper: Fantasy and Knowledge*

in Early Kamakura Buddhism. Cambridge, MA: Harvard University Press.

Tanaka Hisao 田中久夫. 1983. "Jizō shinkō no denpasha no mondai: *Shasekishū, Konjaku monogatarishū* no sekai" 地蔵信仰の伝播者の問題：「沙石集」「今昔物語集」の世界. In Sakurai Tokutarō 1983b, 139–166.

———. 1986a. "Jizō shinkō" 地蔵信仰. In *Bukkyō minzoku to sosen saishi* 仏教民俗と祖先祭祀, 1–129. Kyoto: Nagata bunshōdō.

———. 1986b. "Urabone to muen botoke" 盂蘭盆会と無縁仏. In Itō Yuishin 1986, 97–118.

———. 1989. *Jizō shinkō to minzoku* 地蔵信仰と民俗. Tokyo: Mokujisha.

———. 1998. "Happyaku bikuni no koto" 八百比丘尼のこと. *Shinjodai shigaku* 15:27–68.

Tanaka Jun 田中純. 2001. *Aby Warburg: Kioku no meikyū* アビ・ヴァールブルグ：記憶の迷宮. Tokyo: Seidosha.

Tanaka Ryokkō 田中緑紅. 1954. *Mibu dainenbutsu kyōgen* 壬生大念仏狂. Tokyo: Hana hakkōjo.

Tanaka Takako 田中貴子. 1995. "Torai suru kami to dochaku suru kami" 渡来する神と土着する神. In *Kami no shigen* 神の始原. Vol. 1 of *Nihon no kami* 日本の神, ed. Yamaori Tetsuo, 174–208. Tokyo: Heibonsha.

Tani Shindō 谷眞道. 1939. "Heianchō jidai ni okeru Jizō bosatsuzō" 平安朝時代に於ける地蔵菩薩像. *Mikkyō kenkyū* 69:93–105.

Teeuwen, Mark. 1996. *Watarai Shintō: An Intellectual History of the Outer Shrine in Ise*. Leiden: Research School CNWS.

Teeuwen, Mark, and Fabio Rambelli. 2003. *Buddhas and Kami in Japan: Honji suijaku as a Combinatory Paradigm*. New York: Routledge.

Teiser, Stephen F. 1988a. *The Ghost Festival in Medieval China*. Princeton, NJ: Princeton University Press.

———. 1988b. "'Having Once Died and Returned to Life': Representations of Hell in Medieval China." *Harvard Journal of Asiatic Studies* 48 (2): 433–464.

———. 1994. *The Scripture on the Ten Kings and the Making of Purgatory in Medieval Chinese Buddhism*. Honolulu: University of Hawai'i Press.

———. 2006. *Reinventing the Wheel: Paintings of Rebirth in Medieval Buddhist Temples*. Seattle: University of Washington Press.

ten Grotenhuis, Elizabeth. 1999. *Japanese Mandalas: Representations of Sacred Geography*. Honolulu: University of Hawai'i Press.

Tokuda Kazuo 徳田和夫. 1984. "Jigokugatari no ningyō kanjin (engeki to sono shūhen)" 地獄語りの人形勧進（演劇とその周辺）. *Kokugakuin zasshi* 85 (11): 84–98.

———. 1990. "Igyō no kanjin bikuni: Kumano bikuni zenshi no ittan" 異形の勧進比丘尼：熊野比丘尼前史の一端. In *Chūsei henrekimin no sekai* 中世遍歴民の世界, ed. Amino Yoshihiko, 111–116. Tokyo: Heibonsha.

———. 2002. *Otogizōshi jiten* お伽草子事典. Tokyo: Tōkyōdō shuppan.

———. 2003. "Denshō bungei to zuzō: Chūsei setsuwa, otogizōshi, kinsei

kaiga" 伝承文芸と図像：中世説話、お伽草子、近世絵画. In *Denshō bunka no tenbō: Nihon no minzoku, koten, geinō* 伝承文化の展望：日本の民俗・古典・芸能, ed. Fukuda Akira, 417–428. Tokyo: Miyai shoten.

Torii Akio 鳥居明雄. 1989. *Chinkon no chūsei: Nō, denshō bungaku no seishinshi* 鎮魂の中世：能、伝承文学の精神史. Tokyo: Perikansha.

Tsuchiya Megumi 土谷恵. 2001. *Chūsei jiin no shakai to geinō* 中世寺院の社会と芸能. Tokyo: Yoshikawa kōbunkan.

Tsutsui Sanae 筒井早苗. 1999. "Kasuga myōjin to Jōkei, Myōe setsuwa" 春日明神と貞慶、明恵説話. *Setsuwa bungaku kenkyū* 34:139–149.

Tsutsumi Teiko 堤禎子. 1992. "Chūsei Jizō shinkō no topos: Hitachi, Kita Shimōsa (Ibaraki ken) no baai" 中世地蔵信仰のトポス：常陸・北下総（茨城県）の場合. *Gekkan hyakka* 355:4–8; 356:17–22.

———. 1999. "Chūsei zenki no Ibaraki ken hokubu ni okeru jōdoteki sekai" 中世前期の茨城県北部における浄土教的世界. In *Kamakura bukkyō no yōsō* 鎌倉仏教の様相, ed. Takagi Yutaka and Komatsu Kuniaki, 211–248. Tokyo: Yoshikawa kōbunkan.

Tyler, Royall. 1978. "Jizō-mai (The Jizō Dance)." In *Granny Mountains: A Cycle of Nō Plays*. 130–140. Ithaca, NY: East Asia Program, Cornell University.

———. 1989. "Kōfukuji and Shugendō." *Japanese Journal of Religious Studies* 16 (2–3): 143–180.

———. 1990. *The Miracles of the Kasuga Deity*. New York: Columbia University Press.

Tyler, Susan C. 1989. "*Honji Suijaku* Faith." *Japanese Journal of Religious Studies* 16 (2–3): 227–250.

———. 1992. *The Cult of Kasuga Seen through Its Art*. Ann Arbor: Center for Japanese Studies, University of Michigan.

Ueda Sachiko 上田さち子. 1977. "Jōkei no shūkyō katsudō ni tsuite" 貞慶の宗教活動について. *Historia* 75:27–46.

Ueki Yukinobu 植木行宣, ed. 1974. "Katsuragawa Jizō ki" 桂川地蔵記. In *Dengaku, sarugaku* 田楽・猿楽, vol. 2 of *Nihon shomin bunka shiryō shūsei* 日本庶民文化史料集成, ed. Geinōshi kenkyūkai, 355–367. Tokyo: San'ichi shobō.

Umezu Jirō, ed. 梅津次郎. 1980. *Jizō Bosatsu reigenki e: Yata Jizō engi e; Seikōji engi e* 地蔵菩薩霊験記絵・矢田地蔵縁起絵、星光寺縁起絵. In *SNEZ*, vol. 29.

Unno, Mark. 2004. *Shingon Refractions: Myōe and the Mantra of Light*. Somerville, MA: Wisdom Publications.

von Gabian, Annemarie. 1973. "Ksitigarbha-kult in Zentralasien, Buchillustrationen aus den Turfan-Funden." In *Indologen-Tatung (Verhandlungen der Indologichen Arbeitstagung im Museum für Indische Kunst Berlin 7–9, Oktober, 1971)*, ed. Herbert Härtel and Volker Moeller, 41–71. Wiesbaden: Franz Steiner Verlag.

Wakabayashi, Haruko. 2002. "The Dharma for Sovereigns and Warriors:

Onjō-ji's Claim for Legitimacy in *Tengu zōshi.*" *Japanese Journal of Religious Studies* 29 (1–2): 35–66.

———. 2009. "Ono no Takamura and Medieval Images of Hell in the *Chikurinji engi.*" *Japanese Journal of Religious Studies* 36 (2): 35–66.

Wakamori Tarō 和歌森太郎. 1951. "Jizō shinkō ni tsuite" 地蔵信仰について. *Shūkyō kenkyū* 124:46–72.

Wakita Haruko 脇田晴子. 2001. *Josei geinō no genryū: Kugutsu, kusemai, shirabyōshi* 女性芸能の源流：傀儡子・曲舞・白拍子. Tokyo: Kadokawa shoten.

———. 2003. *Tennō to chūsei bunka* 天皇と中世文化. Tokyo: Yoshikawa kōbunkan.

Wakita, Masahiko 脇田雅彦. 1980. "Sae no kami ni okeru murasaki sonae to kyōmikon denshō" サエノカミにおける紫供えと兄妹婚伝承. In *Sei to minzoku* 性と民俗, ed. Nagoya minzoku kenkyūkai, 119–136. Seto: Nagoya minzoku kenkyūkai.

Walker, Brett L. 2001. *The Conquest of Ainu Lands: Ecology and Culture in Japanese Expansion, 1590–1800.* Berkeley and Los Angeles: University of California Press.

Wang-Toutain, Françoise. 1998. *Kṣitigarbha en Chine (du VIe siècle au XIIIe siècle) genèse d'un culte populaire.* Doctoral thesis. Université de Paris VII.

Warburg, Aby M. 1932. "Italienische Kunst und Internationale Astrologie in Palazzo Schifanoia zu Ferrara, 1912." In *Gesammelte Schriften*, ed. Gertrud Bing, 457–482. Leipzig and Berlin: B. G. Teubner.

———. 1992. *Ausgewählte Schriften und Würdigungen.* Ed. Dieter Wuttke. Baden-Baden: V. Koerner.

———. 1995. *Images from the Region of the Pueblo Indians of North America.* Trans. Michael P. Steinberg. Ithaca, NY: East Asia Program, Cornell University.

———. 1999. *The Renewal of Pagan Antiquity: Contributions to the Cultural History of the European Renaissance.* Trans. David Britt. Los Angeles: Getty Research Institute for the History of Art and the Humanities.

Washizuka Yasuaki 鷲塚泰光. 1977. "Jizō bosatsuzō: Tōfukuji" 地蔵菩薩像：東福寺. *Kokka* 1001:28.

Watanabe Shōgo 渡邊昭五. 1979. *"Ryōjin hishō" no fūzoku to bungei* 「梁塵秘抄」の風俗と文芸. Tokyo: Miyai shoten.

———. 1999. *Chūseishi no minshū shōdō bungei* 中世史の民衆唱導文芸. 2nd ed. Tokyo: Iwata shoin.

Watari Kōichi 渡浩一. 1980. "Heian makki minkan Jizō shinkō no kōzō: Minkan Jizō shinkō no ichi kōsatsu" 平安末期民間地蔵信仰の構造：民間地蔵信仰の一考察. *Bukkyō minzoku kenkyū* 5:11–36.

———. 1994. "Kegonkyō hajigoku ge o megutte: Ō shi sōsei setsuwa to kanjin jikkaizu o chūshin ni" 華厳経破地獄偈をめぐって：王氏蘇生説話と観心十界図を中心に. In *Setsuwa: Sukui to shite no shi* 説話・救いとしての死, ed. Setsuwa denshō gakkai, 165–187. Tokyo: Kanrin shobō.

———. 1996. " 'Sai no kawara' no denshō: 'Fuji no hitoana zōshi' to 'Sai no kawara Jizō wasan' o chūshin ni" 「賽の河原」の伝承：「富士の人穴草子」と「賽の河原地蔵和讃」を中心に. *Setsuwa, denshōgaku* 5:60–73.

———. 1997. Review of *Jizō no sekai* 地蔵の世界, by Ishikawa Jun'ichirō 石川純一郎. *Nihon minzokugaku* 209:127–132.

———. 1999. "Osanaki bōshatachi no sekai: 'Sai no kawara' no zuzō wo megutte" 幼き亡者たちの世界・「賽の河原」の図像をめぐって. In *"Sei to shi" no zuzōgaku* 「生と死」の図像学, ed. Meiji daigaku jinbun kagaku kenkyūjo, 193–243. Tokyo: Kasama shobō.

———. 2001a. "Kūyadō zō 'Kūya shōnin ekotobaden' to 'Sai no kawara kugōden': 'Sai no kawara' denshō o chūshin ni" 空也堂蔵「空也上人絵詞伝」と「西院河原口号伝」：「賽の河原」伝承を中心に. *Meiji daigaku kyōyō ronshū* 339:43–71.

———. 2001b. "Oni to kodomo to Jizō: 'Kotoro-kotoro' no kigen densetsu o megutte" 鬼と子どもと地蔵：「子取ろ子取ろ」の起源伝説をめぐって. *Meiji daigaku jinbun kagaku kenkyūjo kiyō* 49:95–108.

———. 2005. " 'Sai no kawara Jizō wasan' no shōdō: Kangebon 'Sai no kawara kugōden' o chūshin to shite" 「西院河原地蔵和讃」の唱導：勧化本「西院河原口号伝」を中心として. *Nihon shūkyō bunkashi kenkyū* 9 (1): 67–83.

———. 2006. "Shiryō shokai: Yamatogun Yamashi Yatadera zō, shinshutsu 'Yata Jizō maigetsu nikki e' ni tsuite" 資料紹介　大和郡山市矢田寺蔵・新出「矢田地蔵毎月日記絵」について. *Meiji daigaku kyōyō ronshū* 404:89–107.

Watson, James. 1982. "Of Flesh and Bones." In *Death and the Regeneration of Life,* ed. Maurice Bloch and Jonathan Parry, 155–186. Cambridge: Cambridge University Press.

Williams, Duncan Ryūken. 2005. *The Other Side of Zen: A Social History of Sōtō Zen Buddhism in Tokugawa Japan.* Princeton, NJ: Princeton University Press.

———. 2008. "Funerary Zen: Sōtō Zen Death Management in Tokugawa Japan." In Stone and Walter 2008, 207–246.

Williams, Joanna. 1973. "The Iconography of Khotanese Painting." *East and West* 23 (1–2): 109–154.

Wilson, Jeff. 2009. *Mourning the Unborn Dead: A Buddhist Ritual Comes to America.* Oxford: Oxford University Press.

Wind, Edgar. 1993. "Warburg's Concept of *Kulturwissenschaft* and Its Meaning for Aesthetics (1930)." In *The Eloquence of Symbols: Studies in Humanist Art,* ed. Jaynie Anderson, 21–35. Oxford: Clarendon Press.

Woodfield, Richard. 2001. "Warburg's 'Method.' " In *Art History as Cultural History: Warburg's Projects,* ed. Kathryn Brush and Richard Woodfield, 259–293. Amsterdam: G+B Arts International.

Yabuki Keiki 矢吹慶輝. 1927. *Sangaikyō no kenkyū* 三階教の研究. Tokyo: Iwanami shoten.

Yagi Seiya 八木聖弥. 1981. "'Mibu kyōgen' no seiritsu ni tsuite" 「壬生狂言」の成立について. *Bunka shigaku* 37:107–113.

Yagi Tōru 八木透. 1986. "Chinnōji no rokudō mairi" 珍皇寺の六道参り. In Itō Yuishin 1986, 397–413.

Yagi, Yasuyuki. 1988. "*Mura-Zakai*—The Japanese Village Boundary and Its Symbolic Interpretation." *Asian Folklore Studies* 47 (1): 137–151.

Yamada Itsuko 山田厳子. 2006. *Aomori ken ni okeru bukkyō shōdō kūkan no kisateki kenkyū: Zuzō, onsei, shintai* 青森県における仏教唱導空間の基礎的研究：図像・音声・身体. Hirosaki: Hirosaki daigaku.

Yamada Shōzen 山田昭全, ed. 2000. *Jōkei kōshiki shū* 貞慶講式集. Tokyo: Sankibō.

Yamada Yūji 山田雄司. 2007. *Bakkosuru onryō: Tatari to chinkon no Nihon shi* 跋扈する怨霊：祟りと鎮魂の日本史. Tokyo: Yoshikawa kōbunkan.

Yamaguchi Masao 山口昌男. 1989. *Tennōsei no bunka jinruigaku* 天皇制の文化人類学. Tokyo: Rippū shobō.

Yamaji Kōzō 山路興造. 1987. "Kamigakari kara geinō e: Minzoku gyōji ni okeru kamigakari no shisō" 神懸かりから芸能へ：民俗行事における神懸かりの思想. In *Matsuri wa kamigami no pafōmansu: Geinō o meguru Nihon to higashi Ajia* 祭りは神々のパフォーマンス：芸能をめぐる日本と東アジア, ed. Moriya Takeshi, 152–174. Tokyo: Rikitomi shobō.

Yamaji Sumi 山地純. 2002. "Kasuga Jizō raigō shōkō" 春日地蔵来迎小考. *Kanazawa bunko kenkyū* 308:18–34.

Yamakami Izumo 山上伊豆母. 1981. *Miko no rekishi: Nihon shūkyō no botai* 巫女の歴史：日本宗教の母胎. Tokyo: Yūzankaku.

Yamakawa Hitoshi 山川均. 2006. *Sekizōbutsu ga kataru chūsei shokunō shūdan* 石造物が語る中世職能集団. Tokyo: Yamakawa shuppansha.

Yamamoto Eigo 山本栄吾. 1983. "Chōgen nissōden shiken" 重源入宋伝私見. In *Chōgen, Eison, Ninshō* 重源・叡尊・忍性, ed. Nakao Takashi and Masaharu Imai, 38–64. Tokyo: Yoshikawa kōbunkan.

Yamamoto Hiroko 山本ひろ子. 1998. *Chūsei shinwa* 中世神話. Tokyo: Iwanami shoten.

———. 2003. *Ishin: Chūsei Nihon no hikyōteki sekai* 異神：中世日本の秘教的世界. Tokyo: Heibonsha.

Yamamoto Hiroko 山本ひろ子 and Sakayori Shin'ichi 酒寄進一. 2006. *Sairei: Kami to hito to no kyōen* 祭礼：神と人との饗宴. Tokyo: Heibonsha.

Yamamoto Kōji 山本興二. 1974. "Amida Jōdozu to Amida raigōzu" 阿弥陀浄土図と阿弥陀来迎図. In *Jōdokyō bijutsu no tenkai: Kenkyū happyō to zadankai* 浄土教美術の展開：研究発表と座談会, ed. Matsushita Takaaki, 19–21. Kyoto: Bukkyō bijutsu kenkyū ueno kinen zaidan josei kenkyūkai.

Yamamoto Tsutomu 山本勉. 1982. "Nara, Ōkuraji Jizō bosatsu zazō saikō: Kamakura jidai chūki no Enha busshi no sakurei to shite" 奈良・大蔵寺地蔵菩薩坐像再考：鎌倉時代中期の円派仏師の作例として. *Museum* 371:4–14.

Yamashita Masaji 山下正治. 1974. "Shasekishū no kenkyū (5): Jizō shinkō ni tsuite" 沙石集の研究(五) : 地蔵信仰について. *Risshō daigaku bungakubu ronsō* 50:85–109.

Yamazaki Shōzō 山崎省三. 1995. *Dōsojin wa maneku* 道祖神は招く. Tokyo: Shinchōsha.

Yanagita Kunio 柳田國男. 1997–2004. *Yanagita Kunio zenshū* 柳田國男全集. 32 vols. Tokyo: Chikuma shobō.

———. 1998. "Ishigami mondō" 石神問答. In *Yanagita Kunio zenshū* 柳田國男全集, 12:487–627. Tokyo: Chikuma shobō.

———. 1999. "Jizō dono no myōji" 地蔵殿の苗字. In *Yanagita Kunio zenshū* 柳田國男全集, 24:273–275. Tokyo: Chikuma shobō.

Yasuda, Takako 安田孝子, et al., eds. 1982. *Senjūshō chūshaku* 選集抄注釈. Nagoya-shi: Senjūshō kenkyūkai.

Yiengpruksawan, Mimi. 1994. "What's in a Name? Fujiwara Fixation in Japanese Cultural History." *Monumenta Nipponica* 49 (4): 423–453.

———. 1998. *Hiraizumi: Buddhist Art and Regional Politics in Twelfth-Century Japan*. Cambridge, MA: Harvard University Press.

Yoshida Kazuhiko 吉田一彦. 2006. "Suijaku shisō no juyō to tenkai: Honji suijaku setsu no seiritsu katei" 垂迹思想の受容と展開 : 本地垂迹説の成立過程. In *Nihon shakai ni okeru hotoke to kami* 日本社会における仏と神, ed. Hayami Tasuku, 198–220. Tokyo: Yoshikawa kōbunkan.

Yü, Chun-fang. 2001. *Kuan-yin: The Chinese Transformation of Avalokiteśvara*. New York: Columbia University Press.

Zeami 世阿弥. 1974. *Go'on, Sarugaku dangi* 五音、申楽談義. In *Zeami, Zenchiku* 世阿彌、 禪竹, ed. Omote Akira and Katō Shūichi, 205–232, 259–314. Tokyo: Iwanami shoten.

Zenchiku [Konparu Zenchiku] 禪竹 ［金春禅竹］. 1974. *Meishūkushū* 明宿集. In *Zeami, Zenchiku* 世阿彌、 禪竹, ed. Omote Akira and Katō Shūichi, 399–416. Tokyo: Iwanami shoten.

Zhiru [Ng, Sok-keng Lilian]. 2000. "The Emergence of the Sahā Triad in Contemporary Taiwan: Iconic Representation and Humanistic Buddhism." *Asia Major* 13 (2): 83–105.

———. 2005. "The Maitreya Connection in the Tang Development of Dizang Worship." *Harvard Journal of Asiatic Studies* 65 (1): 99–132.

———. 2007. *The Making of a Savior Bodhisattva: Dizang in Medieval China*. Honolulu: University of Hawai'i Press.

Zuikei Shūhō 瑞溪周鳳 and Ikō Myōan 惟高妙安. 1961. "Gaun nikkenroku batsuyū" 臥雲日件錄抜尤. In *Dai Nihon kokiroku* 大日本古記録, vol. 13, ed. Tōkyō Daigaku Shiryō Hensanjo. Tokyo: Iwanami Shoten.

Index

Illustrations are indicated by **boldface** type.